The Illustration of the Pauline Epistles

in French and English Bibles
of the
Twelfth and Thirteenth
Centuries

The Illustration of the Pauline Epistles

in French and English Bibles of the Twelfth and Thirteenth Centuries

LUBA ELEEN

CLARENDON PRESS · OXFORD

1982

Oxford University Press, Walton Street, Oxford OX2 6DP

London Glasgow New York Toronto
Delhi Bombay Calcutta Madras Karachi
Kuala Lumpur Singapore Hong Kong Tokyo
Nairobi Dar es Salaam Cape Town
Melbourne Auckland
and associate companies in
Beirut Berlin Ibadan Mexico City

Published in the United States
by Oxford University Press, New York

This book has been published with the help of a grant from the Canadian
Federation for the Humanities, using funds provided by the Social
Sciences and Humanities Research Council of Canada, and with the aid
of a grant from the Millard Meiss Foundation.

British Library Cataloguing in Publication Data
Eleen, Luba
The illustration of the Pauline Epistles in French
and English Bibles of the twelfth and thirteenth
centuries.
1. Bible .N.T. Epistles of Paul. Latin—
Illustrations
2. Illumination of books and manuscripts, Medieval
—England 3. Illumination of books and manuscripts,
Medieval—France
I. Title
745.6'7'0942 ND3361.E/
ISBN 0-19-817344-X

Printed in Great Britain by
BAS Printers Limited
Over Wallop, Hampshire

To my mother,
Lena Kolchin

Acknowledgements

This study began as a doctoral dissertation, eventually submitted to the Centre for Medieval Studies at the University of Toronto in 1972. During the many years in which I was engaged in research and writing, first of the thesis and then of the book, I was fortunate to be the recipient of generous advice and encouragement from a great number of scholars. I am deeply indebted to Peter Brieger, who first introduced me to the study of Bible illustration, to Beryl Smalley, an inspiration through her writings and in person to everyone working on the Bible in the Middle Ages, and to Stephen Vickers, my patient and astute thesis director, who suggested this subject to me.

I wish also to express my gratitude to the many scholars who with great kindness answered my questions, discussed problems with me, and made valuable suggestions, in particular Elizabeth Alföldi, Adelaide Bennett, Leonard Boyle, Virginia Brown, Hugo Buchthal, Otto Demus, Robert Deshman, Herbert Kessler, John Leyerle, Michael Sheehan, and Edward Synan. Kurt Weitzmann, Alberto Falck, and Gerhard Schmidt kindly helped me to obtain photographs.

I am grateful also to the Librarians of the numerous institutions mentioned in these pages, who made it possible for me to consult their manuscripts, who patiently replied to my questions and supplied me with photographs. This study would not have been possible without the help and co-operation of the directors and staffs of the manuscript departments of the British Library, the Bibliothèque Nationale in Paris, the Bodleian Library in Oxford and the Vatican Library. I spent many fruitful weeks at the Index of Christian Art of Princeton University and in the Research Library at Dumbarton Oaks, and I wish to express my appreciation to their directors, Rosalie Green and Giles Constable.

The starting point of my research on this book was the collection of photographs of Bible illustrations of the Department of Fine Art of the University of Toronto, a resource which made it possible for me to see simultaneously what could previously be viewed only through extensive travel. Ann Hilty shared with me her wide knowledge of this body of material, and she undertook the formidable task of correspondence regarding the photographs and supervised the final typing and many other details, for which I am most grateful. Thanks are due as well to Louise Cormier, Sarah Darrow, and Elizabeth Leesti, graduate students who helped prepare the book for publication.

I have been aided by grants from the University of Toronto Associates in 1966, and from the Social Sciences and Humanities Research Council of Canada—and its predecessor the Canada Council—in 1966, 1967, 1973, and 1975; the Research Council also has generously awarded a subvention to assist in the publication of this book, as has the Millard Meiss Foundation.

My family have been most unselfish in freeing me to carry on the work of research and writing for more than a decade. My husband John Eleen has helped me with unwavering moral support and encouragement, and my daughters Laura and Martha Eleen have contributed by their sympathetic understanding. Finally, I owe the deepest gratitude to my mother, Lena Kolchin, to whom this book is dedicated, who has provided a constant model of intellectual curiosity throughout my life.

PHOTOGRAPH CREDITS

Except where noted below, photographs have been supplied by the collections in which the objects are kept. Numbers refer to the figures.

Alinari, Florence/Editorial Photocolor Archives: 15; Jörg P. Anders, Berlin: 17; Archives Photographiques/SPADEM, Paris: 37, 106; Luigi d'Aurizio, Bologna: 283, 307, 315, 319, 329; Benedettine di Priscilla, Rome: 29; Bildarchiv Foto Marburg: 58, 127, 170; Bildarchiv zur Buchmalerei, Univ.-Bibl. Saarbrücken: 278, 289, 306; Bodleian Library, by permission of New College, Oxford: 90–103; Hugo Buchthal, London: 14; Mme J. Colomb-Gérard, Paris: 52, 137, 140, 154, 157, 189; Louise Cormier, Toronto: 44; Courtauld Institute of Art, London: 195, 224; Gabinetto Fotografico Nazionale, Rome: 162, 181; François Garnier, Mézières-Les-Clery: 69, 104, 105, 108, 248, 252, 263, 269, 277, 280, 287, 291, 305, 311, 320, 323, 328; Harvard Fine Arts Library, A. K. Porter Collection: 39; Hauchard, Valenciennes: 60; L. Hay, Avranches: 143, 149, 153, 159, 163, 175, 179, 197, 202, 204, 205, 209–11; Hill Monastic Manuscript Library, Collegeville, Minn.: 264; Hirmer Fotoarchiv, Munich: 35, 194; R. Lalance, Meudon-La-Fôret: 63–7, 297; MAS, Barcelona: 38, 75, 122, 242, 244/321, 249, 265, 295, 316, 325; National Museum, Belgrade: 11, 13; R. Ohier, Boulogne-sur-Mer: 120; Aldo Reale, Rome: 51; C. Seltrecht, St. Gallen: 118; University of Michigan, reproduced through the courtesy of the Michigan-Princeton-Alexandria Expedition to Mount Sinai: 10; Stephen Vickers, Toronto: 45, 50, 57, 68, 145, 184; Institut für Kunstgeschichte der Universität Wien: 245, 250, 258, 266, 274, 279, 285, 290, 296, 303, 310, 317, 322, 327; Vivarelli, Rome: 308; Kurt Weitzmann, Princeton: 31.

Contents

List of Figures

Introduction

The bibliography on St. Paul as a historical figure, as a writer, and as a theologian is one of the richest in all literature. Yet relatively little has been written about him as a subject in Christian art, and there has not been a comprehensive analysis of Pauline representation in narrative and symbolic art in many years. Ernst von Dobschütz, in a much cited work, attempted such a survey in 1928.[1] His book is useful in its discussion of the appearance and attributes of Paul in Early Christian art; he also traces these themes in their Romanesque, Gothic, and Renaissance manifestations. Dobschütz was handicapped, however, by a lack of familiarity with the richly varied subject-matter of twelfth- and thirteenth-century Bibles, a disadvantage which led him to conclude that 'only a relatively small proportion of scenes from the life of the apostle Paul appear in art'.[2] This contention is contradicted by the evidence of twelfth- and thirteenth-century Epistle illustrations in Bibles, as is Dobschütz's further observation that episodes from Paul's journeys, trials, etc., did not appear in art until the Renaissance.[3]

In a similar vein, Emile Mâle, with his encyclopaedic knowledge of the monuments of medieval art, did not recognise the wealth of narrative canonical imagery as well as of subtly scholarly doctrinal representations hidden in illuminated Bibles. In *L'Art religieux du XIIIe siècle en France*,[4] which first appeared in 1898, and later in a posthumous article in the *Revue des deux mondes*, he reiterated his opinion that virtually all Pauline iconography of the thirteenth century was drawn from the Apocrypha: 'When we turn to the life of St. Paul, we are surprised to discover that the Middle Ages has not represented a single episode, if we set aside the two apocryphal scenes.'[5]

The hitherto uninvestigated images in Bibles, the subject of this book, do not appear suddenly in the twelfth century without warning; they are the product of a gradual accretion of pictorial tradition over many centuries that was more extensive than Dobschütz and Mâle imagined. If these authors were writing today they would have been able to draw on the achievements of more than a few scholars of the past generation, particularly the last ten years, who, in the course of re-evaluating individual monuments, have introduced or refreshed our memories about a substantial body of single images and more extended sequences in which the Apostle to the Gentiles appears. Stephan Waetzoldt's careful renaming of the scenes in San Paolo fuori le mura in Rome, for example, is particularly helpful in any study of transmission of iconographic motifs, and Pasquale Testini has put into order a great many of the images of Paul in the 'minor arts' in the Early Christian period.[6] The studies of Otto Demus and Ernst Kitzinger of

[1] E. von Dobschütz, *Der Apostel Paulus* (Halle, 1928), Teil 2, 'Seine Stellung in der Kunst'; and E. von Dobschütz, 'Die Bekehrung des Paulus', *Repertorium für Kunstwissenschaft*, 5 (1929), 87–111.

[2] Dobschütz, *Paulus*, 8.

[3] Ibid., 30.

[4] E. Mâle, *L'Art religieux du XIIIe siècle en France*, rev. ed. (Paris, 1923), 296–300.

[5] E. Mâle, 'Les Apôtres Pierre et Paul', *Revue des deux mondes*, 15 July, 1 August 1955, 193–208, 385–97.

[6] S. Waetzoldt, *Die Kopien des 17. Jahrhunderts nach Mosaiken und Wandmalereien in Rom*, Römische Forschungen der

the Sicilian mosaics have clarified a number of themes from the life of Paul recounted in the Acts of the Apostles.[7] More recently, the Carolingian Bibles have been thoroughly examined in a book by Herbert Kessler and in articles by Joachim Gaehde, Hugo Buchthal, and Erika Dinkler-von Schubert, all of whom have helped to cast light on the relation of the Carolingian Acts sequences to those of Early Christian and Byzantine art.[8] The iconography of the book of Acts *per se*, a long-neglected aspect of Christian iconography, has attracted attention, and there have been articles on this subject by Kessler, Dorothy Glass, and myself.[9] Nevertheless, these are all studies of single monuments, or problems, and the comprehensive work remains to be written, although the most recent dictionary of iconography contains a more complete summary of Pauline imagery than has any of its predecessors.[10] I have therefore considered it necessary to devote Chapter One of my study to a review of the pictorial traditions of the earlier Middle Ages, the point of departure for later Bible illustration.

There is another aspect to the iconography of St. Paul, one that is the principal concern of this book. Very little has been said about pictorial imagery that directly or indirectly expresses the message of the Epistles. A pioneering effort, never followed up, was written by Adalbert Erbach-Fürstenau in 1910 as an appendix to his work on the Manfred Bible.[11] He collected and described a cycle of mysterious Pauline scenes which was used to illustrate all fourteen Epistles in five Bibles. Unfortunately all but two of Erbach-Fürstenau's manuscripts were inferior examples of this recension, but he described them with great accuracy although he had no idea what they meant. Subsequent literature has ignored his discovery, although Robert Branner, again writing in another context, also has identified some of these themes.[12]

The purpose of my book is to describe and interpret the iconography of the historiated initials accompanying the Pauline Epistles in Bibles of the twelfth and thirteenth centuries. I have been fortunate to be the first to draw on what promises to become a key source for the study of medieval Bible imagery, the *Corpus of Bible Illustrations* in the Department of Fine Art in the University of Toronto. The *Corpus* consists of detailed descriptions and photographs of almost

Biblioteca Hertziana, Band XVIII (Wien-München, 1964), 55–64, Figs. 366–407; and P. Testini, 'L'iconografia degli apostoli Pietro e Paolo nelle cosidette "arti minori"', *Saecularia Petri et Pauli*, Studi di Antichità Cristiana, 28 (Vatican City, 1969), 241–323.

[7] O. Demus, *The Mosaics of Norman Sicily* (London, 1949); and E. Kitzinger, *I mosaici di Monreale* (Palermo, 1960).

[8] H. L. Kessler, *The Illustrated Bibles from Tours* (Princeton, 1977); J. E. Gaehde, 'The Turonian Sources of the Bible of San Paolo Fuori Le Mura in Rome', *Frühmittelalterliche Studien*, 5 (1971), 359–400; H. Buchthal, 'Some Representations from the Life of St. Paul in Byzantine and Carolingian art', in *Tortulae: Studien zu altchristlichen und byzantinischen Monumenten*, ed. W. N. Schumacher (Freiburg, 1966), 43–8; and E. Dinkler-von Schubert, '"Per Murum Dimiserunt Eum": zur Ikonographie von Acta IX, 25 und 2 Cor. XI, 33', in *Studien zur Buchmalerei und Goldschmiedekunst des Mittelalters* (Marburg, 1967), 79–92.

[9] D. Glass, 'The Archivolt Sculpture at Sessa Aurunca', *Art Bulletin*, 52 (June, 1970), 119–31; H. L. Kessler, 'Paris, Gr. 102: A Rare Illustrated Acts of the Apostles', *Dumbarton Oaks Papers*, 27 (1973), 211–16; L. Eleen, 'Acts Illustration in

Italy and Byzantium', *Dumbarton Oaks Papers*, 31 (1977), 253–78. Several theses relevant to this subject have been written: A. Weil Carr, 'The Rockefeller-McCormick New Testament: Studies Toward the Reattribution of Chicago, University Library MS. 965' (Diss. University of Michigan, 1973); C. Kinder Carr, 'Aspects of the Iconography of Saint Peter in Medieval Art of Western Europe to the Early Thirteenth Century (Diss. Case Western University, 1978); T. Martone, 'The Theme of the Conversion of St. Paul in Italian Paintings from the Early Christian Period to the Early Renaissance' (Diss. New York University, 1977).

[10] *Lexikon der christlichen Ikonographie*, vol. VIII (1976), cols. 128–47, s.v., 'Paulus'. Cf. K. Künstle, *Ikonographie der Heiligen*, vol. II of *Ikonographie der christlichen Kunst* (Freiburg, 1926), 487–90; and L. Réau, *Iconographie de l'art chrétien*, vol. III (Paris, 1959), 1038–50.

[11] A. Erbach-Fürstenau, *Die Manfredbibel*, Kunstgeschichtliche Forschungen herausgegeben vom königlich preussischen historischen Institut in Rom, Band I (Leipzig, 1910), 34–5, 54–8.

[12] R. Branner, *Manuscript Painting in Paris During the Reign of Saint Louis* (Berkeley, Los Angeles, London, 1977), 194–5.

all of the twelfth- and thirteenth-century Bibles known to thave been made in the areas contained by the modern political boundaries of England, France, and Belgium. Not all of these include the Pauline Epistles and many are decorated with ornamental designs only, but there is still a significantly large number of Bibles with historiated initials for the Epistles.[13]

The main body of my material—that is, the Bible iconography—has been divided into three categories corresponding to Chapters Two, Three, and Four. Chapter Two explores the relationship to the Epistles texts of a group of simple scenes—non-narrative for the most part—which appear most frequently as Epistle illustration. These are interesting because they give insight into the thinking of medieval iconographers in regard to the connections between the pictures and texts. The general principles elucidated here also apply—in a more complex way—to the subjects studied in Chapters Three and Four; thus Chapter Two serves as a bridge between the topic of Pauline iconography in general and Pauline iconography applied to Bible illustration. Chapter Three deals with the small but important group of Bibles which employ scenes from Acts as illustrations for the Epistles. This is a continuation of some of the themes dealt with in Chapter One, seen now within the context of the book of which the picture is a part. Finally, in Chapter Four I discuss a group of manuscripts illustrated with a complex doctrinal scheme based on a literal and allegorical interpretation of the texts of the Epistles and of the Prologues accompanying them. Some members of this group were discovered by Erbach-Fürstenau, and I have collected eighteen examples which can be included in it.

The logic of the sequence is twofold: it develops from simplicity to complexity and from tradition to innovation. While the subjects dealt with in Chapters Two and Three have their roots in the past, Chapter Four represents a new departure. The Epistles and the pictures associated with them are looked at with fresh eyes, and Pauline imagery is used in a new way. The illustrations begin to function almost as commentaries on the text. These visual commentaries have a wider than art-historical significance and might prove of possible interest to the theologian and to the student of intellectual history.

[13] See Appendix A for a comparative chart of Pauline Acts iconography and Appendix B for a chart of iconography in historiated Epistle initials.

CHAPTER ONE

A Survey of Pauline Iconography to the
Thirteenth Century

As will be seen from these pages, images of St. Paul were popular in medieval art from the earliest times, in both East and West. He appeared alone, or in company with Peter and the other apostles, in a variety of symbolic and narrative scenes. This first chapter, which traces the chronology of these depictions, is not intended as an exhaustive catalogue of every monument in which the figure of Paul appears. Rather, it should serve as a fund of information to which the Bible illustrations—the primary concern of my study—can be related. Subjects which are of relevance to later discussions are examined at some length; others are simply recorded, to contradict the notion that there was little interest in Pauline imagery, especially narrative imagery, in the Middle Ages, and to define the iconographic milieu in which book illumination was undertaken. Although this section is concerned for the most part with monumental art, portable objects, and manuscripts other than Bibles up to the thirteenth century, there are some exceptions to this rule: Pauline subjects in the Carolingian Bibles and in several Byzantine and Italian New Testaments are examined in detail. My interest here is in their connection with the iconography of St. Paul in general. When some of these manuscripts reappear in later sections, it is in the context of Pauline subjects as they relate to the text of the Epistles.

A recurring theme in my investigation will be the consideration of *traditio* and *renovatio*. Is there a 'history' of Pauline iconography? To what extent does the later Middle Ages inherit material from earlier times—through direct descent or renewal—and how much is newly invented? At the present stage of knowledge, it is difficult, if not impossible, to provide final answers, but an airing of the problems will, perhaps, benefit future research.

I. EARLY CHRISTIAN MONUMENTS UP TO *c*.700[1]

The figure of Paul occurs frequently in Early Christian art, often in the company of Peter, as in the representations of the *traditio legis*—Christ giving the scroll of the Law to Peter in the presence of Paul (Fig. 1)[2]—or simply in commemorative medals or pieces of gold-glass displaying the portraits of both saints (Figs. 2, 5).[3] The joining of these two sacred figures is not surprising, since Rome was the accepted site of martyrdom of the two principal apostles. By the third century their

[1] See Dobschütz, *Paulus*, 12–16; H. Le Clerq, in *Dictionnaire d'archéologie chrétienne et de liturgie* (hereafter *DACL*), XIII, ii (1938), s.v., 'Paul (Saint)', cols. 2694–9; and P. Testini, 'L'iconografia'.

[2] e.g. in a gold-glass plaque in the Toledo (Ohio) Museum of Art, of the 4th c. (acc. no. 67.12); see W. N. Schumacher, 'Dominus Legem Dat', *Römische Quartalschrift*, 54 (1959), 1–39. In several Ravenna sarcophagi Paul is the recipient; see

Corpus della scultura paleocristiana bizantina ed altomedioevale di Ravenna, ed. G. Bovini, II (Rome, 1968), 27–9, 31–2, Figs. 8b, 9a, 12a. The question of the relative prominence of Peter and Paul is summed up by E. Kitzinger, 'A Marble Relief of the Theodosian Period', *The Art of Byzantium and the Medieval West: Selected Studies* (Bloomington and London, 1976), 17–18.

[3] Testini, 'L'iconografia', 273–6, Figs. 21–5.

joint feast day of June 29 had been established and a cult of veneration was developing.[4] Much of the literature describing the role of Paul in visual art has been concerned with these joint Peter–Paul portraits and the group scenes of the apostles in which Peter and Paul occupy a prominent place. Such questions as the relation of Peter and Paul to each other, and the reason why Paul is represented on Christ's right and Peter on the left, have received their share of attention.[5]

It is of interest to trace the emergence of the typical physiognomy of Paul. The only description in Scripture is that given in II Corinthians 10: 10 in which Paul quotes his opponent's opinion of him: 'His letters are weighty and strong, but his bodily presence is weak, and as a speaker he is beneath contempt.'[6] The sparse information contained in II Corinthians was amplified in the second century. Sometime around AD 160 an apocryphal tale recounting the exploits of Paul was composed by a presbyter in Asia giving a more specific description of him as a man of short stature, with close-cropped, bristling hair, a bald head, crooked legs, eyebrows meeting, and aquiline nose, but full of grace.[7] True or invented, this description, with the addition of a pointed beard, provided the pattern for the portrait of Paul that eventually became commonplace in Christian art, so that it is usually possible to recognize him immediately without the addition of symbolic attributes, no matter how inept the artist.

Recent discussion of Christian portraiture in the late antique period has tended to advance the dates of the earliest portraits, from the third to the mid-fourth century.[8] Whatever the chronology of the Christian portrait in general, Paul was one of the first to be represented in a characteristic manner. Epiphanius of Cyprus, for example, writing at the end of the fourth century, indicates that he is familiar with bearded, bald and half-bald depictions of Paul.[9]

The standard formula for Paul, however, was not universally accepted immediately. Some of the earliest portraits of him can be recognized only by their inscriptions. One example is a gold-glass fragment in the Metropolitan Museum of Art in New York of *c.*350 in which both Paul and Peter are youthful and unbearded, with full heads of hair (Fig. 2).[10] A somewhat later but

[4] V. L. Kennedy, *The Saints of the Canon of the Mass*, Studi di Antichità Cristiana, 14 (Vatican City, 1938), 93–102; E. Josi, 'La venerazione degli apostoli Pietro e Paolo nel mondo cristiano antico', *Saecularia Petri et Pauli*, 149–97; and V. Saxer, 'Le culte des apôtres Pierre et Paul dans les plus vieux formulaires romains de la messe du 29 juin', ibid. 199–240. By the seventh c., a second feast on 30 June was added, dedicated only to Paul (*The Oxford Dictionary of the Christian Church* (hereafter *ODCC*), ed. F. L. Cross (London, 1957), s.v. 'Paul', 1030).

[5] For example, in Dobschütz, *Paulus*, 1–30, and Mâle, 'Apôtres'.

[6] II Cor. 10: 10: 'Epistolae, inquiunt, graves sunt et fortes, praesentia autem corporis infirma, et sermo contemptibilis.'

[7] 'statura brevis, attonso capite et reburro, cruribus scambus, necnon subcaluaster, superciliis iunctis, naso aquilino et gratia plenus.' This description of Paul is given in the *Acta Pauli et Theclae*, which was known in the west at an early date. (Tertullian, in *De Baptismo*, ed. J. M. Lupton (Cambridge, 1908), Part XVII, 48–9, refers to an episode from the legend.) For the Latin text see *Passio Sanctae Theclae Virginis: Die lateinischen Uebersetzungen der Acta Pauli et Theclae*, ed. O. von Gebhardt, in *Texte und Untersuchungen*, NS VII, 2 (Leipzig, 1902), 9. Paul shares equal honours with Thecla in this version of the life of Paul, one of several

fragments which circulated independently. The few pictorial representations of Apocryphal Pauline themes surviving from the early Christian period seem to have been inspired by it (see below, n. 16). In *Acta Apostolorum Apocrypha*, ed. R. A. Lipsius and M. Bonnet (Leipzig, 1891, repr. Darmstadt, 1959), I, 235–72, only the Greek text, as known in 1891, is given. There has been some confusion regarding the kinship between several Apocryphal legends of St. Paul. See Edgar Hennecke, *New Testament Apocrypha*, ed. Wilhelm Schneemelcher, transl. R. McL. Wilson (Philadelphia, 1965), II, 322–90; and W. Schneemelcher, 'Die Acta Pauli: Neue Funde und neue Aufgaben', *Theologische Literaturzeitung*, 89 (1964), 241–54 (also see below, n. 106).

[8] J. D. Breckenridge, 'Apocrypha of Early Christian Portraiture', *Byzantinische Zeitschrift*, 67 (1974), 101–9. Testini, 'L'iconografia', also favours a later chronology.

[9] K. Holl, *Gesammelte Aufsätze zur Kirchengeschichte* (Tübingen, 1928, repr. Darmstadt, 1964), 362, no. 26: Nicephorus adv. Epiph. XIX 86, cited by Kitzinger, 'Marble Relief', 17, n. 64, who points out that the portrait of Paul was defined in pictorial art before that of Peter.

[10] No. 11.91.4. See *The Gold-Glass Collection of the Vatican Library with Additional Catalogues of Other Gold-Glass Collections*, text by C. R. Morey (Vatican City, 1959), for other representations of Paul as a beardless youth: in the Museo

extremely interesting provincial example with what might represent two portraits of Paul can be seen in the so-called 'Freising Fragments'.[11] This manuscript, which was probably produced in Africa and Spain in the sixth and seventh centuries, contains an Old Latin version of the text of the Pauline Epistles. The beginning of each Epistle is ornamented with an enlarged initial P. In two of the initials are drawn heads, one in profile with a laurel wreath (Fig. 3), and the other in full face, unbearded, with an ample head of hair. The heads might be intended as author portraits of Paul, and if so they indicate that even as late as *c*.600 the standard Paul-type was not yet established in provincial centres.[12]

In Rome and Constantinople, however, there are few examples of the youthful, non-specific type later than the fifth century, by which time the characteristic portrait of Paul was well established. An early depiction on a gold-glass vessel in the Vatican Museum already displays the fully developed Pauline physiognomy: a distinctive hairline—completely bald on top with a curled fringe remaining at the sides—combined with a pointed beard and a prominent nose (Fig. 4).[13] Very close to this face in type and date is that on a bronze medal—a portrait of Peter and Paul—in the same museum (Fig. 5); in it Paul displays the typical hairline, and only the shape of his beard differs from that in the gold-glass portrait, but it is still different from Peter's.[14] The well-known sarcophagus of Junius Bassus, who died in AD 359, also presents the standard image of Paul in the scene of his arrest; here he has a shorter and more curling beard but he is easily recognizable, the more so when linked with Peter, who, as usual, is of the type of the patriarch, with a full head of curling hair and a 'philosopher's' beard.[15]

Although the life of Paul, as contrasted with depictions of Paul in dogmatic statements such as the *traditio legis*, is not a frequently occurring subject in extant works of Early Christian art, surviving evidence suggests that there once existed a wider repertoire of narrative Pauline themes than is generally recognized.

Principal sources of information about Paul's experiences are the Acts of the Apostles—in which Paul plays the most prominent role—and the Apocrypha. Both sources inspired works of art in Early Christian times, although the Apocryphal tales did not come into their own as pictorial subjects until the eighth century at the earliest.[16]

Civico in Bologna (p. 47, no. 270, pl. XXVII); in the British Museum (p. 55, no. 323, pl. XXX); and in Pusey House, Oxford (p. 60, no. 360, pl. XXXI).

[11] Munich, Staatsbibl. Clm 6436 and loose folios in Clm 6230 + Universitätsbibl. 4° 928 + Göttweig s.n. (r [r², r³]); *Vetus Latina* 64. A complete bibliography can be found in H. J. Frede, *Altlateinische Paulus-Handschriften*, Bd. IV of *Vetus Latina: Die Reste der altlateinischen Bibel* (Freiburg, 1964), 102–20. The MS was edited by D. De Bruyne, *Les Fragments de Freising, Collectanea Biblica Latina*, V (Rome, 1921).

[12] C. Nordenfalk, *Die spätantiken Zierbuchstaben*, Bd. II of *Die Buchornamentik der Spätantike* (Stockholm, 1970), 144–5, pls. IV, 51a, 52a, who dates the manuscript at the beginning of the 6th c., doubts that the heads are author portraits. His argument that they do not conform to the standard type of Pauline physiognomy can be countered by the examples of the youthful Paul given above, which might have been made

as late as the 5th c.

[13] Morey, *Gold-Glass*, 13–14, no. 54, pl. IX; Testini, 'L'iconografia', no. 181, and F. Gerke, *Das heilige Antlitz* (Berlin, 1940), 37–49, Figs. 38, 53, 55, 56, give other examples of this type.

[14] Testini, 'L'iconografia', no. 76, Fig. 26.

[15] J. Wilpert, *I sarcofagi cristiani antichi*, I (Rome, 1929), 24, 35, 37, 131, 164, pl. XIII; F. Gerke, *Der Sarkophag des Junius Bassus* (Berlin, 1936), Fig. 25.

[16] See below, pp. 9–10, n. 51. Some examples of apocryphal imagery, drawn for the most part from the *Acta Pauli et Theclae* (n. 7) are: El Bagaouat, Necropolis, cupola of chapel no. 80, fresco depicting Thecla tortured in a brazier, 4th c. or later (see H. Stern 'Les mosaïques de l'église de Sainte-Constance à Rome', *Dumbarton Oaks Papers*, 12 (1958), 157–218, especially 183, no. 120); London, British Museum, ivory plaque (see below, n. 33); Etschmiadzin, Monastery Church, relief of the 5th to the 6th c., depicting

The major monument of Early Christian art devoted to the iconography of Paul's life, as recounted in Acts, was the fresco cycle decorating the left wall of the nave in the basilica of San Paolo fuori le mura in Rome, destroyed by fire in 1823.[17] The frescoes, probably made in the fifth century,[18] were restored several times, including the effort of Cavallini in the late thirteenth century,[19] and are known to us today only from the drawings made on orders of Cardinal Francesco Barberini in 1634.[20] As a consequence of their unfortunate history, it is only natural that a certain amount of controversy should have arisen during the course of the investigation of the San Paolo frescoes. There are two opposing opinions in regard to the iconography of the Acts scenes.

One group of authorities accepts the theory of Josef Garber that nothing of the Early Christian paintings on the left wall can be discerned in the Barberini drawings. According to this view, reiterated recently by Erika Dinkler-von Schubert, either the restoration substituted an entirely new set of subjects for a previous Christological cycle, or, at best, the original choice of scenes from the story of the apostles was followed, but amended drastically in terms of the new iconographic language of the thirteenth century.[21]

Another approach is represented by Stephan Waetzoldt, who insists that the original iconography can be detected in the seventeenth-century drawings. Waetzoldt accepts a date within the pontificate of Leo the Great (440–61) for the original design of the frescoes. The comments of John White in regard to the depiction of pictorial space within the scenes support this date as appropriate, although he assigns to the restoration a higher proportion of the remains than does Waetzoldt.[22]

Dinkler-von Schubert's argument against the suggestion that the fifth-century church of San Paolo was adorned with scenes from the life of its titular saint must be taken seriously. She maintains that it was unlikely that the iconographic programme of Paul's church should deviate in principle from the pattern set at Old St. Peter's: that is, confronted sequences of Old Testament and Christological scenes along the right and left nave walls. If the Prince of Apostles had not been commemorated in his own church with a pictorial cycle of his own life, according to

Thecla before Paul (see S. Der Nersessian, *Armenia and the Byzantine Empire* (Cambridge, Mass., 1945), 95); Rome, Museo Capitolino, relief on a fragment of a cover of a sarcophagus, showing Paul as a fisherman in a boat labelled 'Thecla' (M. Simon, 'L'Apôtre Paul dans le symbolisme funéraire chrétien', *Mélanges d'Archéologie et d'Histoire*, 50 (1933), 156–82).

[17] A bibliography and summary of scholarship is given by Waetzoldt, *Kopien*, 55–9; see also E. Dinkler-von Schubert, 'Per Murum', 82, 90, nn. 28 and 29.

[18] *Le Liber Pontificalis*, ed. L. Duchesne, I (Paris, 1886), 239. Under the heading of 'Leo (440–461)', it is recorded that 'Hic . . . basilicam . . . beati Pauli post ignem divinum renovavit.'

[19] Cavallini's work on San Paolo is noted by Ghiberti, 'dentro nella chiesa tutte le parieti della nave di meço erano dipinte [i.e. by Cavallini] storie del testamento vecchio'. J. von Schlosser, *Lorenzo Ghibertis Denkwürdigkeiten* (Berlin, 1912), I, 39. Most critics agree with Garber (see n. 21), that Ghiberti was correct in attributing the paintings of both sides of the nave to Cavallini, but in error in calling both 'testamento vecchio', possibly because the rarity of the

subjects from Acts made identification of the left wall difficult (p. 68). There is general agreement that the frescoes of the right wall already in the 5th c. depicted scenes from Genesis.

[20] Preserved in the Codex Vat. Barb. Lat. 4406, fols. 23–128.

[21] J. Garber, *Wirkungen der frühchristlichen Gemäldezyklen der alten Peters- und-Pauls-Basiliken in Rom*, Wiener kunstgeschichtliche Forschungen (Berlin-Wien, 1918), 27, 28, n. 2; Dobschütz, *Paulus*, 24; and Dinkler-von Schubert, 'Per Murum', 82, 90, n. 29, agree with Garber.

[22] Waetzoldt, *Kopien*, observes that 'Wir wissen, dass Cavallini bei der Uebermalung genau dem alten ikonographischen Bestand gefolgt ist' [i.e. for the Old Testament scenes] (p. 57); and further, 'Es lassen sich wieder zweifelsfrei Reste älterer Malerei erkennen' [of the Acts scenes] (p. 58). J. White, 'Cavallini and the Lost Frescoes in S. Paolo', *Journal of the Warburg and Courtauld Institutes*, 19 (1956), 84–95, also accepts the notion that substantial early Christian remains underlay Cavallini's work, as does H. Buchthal, 'Life of Paul', 46–8. White suggests that in those scenes which seem to reflect the earliest stage of the cycle the settings resemble other 5th-c. monuments.

this viewpoint, it was unlikely that St. Paul would have been so honoured. The evidence of the present study, however, tends to confirm the theory that the San Paolo New Testament cycle from its inception was illustrated with subjects taken from the Acts of the Apostles, and that some details of the original iconography can be detected in the drawings, albeit in distorted form. For example, the several depictions of Baptism show the rite taking place in natural springs or streams; in contrast, in the later medieval period, the inclination was to portray baptisms in fonts.[23]

It would be impossible to deny, however, that subsequent artists, including Cavallini, left marked impressions upon the remaining designs. In addition, Cavallini's apparent use of post-Iconoclastic Byzantine iconography, which I discuss below, complicates any attempt to reconstruct the original appearance of the frescoes. The question arises constantly as to whether the seemingly Byzantine elements at San Paolo derive from an Early Christian model, independently reflected at San Paolo and in Byzantium, or whether what remains now is substantially of the thirteenth century. A working hypothesis, taking into account both alternatives as well as later Western evidence, is that Cavallini repeated the Early Christian subjects, altering or amplifying them from new Byzantine or other sources where the original was inadequate; a careful consideration of individual scenes reveals certain of them to have withstood the confusing effects of both the late thirteenth-century and other restorations and the seventeenth-century copying.

Many of the scenes from the life of Paul in the frescoes are quite difficult to understand, perhaps because they were already mutilated when they were copied and the thirteenth-century restorer no longer grasped their exact meaning. Waetzoldt has published and relabelled every one of the Pauline scenes from San Paolo. His new titles mark a significant forward step towards the solution of the problem of understanding the frescoes, although it is possible to correct him in individual instances.[24] As one important contribution, he has fitted all the scenes, with one exception, into the canonical scheme of Acts. In contrast, Garber's previous identifications, on insufficient grounds, interpreted certain scenes as having been based on apocryphal texts: for example, where a woman appeared, she was often described as 'Thecla' (the heroine of the *Acta Pauli*). Dobschütz, too, thought that the Apocrypha were represented in San Paolo.[25]

Waetzoldt's designations are reasonable on the basis of the visual evidence, but also because it was unlikely, at that period, that apocryphal scenes would have been acceptable in one of the most important churches in Rome. Documentary evidence from the sixth century attests that the legends of the saints were held in low esteem officially and were little known at this date,[26] although within three centuries they were to be officially accepted to be read in the Office.

[23] See below, for the Conversion (pp. 8, 35), the Baptism of Paul (p. 35), Paul Preaching in Damascus (p. 14, n. 75), Paul's Escape (p. 111) and Paul and Silas Flogged in Philippi (pp. 10, 35).

[24] See below, n. 75.

[25] Dobschütz, *Paulus*, 24. For Thecla, see nn. 7, 16.

[26] The Decretal of the Pseudo-Gelasius, *De libris recipiendis et non recipiendis*, stipulates reservations in accepting the *Gesta Martyrum*: 'item gesta sanctorum martyrum ... sed ideo secundum antiquam consuetudinem singulari cautela in sancta Romana ecclesia non leguntur, quia et eorum qui conscripsere nomina penitus ignorantur et ab infidelibus et idiotis superflua aut minus apta quam rei ordo fuerit esse putantur' (E. von Dobschütz, *Das Decretum Gelasianum de*

libris recipiendis et non recipiendis, Texte und Untersuchungen zur Geschichte der altchristlichen Literatur, III Reihe, Bd. 8, 4 (Leipzig, 1912), 9). Later in the century Gregory the Great wrote to Eulogius, Bishop of Alexandria, indicating that the legends of the saints were not to be found in Roman libraries of the time (see below, n. 49). The texts are published and discussed in Kennedy, *The Saints*, 79–88; see also A. Dufourcq, *Étude sur les Gesta martyrum romains* I (Paris, 1900), 78–80. It is also true that the opposing position is revealed in the preface to the *Passio Sanctae Anastasiae*, ed. H. Delehaye, *Étude sur le légendier romain* (Brussels, 1936), 221–2, which celebrates the benefits to be attained in the study of the 'non-canonical' stories of the martyrs.

Another item of evidence not noted previously which supports the early origin of the cycle is the arrangement of the scenes. Unlike later medieval pictorial programmes, which usually are organized from left to right starting to the right of the triumphal arch and running continuously around both sides in a clockwise order,[27] the San Paolo sequences followed two separate parallel progressions. Both the Old Testament and the Acts cycles started at the triumphal arch and both culminated at the entrance wall.[28] This is the method of organization of at least two Early Christian decorative ensembles close in time to the proposed date of the original San Paolo cycle, Santa Maria Maggiore in Rome, and Sant' Apollinare Nuovo in Ravenna.[29]

The Pauline cycle at San Paolo, because it was situated on the left wall, ran from right to left. This feature accounts for one of the idiosyncrasies in the Pauline representations, in that many of the compositions are intended to be read from right to left and therefore differ in organization from more typical examples of the same subjects.

Acceptance of the San Paolo frescoes as products of the fifth century, and as depictions of subjects in Acts, gives rise to the question of their precise relation to the text of Acts and its illustrated manuscripts. It is obvious that the frescoes are a selection from the text, concentrating on the career of Paul and ignoring the other apostles, except in so far as they are in contact with Paul. According to Waetzoldt, the scenes were devised in conformity with the unified decorative programme of the entire church celebrating Paul's career as Apostle to the Gentiles.[30] Waetzoldt's view is based on the premiss that the monumental cycle in San Paolo, or that in any other edifice for that matter, could have been, and indeed probably was created for the building in question, and is not necessarily linked to manuscript illustration. The theories of Kurt Weitzmann, on the other hand, suggest that programmes of this sort were based on models in manuscripts. In antiquity, according to Weitzmann, narrative pictorial cycles deriving from texts usually were devised as illustrations for those texts, eventually migrating to monumental art as copies of text pictures.[31] There are no extant illustrated texts of Acts from the Early Christian period, but the recent contributions of Herbert Kessler and others in regard to the inter-related Eastern and Western manuscript cycles of Acts imagery lend support to Weitzmann's theory that the book of Acts was illustrated at an early date. Hugo Buchthal and Joachim Gaehde cautiously accept the San Paolo frescoes as an expression of this text cycle.[32] While the present study does not provide proof positive that the frescoes were based on a manuscript model, neither does it refute this possibility. If such a model did exist, its verification lies in other evidence than the ill-starred San Paolo scenes.

[27] O. Demus, *Romanische Wandmalerei* (Munich, 1968), 18; see e.g. Sant' Angelo in Formis (ibid. p. 116, chart A/B); and Monreale (E. Kitzinger, *Monreale*, Figs. I–IV). I am grateful to Prof. Demus for discussing with me the sequential order of Early Christian and medieval mural decorations.

[28] Although the drawings of individual scenes do not themselves demonstrate the exact sequence of all the panels, there also remains a sketch of a section of the Acts wall, labelled 'mano manca', together with a similar series from the Old Testament wall, labelled 'man diritta entrando'. (Vat. Lat. 9843, fol. 4; see Waetzoldt, *Kopien*, cat. 670, Fig. 408.) The former has twelve scenes in two registers, some of which can be verified against the text order; their arrangement supports the contention that the programme ran from right to left.

[29] For Sta. Maria Maggiore, see H. Karpp, *Die frühchrist-lichen und mittelalterlichen Mosaiken in Santa Maria Maggiore zu Rom* (Baden-Baden, 1966), 13–14; and B. Brenk, *Die frühchristlichen Mosaiken in Santa Maria Maggiore zu Rom* (Wiesbaden, 1975), 152, who argues that the work on the mosaics proceeded in the same order as the text, from the triumphal arch to the entrance wall; and for S. Apollinare Nuovo, see G. Bovini, *Mosaici di S. Apollinare Nuovo di Ravenna, il ciclo cristologico* (Florence, 1958), 12–13.

[30] *Kopien*, 57; see also S. Waetzoldt, 'Zur Ikonographie des Triumphbogenmosaiks von St. Paul in Rom', *Miscellanea Bibliothecae Hertzianae* (1961), 19–28, esp. 23 f.

[31] 'The Illustration of the Septuagint', *Studies in Classical and Byzantine Manuscript Illumination*, ed. H. L. Kessler (Chicago and London, 1971), 48–9.

[32] *Illustrated Bibles*, 124; Gaehde, 'Turonian Sources', 388, n. 122; and Buchthal, 'Life of Paul', 46.

Although there are only isolated examples of subjects from Acts in Early Christian art outside of the San Paolo frescoes,[33] the possibility that there was a transmitted tradition of Acts imagery is supported by indirect testimony. One such indication can be found in literary sources, which suggest that at least one section of Acts was represented pictorially. The passage in question is the brief but eventful sequence narrated in Acts 9:1–22, recounting the circumstances leading up to and following Paul's conversion on the road to Damascus: Saul persecutes the Christians in Jerusalem;[34] he is given letters by the High Priest authorizing him to go to Damascus to continue the persecutions there; on his way he falls to the ground and is blinded when a light flashes and he hears the voice of the Lord; he is led blind to Damascus where, three days later, he is healed and baptized by Ananias; Paul preaches in Damascus, but the Jews hatch plots against him and he is forced to flee over the walls in a basket (the story is retold in slightly different words in Acts 22:4–16 and 26:9–20).

Passages in Augustine and Prudentius point to the possibility that there were multi-episode representations of the Pauline Conversion sequence in monumental art; both authors also mention in the same context the Stoning of Stephen, another scene from Acts in which Paul appears (7:55–8:1). In one of his sermons Augustine states that 'there are most beautiful pictures, where you see Stephen stoned, [and] you see Saul giving the clothing of the stoners. This is Paul the Apostle ... you hear the voice plainly: Why do you persecute me? You are prostrate, you are upright. The persecutor is prostrate, the preacher is upright.'[35] It is not clear, of course, whether the congregation 'sees' literally or figuratively, but the former is a distinct possibility.

Prudentius, Augustine's contemporary, in his *Dittochaeon* included the same subjects among a scheme of forty-nine scenes to be used as the adornment of a church.[36] His description of the Conversion of Paul was not confined to a single event. Like Augustine, he presented the Conversion as a process, or a series of moments: '*The Chosen Vessel*: Here one who was formerly a ravening wolf is clothed in a soft fleece. He who was Saul loses his sight and becomes Paul. Then he receives his vision again and is made an apostle and a teacher of the nations, having power with his lips to change crows into doves.'[37] Again, it is not known if Prudentius was describing existing pictures in an actual building or was inventing a scheme of ideal decoration, but it is feasible that there were monumental representations of the Conversion of Paul in antiquity.

[33] Some examples of Acts iconography, usually combined with scenes from other sources: Florence, Bargello, ivory diptych, right wing: a series of scenes representing Paul on Malta, end of the 4th c. (W. F. Volbach, *Elfenbeinarbeiten der Spätantike und des frühen Mittelalters* (Mainz, 1952), no. 108, pl. 32); Marseilles, Mus. d'Archéologie, sarcophagus, after 350: Paul Stoned at Lystra, together with four Christological scenes (Wilpert, *Sarc. cris.*, I (1929), 40, 107, pl. XXXIII (3)); London, British Museum, ivory plaques from a casket, early 5th c.: Paul Stoned at Lystra, Paul Reads to Thecla (apocryphal), among Old and New Testament scenes (J. Beckwith, 'The Werden Casket Reconsidered', *Art Bulletin*, 40 (1958), 5, Fig. 6).

[34] There is confusion in the text of Acts as to the moment when Saul becomes known as Paul. In this study the change of name is made at the moment of conversion.

[35] Sermon 315, *PL* 38, 1434: 'Dulcissima pictura est haec ubi videtis sanctum Stephanum lapidari, videtis Saulum lapidantium vestimenta servantem. Iste est Paulus apostolus ... Bene audistis vocem: Quid me persequeris? Stratus es, erectus es: Prostratus persecutor, erectus praedicator'; see Dinkler-von Schubert, 90–1, n. 44.

[36] Prudentius, *Tituli Historiarum (Dittochaeon)*, in *Prudentius*, trans. by H. J. Thomson (Cambridge, Mass., 1953), II, 368–9.

[37] Op. cit. 'VAS ELECTIONIS: Hic lupus ante rapax vestitur vellere molli:/Saulus qui fuerat, fit adempto lumine Paulus. / mox recipit visum, fit apostolus ac populorum / doctor et ore potens corvos mutare columbis.' Prudentius also included two other episodes from Acts: the Stoning of Stephen and the Healing of the Lame Man at the Beautiful Gate (by St. Peter). His description of the Stoning of Stephen reads: Op. cit. 'PASSIO STEPHANI: Primus init Stephanus mercedem sanguinis imbri / adflictus lapidum; Christum tamen ille cruentus / inter saxa rogat ne sit lapidatio fraudi / hostibus. o primae pietas miranda coronae!'

Gregory the Great, for example, writing at the turn of the seventh century, showed familiarity with the pictorial image of the fallen Paul.[38]

On several noteworthy points Augustine and Prudentius coincide. Both authors associate the Conversion of Paul with the Stoning of Stephen; this choice and juxtaposition was repeated as a programme in monumental art throughout the Middle Ages.[39] The two accounts also exhibit affinity in that they isolate the Conversion as the central Pauline event, characterized as a sequence of episodes in which Saul the persecutor is transformed into Paul the preacher. This interpretation, too, is important for later art, for it conforms to the way in which the Conversion is depicted from at least the ninth century, in both East and West.

In the San Paolo frescoes as well, the Conversion of Paul was depicted in several episodes (Fig. 16), in contrast to the majority of its scenes, in which each panel was restricted to a single action. The badly mutilated representation of the Conversion, which might even include confusing remains of earlier layers of fresco revealed by a fall of plaster, seems to comprise four episodes. These have been variously explicated. A possible interpretation is this, reading from right to left: Saul Receives Letters; the Conversion; Paul Led Blind to Damascus; the Blind Paul in Damascus Waiting to Be Healed (or the Dream of Ananias). We can be quite sure about the second and third items, but the first and fourth are more uncertain.[40] The crucial point is that it is a continuous narrative treatment of the subject. Other events from the Conversion sequence were shown in adjacent panels, so that the Damascus section of the text was the most densely illustrated of the whole series.

Like the San Paolo cycle as a whole, the Pauline Conversion sequence in itself does not prove that an illustrated Acts text was the model for this or other wall paintings. The rapidity of the action, however, in which each changing situation in the text is reflected in a new episode, does indicate a close adherence to the text, and strengthens the possibility that the pictorial iconography of this limited section of Acts might have originated in book illustration.

There was, undoubtedly, a compelling purpose behind the choice and concentration on this sequence in the fresco cycle, as well as in the passages quoted from Augustine and Prudentius. The reason probably can be found in the growing tendency of the Early Christian world to systemize the veneration of its saints.[41] Although this practice centred for the most part on the commemoration of martyrdoms, there is some evidence to show that other aspects of saints' lives were beginning to be memorialized. The Conversion of Paul is a case in point. St. Augustine's sermon quoted above was in honour of the Conversion, and was delivered at Easter, since, even at this early date, readings from Acts formed the Epistle lesson at Eastertide. Not until the eighth century was there a special date—25 January—set aside for observation of the Conversion of Paul;[42] the same century witnessed the emergence of the lectionary, a mass book of excerpted readings from scripture, each assigned to a regular date.[43] Since neither the fixed celebration nor

[38] See below n. 85.

[39] The two themes are joined as well in the *Christian Topography* of Cosmas Indicopleustes; below, n. 155.

[40] Gaehde, for example, who has not observed that the order is from right to left, suggests that the group of three figures at the left might represent Paul receiving letters from the High Priest, at the centre is the Conversion, and Paul Led to Damascus is on the right ('Turonian Sources', 388, n. 122). See also Waetzoldt, *Kopien*, cat. no. 632, fig. 370, and Kessler, *Illustrated Bibles*, 117.

[41] L. Duchesne, *Origines du culte chrétien* (Paris, 1925), 293–308; H. Delehaye, *Les origines du culte des martyrs* (Brussels, 1933), 40–1, 50–1, 260–3; and P. Batiffol, *Histoire du bréviaire romain* (Paris, 1895), 12–14.

[42] Baudot and Chaussin, *Vie des saints et des bienheureux*, I (Paris, 1935), 497–8.

[43] G. Godu, in *DACL*, V, i (1922), s.v. 'Épitres', cols. 245–344, esp. 256–61; A. Chavasse, 'Les plus anciens types du lectionnaire et de l'antiphonaire romains de la messe', *Revue Bénédictine*, 42 (1952), 1–94, esp. 94.

the lectionary existed in the fifth century, it would be unreasonable to suggest that the pictorial imagery of the continuous Conversion sequence was directly linked with the commemorative rite, nor can it have been devised as the actual accompaniment to the extracted Acts text in a liturgical book.[44] Nevertheless, it is, perhaps, permissible to label as 'proto-liturgical' this growing confluence of iconography and rite. We can be reasonably sure that the picture sequence existed in Early Christian times; the precise process of invention and transmission has yet to be defined.

There is another sense in which Pauline imagery is used in conjunction with emerging liturgical practice. The widespread phenomenon of the appearance on sarcophagi of the apostle Paul, often in the apocryphal scenes of his arrest and martyrdom,[45] is an expression of the deep esteem felt for Paul and Peter, whose commemorative ceremonies were celebrated with elaborate ritual, and who led the list of saints enumerated during the mass.[46]

The invariable way in which Paul's martyrdom was represented in Early Christian art can be seen on a sarcophagus of the fourth century from San Sebastiano in Rome (Fig. 29), in which Paul is shown standing with his hands tied behind his back while a soldier unsheathes his sword. The scene is accompanied, as is often the case with the so-called 'passion sarcophagi', by depictions of Peter led to execution, Christ and the apostles, and Christ before Pilate.[47] It is the moment before Paul's execution that is depicted, not the gruesome act of decapitation that appears in medieval art from about the eighth century onward (Figs. 34, 35).

These early representations of the arrests and martyrdoms of Peter and Paul were applicable not only to the celebration of these saints, but also as a universal statement of funerary symbolism.[48] The events are represented in a formal, generalized manner, with little attention to the rich anecdotal detail of the apocryphal tales which, as has been pointed out, were little known in Rome at this time, when martyrdoms were celebrated simply by the reading of the saint's name, and the place and date of the passion, without additional amplification.[49] Like the lectionary, the 'historical martyrology'—that is, the collection of narrative accounts of martyrdoms intended to be read aloud during commemorative services—makes its appearance c.700.[50] It is no accident that the elaborated pictorial representations of the apocryphal legends appear around the same time. The destroyed mosaic sequence in the Chapel of John VII at Old St. Peter's (705–7) was the earliest known monument to show the martyrdom of Paul as part of the

[44] Dinkler-von Schubert has made this suggestion, p. 86.

[45] This imagery occurs e.g. on the so-called 'Passion Sarcophagi'. Wilpert, *Sarc. cris.*, III, supplemento (1936), pls. CCLXXXIII, CCLXXXIV (3); I, pls. CXLII (2 and 3), CXLV (1), CXLVI (1), and XVI (3); F. Gerke, *Die Zeitbestimmung der Passionssarkophage*, special issue of *Archaeologiai Értesitö*, 52 (1940), 67–130!; H. von Campenhausen, 'Die Passionssarkophage', *Marburger Jahrbuch für Kunstwissenschaft*, 5 (1929), 39–85, esp. 41–3, 79–85. For the apocryphal texts see Lipsius-Bonnet, *Acta Apostolorum*, I, 104–17; Schneemelcher, in Hennecke, *Apocrypha*, 383–7.

[46] See above, n. 4.

[47] Wilpert, *Sarc. cris.*, III, suppl. (1936), pl. CCLXXXIII.

[48] See M. Simon (above, n. 16); and A. Grabar, *Christian Iconography* (Princeton, 1968), 50, who calls these images a 'testimony of sympathy' for martyrs in general. Campenhausen, 'Passionssarkophage', interprets this phenomenon similarly.

[49] Dufourcq, *Gesta martyrum*, 78–80. A letter of Greogry I to Eulogius, Bishop of Alexandria, in response to the latter's request for a copy of the Gesta Martyrum of Eusebius of Caesarea, makes it clear that the commemorations of martyrdoms were of a rigorous simplicity: 'Nos autem paene omnium martyrum distinctis per dies singulos passionibus collecta in uno codice nomina habemus atque cotidianis diebus in eorum veneratione missarum sollemnia agimus. Non tamen in eodem volumine, quis qualiter sit passus, indicatur, sed tantum modo nomen, locus et dies passionis ponitur.' (*Monumenta Germaniae Historica—Epistolarum* II (Berlin, 1899), 29.) In Africa, in contrast, the Acts of the Saints were read on their feast days (Council of Hippo 393, Canon 40, Hefele-Leclerq, *Histoire des Conciles* II, I (Paris, 1908), 89).

[50] H. Quentin, *Les martyrologes historiques* (Paris, 1908), 1–4, 682–90.

series of episodes representing the *Passio Petri et Pauli*, and culminating in graphic depictions of the executions of the two saints (Fig. 30).[51] With the appearance of a narrative martyrdom cycle, we are already in the Middle Ages.

II. CAROLINGIAN MONUMENTS

Carolingian works in which Pauline subjects are depicted, while few, are of considerable importance. Both canonical and apocryphal subjects occur, many of them in forms similar to those we have already encountered. To a limited extent, and cautiously, we can attempt to reconstruct aspects of Early Christian iconography by examining Carolingian versions of the same subject. For example, certain of the ninth-century representations can be linked to parallels in the San Paolo frescoes, thus strengthening the argument in favour of the antiquity of the latter. At the same time—and here we are on firmer ground—the Carolingian imagery is the principal source from which the Pauline iconography of the tenth, eleventh, and twelfth centuries derives.

Although the celebrated Carolingian Bibles are central to the study of Pauline iconography, I shall postpone consideration of them and begin my survey with some examples of monumental art, all of them older than the Bibles.

Three small churches in the valley of the River Adige in northern Italy are decorated with wall-paintings in which Pauline themes are represented, perhaps the remnants of a once common tendency to use Paul as a subject in monumental schemes of decoration.

At San Benedetto, Malles, in the Val Venosta, the murals of the north wall include three scenes (originally four) depicting episodes from Acts, painted in the early ninth century.[52] The surviving scenes, in poor condition, have been identified by Garber as the Stoning of Stephen, the Conversion of Paul, and Saul Persecuting the Christians (Fig. 181).[53] This last title is incorrect. It should be 'Paul and Silas Flogged at Philippi'. Paul's features are clearly visible on the face of the foremost victim, and the design is quite similar to the prone flogging scenes in the San Paolo frescoes (Figs. 180, 183)[54]—including the one representing the same episode—but Malles is more crowded with bystanders. The Carolingian version points to an archetype resembling the San Paolo scene, and therefore reinforces the credibility of the latter as Early Christian.

On the south wall of the church of San Procolo in Naturno—like Malles in the Val Venosta— are two frescoes of the early ninth century which have been interpreted as representations of

[51] Preserved in a number of drawings, including one in Vat. MS Barb. Lat. 2732, fol. 75[v]. Wilpert, *Die römischen Mosaiken und Malereien*, I (1916), 399–400, Fig. 136. In addition to three depictions of Peter preaching in Jerusalem, Antioch [sic], and Rome, there were scenes of Peter and Paul before Nero (confronting Simon Magus), the Flight of Simon Magus, the two apostles praying previous to martyrdom, and of their executions, Peter crucified head down and Paul beheaded. (It should be Paul who is preaching in Antioch; the copyist (and Wilpert) have mistaken this figure for Peter because he carries keys; see my Fig. 41a for a later Roman depiction of Paul carrying keys as well as Peter.) This sequence, which differs from the account of Paul's martyrdom in the *Acta Pauli* (n. 7), is inspired by the *Passio Petri et Pauli*, and properly belongs in the realm of Petrine

iconography. Lipsius-Bonnet, *Acta Apostolorum*, 223–4; and W. Schneemelcher, in Hennecke, *Apocrypha*, 575; see also below, n. 104.

[52] *Karl der Grosse—Werk und Wirkung*, catalogue of an exhibition held in the Rathaus, Aachen, 26 June to 19 Sept. 1965, 479, cat. no. 656–7; J. Garber, 'Die karolingische St. Benediktkirche in Mals', *Zeitschrift des Ferdinandeums*, 59 (1915), 1–10, pl. I; idem., *Die romanischen Wandgemälde Tirols* (Vienna, 1928), 46 f., pls. 11–19.

[53] Garber, 'St. Benediktkirche', pl. I.

[54] Waetzoldt, *Kopien*, cat. no. 640, Fig. 378. See below, pp. 34–5, 97–8, for a discussion of this scene. A very similar prone flogging is represented on a relief from a catacomb of *c*.270 (F. Gerke, *Die christlichen Sarkophage der vorkonstantinischen Zeit* (Berlin, 1940), 96, pl. 37.)

events in the life of Paul (Fig. 162).[55] One scene is thought to be the Execution of Paul; only the figures of five veiled women remain, some carrying vessels or books, one a veil: this figure might represent Plautilla.[56] The second scene depicts Paul escaping from the walls of Damascus in a basket (Acts 9:25); the basket is rendered in such a way that Paul appears to be hanging in a swing. It is quite different from the representation in the San Paolo fresco (Fig. 169), in which Paul is shown reclining sideways in the basket, his outstretched feet projecting.[57]

Dinkler-von Schubert has argued that the apparent omission of the basket at Naturno is a new invention, having a textual basis in a recension of the Greek text of the Epistles, and that this Carolingian version does not show evidence of a continuity of transmission from the San Paolo type.[58] But the primitive nature of the Naturno wall-painting warns against placing too much emphasis on the way in which the basket is represented. Despite its naïveté, however, Naturno is not a unicum. Comparison of the Naturno scene of Paul's Escape from Damascus with later representations of the same subject, especially those in which symmetry and frontality prevail, as in the later Carolingian San Paolo Bible (Fig. 7), suggests that Naturno belongs to a continuing iconographic tradition.

Admittedly, the San Paolo fresco differs in important ways from this type of representation. Nevertheless, Dinkler-von Schubert's claim that the extant design of the San Paolo fresco—that is, in the seventeenth-century drawing—was an *ad hoc* invention of Cavallini, drawing for inspiration on sources other than Acts imagery, is not convincing. First of all, there exists a group of representations of Paul's escape with laterally organized compositions, bringing the San Paolo fresco more in line with established traditions. Further, the San Paolo depiction, with the figures of Paul's helpers seen at half-length reaching over a parapet, has more in common with other medieval versions of this scene, including Naturno, than it has with Dinkler-von Schubert's proposed parallel, the sixth-century mosaic in Sant' Apollinare, Ravenna, depicting Christ Healing the Paralytic (Luke 5:18–20).[59] Naturno, therefore, like Malles, tends to support the authenticity of the San Paolo frescoes.

St. John's monastery church in Müstair, in the same district as the other buildings but now on the Swiss side of the border,[60] is decorated with, among other subjects, a series of apocryphal scenes illustrating the *Passio Sanctorum Apostolorum Petri et Pauli*. Parts of the triple apse date from the early ninth century, and it is possible to reconstruct almost the entire programme, since it was repeated, with minor alterations, in the twelfth-century overpainting. The left apse included scenes of Peter and Paul preaching, the two apostles before Nero, the fall of Simon Magus, and, most likely, the martyrdoms of the two saints, as in the Chapel of John VII.[61] In the south apse are scenes from the passion of Stephen (Acts 7:58–8:1), including one showing Stephen condemned by Saul. We have seen that the detailed portrayal of the apocryphal tales of martyrdom began to

[55] See n. 28 for an explanation of the reversed compositions in the San Paolo frescoes. *Karl der Grosse*, 477–8, cat. nos. 653–5; G. Gerola, 'Gli Affreschi di Naturno', *Dedalo*, 6 (1925–6), 414–40; Garber, *Die romanischen Wandgemälde*, 37–46. Further bibliography is given in Dinkler-von Schubert, 'Per Murum', 89, nn. 4, 5.

[56] See below, n. 106 and Ch. 3: the *Passio Sancti Pauli Apostoli*.

[57] Waetzoldt, *Kopien*, cat. no. 636, fig. 374. See below, pp. 15–16, 31, 34, 37, 91–4, for the scene of Paul's Escape from Damascus.

[58] 'Per Murum', 84; the omission of 'basket' occurs in the Greek portion of two bilingual Epistles MSS: Codex Boernerianus (Dresden, Saechs. Landesbibliothek), and Codex Augiensis (Cambridge, Trinity Coll. Libr.).

[59] 'Per Murum', 82, Fig. 4.

[60] *Karl der Grosse*, 479–80, cat. nos. 658–61; L. Birchler, 'Zur karolingischen Architektur und Malerei in Münster-Müstair', *Frühmittelalterliche Kunst in den Alpenländern*, Akten zum III. Internationalen Kongress für Frühmittelalterforschung (Olten and Lausanne, 1954), 167–252, esp. 221–5, Figs. 94, 96; B. Brenk, *Die romanische Wandmalerei in der Schweiz* (Bern, 1963), 44–9, Figs. 3a, 3b, 20–30.

[61] See above, n. 51.

appear in monumental art *c*.700. The presence of such a cycle at Müstair is consistent with the interests of its age, and presents us with another link between Carolingian Pauline imagery and later medieval art.

The existence of these monuments with a quite wide range of subject matter drawn from Acts and the Apocrypha is of interest to any study of the antecedents of the twelfth- and thirteenth-century cycles. Particularly noteworthy is the scene of Paul's Escape from Damascus, represented at Naturno and destined to become popular in subsequent art. The Carolingian frescoes, therefore, function as a link between the Pauline imagery of antiquity and that of the Middle Ages.

The surviving Carolingian works of greatest consequence for the understanding of later Pauline iconography are the two Bibles of Charles the Bald: the Vivian Bible (Paris, BN MS lat. 1), produced at Tours before 846 (Fig. 6),[62] and the Bible of San Paolo fuori le mura, from a scriptorium affiliated with Reims, *c*.866–9 (Fig. 7).[63] Each introduces the Pauline Epistles with a full-page series of scenes based on Acts 9 : 1–25 ; in other words, like Augustine and Prudentius in the passages quoted above, they illustrate the events leading up to and following Paul's conversion at Damascus. The later Bible includes a wider spectrum of events.

It is apparent that the full-page frontispieces to the Pauline scenes in the two Carolingian Bibles were new designs drawing on a variety of sources. The process as seen by previous scholarship can be reconstructed as follows :[64] Wilhelm Koehler, writing in the 1930s, postulated that the scriptorium at Tours had as a model a fifth-century Bible going back to Pope Leo the Great (d. 461). Another Tours Bible earlier than our two examples, the Moutier-Grandval Bible (London, BL Add. MS 10546), *c*.834, according to Koehler is the purest copy of this model, and he maintained that the absence of Acts imagery in this manuscript reveals that there were no illustrations of Pauline scenes in the fifth-century biblical model.[65] The Vivian Bible (Fig. 6), produced about ten years later, repeats the four frontispiece designs going back to the so-called 'Leo Bible'.[66] In addition it has four new pages of scenes, including the Acts cycle used as an introduction to the Epistles,[67] which, Koehler concluded, must have been a new invention of the Turonian artist. (Made a generation later, the Bible of San Paolo (Fig. 7) has twenty-four frontispieces—an extraordinary amplification—but the cycle of Pauline scenes acting as a preface to the Epistles is recognizably similar to that in the earlier manuscript.)

More recent scholarship tends to reject Koehler's interpretation of the relationship of the Acts cycle in the Carolingian Bibles to the art of antiquity. Buchthal, Gaehde, and, most recently, Kessler, all, in different ways, postulate Early Christian precedents for at least a portion of the cycle.[68]

Before we turn to an examination of these arguments, a brief description of the full-page compositions in the Vivian and San Paolo Bibles, so influential in future Western art, is in order.

In both books the story is unfolded in a continuous narrative arranged in three registers. The Vivian Bible version begins with the Conversion of Paul on the road to Damascus (Acts 9 : 3–8):

[62] W. Koehler, *Die Schule von Tours*, Bd. I, ii, of *Die karolingischen Miniaturen* (Berlin, 1933, repr. 1963), 27–65, 219–20, pls. 69–76; Kessler, *Illustrated Bibles*, 111–24.

[63] Gaehde, 'Turonian Sources', 386–92; idem, 'The Bible of San Paolo fuori le mura in Rome : its date and its relation to Charles the Bald', *Gesta*, 5 (1966), 9–21.

[64] Kessler sums up the historiography of the Carolingian Bibles in *Illustrated Bibles*, 3–12, 139–51.

[65] Koehler, *Schule von Tours*, ii, 147, 213; see n. 92.

[66] Genesis, fol. 10ᵛ; Exodus, fol. 27ᵛ; Majestas, fol. 329ᵛ; Apocalypse, fol. 415ᵛ.

[67] Jerome, fol. 3ᵛ; dedication scene, fol. 423; David, fol. 215ᵛ; Paul, fol. 386ᵛ.

[68] Buchthal, 'Life of Paul'; see also nn. 62, 63.

Saul in military dress, having left Jerusalem in the company of three soldiers, is blinded by golden rays issuing from the hand of God; he is represented twice—standing while the rays strike his face and then lying stiffly on his side, as if in a trance. In the second episode, one of his companions leads the blind Paul to the gates of Damascus (Acts 9:9). There, Ananias sleeping in bed is addressed by the hand of God (9:10–16); later, within the city walls, Ananias gestures at Paul and cures his blindness (9:17–18). Paul is then shown in a colonnaded building addressing a symmetrically disposed group of armed men (9:20–2).

All of these episodes appear again in the San Paolo Bible,[69] framed within two additional scenes at the beginning and end of the narrative: the sequence starts with a representation of Saul Receiving Letters from the High Priest in Jerusalem, authorizing him to continue his persecutions of the Christians (9:1–2), and ends with the scene of Paul's Escape from the Walls of Damascus (9:25)—a theme we have encountered at Naturno—and his departure on his missionary journey.

As well as additions in the later manuscript, there are certain interior changes. The most important of these is the variant interpretation of the moment of conversion. In contrast to the earlier version, in which Paul is seen twice—upright and fallen—in the later manuscript only the active moment is shown: Paul is falling back, energetically reacting rather than lying rigidly on the ground. The other major change is one of design, but it results in interruption of the narrative order: the episode of the dream of Ananias is transferred to the right of the healing scene, although it precedes the healing in time. The artist has chosen to make a dramatically effective statement, and to emphasize the significance of the encounter of Paul and Ananias in Damascus, at the expense of chronological sequence. Both of these alterations are, in fact, consistent with the artistic personality of the San Paolo Bible master, who exhibits a penchant for vigorous, heightened gesture and strenuous movement.[70] Minor differences between the two versions can be ascribed for the most part to variations in style, rather than iconography. For example, both representations of Paul Led Blind to Damascus—a scene which has been singled out as an expression of the dissimilarity between the two cycles[71]—show Paul's disciple turning his back to the open gate of Damascus to face his blind master, guiding him by the hand. The more fluent skill of the later artist enabled him to represent the disciple as moving forward and simultaneously turning back, a complex pose that eluded the simpler arts of the earlier illuminator.

The similarity between the two cycles is reinforced by the evidence of another Carolingian manuscript, an edition of the Pauline Epistles now in Munich,[72] which has a two-episode Conversion sequence very like the corresponding scenes in the Vivian Bible: Paul is shown lying on his side, this time with his knees drawn up, and then led by the hand to Damascus (Fig. 8). Affinities between the Carolingian versions can be explained by their descent from a common archetype,[73] although in each case the miniaturist has made a different selection of episodes as well as interpreting the episode in a personal way.

[69] J. O. Westwood, *The Bible of the Monastery of St. Paul near Rome* (Oxford, 1876), and the forthcoming facsimile edited by Gaehde.

[70] Gaehde, 'Turonian Sources', 390–2, 399–400.

[71] Buchthal, 'Life of Paul', 47.

[72] Munich, Bayerische Staatsbibliothek MS lat. 14345, from the Rheinhessen region, has scenes of the Stoning of Stephen (fol. 1ᵛ), and Paul Preaching (fol. 7ᵛ), in addition to the Conversion and Paul Led to Damascus (fol. 7). See B. Bischoff, *Die südostdeutschen Schreibschulen und Bibliotheken in der Karolingerzeit* (Wiesbaden, 1960), 239. Kessler, *Illustrated Bibles*, 115–16, discusses these scenes in detail. He calls the pose of Paul in the Conversion scene 'prokynesis', with which I disagree.

[73] Kessler, *Illustrated Bibles*, 116–19, and Gaehde, 'Turonian Sources', 391, 397, are agreed on this point in a general sense, although each proposes a different process of redaction.

What is the source of this Pauline pictorial sequence? According to Koehler, the cycle must have been invented for the Vivian Bible, since it is lacking in the Bibles' predecessor. Other scholars, however, see a longer pedigree. Buchthal and Gaehde both suggest a lost, possibly Turonian Bible as the immediate model for the extant books,[74] but they agree with Kessler that the iconography must derive from a prior tradition. Each of these scholars has, in fact, identified certain of the scenes in the San Paolo frescoes as forerunners of corresponding sections of the Carolingian cycle.[75] In addition, supporting evidence from Byzantine art points to the antique origin of this iconography. As will be seen below, Pauline scenes drawn from the same short dense segment of Acts and similar in many ways to the sequence in the Carolingian Bibles can be found in post-Iconoclastic Byzantine art. The evidence of the present study confirms the theory that similarities in the Pauline Conversion sequence in East and West can be explained by the descent of both traditions from a common source. Gaehde is non-committal in his characterization of this hypothetical early source, although he agrees that it is 'older than the Carolingian miniatures themselves'.[76] Kessler is more specific: he suggests that a densely illustrated Early Christian text of Acts underlies the Carolingian iconography as well as the Byzantine, and that it can be seen as well in many High Medieval monuments: '. . . the Conversion of St. Paul cycles were excerpted from a Byzantine manuscript of the Acts of the Apostles that may have been known in the West perhaps as early as the fifth century.'[77]

Dinkler-von Schubert, on the other hand, has raised the possibility that the pictorial conversion sequence might have originated in a Latin lectionary of the eighth century, in connection with the celebration of the Conversion of Paul, a feast peculiar to the West.[78] This explanation is unsatisfactory, since it does not account for the contemporaneous appearance of the sequence in Byzantium.

None of the Carolingian versions is a precise duplication of their common model. Now one, according to Kessler and Gaehde, now the other, enables us to see backward in time. The two-episode representation of the moment of the Conversion in the Vivian Bible probably is a more accurate reflection of the archetype, as is the depiction in the same book of Paul preaching in Damascus.[79] The San Paolo Bible, conversely, might be closer to the original in its representation of Paul Led to Damascus and, notably, in the greater range of its cycle.[80] Both authors reject, rightly in my opinion, Buchthal's suggestion that because the scene of Paul Receiving Letters from the High Priest appears only in the later exemplar, it must have been imported from

[74] 'Life of Paul', 47; 'Turonian Sources', 359–61, 397. This suggestion was first made by C. Nordenfalk, 'Beiträge zur Geschichte der turonischen Buchmalerei', *Acta Archeologica*, 7 (1936), 281 ff. Kessler thinks that each Carolingian manuscript is an independent adaptation of an early Christian model.

[75] Buchthal e.g. compares the scene of Paul preaching in Damascus (Waetzoldt, *Kopien*, cat. no. 635, Fig. 373) to the same episode in the Vivian Bible; he disagrees with Waetzoldt's identification of another scene (*Kopien*, cat. no. 633, Fig. 371), pointing out its similarity with the depiction of Paul Healed by Ananias in both Carolingian Bibles ('Life of Paul', 46). Gaehde reinterprets a scene called by Waetzoldt Paul Persecuting the Christians (cat. no. 631, Fig. 369) as Paul Preaching in Damascus, comparing it with this subject in the San Paolo Bible ('Turonian Sources', 388).

[76] 'Turonian Sources', 387–8.

[77] *Illustrated Bibles*, 124. Buchthal at one time believed that the affinity between the two traditions appeared only in the later San Paolo Bible, as the result of the importation of a lost post-Iconoclastic Byzantine book into Western Europe some time in the interval between the production of the Vivian and San Paolo Bibles ('Life of Paul', 47). Recently, however, Buchthal has been convinced that both derive from the same archetype. I wish to thank Prof. Buchthal for discussing this question with me.

[78] See below, n. 90.

[79] Kessler, *Illustrated Bibles*, 112, 114. Gaehde, 'Turonian Sources', 390, thinks that the S. Paolo version of Paul preaching in Damascus is more accurate in respect to the model.

[80] Gaehde, 389–90; Kessler, 113.

Byzantium.[81] It is by no means unusual for the later of two similar works of art based on a common model to encompass items omitted in the earlier. Therefore, the proposal that the model contained everything that was included in the San Paolo Bible is acceptable from a logical standpoint.

As to the date of the model, we already have seen that Early Christian literary sources support the possibility that there was such a pictorial representation of the conversion sequence.[82] Whether or not this sequence formed part of a complete illustrated text of Acts, as insisted upon by Kessler, and earlier by Weitzmann,[83] is more problematic.

In the choice of episodes and in details of iconography, the Carolingian version of the Pauline Conversion cycle became the definitive statement of this theme in Western medieval art. From this moment onward, the iconography can be said to have a 'history', its particulars handed down through a tradition of copying. Later sections of the present study will deal more fully with this question, but it is worthwhile here to isolate several themes which will prove to be central.

The first is the representation of the moment of Paul's conversion. We are offered in the Carolingian manuscripts differing interpretations of Paul's physical and mental reaction to the revelation on the road to Damascus. One version presents a continuous narrative, showing the event in two moments of time; the other epitomizes the action in one image. The poses also vary. In one, Paul falls forward on to his side, and appears to be in a trancelike or unconscious state; in the other, he flings himself back as if in the throes of an ecstatic seizure. Later Western depictions will perpetuate these variations. Both the continuous narrative and the single image will continue in use, as will the two types of pose. Italy, the eventual home of the San Paolo Bible,[84] will favour the supine position strongly. The prone type, as represented by the Vivian Bible and the Munich Epistles, will be more popular in the north.

Can such variations in pose be interpreted as intentional expressions of different meanings? Gregory the Great differentiated between the prone and supine falling positions, the former representing penitence, which Gregory associated with Paul, and the latter ignorance of one's sins and their punishments.[85] It is evident that in later art Paul's prostration often was interpreted as the fall of pride,[86] but there is no basis to assume that each variation in pose carried with it a different meaning in a symbolic sense. Rather, the variety probably is due to personal solutions by individual artists, always a factor in Western art.

Paul's Escape from Damascus (Acts 9:25) is one of the images that later enjoyed popularity. Several authors have suggested that this subject was added to the cycle in Carolingian times in response to arguments concerning the ethics and meaning of certain contemporary instances of escape,[87] a proposal rejected by Gaehde as inconsistent with the usual tendency of Carolingian art.[88] Does this mean that the pictorial representation of this theme was an integral part of the conversion sequence, going back to an Early Christian model? Although the supporting indications are not as strong as for the preceding episodes, its early inclusion in the cycle is within

[81] 'Life of Paul', 47.

[82] See above, nn. 35–7.

[83] K. Weitzmann, *Illustrations in Roll and Codex* (Princeton, 1947), 194.

[84] San Paolo fuori le mura in Rome; see below, n. 119.

[85] *Moralia in Job*, ch. 24, PL 76, 597: '*Ut cadat ascensor ejus retro*' [Gen. 49:17]. Ascensor equi est quisquis extollitur in dignitatibus mundi. Qui retro cadere dicitur, et non in faciem, sicut Saulus cecidisse memoratur [Acts 9:4]. In faciem enim cadere est in hac vita suas unumquemque culpas agnoscere, easque poenitendo deflere. Retro vero quo non videtur, cadere, est ex hac vita repente decedere, et ad quae supplicia ducatur ignorare.' I wish to thank Thomas Martone for telling me about this text.

[86] See below, pp. 40–1.

[87] H. Schrade, *Vor- und frühromanische Malerei* (Cologne, 1958), 13–14; and Dinkler-von Schubert, 'Per Murum', 85.

[88] 'Turonian Sources', 389.

the realm of possibility. There is evidence, however, that the absence of this scene in certain of the sequences—for example in the Vivian Bible and in most Byzantine art—might not be an accident of scribal choice. Although we can have little doubt that the imagery was inspired by the narrative text of Acts itself, it is also possible that liturgical practice might have exerted its influence on the iconography. The statements about the Conversion by Augustine and Prudentius noted earlier implicitly regarded the Conversion as a process by which the persecutor becomes an Apostle.[89] Both of these verbal accounts stop short at Acts 9:22 (Paul preaching in Damascus), and do not allude to the episode of Paul's escape. Later liturgical usage continued this preference. In the West the liturgical reading of the conversion sequence in the annual recitation of scripture selections usually ended with Acts 9:22.[90] There might, therefore, have been a natural tendency to regard the shorter version of the story—for example, as it occurs in the Vivian Bible—as a complete statement.

Conversely, the fact that the pictorial sequence in the Carolingian Bibles accompanies the Pauline Epistles might be a factor in the perpetuation, or reintroduction, of the Escape, one of the few autobiographical details described fully in the Epistles (II Cor. 11:33).[91]

One element emphasized by Augustine and Prudentius is missing from the Vivian Bible: the conception of Paul as persecutor, or 'ravening wolf'. The San Paolo Bible conveys this idea in the scene of Saul receiving permission to persecute the Christians. There is a possibility, however, that another Carolingian manuscript expresses the same notion in a different way.

Lacking the full-page Acts cycles of the two later Bibles, the Moutier–Grandval Bible nevertheless includes a notable Pauline representation.[92] The historiated initial P of Romans (Fig. 23) incorporates—in fragmented segments—references to Paul's Execution, and probably to the Conversion as well. Paul's head appears in a roundel in the centre of the stem of the initial, the executioner with his sword in a panel at the bottom, and a hand—presumably of God—at the top. Another roundel in the loop of the initial contains a dove or pigeon, and inside the loop are two animals, a wolf and a lamb or sheep. A coiled serpent occupies the space below the executioner.

[89] See above, nn. 35, 37.

[90] It seems that in the Gallican liturgy up to the eighth century the practice followed by the primitive church of reading Acts at Easter was continued: Easter lections, e.g., in the Bobbio 'Missal' (Paris, BN lat. 13246, 7th–8th c.) included Acts 9:1–9; and, in the lectionary of Sélestat (Cod. 1093, 7th–8th c.), Acts 9:1–22 (P. Salmon, *Le Lectionnaire de Luxeuil* (Vatican City, 1944), CXII, CXIV). After Alcuin's reform of the lectionary in the late 8th c., the Easter reading of Paul's Conversion was discontinued, but Acts 9:1–23 was read on 30 June, the feast of St. Paul (the Escape is not described in any of these readings). Another scriptural reference to the Escape separate from the account of the Conversion, II Cor. 11:33, began to be read on January 25, the feast of the Conversion (Liber Comitis, from the Corbie Lectionary in Leningrad; see W. H. Freyre, *Studies in Early Roman Liturgy III: The Roman Epistle-Lectionary* (Oxford, 1935), 3, 14). Dinkler-von Schubert, who points out that this lection appears *c.*700 in the Missale Gothicum ('Per Murum', 91, n. 58), makes a strong point in contending that the iconography was invented, or imported, to accompany liturgical books in which the feast was included. It is interesting to note that the modern lectionary omits any mention of Paul's escape, since neither Acts 9:25 nor II Cor. 11:33 is in it. The Feast of the Conversion is now celebrated with the appropriate reading of Acts 9:1–22 (*Missale Romanum* (Vatican City, 1954)). Paradoxically, in Byzantium, where the scene of Paul's escape was virtually non-existent in art, both scriptural references were included in the lectionary, Acts 9:25 for the third Friday after Easter, and II Cor. 11:33 on 29 June. (C. R. Gregory, *Textkritik des Neuen Testaments*, I (Leipzig, 1900), 345, 381.) It should be noted, however, that the Escape episode appears in the Eastern reading in a sequence proceeding from Paul preaching in Damascus (9:19), through the Escape (9:25), and ending with events in Jerusalem (9:31), and therefore is divorced from the actual account of the Conversion.

[91] See below, pp. 91–4.

[92] London, BL Add. MS 10546, fol. 411ᵛ. J. Duft, *et al.*, *Die Bibel von Moutier–Grandval* (Bern, 1971). See also Koehler, *Schule von Tours*, i (1930), 194–209, pls. 42–53; ii (1933), 13–27; A. Boinet, *La Miniature carolingienne* (Paris, 1913), II, pls. XLV–XLVII. This Bible has four full-page prefaces, for which see n. 66.

Ellen Beer in a recent study of the initials in the Moutier–Grandval Bible has rectified the former neglect of the symbolic possibilities of the apparently scattered and arbitrary collections of figures and objects within some of the initials.[93] She has recognized that the combination of the hand of God, the head of Paul, and the executioner brandishing his sword in the stem of the P of Romans represents the Execution of Paul. Christian art had provided antecedents for the apocryphal scene of Paul's martyrdom, but the Moutier–Grandval Bible represents one of the earliest surviving examples of its appearance in a manuscript, and it is the first to juxtapose the martyrdom of Paul with the Epistles.

The initial, however, might have another level of meaning unrecognized by Beer. The presence of the hand of God is an intrinsic feature of the Carolingian tradition of another Pauline scene, the Conversion of Paul. Its appearance at the top of the initial letter in the Moutier–Grandval Bible might be a reference not only to the Execution, but, more obliquely, to the Conversion of Paul as well.

In the centre of the loop of the Carolingian initial are two animals, a wolf and a lamb. These take on significance as Pauline iconography when they are compared to the representation of Paul's conversion in the late twelfth-century manuscript of Herrade of Landsberg, the *Hortus Deliciarum* (Fig. 24).[94] In the *Hortus Deliciarum*—the only other example of the Conversion of Paul known to me in which animals appear—Paul is depicted at the moment at which God is revealed to him, kneeling, flanked by a wolf and a lamb. The meaning is made clear by an inscription, *Lupus mutatur in agnum*. In other words, Prudentius' phrase 'a ravening wolf is clothed in soft fleece' is depicted visually.[95] An even more specific literary source for the image of the wolf turning into a lamb is provided by St. Augustine in a sermon: 'Paul the Apostle, formerly a persecutor of the Christians, was made a missionary of Christ. Christ indeed struck down the persecutor in order to make a doctor of the Church: striking him and healing him, killing and reviving. The lamb kills the wolf, making a lamb of the wolf.'[96] This metaphor must have become attached to the apparatus of commentary on the Conversion of Paul, since it was mentioned by Isidore of Seville.[97] In the thirteenth century it was cited by Jacobus de Voragine in the *Legenda Aurea*.[98] The notion that Christ kills the wolf is probably the source of a strange feature in the representation in the *Hortus Deliciarum*, the hand of Christ protruding from the arc of heaven holding a sword.

The animals chosen for contrast by Prudentius and Augustine recur often in Christian imagery. The metaphor of the wolf and sheep or lamb as opposite natures is used frequently in the Bible, notably in the text of Matthew 10:16: 'Look, I send you out like sheep among wolves; be wary as serpents, innocent as doves.'[99] It should be noted that all of the animals cited in this passage are included in the Moutier–Grandval initial, the serpent and dove as well as the wolf and sheep.

[93] E. J. Beer, 'Die Initialen', in Duft, *Moutier–Grandval*, 121–48.

[94] Herrade von Landsberg, *Hortus Deliciarum*, eds. A. Straub and G. Keller, 3 vols. in 1 (Strasbourg, 1879–99), pl. LI bis (supplément).

[95] Prudentius, *Dittochaeon*: see above, n. 37.

[96] 'Paulus apostolus ex persecutore Christianorum annuntiator factus est Christi. Prostravit enim Christus persecutorem ut faceret Ecclesiae doctorem: percutiens eum et sanans, occidens et vivicans. Occidit agnus lupum, faciens agnum de lupo.' *PL* 39, 2098–100.

[97] See below, pp. 116–17, n. 172.

[98] J. de Voragine, *Legenda Aurea*, ed. T. Graesse (Leipzig, 1850), 133–5, Cap. XXVIII 'De conversione sancti Pauli apostoli: . . . Augustinus super hoc verbo: occisus agnus a lupis fecit agnos de lupis.'

[99] 'Ecce ego mitto vos sicut oves in medio luporum; estote ergo prudentes sicut serpentes, et simplices sicut columbae.' I wish to thank Mary Schaefer for identifying this passage for me.

Matthew here is describing the mission given by Christ to the apostles: as missionaries, they are—and should behave like—sheep; the wolves are those who attack them. Similar imagery is used in words ascribed to Paul himself in Acts 20:29: 'I know that when I am gone, savage wolves will come in among you and will not spare the flock.' In each case, the persecutor of the Christian missionaries is described as a wolf, an animal known to the Middle Ages as a synonym for rapacity. In terms of the Conversion of Paul the metaphor stands for Paul, a persecutor, a wolf, becoming a sheep, one of the flock.[100] Resonance with the Matthew text, which must have been intended in the Moutier–Grandval initial, extends the meaning of Paul's role as a 'sheep', and, in combination with the Execution, the image takes on deeper significance: Paul's fate as a Christian martyr, the ultimate outcome of his conversion, is predicted.

Later European art was to benefit from the experiments in the Carolingian Bibles. Although there are apparently no linear descendants of the historiated initial in the Moutier–Grandval Bible—as there are of the Acts cycles in the Vivian and San Paolo Bibles—later illustrations in Epistles initials follow its precedent in choice of subject matter and in the method of referring to several themes and disparate texts simultaneously.

III. MONUMENTS OF THE MIDDLE AGES IN WESTERN EUROPE

Precedents set in the Carolingian period in Pauline iconography continued as the rule in Western Europe to the middle of the twelfth century. There are three broad categories into which the majority of examples of the representation of St. Paul can be fitted.

Monuments with scenes from Acts form the first group, confining their Pauline imagery for the most part to the events of the conversion cycle. Affinities to the Carolingian Bibles can be discerned in Bibles and other manuscripts as well as in monumental schemes, the Sicilian mosaics[101] being the most important. After the eleventh century, the iconography of the conversion sequence, as represented in the San Paolo Bible, was enriched by the inclusion of the scene of Paul Baptized by Ananias. Individual scenes from Acts, not included in the conversion cycle but possibly traceable to the San Paolo frescoes, form a sub-group within this category. There are not many of these, but those that do exist are of value in giving us a picture, however incomplete, of the transmission of Pauline iconography. Included in this group is the depiction of Paul and Silas Flogged at Philippi in the ninth-century frescoes of San Benedetto, Malles (Fig. 181), several examples of the Stoning of Stephen[102] and the famous fresco of the Miracle of the Viper in St. Anselm's Chapel in Canterbury Cathedral.[103] Others can be found in both monumental and manuscript art.

The second category consists of apocryphal scenes. The majority of these are drawn from the *Passio Sanctorum Petri et Pauli*, a popular legend including the episodes of Peter and Paul

[100] 'Ego scio quoniam intrabunt post discessionem meam lupi rapaces in vos, non parcentes gregi.' The double image of Paul—persecutor and apostle—is portrayed dramatically, without the wolf/lamb metaphor, in the Pommersfelden Bible, made in Coblenz before 1077, which depicts Paul, in military dress, wearing a sheathed sword and carrying a shield, struck down by the hand of God in the very act of inflicting pain on a youth, evidently a Christian (Pommersfelden, Schönbornsche Bibliothek, Cod. 333/4, the 'Bible of St. Castor's of Coblenz'; see A. Grabar and C. Nordenfalk, *Romanesque Painting* (n. p., 1958), 166, 186, 190, 191).

[101] See below, 'Italian Monuments' and n. 208.

[102] See e.g. the representation in the crypt of S. Germaine at Auxerre, interesting in its variance from the Byzantine type (*Karl der Grosse*, cat. no. 666, 486–7).

[103] M. Rickert, *Painting in Britain: The Middle Ages* (Harmondsworth, 1954), 74, pl. 76; E. W. Tristram, *English Mediaeval Wall Painting* (Oxford, 1944), I, 21–4.

confronting Simon Magus, which we have already encountered.[104] Although Paul appears in the Simon Magus scenes, and his execution is depicted along with the crucifixion of Peter as part of the pictorial cycle, the legend as a whole belongs in the realm of Petrine iconography and is not the concern of the present study. A separate legend, the *Passio Sancti Pauli Apostoli*, circulated in several versions,[105] the most elaborate being the one ascribed to Linus (according to tradition, the first bishop of Rome after Peter), which is to be found in manuscript illumination from at least the twelfth century (Figs. 201–12);[106] it was later to be of importance as a source of thirteenth-century window decoration. In the Linus version Paul meets Plautilla, a Roman matron, on the way to his place of martyrdom and borrows her veil to bind his eyes. After his head is struck from the body, milk spurts upon the cloak of the soldier. Later, Paul appears to Plautilla and returns the blood-stained veil, which she shows triumphantly to the returning soldiers. Plautilla is often portrayed as present at the decapitation. Still later, Paul appears before Nero.

The third category consists of monuments unconnected with either Acts or the Apocrypha. These are to be found mainly in Rome, where a special veneration of Paul attached to the place of his martyrdom.[107]

Manuscript Illumination

Continuance of Carolingian iconography is exemplified in a number of manuscripts, one of the eleventh century, the others slightly later. The first, the Pericopes of Prüm, made in Prüm in the

[104] Lipsius-Bonnet, *Acta Apostolorum*, I, 119–77. The monumental examples of this cycle are: Rome, Old St. Peter's, Chapel of John VII (705–7): destroyed mosaics known through Grimaldi's drawings in Vat. Barb. lat. 2732, fol. 75ᵛ (see above, n. 51); Müstair, St. John's: nave frescoes, 9th c. (see above, n. 60); San Pietro in Tuscania: damaged frescoes of the 11th or 12th c.; Palermo, Cappella Palatina: mosaics of the north aisle, 1160s or 1170s; Monreale Cathedral: mosaics of the south chapel, completed by 1189; Sessa Aurunca: a full cycle in sculpture of the last decade of the 12th c.; Rome, Old St. Peter's: destroyed frescoes in the exterior portico, 1250–1350; San Piero a Grado, near Pisa: nave frescoes of the 13th to the 14th c., copies of St. Peter's portico frescoes. Partial cycles can be found in MS illumination and sculpture. This subject has been examined thoroughly in Glass, 'Sessa Aurunca', *passim*.

[105] See above, n. 7. The text of the *Passio Pauli* (as distinct from the *Acta Pauli et Theclae*) is given in Latin in Lipsius-Bonnet, *Acta Apostolorum*, I, 104–17, and an improved version in English translation in Hennecke, *New Testament Apocrypha*, 383–7.

[106] See Hennecke, 575, for a bibliographical note. The next reads: 'ligans sibi de Plautillae maforte oculos, in terram utrumque genu fixit et collum tetendit. spiculator vero bracchium in altum eleuans cum uirtute percussit et caput eius abscidit. quod postquam a corpore praecisum fuit, nomen domini Iesu Christi hebraice clara uoce personuit; statimque de corpore eius unda lactis in uestimento militis exiliuit et postea sanguis effluxit. stola uero qua sibi ligauerat oculos, cum eam quidam uellent rapere, non comparuit: ...

'Reuertentes uero qui missi fuerant accelerare interfectionem eius, peruenerunt ad portam ciuitatis, ubi inuenerunt Plautillam laudantem et glorificantem dominum in omnibus quae audiit et uidit per eius sanctum apostolum.

et interrogauerunt eam cum irrisione, cur caput suum non operiret de maforte quam praestiterat suo Paulo. quae accensa calore fidei cum magnanimitate respondit: O uani et miseri, qui credere nescitis, quae oculis uidetis et manibus attrectatis! uere habeo eundem quem illi porrexeram pannum, de infusione gloriosi sui sanguinis preciosum. nam de caelo ueniens innumerabilium candidatorum caterua comitatus illum mihi ueracissime rettulit, et rependens gratiam pro benignitate in eum habita dixit: Tu mihi Plautilla in terris obsequium praestitisti; ego te quantocius ad caelestia regna pergentem deuotissime obsequar. in proximo namque pro te reuertar et tibi inuicti regis gloriam demonstrabo. Et extrahens Plautilla pannum a sinu roseo perfusum sanguine illis ostendit ... venit Paulus circa horam nonam ianuis clausis stetique ante Caesarem et ait: Caesar, ecce ego Paulus, regis aeterni et inuicti miles; uel nunc crede, quia non sum mortuus, sed uiuo deo meo' (Lipsuis-Bonnet, *Acta Apostolorum*, I, 40–2).

[107] Some examples are: Rome, Lateran Palace: mosaic in the council chamber, 795–816; in the semi-dome of the apse, Mary as an orant is flanked by Peter and Paul, among others; below, the scene of Paul saved from shipwreck, is balanced by one of Peter saved from the waves (preserved in a sketch by Ugonio in Vat. Barb. lat. 2160, fol. 1ᵛ; see Waetzoldt, *Kopien*, 40–1); Rome, S. Prassede: the mutilated transept frescoes of the 9th c. included a scene of Paul and Pudens of Rome teaching Praxides of Rome (Wilpert, *Römische Mosaiken*, II, 1198; IV, pls. 202–4); Rome, Oratory of the Convent of Pudenziana: fragments of a fresco of the 11th c. renewed in the 13th c., with a series of scenes of Paul preaching, baptizing, and ordaining Timothy (preserved in the drawings of Eclessi in the Dal Pozzo Collection at Windsor Castle; Waetzoldt, *Kopien*, Figs. 512, 513).

Rhineland between 1026 and 1068 (Fig. 25),[108] illustrates the Feast of the Conversion of Paul on two facing pages. Three episodes from the Conversion sequence are depicted in a continuous narrative, the landscape extending from the verso of one folio to the recto of the next, which gives the illusion of spatial as well as a temporal unity. On the left, two episodes are conflated: the Conversion and Paul Led Blind to Damascus. Paul is shown led by the hand to Damascus, as in the Carolingian manuscripts, and at the same time rays appear from heaven towards his head, symbolic of the Conversion. From inside the city on the right to which he is being led, Paul is let down in a basket, also in a design similar to that in the Carolingian version.

The second manuscript, an edition of the works of St. Jerome of the late eleventh or early twelfth century now in Brussels (Fig. 26),[109] has a full-page introduction to the commentary on the Epistles, again closely reminiscent of the Carolingian iconography. The page is undifferentiated as to space; there are no frames and a number of actions are represented simultaneously. At the top, Christ is seated in a round mandorla holding a scroll inscribed with a quotation from Acts 9:4, gesturing at Paul who is collapsing, supported and led by two men (again a conflation of two episodes, the Conversion and Paul Led to Damascus). On the right, inside a building, Paul is baptized by Ananias, who gestures at his eyes. This is a literal rendering of the text of Acts 9:18: 'And immediately it seemed that scales fell from his eyes and he regained his sight. Thereupon he was baptized.'[110] The artist probably is again conflating two episodes, the Healing by Ananias and the Baptism.[111] At the bottom of the page Paul preaches to a group of men and women.

Both the Pericopes of Prüm and the Brussels manuscript show similarity to the San Paolo Bible (Fig. 7) in the depiction of Paul led to the gate of a city inside which another scene is enacted at the same time. Another point of comparison with Carolingian precedent is the Brussels Baptism of Paul, which is obviously derived from the Carolingian Healing of Paul (Fig. 6). The main additions in the later version are the font and two inscriptions: one is on the book held by Ananias—*Credis in Dominum*; the other is Paul's response, issuing from his mouth—*Credo*. The inclusion of Paul's baptism in the Brussels manuscript is noteworthy in that it is one of the earliest Western monuments in which this subject is incorporated into the conversion cycle, where it logically belongs.[112]

Persistence of Carolingian iconographic traditions also can be seen in two English manuscripts of the mid-twelfth century. The first, an edition of Anselm's prayers and meditations now in Oxford (Fig. 27),[113] makes use of the Conversion as an allegorical adjunct to the text,

[108] Manchester, Rylands 7, fols. 133ᵛ, 134. See H. Swarzenski, *Monuments of Romanesque Art*, 2nd ed. (London, 1967), Fig. 177; R. Schilling, 'Das Ruotpertus-Evangelistar aus Prüm, MS. 7 der John Rylands Library in Manchester', in *Studien zur Buchmalerei und Goldschmiedekunst des Mittelalters* (Marburg, 1967), 143–54. Dinkler-von Schubert, 'Per Murum', 79 ff., and Kessler, *Illustrated Bibles*, 117–18, 123, both discuss the Pauline scenes.

[109] Hieronymus, *Opera*, Brussels, Bibl. Royale 10752, fol. 6, from the Monastery of St. Lawrence, near Liège. See C. Gaspar and F. Lyna, *Les principaux manuscrits à peintures de la Bibl. Royale de Belgique* (Paris, 1937), I, pl. XVIIIa.

[110] 'Et confestim ceciderunt ab oculis ejus tanquam squamae, et visum recepit; et surgens baptizatus est.'

[111] See below, pp. 88–91 nn. 57, 58, for a discussion of the relation of the Healing to the Baptism.

[112] The relief sculpture at Ripoll in Spain, contemporary with the Brussels MS, also includes the Baptism of Paul, as does the Vercelli Rotulus (see below, pp. 23, 34).

[113] Oxford, Bodl. Auct. D. 2. 6., fol. 170ᵛ. See O. Pächt and J. J. G. Alexander, *Illuminated Manuscripts in the Bodleian Library Oxford*, 3 (Oxford, 1973), no. 154, 18; and C. M. Kauffmann, *Romanesque Manuscripts 1066–1190* (London, 1975), no. 75, 103–4. O. Pächt, 'The Illustrations of St. Anselm's Prayers and Meditations', *Journal of the Warburg and Courtauld Institutes*, 19 (1956), 68–83, Fig. 24b, discusses the relation of text and illustration. Another illustrated version of the same text actually depicts Paul raised to the Third Heaven (my Fig. 264), which Pächt incorrectly identifies as the Conversion of Saul (ibid. 77, Fig. 20b).

rather than in its literal meaning. Accompanying Anselm's prayers to St. Paul in which Paul's mystical elevation to the third heaven (II Cor. 12:1–5) is invoked[114] are scenes from the Conversion sequence. The iconographers obviously have given an anagogical interpretation to historical events as represented by the narrative pictorial tradition. On the left is the prostrate Paul, his companions bending over him, with the bust of Christ in the arc of heaven. Next, the dream of Ananias is rendered in typical twelfth-century fashion, with an angel acting as messenger from God. Finally, Ananias heals the bedridden Paul with a gesture. Despite the evolved nature of many of the motifs, dependence on the Carolingian sequence is still apparent.

Paul's history continues in a second English manuscript of the same date, a glossed edition of the Epistles also in Oxford (Fig. 28),[115] in which the historiated initial introducing the Epistles includes depictions of Paul Preaching in Damascus and Paul's Escape that echo to some extent the San Paolo Bible in composition and gesture: the upward glance of Paul in the basket, for example, and the recoil of the foremost of the spectators in the preaching scene. It is also like the Moutier–Grandval Bible (Fig. 23) in representing the Execution of Paul in the stem of the initial, and in its reference to Paul as a 'lamb'—that is, as a preacher—in the loop.[116]

Between them the two English manuscripts include six of the possible nine episodes of the ninth-century cycle, with details so circumstantial as to suggest that a model similar to the Pauline sequences in the Carolingian Bibles was available to them. All of the foregoing examples originate in fact in areas where Carolingian influence was strong, England and the valleys of the Rhine and Meuse. The Benedictine Abbey in Prüm, for example, is reputed to have owned a Bible similar to the Grandval and Vivian manuscripts.[117]

In Italy, too, there is evidence of dissemination of the Carolingian iconography. A group of New Testaments produced in Verona in the thirteenth century[118] have single-page conversion cycles (Figs. 20, 21)—among other Acts scenes—that repeat many features of the ninth-century iconography and composition, and in fact are so close to the San Paolo Bible itself as to suggest direct affiliation. I have noted already the tendency for the stricken Paul in the conversion scene to be shown in a supine position in Italy. Since it is known that the San Paolo Bible was in Italy at the latest by the end of the eleventh century, and possibly as early as the ninth century,[119] the possibility of the influence of this prominent manuscript is not difficult to accept. It is but one aspect of the circulation of Carolingian exemplars serving as the inspiration of Pauline Acts imagery up to the twelfth century.

Another stream of transmission of iconographic themes, possibly linked to the San Paolo frescoes, can be seen in the Hamilton Psalter, a twelfth-century manuscript from North Italy in which narrative scenes from a multitude of texts, including Acts, are used to illustrate the Psalms (Fig. 17).[120] It has a number of episodes not found in Carolingian art which repeat subjects in the frescoes, but its imagery tends to be imprecise, making it difficult to identify sources with any certainty. The Hamilton Psalter, along with the Verona New Testaments, will be considered in greater detail in the discussion of Italian monuments.

[114] *PL* 158, 975.

[115] Oxford, Bodl. Auct. D. 1. 13. Pächt and Alexander, *Illuminated MSS*, 3, no. 130, 16, pl. XII; and Kauffmann, *Romanesque*, no. 79, 106–7, ill. 212; it probably was made in Winchester.

[116] See above, n. 92.

[117] Kessler, *Illustrated Bibles*, 6–8, discusses this and other evidence for the later influence of the Carolingian Bibles.

[118] See below, n. 187.

[119] J. Gaehde, 'The Painters of the Carolingian Bible Manuscript of San Paolo Fuori le Mura in Rome', unpublished Ph.D. dissertation, New York University, 1963, pt. II, 1–5.

[120] Berlin, Staatliche Museen, Kupferstichkabinett, cod. 78 A 5; see below, n. 190.

Numerous episodes from the Apocrypha are to be found as well in manuscripts of this period, mainly in liturgical books. From the ninth century onward apocryphal legends were read aloud during the Office and even were included in early breviaries;[121] it is not surprising that representations of the scenes they described came to decorate the pages of these books. The several versions of the Pauline–Petrine Apocrypha gave rise to a variety of pictorial interpretations that were used as illustrations of liturgical readings for the joint feast of Peter and Paul on 29 June and the feast of Paul on 30 June.

In their simplest form the Apocrypha-inspired illustrations recorded the culminating point of the *Passio*, the beheading of Paul, usually depicted as occurring simultaneously with the Crucifixion of Peter. The Peter–Paul martyrdom in the Benedictional of Aethelwold of 963–84 exemplifies this type (Fig. 32).[122] In a symmetrical arrangement, the upside-down Crucifixion of Peter occupies the top half of the panel, with Paul kneeling before the executioner on the bottom. It is characteristic of the early period in that the moment previous to the decapitation is depicted. In contrast, in the execution of Paul in the slightly later Sacramentary of Warmundus of 969–1002 the head is completely severed (Fig. 34), a motif that points to the future.[123] The latter scene is also slightly more complex in that Nero is shown directing the martyrdoms.[124]

More extended cycles of scenes from the *Passio Petri et Pauli* comprise the imagery of another group of manuscripts, and again a process of chronological development is apparent. In the earlier versions, such as the Antiphonary of Prüm of the late tenth century (Fig. 33),[125] the sequence of scenes showing the appearances of the Apostles before Nero and the struggle with Simon Magus culminates in their executions; but it is again the moment before the decapitation that is pictured. By way of contrast, in later works, from the Fulda Sacramentary in Göttingen of the tenth or early eleventh century onward (Fig. 35),[126] the decollation of the head is shown in gruesome detail.

A special place is occupied by the Salzburg Antiphonal of the mid-twelfth century in which

[121] P. Batiffol, *Bréviaire*, 136–41; Mâle, 'Les Apôtres', 206.

[122] London, BL Add. 49598, fol. 95[v]; G. Warner, *The Benedictional of St. Aethelwold* (Oxford, 1910); and R. Deshman, 'The Iconography of the Full-Page Miniatures of the Benedictional of Aethelwold', unpublished Ph.D. dissertation, Princeton University, 1970, 153–7.

[123] Ivrea, Bibl. Capitolare MS LXXXVI, fol. 90[v]; see L. Magnani, *Le miniature del sacramentario d'Ivrea* (Vatican City, 1934), pl. 23. In general, before the end of the 11th c., the moment before the beheading is depicted, with Paul's head still attached to his body.

[124] Many examples of MSS with a similar iconography are to be found, which depict the Execution of Paul (taking place alongside that of Peter) with Paul's head partially or completely severed. In certain of these Nero is present: Stuttgart, Landesbibl. Bibl. fols. 56, 57, 58, Passional, 12th c., fol. 15[v]; New York, Morgan Library 710, Bertholdus Missal, early 13th c., fol. 96. In others the figure of Nero is excluded: Munich, Staatsbibl. Clm 16002, Pericopes of Passau, pre-1174, fol. 32[v]; Salzburg, Stiftsbibl. St. Peter a.IX.11, Gradual, *c*.1200, fol. 131 (the Execution of Paul only); Karlsruhe, Landesbibl. St. Peter 7, Lectionary, 12th to 13th c., fol. 9 (Execution of Paul together with Peter Receiving the Keys). Some examples of other MSS which include

representations of the Conversion as well as the Execution of Paul without Peter (in all except the first Nero is present) are: Stuttgart, Landesbibl. Hist. fol. 415, Martyrologium, second half of the 12th c., fol. 20 (Conversion), fol. 45 (Execution), among the martyrdoms of a number of saints; Oxford, Keble College, Legendarium, second half of the 13th c., fol. 47[v] (Conversion), fol. 104 (Execution); Maihingen, Wallerstein Lib. I.2.8.vo 6., Breviary, second half of the 13th c., fol. 11 (Conversion, Paul Baptized by Ananias), fol. 79 (Execution); Baltimore, Walters 757–60, Antiphonal of Beaupré, 1290, I, fol. 153 (Execution), III, fol. 162[v] (Conversion).

[125] Paris, BN lat. 9448, fols 54[v] and 55; see A. Goldschmidt, *German Illumination*, II (New York, n.d.), 17, pl. 68; and R. Schilling, 'Das Ruotpertus-Evangelistar aus Prüm, MS. 7 der John Rylands Library in Manchester', *Studien zur Buchmalerei und Goldschmiedekunst des Mittelalters* (Marburg, 1967), 144, n. 10. In the Drogo Sacramentary (Paris, BN, lat. 9428, fol. 86), although the confrontation with Simon Magus does not appear, there are four scenes, and the Execution of Paul is of the early type; see W. Koehler, *Drogo-Sakramentar*, ed. F. Mütherich (Graz, 1974), 26.

[126] Göttingen, Univ. Bibl., cod. Theol. 231, fol. 93; see Goldschmidt, *German Illumination*, II, notes to pl. 106.

the final moments of the Linus *Passio Pauli* are depicted (Fig. 201):[127] Paul receives the veil from Plautilla on the left and falls, decapitated, his eyes bound, at the feet of the executioner on the right, watched by a group of spectators.

Medieval miniaturists seem to have taken a special delight in making Paul's decapitation as grisly as possible. But there was another tradition as well. When Bible illustration of the latter part of the period is considered, it will be seen that in Bibles the iconography of the Execution of Paul is drawn from another source: namely, either the Early Christian (Fig. 29) or the Byzantine traditions (Figs. 14, 31), in which the moment previous to the beheading is commemorated.

Sculpture

Sculptural depictions of Pauline subjects, while fewer and worse preserved than images in illuminated manuscripts, are more plentiful than was suspected by Mâle and Dobschütz,[128] especially if non-French monuments are taken into consideration.[129] Of the Romanesque and Gothic churches with sculptured Pauline scenes, Santa Maria in Ripoll, constructed in the late eleventh or early twelfth century, seems to have had the most extensive cycle (Fig. 38).[130] The sculptures of the portal of Ripoll are generally supposed to have been copied from either the frescoes of its then existing interior decoration,[131] or from an eleventh-century Bible similar to the Roda and Ripoll Bibles.[132] Canonical and Apocryphal Peter scenes rise up one side of an archivolt of the west portal, culminating in the Crucifixion of Peter. On the Paul side are two episodes from the Conversion sequence: the Conversion and Paul Baptized by Ananias; another Acts episode depicting Paul debating or preaching (Paul Argues with the Stoics and Epicureans); and three Apocryphal events: Paul Arrested by Two Soldiers, the Execution (Paul's eyes bound by a veil, the sword held at his neck—that is, the Linus version of the *Passio* as in the Salzburg Antiphonal), and finally, Paul Stands Decapitated, the executioner raising the severed head (the upright pose is due, of course, to the shape and position of the block on the archivolt).

Several later churches echo Ripoll by featuring Pauline scenes in prominent places and combining episodes from the Conversion sequence with the *Passio*. On the west exterior frieze of St. Paul de Varax in Burgundy, of the twelfth century,[133] for example, are two episodes of the Execution of Peter and two of the Execution of Paul, together with the Conversion. A century later, in Santa Maria di Regla in Leon, on an archivolt of the left portal, among unidentified scenes, are depictions of the Conversion, Paul Led to Damascus, Paul Preaching and Paul Baptized by Ananias, as well as the Arrest (hands bound, Paul follows two armed men).[134]

Romanesque fantasy sometimes results in distortion of iconographic tradition, as at St.

[127] Vienna, Nationalbibl. Ser. Nov. 2700 (formerly Salzburg, Stiftsbibl. St. Peter a.XII.7), Antiphonal, mid-12th c., p. 368 (the separate martyrdom of Peter is on p. 366). See above, n. 106, for the Linus *Passio*; and *Das Antiphonar von St. Peter*, commentary by F. Unterkircher and O. Demus (Graz, 1974), 322–34.

[128] See above, *Introduction*, nn. 1, 4, 5.

[129] A recurring motif in this investigation is the interesting Spanish element in sculpture as well as in other media, suggesting that a more detailed examination of the Spanish iconography of St. Paul would probably be a rewarding venture. See, e.g., the summary of Paul's career by Isidore of Seville (below, Ch. 3, n. 172), and the unpublished illustrated 12th-c. commentary on the Epistles, New York, Morgan M. 939, formerly Dublin, Beatty MS 44.

[130] A. K. Porter, *Romanesque Sculpture of the Pilgrimage Roads* (Boston, 1923), V, pls. 560–93, and *Spanish Romanesque Sculpture* (Florence–Paris, 1928), II, 23–4. The main theme is the Apocalypse.

[131] Grabar and Nordenfalk, *Romanesque Painting*, 71.

[132] Porter, *Spanish Romanesque Sculpture*, 23. Neither the Roda Bible (Paris, BN lat. 6) nor the Ripoll Bible (Rome, Vat. lat. 5729) includes surviving Pauline subjects. The Roda Bible has been mutilated, and the centres of the initials of the Pauline Epistles, possibly with historiated scenes, excised.

[133] Porter, *Pilgrimage Roads*, II, pls. 86–90.

[134] F. B. Deknatel, 'The Thirteenth Century Gothic Sculpture of the Cathedrals of Burges and Leon', *Art Bulletin*, 17 (1935), 243–389, Fig. 72.

Lazare, Autun, *c*.1120–32,[135] where there is an unusual conversion scene on a pier of the north wall. Paul appears to be seated in mid-air, hands crossed, showing his submission to Christ, who stands in front of him, observed by an angel;[136] it is combined with Paul Baptized by Ananias. A depiction of St. Peter in Chains occupies another face of the pier, and on a corresponding pier on the south wall are scenes from the *Passio Petri et Pauli*.

Other ensembles concentrate on the Conversion, one of the most notable being the relief on the Episcopal Throne in Parma attributed to Benedetto Antelami, who is supposed to have made it shortly after 1178 (Fig. 44).[137] It is generally accepted as a depiction of Paul, recognized by the typical physiognomy. He is mounted, falling backwards along the rump of the horse, his right leg flying upwards, his left in the stirrup. The panel is paired with a depiction of St. George and the Dragon on the opposite side, the parallel obviously arising from the equestrian theme.[138]

At Reims, two of the lintels of the west façade of *c*.1250 depict the Conversion sequence.[139] On the north lintel there is a Conversion in the company of six companions: Paul apparently has fallen from his horse and is kneeling in the foreground (the sculpture is mutilated and difficult to read). The south lintel continues the sequence: Paul Led to Damascus (by three men), Paul Healed by Ananias, and Paul Baptized by Ananias.

Like the manuscripts described above, the representations in sculpture repeat for the most part themes established in Carolingian art. One feature characteristic of the sculptural ensembles—and of monumental art in general—is the inclination towards combining canonical and apocryphal subjects, often with equal stress, in contrast to manuscripts, which tend to concentrate on one or the other.

Twelfth- and Thirteenth-Century Monumental Painting

Emphasis on the apocryphal legends found ample expression in the twelfth and thirteenth centuries. In fact, Emile Mâle, basing his conclusions mainly on sculpture and stained glass in France, confined his discussion of Paul to his chapter on the Apocrypha.[140] It is easy to see how the legends, narrated and even illustrated in liturgical books, could have been elevated to the windows, visible to the congregation during the readings. We have the example of Chartres, where the text of the Linus version of the *Passio Sancti Pauli Apostoli* was included in the Lectionary from the tenth century onwards, and was depicted on a window of the thirteenth century (Fig. 36).[141]

It is true that the legends were most important in the art of this period, particularly the story of the struggle against Simon Magus, with or without the elaborations added by Linus. The windows at Lyon of the twelfth century, and of Poitiers, Tours, and Troyes of the thirteenth

[135] D. Grivot and G. Zarnecki, *Gislebertus, Sculptor of Autun* (New York, 1961), 74, 160, pls. 32a, 32b.

[136] Ibid. 160. The authors suggest a 'mystery play' as the possible source for this unusual motif.

[137] G. de Francovich, *Benedetto Antelami* (Milan, 1952), 161–5; see *Introduction*, for a discussion of the Parma sculptures.

[138] A mounted figure on a cloister capital at Arles of the 1180s has also been identified as Paul in the Conversion scene; see Porter, *Pilgrimage Roads*, IX, pl. 1360; and P. Deschamps, *French Sculpture of the Romanesque Period* (Florence, 1930), 86–7, 97, 136, n. 347. It is matched with the Entry into Jerusalem on the paired capital, again suggesting equestrian symbolism, as at Parma. The youthful, beardless

figure at Arles, however, is difficult to accept as Paul, nor is the identification as Constantine (C. Enlart, *Les Monuments des croisés dans le royaume de Jérusalem*, II (Paris, 1928), pl. 194, Fig. 390) more convincing. For a refutation of previous interpretations of this and other mounted figures see R. Crozet, 'Le thème du cavalier victorieux dans l'art roman de France et d'Espagne', *Principe de Viana*, 32 (1971), 125–43.

[139] W. Sauerländer, *Gotische Skulptur in Frankreich, 1140–1270* (Munich, 1970), Fig. 222; and E. Moreau-Nélaton, *La Cathédrale de Reims* (Paris, 1915), pls. 40, 47.

[140] See above, p. 1, nn. 4, 5.

[141] Y. Delaporte and E. Houvet, *Les Vitraux de la cathédrale de Chartres* (Chartres, 1926), 284–90, pls. 86–8.

century,[142] confined themselves to the Apocrypha. However, certain other windows included canonical scenes. The window at Bourges (Lady of Lourdes Chapel) had only one canonical Acts scene (The Lystrians Bearing Gifts),[143] and there were two—the Stoning of Stephen and the Conversion of Paul—in the Chapel of the Virgin at Amiens.[144] Three windows of the thirteenth century—at Chartres, Rouen, and Sens—were decorated with extensive cycles of Pauline scenes, in which canonical and apocryphal subjects were combined. The iconography of these windows moves beyond the limits of Carolingian subject-matter. They are contemporary with the innovations in thirteenth-century Bible illumination, and the individual scenes will be discussed in that context in Chapter Three. My purpose at this point is to list the subjects known to us today in these restored and rearranged windows, to help give a general picture of the terms of reference of the medieval artist working with Pauline imagery.

The large lancet window in the central apse at Chartres (Fig. 36) consists of thirty-six panels arranged in tiers of three, of which fifteen are nineteenth-century restorations.[145] The remaining scenes that can be identified, in the order of present placement, are: the Arrest of Paul; Paul Baptizes a Youth; Baptism *in extremis* (or a healing scene); the Miracle of Eutychus (or Patroclus) in five scenes; Paul Baptizes Three People in a Font; the *Passio Petri et Pauli* in three scenes; Paul Condemned by Nero; Plautilla Gives the Veil to Paul; the Execution; Paul Returns the Veil, Paul Appears to Nero.

At Rouen, the restored window in the Sacristy (Fig. 37) also is a single large lancet, but arranged in tiers of two panels; it was at one time in the Chapel of Peter and Paul in the north ambulatory.[146] The original order of the panels cannot be determined now, but it is obvious that some events were depicted as a continuous narrative in a number of scenes, while other single episodes were spread over several adjacent panels. The subjects in their present order are: the Conversion of Paul, from a horse; Paul Led to Damascus; Paul in Bed Fed and Healed by Ananias;[147] Paul Preaching in Damascus; the Miracle of Eutychus (or Patroclus) in two scenes; Paul Led before a King; Paul and Peter in Rome in ten scenes; Paul and Peter before Nero in one scene spread over two panels; Paul Receives the Veil from Plautilla; the Execution; Paul Returns the Veil; Angels Bear Paul's Soul to Heaven.

The window in the Chapel of St. Savinianus at Sens is of a different type than those at Chartres and Rouen.[148] It consists of two lancets surmounted by a rose. In the left bay the following subjects were represented: Paul's Departure for Damascus (he carries a spear, riding on a horse); the Conversion, on horseback; Paul Baptized by Ananias; Preaching in Damascus; Flight from Damascus; Paul Pursued by Soldiers. In the right bay are: Paul Preaches to the Athenians; the Incredulity of the Athenians (?); Healing of a Blind (?) Man; Paul Appears before Festus; Paul Visited by Christ; Shipwreck on Malta; the Execution. The medallion of the rose is occupied by the seated figure of Paul.

It is obvious that the range of Pauline subject-matter, apocryphal and canonical, had expanded. The majority of the new canonical themes were included as well in the San Paolo frescoes,[149] but, as we shall see next, many of them also were to be found in post-Iconoclastic

[142] All four are described in Mâle, *Art religieux*, 298–9.

[143] S. Clément and A. Guitard, *Vitraux de Bourges* (Paris, 1900), pl. xv.

[144] Mâle, *Art religieux*, 300, n. 3.

[145] Window no. 32; see n. 141.

[146] G. Ritter, *Les Vitraux de la Cathédrale de Rouen* (Paris, 1926), 48–50, pls. XXIV–XXVI.

[147] See below, pp. 89–90, for occurrences of this scene in manuscripts.

[148] L. Bégule, *La Cathédrale de Sens* (Lyon, 1929), 55, 56, Figs. 69, 70.

[149] Prominent among these are: the Baptism (Waetzoldt, *Kopien*, cat. no. 634, Fig. 372); the Raising of Eutychus (cat. no. 639, Fig. 377); the Lystrians Bearing Gifts (or, Flight

Byzantine art. Both of these possibilities, therefore, should be considered in the search for sources. In the thirteenth century, of course, invention of new imagery was common practice.

By this time also the art of stained glass had become innovative, acting as mentor to the other media in questions of style, iconography, and design. We can expect, therefore, that the influence of this rapidly expanding body of material will find its way to the scriptoria and other workshops.

IV. BYZANTINE MONUMENTS

Byzantine Pauline imagery provides a wide repertoire of subjects; I shall concentrate here on representations of scenes from the Acts of the Apostles, a topic which has been investigated actively in recent years. Kurt Weitzmann, Hugo Buchthal, Herbert Kessler, and the present writer, from different viewpoints, have suggested that Byzantine scriptoria produced editions of the text of Acts which must have been accompanied by pictures.[150] That such manuscripts existed is attested by the Rockefeller-McCormick New Testament in Chicago of the late twelfth or early thirteenth century (Figs. 9, 12, 172),[151] in which thirteen—originally seventeen or eighteen—miniatures are placed as panels within the text of Acts; of these, four (probably originally six) are Pauline subjects. This almost lone survivor, unfortunately, does not rise to the high standard of narrative precision of which Byzantine painting was capable; some of its miniatures are weak or simplified derivatives, while others are symbolic rather than narrative interpretations. Even more unfortunately from our standpoint, the crucial pages in which the Conversion sequence was no doubt depicted have been excised.

Other monuments, however, provide indirect evidence of the scope and textual fidelity that must at one time have prevailed in Acts illustration. These works range from manuscripts of the New Testament with one or a few pictures—usually functioning as prefaces—accompanying Acts or the Epistles to a host of other editions in which 'migrated' scenes from Acts are juxtaposed to other texts, and extend to mural decoration as well. Included in the list of manuscripts with partial cycles or single scenes are two copies of the New Testament now in England: Phillipps MS 7681, an edition of the Acts and Epistles made in 1107,[152] in which the frontispiece to the Epistles consists of two Pauline scenes, the Conversion and the Execution (fol. 121v, Fig. 14); and the twelfth-century 'Codex Ebnerianus' in Oxford, with the Conversion in the headpiece at the beginning of the Epistles.[153] (Another Acts and Epistles of the twelfth century

from Apotheosis (cat. no. 657, Fig. 395)); Paul Visited by Christ (cat. no. 664, Fig. 402); Shipwreck on Malta (cat. no. 667, fig. 405); the Miracle of the Viper (cat. no. 668, Fig. 406).

[150] See above, n. 31; and Buchthal, 'Life of Paul', 48; also K. Weitzmann, 'The Selection of Texts for Cyclic Illustration in Byzantine Manuscripts', *Byzantine Books and Bookmen* (Washington, 1975), 76–7; Kessler, 'Paris gr. 102', and Eleen, 'Acts Illustration', the Appendix of which lists the subject-matter of a number of Byzantine and related monuments.

[151] Chicago University Lib. cod. Greg. 2400 (or cod. 965); see *The Rockefeller McCormick New Testament*, ed. E. J. Goodspeed *et al.*, 3 vols. (Chicago, 1932); and H. R. Willoughby, 'Codex 2400 and Its Miniatures', *Art Bulletin*, 15 (1933), 3–74; *Illuminated Greek Manuscripts from American*

Collections, catalogue of an exhibition held in Princeton, April 14–May 20 1973, ed. G. Vikan (Princeton, 1973), no. 45, 162–5; and A. Weil Carr, 'The Rockefeller McCormick New Testament: Studies Toward the Reattribution of Chicago, University Library MS. 965 (unpublished Ph.D. dissertation, University of Michigan, 1973). See below, Appendix A, for a chart of Acts iconography, actual and hypothetical, in this manuscript.

[152] Now owned by the Robinson Trust, London. See Buchthal, 'Life of Paul', pl. 9.

[153] Oxford, Bodl. Auct. T. infra I.10 (misc. 136), fol. 312v; see *Byzantine Illumination*, Bodleian Picture Book no. 8 (Oxford, 1952), Fig. 17; C. Meredith, 'The Illustration of Codex Ebnerianus: A Study in Liturgical Illustration of the Comnenian Period', *Journal of the Warburg and Courtauld Institutes*, 29 (1966), 419–24.

has four scenes from Acts prefacing Acts itself, but only one of these is a Pauline subject.)[154]

Key witnesses to traditions of Pauline imagery are three editions of the *Christian Topography* of Cosmas Indicopleustes: one from the ninth century in the Vatican Library and two from the eleventh century, at Mt. Sinai (Fig. 10) and in the Laurentian Library in Florence.[155] In addition, the Conversion and Execution of Paul are used as illustrations in the well-known Homilies of Gregory Nazianzen, made in 880–6,[156] and the Execution in a Menologion of the eleventh to the twelfth centuries (Fig. 31).[157] A number of scenes, both canonical and apocryphal, serve as marginal illustrations in the ninth-century manuscript of the *Sacra Parallela* of John of Damascus.[158] Byzantine Psalters also occasionally employed scenes from the activities of Paul to illustrate the Psalms. Thus, the Bristol Psalter of the eleventh century illustrates Psalm 18 with a scene of Paul preaching,[159] and a Psalter of the eleventh century in the Vatican has as its illustration to Psalm 8 a complex series of preaching and liturgical scenes involving Paul.[160]

There is also literary evidence of pictorial imagery from Acts and the Apocrypha in Byzantium. The 'Painter's Manual of Dionysius of Fourna',[161] the best-known of several artists' handbooks, evidently was written in the eighteenth century, but has been thought to embody earlier traditions, although there is much in the history of its discovery and interpretation that is suspect. In fact, the six canonical—and one apocryphal—Pauline scenes recorded in the Painter's Manual are confirmed by supporting evidence in Byzantine and related art, and in turn the descriptions in the Manual help to identify the particulars of Byzantine iconography.[162]

Finally, the fourteenth-century fresco cycle at Dečani in Serbia (Figs. 11, 13, 182),[163] although falling beyond the chronological limits of the present study, is relevant to it because these paintings form the most complete Acts sequence in Byzantine art. Comparison of selected scenes at Dečani with older versions indicates that the iconography derives from that of an earlier period.

[154] Paris, BN gr. 102, fol. 7ᵛ; the Stoning of Stephen is included with 3 other Acts episodes (Kessler, 'Paris gr. 102', Fig. 1).

[155] Mount Sinai, St. Catherine's Monastery MS 1186 (10th to 11th c.), fol. 128ᵛ: see K. Weitzmann, *Die byzantinische Buchmalerei des 9. und 10. Jahrhunderts* (Berlin, 1935), 58–9, Fig. 388; Rome, Vat. gr. 699 (9th c.), fol. 83ᵛ: ibid., 4, 38, Fig. 16; and Biblioteca Medicea-Laurenziana, cod. Plut. IX.28 (11th c.), fol. 170ᵛ: *Byzantine Art, An European Art*, catalogue of an exhibition held in Athens, 1964, no. 366, 346 f. The Pauline scenes in the Cosmas manuscripts are: the Stoning of Stephen, Saul Receives Letters, the Conversion, Paul led to Damascus.

[156] Paris, BN gr. 510, fols. 32ᵛ, 264ᵛ. See H. Omont, *Miniatures des plus anciens manuscrits grecs de la Bibliothèque Nationale du VIᵉ au XIVᵉ siècle* (Paris, 1929), 24 f., pls. XXII, XLII.

[157] Jerusalem, Gr. Patr. Saba 208, fol. 87ᵛ. See A. Baumstark, 'Ein illustriertes griechisches Menaion des Komnenenzeitalters', *Oriens Christianus*, 3, Ser. 1 (1926), 67–79, pl. II (2).

[158] Paris, BN gr. 923, fol. 13, Paul with the Epicureans; fol. 28ᵛ, Paul Preaching; fol. 146ᵛ, Peter and Paul with Simon Magus; fol. 213ᵛ, Miracle of the Healing of the Father of Publius; fol. 188ᵛ, Paul Addresses the Elders of Ephesus (among other Acts scenes). See Weitzmann, *Byzantinische Buchmalerei*, 80–1; idem, 'Cyclic Illustration', 76–7; and

[159] London, BL Add. 40731, 'Bristol Psalter', fol. 31; Psalm 18:4; see S. Dufrenne, 'British Museum 40731', in *L'Illustration des psautiers grecs du moyen âge*, I. Bibliothèque des Cahiers Archéologiques (Paris, 1966), 47–51, pl. 49.

[160] Rome, Vat. gr. 752; see Weitzmann, *Roll and Codex*, 121 f.

[161] P. Hetherington, *The 'Painter's Manual' of Dionysius of Fourna* (London, 1974), 66–7. The Pauline scenes described by Dionysius are 'Paul called by the Lord on the road', 'Paul baptised by Ananias', 'Paul, lowered from the walls in a basket, flees from the hands of the Jews', 'Paul, blinding the magician Bar-Jesus', 'Paul healing the woman with the spirit Python', 'Paul, having shaken off the viper that bit him into the fire, burns it'. See also J. von Schlosser, *La letteratura artistica*, 3rd Italian ed. (Florence, 1964), 16–18; V. Grecu, 'Byzantinische Handbücher der Kirchenmalerei', *Byzantion*, 9 (1934), 675–701.

[162] Eleen, 'Acts Illustration', *passim*.

[163] V. R. Petkovitch, 'Un cycle des peintures de l'église de Dečani' (in Serbian with a French summary), *Bulletin de la Société Scientifique de Skopje*, 7–8, Section des Sciences Humaines, 3–4 (1930), 83–8; idem., *Dečani*, Monumenta Serbica Artis Mediaevalis, II (Belgrade, 1941). I have discussed the relation of Dečani to earlier Byzantine art in 'Acts Illustration'.

Kessler, 'Paris gr. 102', nn. 6, 7; at the time of writing we await Prof. Weitzmann's publication of the *Sacra Parallela*.

For example, the Pauline Conversion sequence at Dečani (Fig. 13) is recognizably similar—despite its additional crowd of bystanders—to the same sequence in the eleventh-century codex of Cosmas Indicopleustes at Mt. Sinai (Fig. 10). As in the earlier version, in the Dečani cycle the story is told in three episodes, combined in one unified composition: on the left, the enthroned High Priest hands a letter to Saul, whose movement and pose repeat the earlier depiction; Paul performs *proskynesis* in the centre—the actual moment of the Conversion—while his friends gesture in awe (a previous moment in the continuous narrative, the Blinding, has been eliminated, a common occurrence in the transmission of imagery); in the third episode Paul's companion leads him to Damascus. Such innovations as the inclusion of the bust of Christ in the arc of heaven and the placement of the buildings in the foreground rather than in the distance are changes typical of later approaches to iconography and style. One noteworthy difference is in the scene of Paul Led to Damascus: at Dečani he is led forward by a youthful companion wearing a short tunic, instead of being guided from behind by Ananias clad in a pallium, as in the Cosmas representation.[164] If, however, we substitute the same subject in the Rockefeller-McCormick New Testament (Fig. 9) for the one in the Cosmas manuscript, it is evident that all of the Conversion episodes at Dečani exhibit continuity with earlier Byzantine art.

Paul's Baptism by Ananias at Dečani (Fig. 11) also recalls the same subject in the Rockefeller-McCormick New Testament (Fig. 12): Paul, naked and gesturing in a cistern-shaped font, is baptized by Ananias standing on the left, holding his garment in his left hand. The Painter's Manual describes this episode in similar language.

Individual Pauline Acts scenes at Dečani, therefore, can be traced back to precedents in the ninth (the Vatican Cosmas), tenth (the Menologion of Basil II),[165] eleventh (the Mt. Sinai and Florence Cosmas codices), and twelfth centuries (the Rockefeller-McCormick New Testament). The Dečani sequence, however, is more than a collection of episodes, each with a separate origin. It is more likely that Dečani is an integrated whole, going back to an earlier complete cycle, and that a wide range of Pauline Acts imagery obtained in Byzantium fairly early in the post-Iconoclastic period. The close reliance on the Acts text at Dečani and in related monuments suggests that the integrated cycle could have originated and been handed down by means of an illustrated Acts text, with a cycle of miniatures at least as complete as that of Dečani.

Corroborative evidence is provided by Italian versions of the same iconography, found in at least five New Testament manuscripts of which the most important are three produced in Verona in the first half of the thirteenth century[166] (Figs. 20–2, 136, 173–4, 178, 186, 196), together with a number of examples of monumental art, notably the destroyed Romanesque frescoes of Sant' Eusebio in Vercelli (Figs. 18, 191), known today from a Rotulus in the Cathedral Archives in Vercelli.[167] This Italian material, all of it later than the beginning of the eleventh century, repeats idiosyncratic features of the Byzantine cycle.

Three examples will serve to demonstrate the affinity of the Italian iconography with that of Byzantium. The first is the depiction of Paul Baptized by Ananias in the Vercelli Rotulus

[164] The Cosmas scene, obviously deriving from the narrative depiction of Paul Led to Damascus, has been assimilated to another meaning; see below, n. 177.

[165] Vatican, cod. gr. 1613. See *Il Menologio di Basilio II*, Codices e' Vaticanis Selecti VIII (Turin, 1907). There are three Acts scenes in this MS, including the Stoning of Stephen (p. 275). See Kessler, 'Paris gr. 102', 214 f., Fig. 11; Eleen, 'Acts Illustration', 270.

[166] Vat. cod. lat. 39; Vat. cod. Chigi A.IV.74; Venice, Giustiniani Collection MS XXXV (465). See below, n. 187.

[167] For Vercelli, see below, n. 184 and Appendix A. The archivolt sculpture at Sessa Aurunca also is important as an example of monumental art, but is omitted here because, although devoted to Acts, it does not include Pauline representations.

(Fig. 18), which recalls the Byzantine versions discussed here, even to the repetition of the way in which Ananias holds his garment. Links with Byzantine art also can be seen in our second example, the representation of the Stoning of Stephen in the Verona New Testament (Fig. 136). It is similar to a Byzantine type (Fig. 134) which shows Saul seated on the left, directing Stephen's tormentors who raise and hold the stones, with comparable gestures repeated in all of the members of the Byzantine and Italian families. Stephen himself in all these examples is kneeling or moving into a kneeling pose on the right, blessed by the hand of God emerging from the arc of heaven. In addition, the Verona manuscripts incorporate an additional motif, one that appears elsewhere only in the Florence and Sinai Cosmas miniatures, where it is shown as a separate episode: the Laying of Coats, in which Stephen's executioners bring their coats to Saul.[168] Verona's conflated version apparently preserves material from older Byzantine iconography that is rare in extant Byzantine art. Finally, a third subject, the Miracle of the Viper (Acts 28:3–5), known to exist in Eastern art only from the description in the Painter's Manual, is found in three members of the Italian Acts group (Figs. 195, 196).[169]

It is likely that a Byzantine narrative cycle of Acts pictures—perhaps in an illustrated New Testament, since these existed in both Byzantium and Italy—was imported into Italy in the eleventh or twelfth century, forming the basis for the expansion of Acts imagery in Italy during the High Middle Ages and later. The forty-nine scenes in this Italo-Byzantine cycle, twenty-four of them Pauline, go far beyond the range of earlier Acts subject-matter in the West—the San Paolo frescoes excepted—and they are also more numerous than the surviving material in the East. Their iconography is not unreservedly Byzantine, but they can be used to build up a picture of the narrative Acts cycle in circulation in the East in post-Iconoclastic times.

A portion at least of this Byzantine Acts tradition can be shown to have an ancient ancestry: that is, the Pauline Conversion sequence in the Cosmas manuscripts, the earliest of which—Vat. Gr. 699—is of the ninth century. Pauline subject-matter in the Cosmas miniatures, as Weitzmann has observed, extends beyond the requirements of the brief Cosmas text, encompassing items obviously taken from a narrative pictorial interpretation of the Acts text.[170] This source would predate the Cosmas illustrations, which themselves might have been contemporary with Cosmas' text (the sixth century).

Does the most complete of the Cosmas sequences—the eleventh-century version at Mt. Sinai (Fig. 10)—render this hypothetical model accurately? It must be admitted that the Cosmas imagery probably has evolved away from its model, assuming that the latter was inspired by a narrative text. For example, we have observed the disparity between the Sinai Cosmas and Dečani in the depiction of Paul Led to Damascus. The Cosmas iconography is inaccurate in respect to the text in showing Paul guided from behind, rather than led by the hand, and in picturing Ananias, rather than one of Paul's youthful companions, as the guide. Other Byzantine versions in the Chicago New Testament and at Dečani are more in tune with Acts, and therefore are probably closer to the original model. Pauline representations in the Cosmas codices, therefore, while pointing to an early origin of the iconography, do not always provide us with

[168] See Kessler, 'Paris gr. 102', 214–15, for a discussion of the early origin of the episode of the Laying of Coats; and Eleen, 'Acts Illustration', 271–2.

[169] *Painter's Manual*, 67. There is also an early Christian depiction of this theme, on the wing of an ivory diptych in the Bargello, Florence; see above, n. 33. The three occur-

rences in Italian monuments are in the Abbey Bible, fol. 423, the Giustiniani Codex, fol. 143, and Vienna 1191, fol. 444ᵛ (see below, n. 187).

[170] *Roll and Codex*, 142; see also Buchthal, 'Life of Paul', 44–5.

that iconography in its purest form. In order to reconstruct the Byzantine narrative Acts imagery, we must use now one, now another, of the extant versions, including in some cases Italian examples. On the whole, Dečani, the fullest, is probably the best indicator of the complete cycle.[171]

Kurt Weitzmann was the first to note the affinity between the Pauline sequences in the Cosmas manuscripts and in the Carolingian Bibles, particularly the one at San Paolo,[172] an observation that still holds good today. If we compare the upper register and the first scene in the middle register in the San Paolo Bible (Fig. 7) with the representation in the Mt. Sinai Cosmas (Fig. 10) it is clear that the rhythm of the narrative and many of the details are similar, despite certain obvious differences. Saul's stride forward to receive the letter is comparable in the two depictions, as is the pose and gesture of the high priest. The Cosmas version, like the Vivian Bible (Fig. 6)—which as we have noted is thought to be closer to the model in this instance[173]—portrays the Conversion as two consecutive moments: Paul is blinded and then prostrated. Disagreement between the two interpretations of the third episode—Paul Led to Damascus—can be resolved by introduction of the alternate Byzantine type, found in the Chicago New Testament and at Dečani (Figs. 9 and 13), and recognizably similar to the Carolingian scenes. The proposal that the Byzantine and Carolingian sequences derive from a single archetype is entirely acceptable, as is the suggestion that the iconography is of antique origin.[174]

Confrontation of Eastern and Western imagery brings into relief certain crucial motifs by which the two traditions can be differentiated. Foremost of these is the dissimilarity in the depictions of Paul's prostration at the moment of his conversion. The Western interpretations all include an element of spontaneous personal feeling, varying in mood from surprise through unconsciousness to ecstasy. In contrast, all of the Byzantine versions show some type of *proskynesis*, a ritual obeisance which could take a wide variety of forms and was especially popular in post-Iconoclastic art as a way of showing the relation of man and Deity.[175]

Differences in costume also serve to distinguish the two traditions. In the Byzantine versions Paul is clad throughout in the dignified tunic and pallium of the apostle, as is Ananias in the Cosmas miniatures (although Paul's youthful companion guiding him to Damascus wears a short tunic in the Rockefeller-McCormick New Testament and at Dečani). In contrast, the short garment tends to predominate in the Western versions, except for the Vivian Bible, in which Paul wears the tunic and pallium after he has arrived in Damascus, possibly another example of the fidelity of this manuscript to an older source.[176]

Another point of difference is in the choice of subject-matter. We have seen that the three-episode sequence ending with Paul Led to Damascus is common to both traditions. After this come the Damascus events. Two of the episodes represented in the West—the Dream of Ananias and Paul Healed by Ananias—have not been discovered in extant Byzantine art.[177] The Baptism

[171] In 'Acts Illustration', *passim*, I have argued this point in more detail.

[172] See above, n. 83.

[173] See above, n. 79.

[174] This position has been stated most completely by Kessler, *Illustrated Bibles*, 114–16, 124.

[175] See A. Cuttler, *Transfigurations—Studies in the Dynamics of Byzantine Iconography* (University Park and London, 1975), 53–110, esp. 92–3.

[176] Kessler, *Illustrated Bibles*, 123, deals with the tradition of costume in the conversion sequence.

[177] The Cosmas miniaturist seems to have interpreted the

episode of Paul led to Damascus as a healing scene. The inscription in the Sinai MS reads 'Ananias Cures Saul' ('Ανανίας ῥ'ώμενος τὸν Σαῦλον [λον in ligature]). In Vat. gr. 699 it is Παῦλον rather than Σαῦλον. I wish to thank Thomas Martone for telling me about this detail and Elisabeth Alföldi for translating and transcribing it. This interpretation, obviously an adaptation of the Cosmas miniaturist to suit his own purposes, does not provide evidence for the presence of this scene in the narrative cycle; in fact, it points to the absence of a model for the Cosmas illustrator; see also Buchthal, 'Life of Paul', 45.

of Paul by Ananias, on the other hand, seems to have been exclusive to the East up to the eleventh century.[178]

Paul's Flight from Damascus also is absent from surviving Byzantine art, although we know that it might have been represented there, since it is recorded in the Painter's Manual.[179] It has been mentioned above that Byzantine liturgical readings from Acts narrating Paul's conversion did not include the passage describing his escape,[180] a factor which must have been influential in determining the infrequent occurrence of this theme in the Eastern conversion cycle. For example, Dečani does not include the Escape, despite the relative completeness of its cycle. In general, although the presence or absence of this scene is not conclusive proof of provenance of iconographic schemes, in many of the Byzantine-influenced cycles, such as those at Vercelli and in the Verona New Testaments (Figs. 18, 20, 21), it is left out.

It should be admitted, however, that all of these missing scenes are to be found in the strongly Byzantinized cycles in Sicily.[181] If these could be proven to be completely Eastern in inspiration, a point which cannot be demonstrated at the present time, this distinction of choice would disappear.

One final contrast between Eastern and Western Pauline imagery should be mentioned. Episodes from the apocryphal *Passio Sanctorum Petri et Pauli* also were illustrated in Byzantium, the entire sequence less frequently than in the West.[182] The final scene, however, showing the decapitation of Paul, was quite common. Unlike the graphic Western depictions of Paul's martyrdom (Figs. 34, 35), the Byzantine approach to the subject exhibits restraint: Paul kneels always at the moment before his head is struck off by an executioner wielding an upraised sword (Figs. 14, 31).[183]

Byzantine iconography, while of the greatest interest for its own sake, has been reviewed here in some detail because of its relevance to Western medieval art. On the one hand, the search for origins of Pauline imagery cannot be pursued without a comprehensive consideration of Eastern developments. Of greater moment for the purposes of this study, however, is the question of the impact of Byzantine art on the West. The importation of a complete Acts cycle into Italy is but one event, albeit a decisive one, in what was a continuing process. In the pages that follow, we shall be encountering additional instances of Byzantine Pauline iconography serving to enrich Western imagery, with the Italo-Byzantine recension itself acting as a key factor in this process.

V. ITALIAN MONUMENTS

Italian examples already have been introduced as witnesses to the Byzantine narrative Acts cycle. At this point it is pertinent to examine them as monuments in their own right. Their iconography, we shall find, combines Byzantine with Western features in a blend that is unique to

[178] It is possible that Western iconographers viewed the scene of Paul Healed by Ananias as representing both the healing and the baptism, apparent differences in choice of subject reflecting disparate notions regarding the theology of baptism. See below, Ch. 3, *Paul Healed by Ananias* and *The Baptism of Paul by Ananias.*

[179] 'Painter's Manual', 67.

[180] See n. 90 for instances of Byzantine liturgical readings in which Paul's escape is described.

[181] See below, n. 211.

[182] e.g. in the 12th-c. Psalter Vat. gr. 1927, fol. 93[v]:

accompanying scenes of Saul and David, Peter is shown condemning the fallen Simon Magus (E. T. DeWald, *The Illustrations in the Manuscripts of the Septuagint*, III, 1 (Princeton, 1941), 18, pl. 23); and also in the destroyed copy of Physiologus-Cosmas of the Smyrna Evangelical School Library, MS B. 8, fol. 222, of the 11th to 12th c. (J. Strzygowski, *Der Bilderkreis des griechischen Physiologus* (Leipzig, 1899), 17; and 'Painter's Manual', 66).

[183] For example, Paris, BN gr. 510, fol. 264[v]; Jerusalem, Gr. Patr. Saba 208, fol. 87[v]; Phillipps 7681, fol. 121[v]; 'Painter's Manual', 67.

Italy. The definition of this peculiarly 'Italo-Byzantine' variation can help us to evaluate other more problematic ensembles, such as the San Paolo frescoes and the Sicilian mosaics.

The church of Sant' Eusebio at Vercelli was decorated with a complete cycle of scenes from Acts (Figs. 18, 191),[184] the study of which is central to an investigation of the transmitted tradition of Pauline iconography. Known to us today from drawings in a rotulus now in the Archivio Capitolare in Vercelli, the cycle has been the subject of a certain amount of speculation both as to the date of execution of the Rotulus as well as that of the frescoes from which it was copied. The argument hinges on the type of architectural background prominent in most of the scenes—the details of which are obviously not of antique origin, although the church itself was built in the sixth century—and on the paleographical evidence of the inscriptions. Whether the frescoes had been restored with altered backgrounds (as, for example, was undoubtedly true in some of the scenes in San Paolo fuori le mura), or perhaps, even been modernized by the copyist—working in the twelfth or early thirteenth century—has been touched on by at least one author.[185] Most commentators have followed the suggestion made by Cipolla in 1901 that the frescoes were made in 'the Romanesque period'.[186]

Eighteen panels in the nave were extensively illustrated with scenes depicting the events narrated in Acts 2–21; not all were devoted to Paul, but there were fifteen episodes from his life. As at San Paolo, the scenes did not follow each other sequentially—at least they do not in the roll which is our only source for the frescoes.

Vercelli's iconography, as I have noted, exhibits affinities with that of a group of Italian manuscripts, and can be assumed to derive from a common source. At the head of this group are three codices of the New Testament, produced in Verona in the first half of the thirteenth century.[187] Two of the Verona books are complete New Testaments, Vatican Library MSS Lat. 39 (Figs. 21, 136, 174, 186) and Chigi A.IV.74 (Fig. 173), with the illustrations placed as text pictures at appropriate points in the narrative; the Gospels and Apocalypse are densely illustrated as well. The third manuscript, a codex in the Giustiniani Collection in Venice (Figs. 20, 22, 178, 196) which is the earliest of the three (*c*.1220) and also has the fullest Acts cycle, is made up of a fragment comprising Acts and the Epistles of what was evidently a similar edition, but now bound together with the remaining New Testament books from a different source.[188] This

[184] C. Cipolla, 'La Pergamena rappresentante le antiche pitture della Basilica di S. Eusebio in Vercelli', R. *Deputazione Sovra gli Studi di Storia Patria per le Antiche Provincie e le Lombardia*, Miscellanea di Storia Italiana, Ser. 3, VI (Turin, 1901), 3–12. See also V. Viale, *Opere d'Arte preromanica e romanica del Duomo di Vercelli* (Vercelli, 1967), 28–9. A full bibliography is given in R. W. Scheller, *A Survey of Medieval Model Books* (Haarlem, 1963), 95–6. See the list of subject-matter below, Appendix A. The relationship of the roll to the lost frescoes is attested by a text at the beginning and end of the roll: 'Hoc notat exemplum media testudine templum/Ut renovet novitas, quod delet longa vetustas. Hic est descriptum media testudine pictum Ecclesie signans ibi que sunt atque figurans' (Scheller, ibid. 95).

[185] P. Verzone, *L'Architectura Romanica nel Vercellese* (Vercelli, 1934), 84 and n. 9.

[186] 'La Pergamena', 41. Demus, *Wandmalerei*, 18, 59, proposes the 11th c. as the date of the frescoes and the 13th c. as that of the Rotulus.

[187] These manuscripts are discussed in my article 'Acts Illustration', and their relationship to Vercelli and to other Italian works elaborated in detail. The Appendix lists Acts subjects in Italian and Byzantine art. For Vat. lat. 39 and Vat. Chigi A.IV.74 see E. Arslan, *La Pittura e la scultura Veronese dal secolo VIII al secolo XIII* (Milan, 1943), 167–71, Figs. 216–24. Other manuscripts in which the Italo-Byzantine Acts iconography appears are cod. 7345 in the Abbey Collection (formerly cod. 51 in the Dyson Perrins Collection, lot 61 at the Perrins sale, Sotheby's, Dec. 1 1959) and cod. 1191 (Theol. 53) in the Nationalbibliothek, Vienna. For the Abbey MS see J. J. G. Alexander and A. C. de la Mare, *The Italian Manuscripts in the Library of Major J. R. Abbey* (London, 1969), 12–19; for Vienna 1191 see H. J. Hermann, *Die italienischen Handschriften des Dugento und Trecento*, 3, *Neapolitanische und toskanische Handschriften der zweiten Hälfte des XIV. Jahrhunderts*, Beschreibendes Verzeichnis der illuminierten Handschriften in Oesterreich, V (Leipzig, 1930), 250–88, Figs. 105–21.

[188] I wish to thank Dr Alberto Falck, Mr Edward Garrison, and Dr Carlo Bertelli for making the Giustiniani Codex available to me.

manuscript also differs from the others in that the illustrations are line drawings, perhaps originally intended to be painted in a style resembling that of the other books.

These codices are linked to Verona by the Calendar in Vat. Lat. 39,[189] which exhibits characteristic Verona features, by the script, and by the style of the illustrations.

Among them the Verona New Testaments include twenty-seven episodes from Acts, of which thirteen are drawn from the career of Paul, eight from Peter, and six deal with other events.[190] Many of the scenes repeat the imagery of the Vercelli Roll, although the Roll appears to be less evolved in that it is closer to the Byzantine model and less 'Romanesque' in its approach to iconography.

The derivation of this unified cycle from a Byzantine source already has been touched upon. The Italo-Byzantine iconography is not, however, purely Eastern. There are two other components which serve to distinguish its imagery from the Byzantine: it incorporates items of Western origin, and it transforms certain of the Byzantine themes in accordance with Romanesque stylistic limitations and the habits of Italian manuscript production.

A case in point is the Pauline Conversion sequence.[191] All of the Italian versions tend to exhibit a family likeness to the Carolingian cycles. The interpretation of Paul's Conversion, for example in Vercelli (Fig. 18), the Verona New Testaments (Figs. 20, 21) and in most of the other Italian works is of the Western type in that Paul reacts in a personal, emotional way instead of making a ritual response.

Furthermore, the entire Conversion sequence in the Giustiniani codex and Lat. 39 appears to be based on the San Paolo Bible (Fig. 7). The Giustiniani manuscript, which might have been copied from a model whose artist had seen the San Paolo Bible (known to have been in Italy by this time),[192] repeats the design of the top register and the first scene in the second register of the Carolingian version. It is also similar in the lively movement of Saul striding forward to receive the letter, in the presence of Paul's two companions gesturing in awe as he throws himself back in ecstasy, and in the interpretation of Paul Led to Damascus, which is a flattened rendition of the same scene in the San Paolo Bible. The most remarkable aspect of the influence of the earlier manuscript can be seen in the pose and even the physiognomy of Paul, a resemblance that becomes even more marked if we turn to the painted version in Lat. 39.[193] The principal

[189] See Eleen, 'Acts Illustration', n. 4.

[190] Other monuments with related iconography, such as the two Bibles cited in n. 187 and the sculpture of Sessa Aurunca repeat many of the subjects in the Vercelli-Verona group, but there are a few additions to the list as well (see Eleen, 'Acts Illustration', Appendix); in addition, the Hamilton Psalter, a North Italian MS of *c*.1174, uses episodes from Acts to illustrate the Psalms (Berlin, Staatliche Museen, Kupferstich-kabinett, cod. 78.A.5). See P. Wescher, *Beschreibendes Verzeichnis der Miniaturen—Handschriften und Einzelblätter—des Kupferstichkabinetts der Staatlichen Museen, Berlin* (Leipzig, 1931), 21–4; and also E. Garrison, *Studies in the History of Medieval Italian Painting*, IV (1960–2), 375. The Pauline scenes are: fol. 56ᵛ, The Lystrians Bring Offerings (Acts 14:11–14; Psalm 65:8); fol. 70, Paul and Silas Released from Prison (Acts 16:23–30; Psalm 78:11, 12); fol. 81ᵛ, Paul Baptized by Ananias (Acts 9:18; Psalm 93:12); fol. 86ᵛ, unidentified scene, probably Paul Preaching (Psalm 34:3); fol. 99ᵛ, Paul Blesses a Disciple (Psalms 114–15:10); fol. 104ᵛ, The Conversion of Paul (Acts 9:3–5; Psalm 118:71 [my Fig. 17]);

fol. 112ᵛ, Paul Preaching to the Jews (Acts 9:20; Psalm 125: 3, 4). In the Hamilton Psalter, the depiction of Paul and Silas Released from Prison shows them being freed by an angel, a motif not in the text which really belongs to Peter Released from Prison (Acts 12:7–8).

[191] Cipolla, 'La Pergamena', pl. III; Vat. lat. 39, fols. 91ᵛ, 92; Vat. Chigi A.IV.74, fols. 126, 126ᵛ; Giustiniani Codex, fols. 128, 128ᵛ, 129; Abbey Bible, fol. 435ᵛ; Vienna 1191, fol. 435ᵛ. The Vercelli Roll is the most complete: it includes depictions of (1) Paul Receives Letters, (2) Paul Departs from Jerusalem, (3) the Conversion, (4) the Dream of Ananias, (5) Paul Healed by Ananias, and (6) Paul Baptized by Ananias (Paul Led to Damascus (7) is inexplicably missing). Lat. 39 and the Giustiniani Codex have items 1, 3, 7, 6; Chigi A.IV.74 has 3, 7, 6; the Abbey Bible has 1, 3; Vienna 1191 has 3 only.

[192] See n. 119.

[193] I have discussed my theory regarding the picture redaction in 'Acts Illustration', 257, n. 9. Briefly, it is this: all three of the Verona New Testaments were copied from

difference between the twelfth- and ninth-century interpretations is the presence of the horse, a feature I shall discuss presently.

Perhaps also in response to the direct influence of the San Paolo Bible, Paul's pose in the Conversion in Italy tends to be of the supine variety, in which he falls backward, whether he is a simple pedestrian (the Abbey Bible) or is accompanied by a horse (Figs. 20, 21), and even when he is mounted (Fig. 44).

Paul's costume also inclines to the Western type in all members of the Italian group: he wears the short tunic in the Verona New Testaments—miraculously lengthened to mid-calf after the Conversion—the same longer tunic in the first two scenes at Vercelli, and the tunic and pallium in the Damascus episodes in the latter, as in the Vivian Bible.

Vercelli in addition gives us the Carolingian version of two of the Damascus events—the Dream of Ananias and Paul Healed by Ananias, combined with the Byzantine Baptism. This last episode is repeated in all of the Verona manuscripts in the more 'Romanesque' form of a chalice-shaped rather than a tub-like font (Fig. 22). A Byzantinizing feature is the significant absence in most of the members of the Italian family of the scene of Paul's Escape. In general, however, the Vercelli–Verona Conversion sequences point to a Western lineage.

Eastern influence, on the other hand, can be seen in the marked expansion in the number of scenes and in the Byzantine character of some of them, the Stoning of Stephen for example (Fig. 136).[194] In other instances, the iconography appears gradually to have taken on specifically 'Italian' forms, a process that can be observed in a comparison of the imagery of the earlier Vercelli Roll with that of the more evolved Verona New Testaments.[195]

One of the hallmarks of the Italian iconography is the tendency to rearrange certain compositions into a vertical format, perhaps in response to the dimensions of the page and column in Italy in this period. This is true of the numerous scenes of flogging. If we compare, for example, the depictions of the Flogging of Paul and Silas (Acts 16:22–3) in the Verona New Testaments and at Dečani (Figs. 186, 182),[196] the upright poses in the former contrast with the prone positions of the Apostle and his companion in the latter, a motif which, as I have shown, might have been a feature of the ancient iconography.[197] Similarly, in the depictions of the Miracle of the Evil Spirit (16:16–18), the possessed girl is standing (Fig. 178), as is the lame man when he is cured by Paul (14:8–11 (Figs. 173–4)), in contrast to Byzantine examples of the same scenes in which these figures are crouched on the ground (Fig. 172).[198]

another complete New Testament, since none is the model for the others, and the text-picture system is already worked out in a sophisticated way in the first, the Giustiniani MS, *c*.1200. The latter was an earlier experiment by the draughtsman of Lat. 39, and when painted would have exhibited similar traits of the abstract, decorative Byzantinizing style.

[194] See above, p. 29.

[195] The depiction of Paul's Conversion reveals this process. Certain non-Pauline scenes also demonstrate the principle of evolution: see 'Acts Illustration', 258–9, for the discussion, e.g. of Philip and the Ethiopian Eunuch (Acts 8:26–38).

[196] Vat. lat. 39, fol. 98; Vat. Chigi A.IV.74, fol. 135; Giustiniani Codex, fol. 135ᵛ; also Abbey Bible, fol. 440.

[197] See above, p. 10, n. 54, for a discussion of Paul and

Silas Flogged at Philippi in the Malles and San Paolo frescoes. At Vercelli both this episode and a later flogging in Jerusalem have upright formats (Cipolla, 'La Pergamena', pls. IV, I). There are other prone floggings in post-Iconoclastic Byzantine art, e.g. at Hagia Euphemia in Istanbul; see R. Naumann and H. Belting, *Die Euphemia-Kirche am Hippodrom zu Istanbul und ihre Fresken* (Berlin, 1966), 122–4, Fig. 36, pls. 25ᵃ, 27.

[198] The Miracle of the Evil Spirit appears in Vat. lat. 39, fol. 97ᵛ; the Giustiniani Codex, fol. 135; the Vercelli Rotulus (Cipolla, 'La Pergamena', pl. IV); and the Abbey Bible, fol. 440; all of these are upright. In contrast, the Painter's Manual describes the miracle in these terms: 'Paul, Barnabas and Luke standing and looking behind them; a young girl kneels behind them, raising her hands to them. A demon comes out of her mouth and Paul blesses her.' In the Rockefeller-

The Italian Acts cycle, therefore, despite obvious affinities with that of Byzantium, has characteristic traits of its own as well as functioning as a vehicle for the perpetuation of Carolingian imagery.

Having defined the Italo-Byzantine iconography, it is helpful to examine in its light other more difficult to characterize monuments in which a mixture of traditions prevails, such as the fresco cycle of San Paolo fuori le mura, which with Cavallini's restoration merits consideration as an Italian work of art.

It must be admitted that, with a few exceptions, where comparable subjects exist there usually is a wide gap between the version in San Paolo and those in other more typical representatives of the Italo-Byzantine iconography. A few examples can demonstrate this contrast.

Two of the depictions of flogging in the frescoes (Figs. 180, 183)[199] can be matched with episodes in the Vercelli Roll and other Italian manuscripts (Fig. 186).[200] In the latter all of the figures are upright—one of the distinctive features of the Italian cycle—in contrast to the prone position of the victims in the San Paolo drawings. The depiction of Paul and Silas in the stocks (Acts 16:24) in San Paolo—they are seated in a building, facing forward—also differs from the same episode in the Verona New Testaments, in which the two disciples are seen from the side standing in the stocks.[201] In the ensuing episode in both cycles, Paul is shown baptizing the jailor's family. The Vercelli Roll follows a common practice of medieval iconography in that the baptism takes place in a font, whereas the depiction in San Paolo was of a baptism in natural water, perhaps a stream.[202] (The latter motif, I believe, points to an early origin for this particular scene.)

Finally, the three-part narration of the Pauline conversion sequence in the San Paolo cycle (Fig. 16)[203] differed markedly from the Carolingian interpretation found in all members of the Italian group: Paul's pose is *proskynesis* rather than the Western type of involuntary reaction; in the next episode he appears to be guided to Damascus by a bearded disciple in a long garment, as in the Cosmas representations (Fig. 10), and he is clad at all times in the tunic and pallium.

Many of these features are to be found as well in Byzantine imagery, as are some of the other motifs that serve to distinguish San Paolo from the other Italian versions. For example, the San Paolo scene of Paul and Silas Beaten at Philippi (Fig. 180) is very similar to one at Dečani (Fig. 182), with Paul prone in *proskynesis* again, Silas facing back.

On the other hand, in several instances the frescoes do bear a resemblance to the Italian iconography; the scene of Paul in a Boat with Priscilla and Aquila (Acts 18:18) in the Chigi and

McCormick New Testament, in the scene of the Miracle of the Lame Man (fol. 122ᵛ), the man crouches on the ground as Paul heals him with a gesture; in contrast, he is standing in Chigi A.IV.74 (fol. 132ᵛ) and the Abbey Bible (fol. 439). See below, for a discussion of these scenes in Avranches cod. 3.

[199] Waetzoldt, *Kopien*, cat. no. 640, Fig. 378, Paul and Silas Flogged at Philippi; and cat. no. 644, Fig. 382, which Waetzoldt identifies as Paul Freed by the Tribune (Acts 22:27–9). In my opinion the second should be titled Paul Flogged by the Jews in Jerusalem (Acts 21:30–3). The inscription, 'IUDEIS QUINQUIES QUADRAGEN . . .', identifies the episode as a flogging by the Jews, since it is a reference to II Cor. 11:24: 'A Iudaeis quinquies quadragenas, una minus, accepi.'

[200] See above, nn. 196, 197.

[201] Waezoldt, *Kopien*, cat. no. 659, Fig. 397; Vat. Chigi A.IV.74, fol. 135; Giustiniani Codex, fol. 135ᵛ. In Vercelli, the scene is closer to the one in San Paolo (Cipolla, 'La Pergamena', pl. IV), strengthening the argument that Vercelli represents a phase in the development of the Italian cycle closer to the Byzantine iconography.

[202] Cipolla, op. cit., Waetzoldt, *Kopien*, cat. no. 660, Fig. 398. The scene in ruinous condition which Waetzoldt identifies as Paul Baptized by Ananias probably also was a baptism in natural water (cat. no. 634, Fig. 372).

[203] See above, p. 8, n. 40.

Giustiniani New Testaments, for example, is very like one of the sea voyages in the frescoes.[204] Several alternative explanations present themselves: both images derive from a common (Byzantine?) model; all the artists depicted existing ships fairly accurately; or Cavallini made limited use of the Italian iconography. The last cannot be discounted, but in general the tendency is toward dissimilarity.

Despite the imprecision of its imagery—so watered down that it is difficult to pin-point its sources—the Hamilton Psalter[205] helps us to place the San Paolo cycle in relation to Italian and Byzantine art. Two of its scenes show similarities to the San Paolo frescoes (the Conversion (Figs. 16, 17) and the Lystrians Bring Offerings (Acts 14:11–14))[206] and two resemble the Vercelli Rotulus (Paul Baptized by Ananias and Paul and Silas Released from Prison (Acts 16:23–30)). One hesitates to come to conclusions about the Hamilton Psalter, which requires a study of its own, but it seems to me to share the Byzantinizing side of these monuments. This point is brought out particularly by the representations of the Conversion in the Psalter and at San Paolo: in both, Paul's falling pose, caught diagonally in mid-air, is reminiscent of the Byzantine versions at Dečani (Fig. 13) and Palermo (Fig. 15), as is the placement of the figure in relation to the crowd of companions behind him. Paul's Baptism by Ananias in the Psalter takes place in a box-shaped font and is of the type found in the Vercelli Roll which derives from Byzantine iconography. The Hamilton Psalter, therefore, is another witness to the importation of Eastern Acts imagery into Italy, and to the influence of the latter at San Paolo and Vercelli.

Although the confrontation of San Paolo with the Italian monuments has shown the frescoes to have been not completely independent of reliance on either the Italian iconography or its sources, the main conclusion to be drawn is that the frescoes themselves were unlikely to have been the model for the Italian works.

Even when there are no exact parallels in Eastern Byzantine art, San Paolo's imagery is resonant with echoes of post-Iconoclastic Eastern pictorial habits. It is apparent that Cavallini at some time in his career had access to Byzantine iconographic and stylistic models, although the exact process of this influence has yet to be defined.[207] As far as the San Paolo frescoes are concerned, he must have adapted or revised some of the pre-existing imagery in accordance with more contemporary Byzantine models. Like the Vercelli–Verona cycle, the San Paolo iconography is a mixture of Byzantine and Western components, but with the additional feature of a residue of Early Christian imagery, and the resulting synthesis is quite different.

The Sicilian mosaic cycles in the Capella Palatina at Palermo (Fig. 15) and in the Cathedral at Monreale (Fig. 19),[208] on the other hand, bring us back to more familiar territory. There can be little doubt that stylistically the Sicilian mosaics are Byzantine.[209] It is generally agreed as well that

[204] Vat. Chigi A.IV.74, fol. 137ᵛ; Giustiniani Codex, fol. 138ᵛ; Waetzoldt, *Kopien*, cat. no. 646, Fig. 384.

[205] See above, n. 190.

[206] Waetzoldt, *Kopien*, cat. no. 657, Fig. 395.

[207] G. Matthiae, *Pietro Cavallini* (n.p., n.d.), 33–4 sums up the current state of understanding of Cavallini in relation to Byzantium.

[208] Demus, *Norman Sicily*, 118–20, 294–9; E. Kitzinger, 'The Mosaics of the Cappella Palatina in Palermo', *Art Bulletin*, 31 (1949), 269–92; and idem, *Monreale*, 36–50, Figs. 5–13. Both include scenes from the apocryphal as well as the canonical Acts. In Palermo the Pauline episodes (and one canonical Peter episode) are on the wall of the south aisle; the

Petrine Acts and apocryphal subjects on the wall of the north aisle. In Monreale the canonical Pauline scenes are in the north chapel; the Execution of Paul is an exception to the rule of canonicity, but it too is separated spatially by being placed on the outside of the chapel; the Petrine and apocryphal scenes are in the south chapel. See Appendix A for a chart of the iconography.

[209] According to Demus, 'the styles [i.e. deriving from Byzantium] of Sicilian mosaic art remained remarkably pure, with little admixture of local elements with the exception of iconography, arrangement and ornamentation' (O. Demus, *Byzantine Art and the West* (New York, 1970), 144–5).

there is some mixing of Eastern and Western traditions in the iconography.

In the sequences devoted to the lives of Peter and Paul, the Petrine canonical portions seem to be almost unreservedly Byzantine,[210] but the Pauline episodes, which bear a strong resemblance to those in the Carolingian Bibles, are problematic. If we concentrate on the more extensive sequence at Monreale (Fig. 19), we can see that it includes—with two anomalies—the same ingredients as the Conversion cycle in the San Paolo Bible (Fig. 7).[211] The differences are the omission of the Dream of Ananias and the inclusion of Paul's Baptism; these point to a Byzantine tendency, as does the act of *proskynesis* in the Conversion (exemplified here by the scene from Palermo (Fig. 15)) and the use throughout of the tunic and pallium as Paul's costume.

On the other hand, there are also features previously associated only with the Western iconography, such as the inclusion of Paul Healed by Ananias and, most notably, of Paul's Escape from Damascus, in a form reminiscent of Carolingian tradition.[212] The chalice-shaped font, the centralized composition, and the interest in liturgical detail in the baptism scene should be noted as well, all traits of the Western imagery. The question arises here, as it did in connection with Vercelli: does the presence in Monreale of these elements point to an earlier stage in the history of the Byzantine cycle in which these themes were included, or does it point to yet another synthesis of Eastern and Western traditions? Kessler prefers the former interpretation, observing that '. . . the mosaics were derived from a model closely related to that on which the ninth-century frontispieces were based',[213] and he regards this model as the precursor of both traditions. In the absence of corroborating evidence of the inclusion in Eastern art of all of the Damascus scenes, and of the particular form of the Escape found in the San Paolo Bible and at Monreale, I continue to leave open the possibility that the Sicilian iconography used a Western as well as a Byzantine source. In any case, it displays distinct differences from post-Iconoclastic Byzantine imagery. It should be pointed out as well that the Pauline sequences in Sicily are limited to the scenes known in Western Europe previous to the expansion epitomized by the Vercelli–Verona iconography.

That there were Western models available in Sicily for some of the Pauline subject-matter is demonstrated by the depiction of the Execution of Paul, included at Monreale but not at Palermo. It appears to have been influenced by a Roman legend that the three springs at the traditional site of Paul's martyrdom—Tre Fontane—came into being when his decollated head bounced three times.[214] The lower left-hand corner of the mosaic was heavily restored after a fire in 1811, so that, according to Kitzinger, it is impossible to decide whether the scene originally showed three streams flowing from or into the head, as it does today, or whether the intention was to depict the imagery of the *Passio Pauli*, which describes milk spurting from the severed head on to the

[210] Eleen, 'Acts Illustration', 265–6.

[211] Possibly because of a difference in the shapes and extent of the surfaces covered by the mosaics, Palermo has fewer scenes than Monreale: Saul Receives Letters, the Conversion, Paul Led to Damascus, Paul Baptized by Ananias, Paul Preaching in Damascus, and the Escape from Damascus. Monreale repeats all of these and adds Paul Healed by Ananias, Paul Giving Letters to Timothy and Silas, and the Martyrdom of Paul. Demus considered the difference a result of the separate copying of the same model by the designers of the two ensembles (*Norman Sicily*, 294), a conclusion disputed by Kitzinger who argued that Monreale was copied from Palermo (*Monreale*, 42). More recently, Kessler has proposed, correctly in my opinion, a solution closer to that of Demus, accepting at the same time that there

were influences from Palermo as well (*Illustrated Bibles*, 120–1).

[212] Kitzinger (*Monreale*, 43) suggests that the scene of Paul Healed by Ananias is an *ad hoc* invention of the mosaicists, having no counterpart at Palermo. The similarity of the Monreale scene to the Vivian Bible and Vercelli contradicts Kitzinger's suggestion. See above, pp. 15–16, 31, 34, for a discussion of Paul's Escape.

[213] *Illustrated Bibles*, 121.

[214] Kitzinger, *Monreale*, Fig. 12. The earliest documented occurrence of the legend is in art rather than literature: in the 13th-c. portico frescoes of Old St. Peter's in Rome (ibid., n. 48; see above, n. 104). It is not mentioned in the Linus *Passio*.

garments of the soldier.[215] In any case, the present evidence indicates that the Execution at Monreale was of the Western type, showing the decapitated head, rather than the Byzantine. A comparison with the Execution in the Greek Menologion in Jerusalem or with the similar scene in the Phillipps manuscript (Figs. 31, 14)[216] immediately brings out the difference between the Western and Byzantine conceptions.

VI. ICONOGRAPHIC INNOVATIONS IN THE TWELFTH CENTURY

Paul the apostle of doctrine—characterized by the attribute of book or scroll—is transformed in the course of the twelfth century into an embodiment of militant, knightly qualities. This change is expressed in two motifs: the sword rather than the book or scroll becomes Paul's most common attribute,[217] and he is depicted as a horseman at the moment of his conversion. Both of these new images are aspects of a reinterpretation of the meaning of his life and work. In the era of the Crusades, when the ideal of the active knight-missionary has replaced the traditional concept,[218] the foremost missionary is seen as a knight.

Around the middle of the twelfth century artists began to depict Paul holding a sword. This attribute tends to occur in joint Peter–Paul portrayals and other non-narrative images, and makes its appearance in monumental art, manuscripts, and other media at around the same time.

There are no securely dated monuments in which Paul holds the sword earlier than the mid-twelfth century,[219] although further study of some of them, such as the reliefs flanking the door of San Pietro in Ferentillo in Umbria[220] and the fragmentary tympanum of the Cathedral of Maguelonne (Hérault) in Provence (Fig. 39),[221] might help establish the invention of this motif more precisely. In both of these sculptures, a depiction of Paul with a sword accompanies Peter with a key.

A manuscript of the second half of the twelfth century also shows them with the same attributes, together receiving a scribe's gift of his book (Fig. 40).[222] As in the case of the sculptures cited here, we can estimate the date by analysis of style and by historical context. More difficult to deal with are a group of lead badges brought back from Rome by pilgrims (Figs. 41a, b).[223] It is not easy to apply criteria of style to these crude specimens of folk art. Rather, dates could be proposed based on the comparative material presented here and especially on the additional evidence to be introduced in Chapter Two. These provide an iconographic criterion, pointing to a dating in the twelfth century for badges in which Peter and Paul both hold keys and to the late twelfth or thirteenth century for those in which Peter holds a key and Paul a sword.

[215] Ibid. 40, n. 50. See above, n. 106. In support of the latter suggestion, Plautilla seems to be present at the left, and Paul's eyes are bound with her veil.

[216] See above, n. 152, 157.

[217] See below, Ch. 2, *The Author as an Attesting Figure*, and Appendix B.

[218] See A. Katzenellenbogen, 'The Central Tympanum at Vézelay, Its Encyclopedic Meaning and Its Relation to the First Crusade', *Art Bulletin*, 26 (1944), 141–51, for a discussion of the Crusades as missionary activity.

[219] E. Rosenstock-Huessy, *Out of Revolution* (New York, 1938), 766–8, pls. between pp. 532 and 533.

[220] A. Bertini-Calosso, in the *Enciclopedia Italiana* (1949, repr. of the 1932 ed.), XV, 19–20, s.v., 'Ferentillo', dates it in the 12th c. Peter and Paul were a not infrequent combination

as jamb figures. See M. L. Thérel, 'Comment la patrologie peut éclairer l'archéologie', *Cahiers de civilisation médiévale*, 6 (1963), 154.

[221] Porter, *Pilgrimage Roads*, IX, pl. 1288.

[222] Paris, BN MS lat. 12004, fol. 1ᵛ; see J. Porcher, *French Miniatures from Illuminated Manuscripts* (London, 1960), 35–6, pl. XXX. I wish to thank Carolyn Kinder Carr for calling this example to my attention.

[223] e.g. those in the Museo Camposanto Tedesco in Rome and the Staatliche Museen in Berlin; see A. de Waal, 'Andenken an die Romfahrt im Mittelalter', *Römische Quartalschrift*, 14 (1900), 54–67, esp. 62–7, for an explanation of the use of such pilgrim tokens; and O. Wulff, *Altchristliche und mittelalterliche, byzantinische und italienische Bildwerke*, II, 2 (Berlin, 1911), 72, no. 1898, pl. VI.

The common explanation for the sword as Paul's attribute is that it represents the mode of the Apostle's martyrdom.[224] However, the usual juxtaposition of this image to that of Peter holding the keys indicates that it is meant as something other than a symbol of martyrdom. E. Rosenstock-Huessy, in a vehemently stated position, maintains that, as a result of the 'Gregorian revolution', the papacy popularized Paul's militancy to symbolize its policy of combining secular and spiritual power. The justification is found in Ephesians 6:17 ('... for sword, take that which the Spirit gives you—the words that come from God;') and Hebrews 4:12 ('For the word of God is alive and active. It cuts more keenly than any two-edged sword ...' (Fig. 122)).[225]

Although Rosenstock-Huessy undoubtedly exaggerates the controlling role of the papacy in this matter, the idea of the militant Paul seems indeed to have been widespread. According to E. Mâle, 'the military and heroic view of St. Paul made a strong impression on the Middle Ages.'[226] William Durandus, for example, records an interesting custom showing that the thirteenth century regarded Paul as a military man. Although it was the practice to remain seated in church during the reading of the Epistle, 'the knights, however, were accustomed to stand in his honour when the Epistles of Paul were read, because he was a knight, from whence he is painted with a sword in his hand as a sign of his military service, and because he described himself in this way in his preaching of the gospel.'[227] By the thirteenth century, therefore, the appreciation of Paul as a knight was firmly entrenched.

One of the major innovations of the High Middle Ages is in the new interpretation of the Conversion: Paul is depicted as a rider, falling or having fallen from his mount. We can regard the twelfth century as the period of invention and development of this theme. Earliest extant examples are of the mid-twelfth century, and it must have been devised around this time; by the thirteenth century it had become very common.[228]

First attempts to render the Conversion as an equestrian subject merely incorporate a horse into one of the traditional versions. For example, in the Verona New Testaments, which, as we have seen, probably derive from a Carolingian prototype in their Conversion cycles,[229] a standing horse is placed in the background (Figs. 20, 21); we therefore interpret Paul's tumbling pose as the result of his having fallen from the horse. As previously noted, the common model for all of the Verona codices must have been made before 1200, but we cannot be certain of the exact date. The motif must have been in use earlier, since another Italian example, the Antelami Conversion in Parma of *c.*1178 (Fig. 44), employs a supine pose similar to that in the Verona manuscipts; this time the rider is falling back on the horse while remaining mounted.

Dobschütz correctly recognized the interpretation in the Admont Bible of *c.*1130–60 (Fig. 42) as the earliest extant mounted Conversion.[230] It actually combines elements present in both of the foregoing examples; at the same time it too is strongly reminiscent of a Carolingian type. In the Admont Bible the continuous narrative of the Vivian Bible (Fig. 6) persists, but with

[224] Dobschütz, *Paulus*, 11; Mâle, 'Apôtres', 391.

[225] Rosenstock-Huessy, *Out of Revolution*, 535–7. My Fig. 122 is a scene from a 13th-c. *Bible Moralisée*, showing Paul confronting a group of Jews. He holds a book and sword, in illustration of Heb. 4:12.

[226] Mâle, 'Apôtres', 392.

[227] *Rationale Divinorum Officiorum* (ed. Venice, 1599), fol. 77ᵛ: 'Milites tamen stare consueverunt, quando Epistolae Pauli leguntur in honorem eius, quia miles fuit, unde in signum militiae suae depingitur cum ense in manu, vel ideo, quia ipse suam praedicationem Evangelium nominavit.'

[228] Although Dobschütz, in 'Bekehrung', was limited in his knowledge of the images in manuscripts, many of his observations hold good today.

[229] See above, pp. 33–4.

[230] Vienna, Nationalbibl. cod. Ser. Nov. 2702, fol. 199ᵛ (formerly Admont, Stiftsbibl. Cod. I, 1 and 2); see Swarzenski, *Salzburger Malerei*, 77–9. The Gumpert Bible of 1195 (my Fig. 126), like the Admont Bible made in Salzburg, has a similar multi-episode mounted Conversion; see below, Ch. 3, n. 14.

Paul on horseback. This time he appears three times instead of twice: first he is struck by the rays while mounted, as in the Antelami version; next he is shown falling from the horse; finally, free of the horse, he falls to the ground in a pose quite similar to that in the Carolingian Epistles in Munich (Fig. 8).[231]

All of these experimental forms, however, in which Carolingian precedents have been altered by the introduction of a horse, are detours on the highroad of Pauline iconography. The almost standardized thirteenth-century versions, in contrast, move away from the Carolingian model. They are characterized by more violent action, involving a complicated display of acrobatics on the part of both horse and rider. In the usual rendering of this type—in Northern Europe at any rate—Paul falls forward, sometimes actually somersaulting because his horse has tripped (Figs. 47, 50). Dobschütz and others have attributed this motif to the inspiration of the pictorial tradition depicting the fall of Pride.[232] There is much to be said for this theory. Even the transitional forms cited here have a great deal in common with early depictions of Superbia brought down by Humilitas as an episode in Prudentius' *Psychomachia* (Figs. 43, 46).[233] By the thirteenth century, in any case, we have firm corroboration of a link between the images of Paul and Superbia. Several thirteenth-century depictions of Superbia are almost interchangeable with contemporary representations of Paul falling from his horse, the best known of the former a relief on the south porch of Chartres[234] and a drawing in Villard de Honnecourt's notebook (Fig. 49).[235] In these, as in a number of the typical depictions of Paul's Conversion, the horse stumbles to the right, his nose dipping to the ground, while Paul falls over the horse's neck, knees raised, cloak flying, bracing himself with both hands.[236] The inspiration of one image for the other is undeniable, and it is a plausible suggestion that Superbia is the pictorial source for the fall of Paul from his horse.

Does the link with Superbia imply a judgement on Paul, in the sense that he might have been regarded as an example of Pride? We have seen that Gregory the Great was aware of the visual metaphor of Pride falling from a horse,[237] but he contrasted this image with Paul's fall, and also distinguished between the prone and supine poses, associating the former with Paul. There is evidence that by the thirteenth century Gregory's distinction no longer applied. In the *Bible Moralisée* in London, for example, the illustration for Acts 9:3 is the usual representation of Paul tumbling on to his face from a horse (Fig. 48). The 'moralization' below, which depicts a nimbed crowned woman (Humilitas?) praying in the presence of two knights bearing chalices and hosts, is accompanied by the inscription, 'By Saul is signified the prideful who conquered for a time and plundered the Catholic Church.'[238] We have seen elsewhere that emphasis was placed on Paul's conversion as a transition from sin to virtue, when the persecutor (wolf) became an apostle

[231] See above, n. 72; Dobschütz, 'Bekehrung', 95, mistakenly interprets the triple depiction of Paul in the Admont Bible as Paul and two companions.

[232] 'Bekehrung', 108–11; H. R. Hahnloser, *Villard de Honnecourt* (Vienna, 1935), 20, n. 9.

[233] R. Stettiner, *Die illustrierten Prudentiushandschriften* (Berlin, 1895), pl. 3, Fig. 1, pl. 195, Fig. 11. Compare, for example, the Conversion in the Admont Bible with the depiction of Superbia in BL MS Cott. Tit. D.XVI., fol. 14[v] (my Figs. 42, 43). Although not a 'transitional' example, the 13th-c. Bible, Amiens MS 23, fol. 271 (Rom.) has an equestrian Conversion very like Superbia in Paris, BN lat.

MS 8318, fol. 51[v] (my Figs. 45, 46).

[234] E. Houvet, *Cathédrale de Chartres* (n.p., n.d.), part 4, Portail Sud, II, Fig. 50.

[235] Hahnloser, *Villard*, 19–21, pl. 6.

[236] e.g. London, BL Add. 15253, fol. 294[v] (Rom.); Rome, Vat. Urb. lat. 7, fol. 386 (II Cor.); Lille, Bibl. Mun., cod. 838, fol. 192 (Col.). In the last the composition is reversed.

[237] See above, n. 85.

[238] BL Harley MS 1527, fol. 64[v]: [p]er Saulu[m] significat[ur] superbi qui de temporalibus sup[er]bunt et eccl[es]iam catholicam dep[re]dant[ur]; see A. de Laborde, *La Bible moralisée illustrée*, III (Paris, 1913), pl. 535.

(lamb). The notion that pride is an expression of the nature of the wolf and humility of the lamb fits in with this conception.

Dobschütz and other authors have suggested that the model for the falling Paul-Superbia can be found in the tradition of battle imagery going back to antique art.[239] Prudentius' *Psychomachia* itself was probably given illustrations at an early date, and might have been dependent on this source, although we have seen that the more stringent parallels between Superbia and Paul belong to the High Middle Ages. There is a Roman theme, however, which might have served as a model for the thirteenth-century type of Paul-Superbia.

Knightly combat and deeds of heroism were popular subjects in Roman art, and among the many individual acts of valour celebrated was the self-sacrifice of the knight Marcus Curtius who, according to Livy, offered himself as a sacrifice of appeasement to the gods by plunging fully armed and mounted on a horse into a chasm which had appeared in the Forum. His brave action elevated him to the status of folk-hero, and there was a cult devoted to him with an altar on the Forum.[240] At least four depictions of Curtius falling with his horse have survived, and they are remarkably similar to Paul-Superbia (Fig. 51).[241] That Curtius' bravery was known to the Christian Middle Ages is shown by Augustine's praise for his action,[242] and it is possible that pictorial representations survived as well.

There is also a theoretical reason why this Roman hero could have been acceptable as a model for Paul, both as a knightly figure and as a warning against pride. Augustine includes the tale of Curtius among other examples of the 'two motives that spurred the Romans on to perform miracles of valour, namely, love of freedom and desire for praise.'[243] The Bishop of Hippo exhorted Christians to emulate the Roman virtues of heroism and self-sacrifice, but added the warning that 'if we do hold them fast let us not be exalted with pride.'[244] Both ideologically and as a pictorial model, therefore, the image of Curtius, the Roman warrior who functioned simultaneously as an admonishment against pride, might have been an inspiration for Paul-Superbia.

This brief survey of Pauline iconography up to the thirteenth century has shown that even without a consideration of the twelfth- and thirteenth-century Bibles St. Paul was by no means

[239] 'Bekehrung', 107–8.

[240] Livy, VII (*Livy*, Loeb Classical Library, transl. B. O. Foster, III (London–New York, 1924), 372–5); see Pauly-Wissowa, IV, cols. 1864–5; and S. B. Platner, *A Topographical Dictionary of Ancient Rome*, revised by T. Ashby (Oxford, 1929), 310–11, s.v., 'Lacus Curtius'.

[241] The best known of these is a relief (no. C/76) in the Museo Capitolino in Rome, of the last quarter of the first century BC; see T. Kraus, *Das römische Weltreich*, Propyläen Kunstgeschichte, II (Berlin, 1967), 224, Fig. 181a. The others have been commented on by A. Furtwängler, *Die antiken Gemmen*, Geschichte der Steinschneiderkunst in klassischen Altertum, III (Leipzig, 1900), 284, pl. XXVII, 42, Fig. 45. There is no doubt as to their affiliation, since they are very like one another. It must be admitted that there is disagreement regarding the subject of the Capitoline relief. Kraus, for example, and E. Nash, *Pictorial Dictionary of Ancient Rome* (London, 1961), I, 542–4, Fig. 1674, identify its central figure as Mettius Curtius, a Sabine youth who rode his

horse into a swamp (Livy, op. cit. I. 12. 10), an identification supported by the reedy setting. Furtwängler and E. Strong, *Roman Sculpture from Augustus to Constantine* (London–New York, 1907), 324–6, however, preferred Marcus Curtius, and G. Lugli, *Roma antica: il centro monumentale* (Rome, 1946), 155–6, accepted either Marcus or Mettius. There was indeed some confusion between the two legends, as noted by Livy. In view of the popularity of the cult of Marcus, and in view of Augustine's praise of him (see the following footnote), the possibility is strong that the relief was understood to represent his sacrifice. In any case the Middle Ages would possibly have known the image through another medium, such as the gemstone and lamps cited by Furtwängler.

[242] *De Civ. Dei*, V., 18 (Augustine, *City of God*, Loeb Classical Library, transl. W. Green, II (London–Cambridge, Mass., 1963), 226–31).

[243] Ibid. 226–7: 'Haec sunt duo illa, libertas et cupiditas laudis humanae, quae ad facta compulit miranda Romanos.'

[244] Ibid. 236–7: 'Si tenuerimus, superbia non extollamur.'

neglected as a subject in medieval art. Both narrative and symbolic imagery existed in every period.

Narrative subject-matter deriving from the rich inspiration of the text of Acts was more abundant than has hitherto been suspected. I have demonstrated that in both East and West, from at least the ninth century, there was a continuous transmission of imagery based on Acts. In Byzantium, in the post-Iconoclastic period at any rate, this pictorial cycle spanned almost the entire Acts narrative. The related iconography in the West, of which extant examples go back to the Carolingian period, is restricted to a briefer section of the Acts text, that is, that recounting the experiences of Paul before, during, and after his conversion on the road to Damascus. This short but dense sequence can, with reasonable assurance, be accepted as having originated in the Early Christian period; the possibility has been canvassed, but not incontrovertibly confirmed, that there was an Early Christian cycle illustrating the entire text of Acts from which both the shorter Carolingian version and the more extended Byzantine sequence descended.

Much of the argument concerning this hypothetical Early Christian cycle revolves around the controversial San Paolo frescoes, shown here to have been devised in the fifth century but much altered by later restorations.

Apocryphal subjects too had a continuous history in the Middle Ages, beginning with the appearance of cycles of passion episodes in the eighth century. These were elaborated in particular in monumental art, but were also common in manuscripts, especially service books, the illustration of which followed a path separate from that of Bibles. This dichotomy in subject-matter, apparent already in Carolingian times, continued up to the High Middle Ages.

Carolingian precedents in fact formed the basis for most Western Pauline iconography previous to the twelfth century. At this point radical departures from tradition became the rule. Although Carolingian usage was by no means forgotten it was now augmented and transformed. This increase in the variety of imagery was due partly to fresh importation from Byzantium—Italy acting as a way-station—but for the most part it was a product of the new inventive spirit of the age. Not only were novel narrative scenes introduced, but Paul began to be perceived in a completely new way as an armed knight, as expression of an all-pervading warrior mentality.

Symbolic imagery, only touched on here, is ubiquitous in the Middle Ages and has received more attention than has narrative iconography. Since the meaning of Paul's life and writings extends to almost every facet of life and thought, the possibilities for making pictures are limitless. The examination of those scenes in which Paul appears with Christ and Peter (as, for example, in the *traditio legis*) is a subject in itself, as is the study of his attributes. Such symbolic images found their way into Bible illustration, sometimes indeed masquerading as narrative; the scholar's task is to search beneath the surface in an attempt to explain these combinations of text and image. Chapter Two begins the investigation of this problem.

CHAPTER TWO

Text and Image

I. EXPANSION OF PAULINE ICONOGRAPHY

Beginning in the twelfth century, and accelerating in the thirteenth, there was a quickening of interest in Pauline imagery in Bibles. To a degree, the new activity was the outcome of the fascination Paul held for the scholar in this period,[1] but it was also the product of a general concern with Bibles and their illumination. The situation of the Epistles, however, was not typical of the Bible as a whole in the twelfth century in that the former held the attention of iconographers at a later date than did the Old Testament. Scholars were interested in the Epistles but their concern was not revealed at first in Bible illustration. Peter Brieger has shown that there was a concerted campaign in the eleventh and twelfth centuries to produce Bibles and to provide them with pictures.[2] This was in response to a spirit of reform in the church, and was directed, according to Brieger, particularly against the heresies of the day which were characterized by rejection of the Old Testament. Therefore, the illustrators of Bibles tended to defend the importance of the Old Testament and to emphasize subjects which brought out the harmony between the Old and New Testaments. The Pauline Epistles do not fit into this scheme, and an interest in their illumination therefore falls into a second period of development of Bible studies, beginning in the late twelfth century and culminating in the great work of revision of the Bible undertaken at the University of Paris under the leadership of Stephen Langton in the second and third decades of the thirteenth century.[3] It was at this point that art caught up with scholarship. This is not to say that the Epistles were overlooked by illustrators in the eleventh and early twelfth centuries, but only to point out that the peak of interest in them was reached at a later period than that of the Old Testament.

The early method of illustrating the Epistles in complete Bibles, going back to Carolingian precedent, was with a single page—or a large panel set into the text—depicting scenes from Acts, used as a preface to all the Epistles (Figs. 6, 7).[4] In contrast, separate editions of the Epistles, or commentaries on the Epistles, usually were illustrated with a simple scene of Paul as a scribe—or as a solitary figure attesting to authorship—likewise serving as a preface to all the Epistles (Figs. 58, 59).[5] Therefore the two differing types of imagery reveal that the two types of manuscript—whole Bibles and Epistles/commentaries—followed separate traditions up to the twelfth century.

[1] B. Smalley, *The Study of the Bible in the Middle Ages*, 2nd ed. (Oxford, 1952), 77, 363.

[2] P. H. Brieger, 'Bible Illustration and Gregorian Reform', *Studies in Church History*, 2 (1965), 154–64.

[3] *Chartularium Universitatis Parisiensis*, ed. H. Denifle, E. Chatelain, I (Paris, 1889), 316–17; H. Quentin, 'Mémoire sur l'établissement du texte de la vulgate', *Collecteana Biblica Latina* (Paris–Rome, 1922), 385–8; S. Berger, 'Les préfaces jointes aux livres de la bible dans les manuscrits de la Vulgate', *Mémoires présentés pars divers savants à l'Académie des Inscriptions et Belles-Lettres*, I Ser., 11 (Paris, 1904), II, 1–78, especially 27–9.

[4] See e.g. the Admont Bible, Vienna, Nationalbibl. Ser. Nov. 2701–2, vol. II, fol. 199v; and the Pommersfelden Bible, Pommersfelden, Schlossbibl. 333–4. This subject is discussed in detail in Chapter 3.

[5] See below, n. 46.

Full-page or panel prefaces gradually were abandoned after *c*.1100, when the practice of decorating Bibles with historiated initials became common,[6] but there are instances of the persistence of the former into the thirteenth century, especially in Germany (Figs. 126, 127).[7] During the course of the twelfth century, there was an increasing tendency for more and more of the initials in the larger and better quality manuscripts to be historiated. As mentioned above, illustration of the initials of the Pauline books lagged behind that of the Old Testament; it is possible to find Bibles made as early as the late eleventh century in which a large number of Old Testament books have been illustrated and only one or two of the Epistles.[8] Often Romans is the only initial of the Epistles to be given a figural scene, a survival of the traditional tendency to treat the Epistles as a block by emphasis on the first of the letters. The proportion of historiated initials in the Pauline Epistles in single Bibles rose steadily in the course of the twelfth century until, in the thirteenth, it became quite common for the initials of the fourteen Epistles to make up between one-sixth and one-fifth of the illustrations in a given Bible.[9] By force of numbers at least, Pauline imagery is of great importance in thirteenth-century Bibles. The Pauline Epistles also outshine the rest of the New Testament in complexity and in variety of subject-matter.

Expansion and innovation in Pauline iconography reached its height in the first half of the thirteenth century. After that, activity lessened, a manifestation of the decline of interest in Bible illustration as a whole after *c*.1250–60. Bibles already had begun to be smaller *c*.1180; poorer quality is manifest about 1250. Uniformity becomes the rule, in contrast to the variety and experimentation characteristic of the earlier period.[10]

It is true that, of this avalanche of Pauline imagery, simple scenes of Paul holding a book or scroll, or as an author, predominate. But in smaller quantity a wide spectrum of other subjects is illustrated, touching on almost every field of speculation in regard to St. Paul, such as the events of Acts, the relation of the Epistles to the life of their author (in particular, to his periods of imprisonment), the literal and allegorical meaning of each Epistle, the commentaries, prefaces, and general apparatus of the Epistles. All of these themes find their way into the small scenes within the thirteen initial 'P's and one initial 'M' that begin the pages of the letters. One can draw an analogy with the Psalter, the rich variety of its illustrations running the gamut from a literal rendering of the text through allegorical interpretations and scenes from the life of David to typological parallels drawn from the Old and New Testaments.[11]

The subject-matter of the historiated initials can be divided into three groups: (1) Uncomplicated repetitive scenes with little or no narrative content, dealt with in the present chapter; (2) scenes from Acts, in the tradition of the Carolingian Bibles, which will be discussed in Chapter Three; (3) a special recension—'The Prologue Cycle'—with both narrative and doctrinal content, to be discussed in Chapter Four.

[6] Brieger, 'Bible Illustration'; Nordenfalk, 'Book Illumination', in Grabar and Nordenfalk, *Romanesque Painting*, 178–82.

[7] Berlin, Staatsbibl. Theol. lat. fol. 379, fol. 467, the Bible of Heisterbach. Both procedures—the panel preface and the historiated initial—are combined on this page; see below, p. 75.

[8] The Stavelot Bible, London, BL Add. 28106–7 (1097–8), has only one historiated initial for the Epistles (Rom.) out of 53.

[9] For example, in Avranches 2 and 3, *c*.1210, there are 14 historiated Epistles out of a total of 86 initials; in Göttweig 55, of *c*.1235, there are 14 out of 74; in Paris, BN 14397 (the Bible of Blanche of Castile), *c*.1245, there are 14 out of 81; in Paris, BN 16719–22 (the Bible of Hugh of St. Cher), of 1248–52, there are 14 out of 73.

[10] There are, of course, many outstanding exceptions to the rule, especially in the form of *de luxe* editions made for rich patrons.

[11] G. Haseloff, *Die Psalterillustration im 13. Jahrhundert: Studien zur Geschichte der Buchmalerei in England, Frankreich und Niederlanden* (Kiel, 1938).

In addition to Bibles, there are a number of illuminated commentaries on the Pauline Epistles, usually composed in the form of a glossed text: that is, the canonical Epistle text—often in larger script—occupies the centre of the page and the commentaries are arranged around the Epistle, in the wide margins and between the lines (Figs. 71, 168). In general, the commentaries—written by scholars for scholars—are not as innovative in their imagery as are the Bibles, although up to *c.*1180 there are a few rare examples of illustrated commentaries with novel and creative treatment of subject-matter.

II. THE WRITINGS REFLECTED IN THE SUBJECT-MATTER OF THE INITIALS

Although the initial which is historiated is that of the first word in each Epistle, the writings which inspired the figural scenes in the initials are not confined to those of the Epistles themselves.

In Chapter One, an outline was given of the tradition of subjects inspired by the text of Acts. Beginning with the Carolingian Bibles, these are associated with the Epistles frequently enough to merit consideration; in the thirteenth-century subjects from the Apocrypha are added to the Acts episodes in Bibles.

Another phenomenon of the thirteenth century, evident in certain Bibles, is the attempt to convey the message of the Epistles themselves. The question of the meaning of the Epistles is a complicated one. In a large part of the Bible, the narrative itself suggests scenes of action; in contrast, the Epistles present a problem to the illustrator. They are letters addressed to communities and individuals, and are made up of a mixture of exhortation, prayer, and doctrine, as well as a certain amount of autobiographical information, including, in some cases, an indication of the conditions under which they were sent. What must the artist select as the single image which communicates the ideas in the individual Epistle? Usually one or two central themes are chosen; occasionally the choice appears to be an obscure one. A detailed examination of the passages illustrated in each Epistle of a given Bible often will uncover a particular theory or approach to the writings of Paul which must have been held by those who invented the scenes.

The most important sources for understanding the medieval view of Paul are the many commentaries on the Pauline Epistles written at this time. As Beryl Smalley has observed, 'It is no accident that the two favourite books for commentators (i.e., in the eleventh and twelfth centuries) were the Psalter and the Pauline Epistles, their creative energy being centred in the latter; St. Paul provided the richest nourishment to the theologian and the logician.'[12] Almost every scholar tried his hand at interpretation of the Epistles.[13] As noted above, occasionally the manuscripts of the commentaries themselves were illustrated. These commentaries with figural scenes, however, are rare, and their iconography is of relatively little interest. An illustrated commentary has not yet been found with pictures as subtle and penetrating as the text they accompany. Certain of the Bible illustrations, on the other hand, do suggest just such an approach to imagery. In their iconography they reveal a desire to penetrate below the surface, the picture acting as an interpretation of the text rather than merely decorating it. Illustrations functioning as commentary can best be seen in two groups of manuscripts discussed below, given in this study the names of 'Apostolic Cycle' and 'Prologue Cycle'.[14] One example which reveals the way in

[12] *Study of the Bible*, 77.
[13] The medieval commentaries are collected together, by author rather than by subject, in F. Stegmüller, *Commentaria: Auctores*, vols. II to VII of *Repertorium Biblicum*

Medii Aevi (Madrid, 1950–61).
[14] The 'Apostolic Cycle' is discussed below in Chapter 3, and the 'Prologue Cycle' in Chapter 4.

which the pictures express the interpretation of the theologians who advised the artists—and, at the same time, shows the ingenious way in which scenes from Paul's life were used in the illustration of the Epistles—is the scene accompanying I Corinthians in the two Bibles of the 'Apostolic' cycle.[15] It illustrates the theme of baptism by depicting the baptism of Paul by Ananias (Figs. 214, 215). Baptism is mentioned seven times in I Corinthians.[16] Some medieval concordance-maker isolated this theme, and that is what appears in the picture used to preface the text.

It is not yet possible, however, to match a complete cycle with a particular commentary; in the course of this study individual instances are suggested where the picture seems to express the interpretation of one or another author. The detailed examination of the medieval commentaries in the light of the information revealed by the subject-matter of the initials is a subject which should be pursued further.

The majority of the manuscripts—that is, those examined in the present chapter—use a simpler and more naïve approach to the texts. They are concerned for the most part with showing that Paul was the author of the letters, that he wrote them as a free man or as a prisoner, that he used messengers, and that his message was destined for individuals or communities.

Medieval Bible scholars must have had theories regarding the organization of the Epistles into groups. Deliberate differentiation is shown in the practice of treating certain of the letters as 'Imprisonment Epistles' or as 'Pastoral Epistles'. The division into categories is revealed to us, as far as I know, not by extant writings, but by the scenes in the initials. In this regard, the study of the historiated scenes might be of wider than art-historical interest, providing modern Bible scholars with insight into the methods and ways of thinking of their medieval counterparts.

One group of texts which were most important in determining the iconography of the Epistles and have not been discussed previously in this context is the set of prologues which accompanied the text in every medieval Bible. The Epistles are profusely provided with prologues: Friedrich Stegmüller lists one hundred and fifty-eight for the Epistles, as compared to ninety-five for the Psalms and seventy-five for all four Gospels, the only near rivals as to quantity.[17]

Not only has the question of the relation of prologues to illustrations been neglected, but the whole study of prologues has received very little attention on the part of modern scholarship. In this century only Samuel Berger has commented on them generally, Donatien De Bruyne has edited them, and Stegmüller has collected lists of them.[18] The De Bruyne effort is more helpful than that of Stegmüller, because he provides the entire text of each prologue rather than the somewhat confusing *incipits* and *explicits*, and because he groups them by author or family, and not by the individual Epistle.

Until the second or third decade of the thirteenth century most manuscripts prefaced each Epistle with several prologues in addition to a complicated apparatus of summaries and concordances, many of ancient origin. Romans especially tended to have a multiplicity of

[15] London, BL Add. 27694 and Paris, BN lat. 13142.

[16] I Cor. 1:13–17 (4 times), 10:2, 12:13, 15:29. Baptism is only mentioned once in each of 2 other Epistles: Rom. 6:3, Gal. 3:27.

[17] F. Stegmüller, *Initia Biblica, Apocrypha, Prologi*, vol. I of *Repertorium Biblicum Medii Aevi* (Madrid, 1940).

[18] S. Berger, 'Préfaces de la Vulgate'; D. De Bruyne, *Préfaces de la bible latine* (Namur, 1920), 214–53, lists the

Pauline prologues; Stegmüller, *Initia*, 253–306, for the Pauline material; see also S. Berger, *Histoire de la Vulgate* (Paris, 1893, repr. New York, n.d.); on pp. 301–27, Berger deals with other aspects of the Bible *apparatus*, but his remarks are applicable to the study of the prologues as well. The Gospel prologues have fared rather better than those for other parts of the Bible; see e.g. J. Regul, *Die antimarcionitischen Evangelienprologe* (Frieburg, 1969).

prologues, some of them general to all the Epistles. An outline of the apparatus of a Bible made about 1100, now in the municipal library in Valenciennes (MS 11), gives us a good picture of the typical situation at that time in regard to prologues and other addenda:[19]

Rom.	fol. 95^v	Prol., Pelagian preface to the Epistles (S. 670, De B. 213–15)
		Prol., Pelagian preface to Romans (S. 674, De B. 215–17)
	fol. 97	Prol., Pelagius (S. 659, De B. 217–18)
		Prol., Jerome (?) (S. 672)
		Prol., Priscillian (S. 656)
	fol. 97^v	Pelagian Concordances (De B. 220–3)
	fol. 98^v	Poem, 'Iamdudum Saulus', by Pope Damasus (S. 654, De B. 234, *PL* 13, 379–81)
		Prol., Isidore (S. 661, De B. 219–20)
		Prol., Marcion (S. 667, De B. 235)
	fol. 99	Chapter headings
	fol. 99^v	Initial, Paul seated writing (Fig. 60)
I Cor.	fol. 105^v	Prol., Marcion (S. 685, De B. 235)
		Chapter headings
	fol. 106	Initial, ornamental
II Cor.	fol. 112	Prol. (S. 696)
		Prol., Marcion (S. 699, De B. 235–6)
		Initial, Paul and Timothy
Gal.	fol. 116	Prol. (S. 713, De B. 251)
		Prol., Marcion (S. 707, De B. 236)
		Chapter headings
	fol. 116^v	Initial, ornamental
Eph.	fol. 117	Prol., Marcion (S. 715, De B. 236)
	fol. 117^v	Chapter headings
		Initial, ornamental
Phil.	fol. 120^v	Prol., Marcion (S. 728, De B. 236)
		Prol., Pelagius (S. 726, De B. 237)
		Chapter headings
	fol. 121	Initial, ornamental
Col.	fol. 122^v	Prol., Marcion (S. 736, De B. 236)
		Prol., Pelagius (S. 737, De B. 237)
		Chapter headings
		Initial, ornamental
I Thess.	fol. 124	Prol., Marcion (S. 747, De B. 237)
		Prol. (S. 749, De B. 246)
		Chapter headings

[19] S. = Stegmüller, *Initia* (entry no.); De B. = De Bruyne, *Préfaces* (p. no.).

	fol. 124ᵛ	Initial, ornamental
II Thess.	fol. 125ᵛ	Prol., Marcion (S. 752, De B. 237) Chapter headings
	fol. 126	Initial, ornamental
Laod.	fol. 126ᵛ	Initial, ornamental
I Tim.	fol. 127	Prol., Marcion (S. 765, De B. 237) Prol., Pelagius (S. 760, De B. 238) Chapter headings Initial, ornamental
II Tim.	fol. 128ᵛ	Prol., Pelagius (S. 770, De B. 238) Prol., Marcion (S. 772, De B. 238) Chapter headings
	fol. 129	Initial, ornamental
Tit.	fol. 130	Prol., Marcion (S. 780, De B. 238) Chapter headings Initial, ornamental
Philem.	fol. 131	Prol., Marcion (S. 783, De B. 238) Chapter headings Initial, ornamental
Heb.	fol. 131ᵛ	Prol. (S. 794, De B. 253–4, *PL* 114, 643) Prol. (S. 787, plus additional text) Chapter headings
	fol. 132	Initial, ornamental

One particular set of prologues, the so called 'Marcionite' prologues,[20] can be found in almost every medieval Bible, from the most ancient—including, for example, the *Amiatinus* and *Fuldensis* Vulgate versions as well as the Old Latin 'Freising fragments'.[21] Because they were a strong influence in determining the subject-matter of some of the historiated initials, the Marcionite prologues are of great interest to the present study.

There are Marcionite prologues for all the Epistles except Hebrews. They are quite short, usually containing the following information, although not all of them include all items:

1. An indication of the destination of the letter and the geographical location (or nationality) of the recipient(s).

2. The place from which it was written and the condition of the sender: that is, whether free or imprisoned.

[20] J. Wordsworth and H. J. White, eds., *Novum Testamentum Domini Nostri Jesu Christi Latine*, II (Oxford, 1941), 41, 155, 279, 355, 406, 455, 490, 523, 554, 573, 615, 646, 668; De Bruyne, *Préfaces*, 235–8; Stegmüller, *Initia*, Nos. 677, 684, 700, 707, 715, 728, 736, 747, 752, 765, 772, 780, 783. See below, Appendix C, for De Bruyne's text. E. E. Flack and B. M. Metzger, eds., *The Text, Canon and Principal Versions of the Bible*, Schaff-Herzog Encyclopedia (Grand Rapids, 1956), 24–5, give an outline of the history of the Marcionite prologues, and of the scholarly controversies surrounding them. See below, Appendix C, for the texts of the Marcionite prologues.

[21] Munich, Clm 6436 and other locations; see above, Ch. 1, n. 11.

3. The name of the messenger who was to deliver the letter.

4. A statement of the relationship of the recipients to the true faith, together with an emphasis on the danger posed by the 'false apostle', who had already lured certain communities away from the faith to a belief in Jewish Law and the prophets, and was threatening other groups of Christians.

(It should be noted that the prologues for II Thessalonians and the so-called 'Pastoral Epistles'—I and II Timothy and Titus—differ from the other Marcionite prologues because, as I shall explain presently, they have a different history: each contains a one-sentence summary of the information in the letter.)

The information given in the prologues does not always accord with the text of the Epistles. For example, the prologue to I Corinthians indicates that the letter is being carried by Timothy, yet the text itself (16: 10–11) gives the impression that Paul and Timothy are separated at the time of the writing of the letter.

It is obvious that the 'theology' of the prologues does not reflect the multiplicity of interests in the letters: it is concentrated upon a single subject, exaggerating it to the extent that Paul's purpose in writing some of the letters is ignored. The prologues were written by an author who was preoccupied with the opposition between the doctrine of Paul and Jewish Law, seeing this as the central problem facing Christianity.

In the early part of this century there was a flurry of interest in the Marcionite prologues, and their history was reconstructed as follows: Marcion, in the second century, wrote the prologues to Galatians, Corinthians, Romans, Thessalonians, Laodicians, Colossians, Philippians, and Philemon in Greek. His followers, in translating them into Latin, changed the prologue for Laodicians to Ephesians and added those of II Corinthians, II Thessalonians, I and II Timothy, and Titus.[22] It is interesting that the prologues to the three Pastoral Epistles (I and II Timothy and Titus)—presumably not included in the original group because Marcion denied their authenticity—are different from the others, in that they include a short summary of the meaning of the Epistle. There is not the same stress on the dangers of the false apostle in the three last-named Epistles. The distinction between the prologues ascribed to Marcion and those written by others had important consequences for the illuminations.

In addition to the thirteen (or fourteen) prologues devised by Marcion and his followers, there is a prologue to Hebrews, written *c*.350–80, of yet another type which always appears with these. It is an explanation of the obvious differences between Hebrews and the rest of the Epistles in method and language, giving the reason that the Apostle demonstrated his humility by speaking to the Jews in their own language, which was later translated by Luke.[23]

During the work of revision of the Bible undertaken at the University of Paris in the 1220s,

[22] The principal exponents of the theory of Marcion's authorship are D. De Bruyne, 'Prologues bibliques d'origine Marcionite', *Rev. Bénédictine*, 24 (1907), 1–16; and A. von Harnack, 'Der marcionitische Ursprung der ältesten Vulgata Prologue zu den Paulus-Briefen', *Zeitschrift für die neutestamentliche Wissenschaft und die Kunde der älteren Kirche* (hereafter *ZNTW*), 24 (1925), 204–18. In an exceedingly acrimonious controversy, some authorities disagreed with the attribution to Marcion. W. Mundel preferred Ambrosiaster as the author (W. Mundel, 'Die Herkunft der marcionitischen Prologe', *ZNTW*, 24 (1925), 56–77); and M. J. Lagrange thought they were written by 'P' who was influenced by Ambrosiaster (M. J. Lagrange, 'Les prologues prétendus Marcionites', *Revue Biblique*, 35 (1926), 161–73); he maintained that the prologues are definitely 'catholic'. The argument does not negate either the antiquity of the prologues or the fundamental bias of their interpretation of Paul, which is admitted by everyone.

[23] Ascribed by De Bruyne to Pelagius (*Préfaces*, 253–4), it is used by Peter Lombard as the prologue to his commentary on Hebrews (*PL* 912, 399); the text is included below in Appendix E.

the number of prologues accompanying each book was cut down, although Berger observes that the prefaces were not as radically altered as the rest of the apparatus.[24] The Marcionite group alone was retained for use in Bibles throughout the late Middle Ages. They were even included in some early printed Bibles,[25] although the use of prologues was discontinued during the Reformation and Counter-Reformation. After 1226,[26] Bibles with prologues other than the Marcionite group are rarely to be found.[27] In fact, the process of reduction was taking place early in the century, and many early thirteenth-century Bibles also are limited to the Marcionite prologues.

Once it is accepted that the Marcionite prologues are ubiquitous and that they contain certain ideas which, if not heretical, are certainly extreme, the question arises as to their relation to an orthodox interpretation of the Bible. It is interesting to note that M. Lagrange's opposition to Marcion as the author of the prologues is based on the theory that, if they had been written by Marcion, they would have been judged heretical and could not have been included with canonical texts. The answer seems to be that these prologues, in spite of their controversial doctrine, were time-honoured and were not much reflected upon during the centuries when they were transmitted along with the Bible text.

It is apparent, however, that the superficial wording of the Marcionite prologues began to be applied to manuscript illumination in the twelfth century; in the thirteenth century the influence can be detected, not only of their words, but of their substance. The earliest expression of the content of the Marcionite prologues that can be seen is that the biographical information in the prologues began to be interpreted visually. There is a group of manuscripts which distinguish between the conditions of freedom and imprisonment of Paul, evidently on the basis of the information in the prologues;[28] another group illustrated with messenger and preaching scenes seems to have been inspired by the descriptions in the prologues of the circumstances of sending and receiving the letters.[29] Finally in the mid-thirteenth century, the doctrine of the prologues is expressed in the iconography.[30]

In 1902, Berger, in a discussion of the benefits that would result from an investigation of the then and still neglected prefaces to the books of the Bible, made a prophecy: 'There will yet be made, perhaps, in the *initia* of our Bible prefaces more than one interesting discovery.'[31] Berger probably was referring to the prefaces *per se* as the *initia*—or beginnings—of the texts, but his statement is applicable to the historiated initials as well.[32] The initials contain many 'interesting discoveries', and among these discoveries can be included the influence on the pictures of the very prefaces that Berger was discussing.

III. THE RELATIONSHIP OF PICTURE AND TEXT

In the *Corpus of Bible Illustrations* in the Department of Fine Art in the University of Toronto, two

[24] Berger, 'Préfaces de la Vulgate', 28; see above, n. 3.

[25] e.g. in the Bibles printed by I. Tornaesius (Jean de Tournes) in Lyons in 1554 and by C. Marnius in Hannover in 1605.

[26] The date suggested by Roger Bacon for the Paris revision of the Bible; see Berger, 'Préfaces de la Vulgate', 29.

[27] Several are included in the 'Prologue Cycle' manuscripts based on a group of prologues by another author, which were given by De Bruyne the collective title 'It 1' (De Bruyne, *Préfaces*, 239–42; see below, Appendix D, for the

text). These fairly long prologues are extremely rare; De Bruyne based his edition on only three texts, compared to thirty-three *exempla* for the Marcionite prologues (see below, Ch. 4, n. 25).

[28] See below, *The Imprisonment Theme*.

[29] See below, *The Cycles of Epistolary Scenes*.

[30] See below, *Paul as Apostle to the Heathen*.

[31] Berger, 'Préfaces de la Vulgate', 26.

[32] It is the Bible text, rather than that of the preface, which usually is historiated.

hundred and five out of two hundred and eighty-six Bibles include the texts of one or more of the Pauline Epistles.[33] Of these, one hundred and forty-one are given historiated initials for at least one of the Epistles. I should like to begin by discussing the scenes most frequently used as illustrations for the Epistles, author portraits, messenger and preaching scenes.

The simplest are the author portraits, either attesting figures or scribes. In the use and frequency of these representations, the images chosen to illuminate the Epistles are typical of the Bible as a whole. They present few problems of interpretation peculiar to the study of the Epistles. However, as the scenes gradually grow more complex, the problems attending their explication become specific to the Epistles, in that they reveal an ever-closer attention to the Epistle and prologue texts on the part of the designers of the iconography. In fact, the most complex of the schemes display a relationship between picture and text which is exceptional in Bible illustration.[34]

In the following presentation the material is arranged in the order of the complexity of the scenes, beginning with the simplest. This arrangement does not coincide with chronological sequence, but there is a chronological aspect as well. The discussion begins with images of Paul as a single figure attesting to authorship, a type which is found throughout the twelfth and thirteenth centuries but undergoes changes in the course of time. The second theme—the scribe portrait and its ramifications—also can be traced through a chronological development corresponding to the increasing complexity of the scenes. The same is true of the third type considered here, the preaching theme. All three types coexist and develop simultaneously. Finally, in a late group of manuscripts which emerges from the preaching type—the 'Cross-and-Sword' group—there is a retreat from complexity. The simplicity of the last group is typical of much, but not all, late thirteenth-century Bible imagery: standardized, reduced in scope, mass-produced.

The Author as an Attesting Figure

The least complicated way of representing Paul's authorship is to depict him standing or seated holding a scroll or book, his traditional attributes up to the twelfth century, indicating that he is the Apostle of doctrine. The figure attests to authorship rather than proving it through a scene depicting the act of writing the letter. The only connection with the Pauline letters *per se* is the portrayal of the unmistakable physiognomy of the author and of his attributes. There is no indication either of the nature of the text illustrated—a letter—or of the ideas contained therein.

Attesting figures as author portraits were widespread in Bible illumination, and might have been adapted for the illustration of the Pauline Epistles from Old Testament or Gospel illustrations. Alternatively, the source might have been the illustrated Epistle Commentaries.[35]

The single figure alone, however, or with a book or scroll, was not a widely popular subject in

[33] See above, Introduction, p. xxv, and below, Appendix B, for a chart giving the frequency of occurrence of Pauline subjects in Bible illumination, based on the *Corpus*. Where examples are not illustrated in the present study, photographs and/or descriptions are in the files of the Toronto *Corpus*. The figure of 286 Bibles refers to those chosen for publication.

[34] See R. M. Walker, 'Illustrations to the Priscillian Prologues in the Gospel Manuscripts of the Carolingian Ada School', *Art Bulletin*, 30 (1948), 1–10, for a parallel study of the influence of prologues on iconography.

[35] Two 11th-c. examples of Epistle commentaries give evidence of the practice of illustrating this type of manuscript with the single figure: Innsbruck, Univ. Bibl. 259, fol. 1 (Rom.): Paul is standing holding a book; Nimes, Bibl. Mun. 36 (Phil.): Paul stands in the shaft of the letter holding a scroll in his hand and gesturing at the bust of Christ in the loop. (See M. Schapiro, 'New Documents on St. Gilles', *Art Bulletin*, 17 (1935), 415–31, Fig. 20, especially 426, n. 38. The MS is a commentary on the Epistles composed of excerpts from the works of St. Augustine.)

the Pauline Epistles in twelfth-century Bibles, as distinct from illustrated commentaries. In most cases where this subject is used in Bibles, only one or two Epistles are historiated. I have chosen a few examples from twelfth-century Bibles to give an idea of the variations in the way the theme is represented. These indicate as well the lively mentality of the artists, who found myriad ways to connect the picture of the author with his writings. Historiated initials, embedded as they are within the body of the text, add resonance, deepening the significance of these apparently ordinary images.

Paris, Bibl. Mazarine 2, Bible, first quarter of the twelfth century, fol. 207ᵛ (Romans (Fig. 52)): Paul stands in the stem of the initial, grasping a bird in the loop. This is the only historiated initial for the Pauline Epistles in the book.

Rome, Vat. lat. 12958 (The Pantheon Bible, an Italian manuscript), second quarter of the twelfth century, fol. 360 (I Thessalonians (Fig. 53)): Paul stands in the loop of the initial, holding a scroll in his left hand, pointing to the text of the Epistle with his right. The attesting author portrait is used frequently in the Pantheon Bible, in both Old and New Testaments, but only three of the Epistles have initials.[36]

Troyes, Bibl. Mun. 458, Vol. II, c.1140, fol. 213 (Philippians (Fig. 54)): Paul is seated holding a scroll, inscribed with a quotation from Philippians: 'To me to live is Christ, and to die is gain.'[37] Therefore the portrait of the author becomes something more than an attesting figure; he is presenting to the reader an aspect of the doctrine in the letter. This Bible has three scenes from Acts (Romans, I Corinthians, Ephesians (Figs. 141, 147, 199))[38] as illustrations to the Epistles, in addition to the single figure in Philippians. The rest are ornamental.

Dublin, Trinity Coll. A.2.2, immediately before 1200: It is only at the end of the twelfth century that we find examples of Bibles in which most of the Epistles are illuminated with the single figure holding a book or scroll; in this manuscript ten of the fourteen Epistles are illustrated in this way; the rest are ornamental.

Reims, Bibl. Mun. 34-6, c.1225-30, Vol. III, fol. 157 (Philemon (Fig. 55)): This is a typical example of the solitary figure with a scroll in its mature development in the thirteenth century. The scroll is inscribed in simulated Hebrew, indicating the attention to precise detail and also the preoccupation with the Jewish origins of Paul typical of the later Middle Ages.[39] All of the Epistle initials in this manuscript are historiated, with a wide variation in subject-matter.[40]

In the thirteenth century the single figure initial is more thickly distributed in individual Bibles, but at the same time, particularly after the middle of the century, the book or scroll is being supplanted as an attribute by the sword. A Bible made *c.1210* shows the patterns that are emerging in respect to the figure of Paul with his attributes:

[36] Rom., fol. 344, Paul as a scribe; II Thess., fol. 361, unidentified single figure. Much of the imagery in this MS derives from French models, and therefore its inclusion here is appropriate.

[37] Phil. 1:21: 'Michi vivere Christus est et mori lu[crum].'

[38] See below, Ch. 3, n. 17.

[39] See below, *Paul as Apostle to the Heathen*.

[40] There are 4 scenes of Paul as a scribe, 3 of Paul with a sword and scroll, 1 of him reading, 2 messenger scenes, 2 of Paul talking to another person, and 2 scenes from Acts.

New York, Morgan Lib. M. 791 (the Lothian Bible): a portrait of the author with a book or scroll illustrates I Corinthians and Titus, and Paul alone, without attributes, all the rest (including Laodicians), except for Philippians and II Thessalonians which are ornamental, and Romans (Fig. 56) and Philemon, in both of which Paul holds a sword, seated frontally on a bench.

The two representations of Paul with a sword in the thirteenth-century manuscript Morgan 791 are the earliest examples of this attribute I have discovered in Bible manuscripts, but we have seen the emergence of this attribute in the twelfth century, as discussed above in Chapter One. The attesting figure with a sword is quite rare up to *c*.1240, but then it rapidly becomes the most common of Pauline subjects; again, an example from Reims 34–6 depicting Paul with both sword and scroll typifies this motif at its best (Fig. 57): the stern expression on Paul's face and the vigour of his gesture reinforce the militant mood established by the attribute.

Strictly speaking, the figure of Paul with a sword is no longer an 'attesting figure'. It is not directly connected with Paul's authorship, but with a concept of the role of Paul's life and thought commonly held in the Middle Ages. There is also a textual basis, however, for using the sword as a symbol of Paul's writings. He himself drew the comparison between words and weapons: 'The word of God is alive and active. It cuts more deeply than any two-edged sword.'[41] This very text is illustrated with an image of Paul holding a book and sword in one of the thirteenth-century *Bibles Moralisées* (Fig. 122);[42] he is sometimes shown with both attributes in regular Bibles with historiated initials, although the picture of Paul holding only a sword is the single most popular Pauline image in the Middle Ages.

Using the illustrations of Philemon as examples, the following table gives an idea of the distribution of the various types of attesting figures of Paul in Bible illumination:[43]

	1100–1250	1250–70
Paul alone	10	3
Paul with a book	5	4
Paul with a book and sword	4	5
Paul with a sword	6	30
	—	—
	25	42

The incidence of representations of Paul holding a sword increases after the middle of the thirteenth century, and the scenes with other attributes (or without attributes) become rarer. Part of the reason, of course, is the increasing uniformity in Bible illustration during the thirteenth century; in addition, the preference for the militant attribute of the sword accorded with the spirit of crusading and suppression of heresy in the second half of the century.

The Author as a Scribe

The attesting figure only tells us who the author is. A portrait of the author as a scribe tells something about the text of the Epistles by emphasizing their epistolary nature. The scribe

[41] Heb. 4:12: 'Vivus est enim sermo Dei, et efficax, et penetrabilior omni gladio ancipiti.'
[42] Toledo, Cath. Lib., vol. III, fol. 152.

[43] See below, Appendix B, for a chart of the frequency of iconographic motifs.

portrait is, of course, a common medieval device to denote authorship in general.[44] In the Pauline context it becomes authorship of a special kind: the penning of letters, which are written works having peculiarly personal characteristics. A letter is expressed in the first and second persons, in contrast to the treatise, written in the third person. It is given a salutation, it is destined for a particular community or individual, and it can be transmitted by a messenger.[45] The designers of Pauline imagery seem to have been conscious of the Epistle as a literary genre. Beginning with the commonplace picture of the author seated at his desk, from the late twelfth century onward the theme is elaborated, becoming increasingly expressive of the implications of the letter as a letter. Occasionally the notion that it is a letter that Paul is writing is underlined by the fact that the salutation—'Paulus'—actually appears on the image of the letter in the picture (Fig. 79). Concentration on the epistolary nature of the text is a reminder that the letter, which has universal significance, originally had a particular application, having been written at a certain time and in definite circumstances. Presumably understanding the original, particular—that is, literal —meaning can serve as an aid to true comprehension of the text. Hebrews, without a salutation and lacking the intimacy of address of the other Epistles, is almost never given a letter-writing scene. The difference in treatment between Hebrews and the first thirteen books supports the notion that the epistolary theme is reserved for those letters which are truly letters.

One of the earliest forms of Pauline imagery in manuscripts, the depiction of Paul as a scribe, can be found in two ninth-century examples. A St. Gall edition of the Epistles, Acts, and Apocalypse from the early ninth century shows Paul seated on a bench writing in a book (Fig. 58), and in a Rhenish manuscript of the Pauline Epistles of *c*.850 he is seated at a desk, hands raised in awe at the inspiration of the hand of God (Fig. 59).[46] Adolph Goldschmidt has suggested that the artist used a late antique model for the daring position of Paul seen in a three-quarter view, partially from the back.[47] If this were true, it could mean that there were Early Christian manuscripts of the Epistles illustrated in this way, but, of course, the model could also have been from another text entirely, adapted by the Carolingian artist for his portrait of Paul as an inspired scribe. The depiction of Paul in communication with the agent of his inspiration changes the psychological content of the scene. No longer can we assume that we are being shown the typical activity of a scriptorium; the event becomes one of spiritual significance, expressed visually by the presence of the hand of God, and by Paul's facial expression and hand gesture.

The scribe portrait is also the ordinary form of illustration of the Pauline Epistles in Byzantine art.[48]

[44] For a study of the author portrait in general, see A. M. Friend, Jr., 'The Portraits of the Evangelists in Greek and Latin Manuscripts', *Art Studies*, 5 (1927), 115–47; 7 (1929), 3–29.

[45] B. Rigaux, *Saint Paul et ses lettres: état de la question* (Paris-Bruges, 1962), 165–9, 'Les formules épistolaires', sums up recent scholarship in regard to the nature of the Epistles; see esp. 166: 'Les lettres pauliniennes sont des vraies lettres, ayant un caractère circonstantiel bien déterminé et s'adressant à des destinataires connus.'

[46] Stuttgart, Landesbibl. HB II 54, fol. 25[v] (A. Goldschmidt, *German Illumination* (N.Y., n.d.), I, pl. 79); and Düsseldorf, Universitätsbibl. A 14, fol. 120 (Goldschmidt, ibid., pl. 88), which is inscribed with the opening words of a

poem by Pope Damasus (Carmen VII): 'Iamdudum Saulus, procerum praecepta secutus/Cum Domino patrias vellet praeponere leges, . . .' *PL* 13, 379–81.

[47] See also, London, BL Add. 28106–7 (The Stavelot Bible), vol. I, fol. 96 (Prol., I Kings); and Paris, BN lat. 648, fol. 172 (I Tim.).

[48] e.g. in a 10th-c. Greek manuscript of the Acts and Epistles now in Oxford (Bodleian Canon. Gr. 110, fol. 176[v]), Paul sits near a desk holding a roll; he is represented as a scribe actually writing the Epistles in an 11th-century MS of the Epistles and Apocalypse (Paris, BN gr. 224, fol. 6[v]); and in an Acts and Epistles of 1045 (Paris, BN gr. 223, fol. 6[v]), he is shown dictating to a scribe.

Our Carolingian examples provide the two main variations on the theme of Paul as an author that became common in later art, as an ordinary scribe and as an inspired scribe. It should be noted that all of the foregoing examples, from East and West, are of separate texts of New Testament books: they are editions of either the Pauline Epistles alone or in combination with other parts of the New Testament. In the West, from the ninth to the early twelfth centuries, complete Bibles usually were treated in a different way, the Epistles either introduced by scenes from Acts, as in the two Carolingian Bibles, or else decorated with foliate ornament only.

Paul's portrayal as a scribe had a certain subsequent history in twelfth- and thirteenth-century Bible illustration but it was not the most frequently occurring image.[49] It remained popular as a subject for the initials of the commentaries on the Epistles, which bears out the hypothesis that there were two separate traditions of transmission for the two types of edition.

The following examples indicate the main ways in which the theme of the scribe was used in twelfth- and thirteenth-century Bibles and commentaries. At the same time the place of the scribe portrait in the total number of historiated initials in a given Bible is noted, supporting the point that has already been made regarding the gradual tendency to increase the numbers of historiated initials in each Bible:

Valenciennes, Bibl. Mun. 9–11, Bible, *c.*1100, vol. III, fol. 99[v] (Fig. 60): Paul is shown at a writing-desk with a full complement of writing-utensils. He is presented here as an ordinary scribe. There is no atmosphere of inspiration and awe, such as Evangelist portraits often convey even when the Evangelist is a scribe. Typical of the early twelfth century, this Bible has only one other historiated Pauline Epistle—II Corinthians—which is of a different type.[50]

Paris, Bibl. Arsenal 4, Bible, *c.*1210–20: The same type of author portrait is used here, but for nine of the initials (the other five are ornamental).

Paris, BN lat. 11535–34, Bible, *c.*1200 (from St. Germain des Prés), vol. II, fol. 300[v] (Romans (Fig. 61)): This is the type of Paul as the inspired author. He sits at the writing-desk, the dove of the Holy Spirit whispering in his ear. Four of the Pauline scenes in this well-known Bible represent Paul as an inspired author.

Cambrai, Bibl. Mun. 345–6, Bible, *c.*1260, vol. II, fol. 319[v] (Ephesians): Here Paul, as a scribe, is inspired by the hand of God, and in fol. 312[v] (II Corinthians) he is inspired by the head of God (cross-nimbus omitted).[51] The distribution of the scenes of the inspired scribe in this example should be noted. It occupies the initials of the first six Epistles, and the rest are decorated with the single figure of Paul with a scroll.[52]

[49] Only 84 of 1781 historiated initials in the Bibles of the Toronto *Corpus* are illustrated with a scene of Paul as a scribe.

[50] The initial for II Cor. (fol. 112) represents Paul addressing another figure.

[51] The substitution of the head of God for the hand is not particular to Pauline iconography, but is a general phenomenon of the mid-13th c. All 3 Bibles in which the motif appears with Paul as an inspired scribe are of that date:

Cambrai 346; New York, Morgan Glazier 42; Oxford, Wadham College 1.

[52] This common phenomenon—that is, for the illustrations to be concentrated in the first Epistles—is probably due to the artist's initial enthusiasm at the beginning of a project gradually diminishing toward the end. The same observation could be made of Bibles as a whole.

Paul Sending a Letter

Except for the portrayal of the typical physiognomy of Paul, the scenes of Paul as a scribe have little to identify them as illustrations of Pauline subjects. The notion of emphasizing the distinctive nature of the text as a letter contains, however, the germ of an idea which permits considerable development. Designers of iconography begin to look ever more closely at the opening passages of the letters for hints as to the circumstances in which they were written and sent. The earliest expansion of the idea of authorship can be seen in a scene of Paul sending a letter and of the addressee receiving it. This subject, quite rare in the early part of the twelfth century, becoming more common in the second half, is popular in the thirteenth.

An early example is to be found in the Epistle to Timothy in a manuscript made *c*.1160 and now in the library of the Assemblée Nationale in Paris (MS 2, fol. 281). Paul is shown giving a book to a tonsured figure, who is probably Timothy (Fig. 62).[53]

A commentary on the Epistles by Peter Lombard, made about 1160–70, in the Bibliothèque Ste. Geneviève in Paris (MS 77), shows in several scenes the development of the idea of authorship and the communication of a message. In this manuscript all the illustrations are variations on the theme of writing and sending a letter, some of them in close conformity to the specifications of the Bible text. Contrary to the usual practice, the initials of the commentary are illuminated, rather than those of the text.

Introduction to the Epistles ('primordia rerum'), fol. 1 (Fig. 63):[54] Paul stands in the centre holding two scrolls which are grasped by two smaller male figures at the bottom; one is tonsured, the other is a layman. They are watched by a small hatted figure perched at the top of the initial, probably a Jew.[55] The two figures at the bottom possibly represent the audience to which Paul addressed his letters: the Christians, lay and clerical. The latter might be Peter Lombard himself, since he sometimes appears at the beginning of his commentary. Because an important part of the letters, and of Lombard's commentary, deals with the relation of Christianity to the Jewish heritage, the Jew is shown as the twelfth century was beginning to see him: excluded and grieving.[56] The picture adequately conveys the notion that Paul is disseminating his doctrine through the written word; it also shows the importance of the author in relation to his readers (the hierarchic scale is used).

I Corinthians, fol. 65 (Fig. 64): Paul and another nimbed figure sit under inhabited architecture, each holding a scroll. The second figure probably is Sosthenes, who is referred to in the opening lines of the letter as the co-sender of the letter. The two scrolls lead upward to the people of Corinth within the city.

[53] The other figural scenes are: Paul preaching: Rom., fol. 269[v]; Heb., fol. 282; single figure: Col., fol. 278[v]; II Thess., fol. 280; Paul in prison: Eph., fol. 277.

[54] The words are the beginning of Peter Lombard's preface to his commentary on the Epistles, *Collectanea in omnes d. Pauli Apostoli Epistolas, PL* 191, 1297–192, 520. The version of the preface (*PL* 191, 1297–1302)—beginning 'principia rerum'—varies slightly from that of Ste. Geneviève 77.

[55] Jews in medieval art are recognized by their pointed or knobbed hats. The demand for Jews to wear distinctive dress was not made official until the IV Lateran Council of 1215, Article 68[3]: 'statuimus ut tales utriusque sexus, in omni Christianorum provincia, et omni tempore, qualitate habitus publice ab aliis populis distinguantur cum etiam per Mosen hoc ipsum legatur eis iniunctum.' J. D. Mansi, ed., *Sacrorum conciliorum nova et amplissima collectio,* XXI (Venice, 1776), col. 1055. However, the practice was widespread before this date, due to both the desire of the Jewish elders and public pressure on them. See S. Grayzel, *The Church and the Jews in the XIIIth Century,* rev. ed. (New York, 1966), 59–70, and E. A. Synan, *The Popes and the Jews in the Middle Ages,* paperback ed. (New York, 1967), 104–5.

[56] See below, *Paul as Apostle to the Heathen.*

II Corinthians, fol. 108ᵛ (Fig. 65): Paul, seated at the right, holds a scroll; below, three small figures (the Corinthians) stretch out their hands to receive it.

Galatians, fol. 132 (Fig. 66): Paul as an author, writing at a desk.

Colossians, fol. 175: Paul, seated at the top of the initial, holds a scroll before six spectators (the people of Colossae).

II Thessalonians, fol. 190ᵛ: Paul and a second, smaller, figure, each holding scrolls, point to a church (i.e. Thessalonica).

I Timothy, fol. 194: Paul and Timothy, dressed as a bishop, together hold the ends of a scroll.

II Timothy, fol. 204ᵛ: Paul seated writing. Timothy as a bishop seated beside him.

Titus, fol. 210ᵛ: Paul hands a scroll to Titus, dressed as a bishop.

Philemon, fol. 214 (Fig. 67): Paul hands a scroll to two men and a woman, whose names are inscribed: Apphia, Archippus, and Philemon. These are the three to whom the letter is addressed, as the text itself tells us. (The rest of the initials are ornamental.)

Ste. Geneviève 77 conveys the idea of sending a letter in a subtle and delicate way, with many variations, but the basic intention is to picture the sender and the recipients; this is typical of the twelfth-century way of expressing the relationship of the author to his constituency. No twelfth-century Bible is as sensitive to the epistolary suggestions of the letters as is Ste. Geneviève 77, but within forty years Bible illustration will have caught up to and overtaken the illustrated commentaries.

The scene of sending a letter is modified in the thirteenth century by the addition of the figure of a messenger. For example, in the initial for Galatians in a Bible of the first quarter of the thirteenth century in Reims (MSS 34–6, vol. III, fol. 138 (Fig. 68)), Paul is shown giving a letter (written in 'Hebrew') to a messenger whose role is made plain by the walking stick he carries. Sometimes the ultimate recipients also are indicated as, for example, in a Bible in the Ste. Geneviève library in Paris (MS 1185, *c.*1220–30, fol. 293ᵛ, Colossians (Fig. 69)), in which the inhabitants of Colossae, Jew and Gentile, watch a tonsured messenger receive the letter destined for them.

The Pastoral Theme

In the list of scenes described above in the Lombard Commentary in the Ste. Geneviève library the two letters addressed to Timothy and the one addressed to Titus received special treatment: the recipient in each case was depicted as a bishop. The inclusion of the addressee specified to be a bishop became the standard way of illustrating these three Epistles.

Although the term 'Pastoral Epistles' was coined in the eighteenth century by Paul Anton,[57] it

[57] *Exegetische Abhandlung der Pastoral-Briefe Pauli an Timotheum und Titum, im Jahr 1726 und 1727 öffentlich vorgetragen, nunmehr aber nach bisheriger Methode treulich mitgetheilet von J. A. Maier*, 2 parts (Halle, 1753–5). Cited in the *ODCC*, s.v., 'Pastoral Epistles', 1023.

is evident that the twelfth century had a similar conception, probably based on the formulae of the Marcionite prologues. As noted above, the latter treat the Pastoral Epistles differently from the others, partly as a consequence of their different history. The letters to Timothy and Titus are unlike the others in that they deal with pastoral matters, in particular with the obligations of bishops, deacons, and elders, and they are illustrated accordingly.

Both Timothy and Titus were traditionally supposed to have been bishops, the former of Ephesus, the latter of Crete.[58] There is no doubt that the many appearances of bishops in the three pastoral Epistles are intended to depict the addressees, often being handed a letter, sometimes a book, sometimes simply being lectured. The illustration of I Timothy in a Bible in the Morgan Library in New York (MSS M. 109–11, vol. III, fol. 187[v] (Fig. 70)), made *c*.1260, is an excellent example of the emphasis on the pastoral content of the letter in the way in which the thirteenth century saw it: Paul, seated on a bench, hands a book impaled on his sword to Timothy, correctly dressed in episcopal vestments.

The pastoral theme is expressed in many ways. In fact, it permeates the iconography of almost all of the cycles. It fits into the simple epistolary schemes in that the recipient of the letter is depicted as a cleric, it is given narrative content in Acts scenes in Bibles illustrated with these, and it is combined with doctrinal iconography in the Prologue Cycle.

The Imprisonment Theme

A scene depicting Paul writing or sending a letter from prison further amplifies the theme of the giving of a letter. The prison is usually a building seen from the outside, Paul's confinement emphasized by the fact that he must hand the letter through a window or from a tower.

We are fortunate in having incontestable evidence that this is indeed the way in which Paul's imprisonment was represented. In an imaginative use of the historiated initial in an Epistle Commentary of *c*.1200 (Paris, BN lat. 648, fol. 190 (Fig. 71)), the stem of the 'P' introducing Philemon has become a tower inscribed 'Roma', while Paul can be seen through the window of a separate structure in the loop labelled 'carcer'. He is accompanied by a second figure, no doubt Timothy, who is mentioned as his companion in the salutation of the letter. Perhaps because we are dealing with an illustrated commentary rather than a Bible, the depiction is atypical, in that Paul is merely writing, rather than sending a letter from prison.

Special treatment of certain letters as Imprisonment Epistles can be found as early as the mid-twelfth century, but the theme was not then as systematically worked out as in later efforts. These are some examples of twelfth-century Bibles using the prison motif:

In the Bible in the library of the Assemblée Nationale in Paris (MS 2), of the mid-twelfth century, only one Epistle—Ephesians (fol. 277)—has an imprisonment scene (Fig. 72) in which Paul is seen at the window of a building pointing at a tonsured messenger, mentioned in both the text of Ephesians (6:21) and in the Marcionite prologue as Tychicus the deacon.[59]

Oxford, Bodl. Laud Misc. 752, of the fourth quarter of the twelfth century includes several scenes from Acts in the Epistle illustrations. In addition, Colossians (fol. 405[v]) is treated as a Prison Epistle (Fig. 73), in the typical way, Paul handing a letter through the window to a nimbed figure on the outside.[60]

[58] Eusebius Pamphili, *The Ecclesiastical History*, trans. by C. F. Crusé, 10th ed. (New York, 1856), Bk. 3, Chapter IV, 'The Successors of the Apostles', 84–5.

[59] See below, Appendix C, for all references to the text of the Marcionite prologues.

[60] Compare Fig. 73, in which Col. is treated as a Prison Epistle, with Fig. 82, in which it is not.

There are two sources for identifying which of the letters were written in prison: the Epistles themselves and the Marcionite prologues. Three of the latter use the phrases *de carcere* or *in carcere* to describe Paul's condition at the time of writing. Modern scholarship has concerned itself with this question mainly from the point of view of establishing a chronology of Paul's life. The argument centres on whether the Imprisonment Epistles were written from Rome (the preferred site previous to the nineteenth century) or Ephesus, as insisted upon by G. S. Duncan and accepted by many scholars, or as a compromise, Caesarea (the nineteenth-century preference).[61]

Both sides have used Marcion's indications of the place of writing to support their own positions; strangely, they use their opponents' reliance on Marcion to demolish the unwelcome argument. Duncan, for example, thinks that Marcion was the recipient of a false tradition when he held that Ephesians, Philippians, and Philemon were written from Rome, but that he was correct in saying that Colossians was written from Ephesus. The main point is that modern scholarship has taken Marcion seriously, if only to take the trouble to refute him.

There is little argument as to which of the Epistles should be included in the imprisonment category: Ephesians, Philippians, Colossians, and Philemon. Passages in the texts of these four letters specify that they were written from prison (Ephesians 3:1, 4:1–2; Philippians 1:7, 1:13; Colossians 1:24, 4:4, 4:10, 4:18; Philemon 10). But the text of II Timothy also has unmistakable indications of imprisonment and expectations of death (II Timothy 1:8, 2:8–9, 4:6–7). The modern list does not include II Timothy, however, because the authenticity of the Pastoral Epistles is rejected by many modern scholars.[62]

It is interesting that the Middle Ages made a similar judgement: II Timothy, although then accepted as authentic, was not regarded as an Imprisonment Epistle. It is here that the Marcionite prologues exerted their influence; because Marcion himself rejected the Pastoral Epistles, they were not given their prologues at the earliest stage: that is, at the moment when Marcion was concerned with Paul's imprisonment.[63] The neglect of Colossians as an Imprisonment Epistle in the Middle Ages also can be traced to the Marcionite prologue, which does not specify that Colossians was written from prison, despite the evidence for it in the text of the letter itself. The Marcionite list of Imprisonment Epistles is shorter, then, than the modern list: Ephesians, Philippians, Philemon; even the position of Philippians is not secure, since *de carcere* is omitted in some versions of the prologue to Philippians—for example, in De Bruyne's edition of the prologues[64]—and, presumably, in a number of Bibles which influenced the illustrations.

The table on page 60 which notes the frequency of occurrence in the Toronto *Corpus* of prison scenes in the Pauline Epistle illustrations, also notes the evidence for considering certain of the letters as Imprisonment Epistles, in both the Bible text and the texts of the prologues.

It can be seen that the prison theme appears most frequently in those letters which the Marcionite prologues designate as 'Imprisonment Epistles', Ephesians and Philemon. The next highest frequency of occurrence of the theme is as an illustration for Philippians, regarded as a Prison Epistle according to a variant tradition of the Marcionite prologues. Finally, there are two

[61] G. S. Duncan, *St. Paul's Ephesian Ministry* (New York, 1930). Duncan later summarized his own position and those of his supporters and opponents in two articles in the *Expository Times*; 'Some outstanding N.T. problems; VI: The Epistles of the Imprisonment in Recent Discussion', *ET* 46 (1934–5), 293–8; and 'Important Hypotheses Reconsidered; VI: Were Paul's Imprisonment Epistles Written

From Ephesus?', *ET* 67 (1955–6), 163–6.

[62] Duncan, *ET* 46 (1934–5); *ODCC*, s.v., 'Pastoral Epistles', 1023.

[63] *ODCC*, s.v., 'Marcion', 854.

[64] De Bruyne, *Préfaces*, 236, n. 32. In addition to those MSS listed by De Bruyne, Göttweig 55 also omits *de carcere* from Phil. See below, Ch. 4, *passim*.

	The Imprisonment Epistles		Frequency of Occurrence in the Toronto Corpus
	Bible Text	Prologue Text	
Rom.			1[65]
Gal.			3[66]
Eph.	*	*	26[67]
Phil.	*	* (variant)	6[68]
Col.	*		3[69]
II Tim.	*		2[70]
Philem.	*	*	20[71]

examples of the prison theme accompanying Colossians and II Timothy, both letters in which the Bible texts themselves refer to the author's imprisonment. There are only four exceptions to the rule that the prison theme is used to illustrate certain designated letters as 'Imprisonment Epistles'.

Therefore, it seems probable that the designers of the iconography often looked at the prologues in their search for scenes which depicted the conditions under which the letters were written.

The way in which Paul's imprisonment is referred to in the Marcionite prologues is exemplified by the ending of the prologue to Ephesians *scribens eis ab urbe roma de carcere per tychicum diaconum*. It will be noted that the prison motif is linked with two other themes, the writing of the letter and the sending of the letter by messenger. Most of the visual interpretations follow the two twelfth-century Bibles cited above in combining the three elements: prison, letter, and messenger. A prison scene in a Bible of the mid-thirteenth century shows that the main components in the iconography changed very little in the course of over one hundred years: in the initial for Ephesians in the Bible of Hugh of St. Cher (Paris, BN lat. 16719–22, vol. IV, fol. 147ᵛ (Fig. 74)): Paul is shown in prison, handing a scroll to a deacon (Tychicus) on the outside.

Evidence that the Marcionite prologues have indeed inspired this imagery is provided by the illustration to Philemon in one of the *Bibles Moralisées* in which the prologue is written as if part of the text.[72] Juxtaposed to its description of Paul sending a letter by a messenger to three recipients is the picture faithfully reproducing all of these details (Fig. 75).

The Cycles of Epistolary Scenes

A good example of the influences of the Marcionite—and one Pelagian—prologues in messenger

[65] Paris, BN lat. 11554, fol. 183ᵛ (a late 13th-c. Bible, in which Rom. is the only historiated Epistle).

[66] In all 3 cases where Gal. is treated as a prison epistle, it is the only such representation in the MS, and might be the result of a mistake: Douai 18, vol. II, fol. 169ᵛ, and Lyons 409, fol. 511ᵛ, are almost identical in their iconography. The third MS is London, BL Royal 1.C.I, fol. 264ᵛ.

[67] The total includes 13 MSS in the 'Prologue Cycle' group.

[68] The total includes 1 MS in the 'Prologue Cycle' group.

[69] Oxford, Bodl. Laud Misc. 752, fol. 405ᵛ; Paris, Bibl. Arsenal 1170, fol. 414; and Paris, BN lat. 16719–22, vol. IV,

fol. 153 (The Bible of Hugh of St. Cher). They are all unusual and independent in their iconography, each one having no known related MSS.

[70] New York, Morgan M. 109–11, vol. III, fol. 189ᵛ; and Oxford, New College 7, fol. 277ᵛ. These 2 MSS are also independent in their iconography.

[71] The total includes 11 Bibles in the 'Prologue Cycle' group.

[72] Toledo, Cath. Lib., III, fol. 149. For the *Bible Moralisée*, see below, Ch. 4, nn. 4, 32.

as well as imprisonment scenes, can be found in the Bible of Robert de Bello,[73] BL MS Burney 3, made *c*.1235–40, a manuscript which shows in initials other than the Pauline a particular and even eccentric care for choice of subjects.

Every Epistle is historiated; the scenes are quite simple, but they leave no doubt as to the distinction between the states of imprisonment and freedom, and as to the circumstances attending the sending of the letters. In many instances they follow the specifications of the prologues with strict literalness.[74]

Romans, fol. 474 (Fig. 76): Paul, seated at the left, hands a letter to a tonsured messenger; three heads appear at windows above. The Marcionite prologue to Romans is absent from Burney 3, a most unusual situation, but substituted for it is a Pelagian prologue, the ending of which can be read in Fig. 76.[75] The prologue enumerates the fourteen letters, giving brief summaries of their contents. It ends by drawing a comparison between Paul and John, both of whom wrote to seven cities. The depiction of the sending of a letter in the lower part of the initial accords with the emphasis given to the epistolary theme in the Pelagian prologue, but it is difficult to explain the three heads looking out of windows. The Burney 3 initial might be a simplification of the type of scene which shows Paul preaching or sending a letter to an entire city (Figs. 108, 109). Some of the latter, to be discussed below, seem to be influenced by the depictions in Apocalypse illustration of John preaching to seven cities. It is possible that the parallel in the Pelagian prologue between John and Paul, both of whom addressed seven cities, suggested the 'city' type of scene to the artists. Unfortunately, the last sentence of the Pelagian prologue has been omitted in Burney 3, but this oversight might be the result of insufficient space having been left for the prologue in the planning of the page. The archetype, of which Burney 3 is a copy or a condensation, possibly included the entire prologue as well as a fuller scene of 'peopled' architecture.

I Corinthians, fol. 480 (Fig. 77): Paul, in an interior, hands a letter to a tonsured youth. This scene is in conformity with the description of the sending of the letter in the prologue: 'he writes to them from Ephesus by Timothy his disciple' (generally depicted as a youth, when he is not a bishop).

II Corinthians, fol. 485ᵛ (Fig. 78): Paul is seated within a building holding a book. The picture does not contradict the specifications of the prologue text, but neither does it follow them.

Galatians, fol. 489ᵛ (Fig. 79): Paul, in an interior, is writing the beginning of the text—'Paulus'— at a desk in the company of a clerk. The prologue specifies that he is writing, but not that he is posting the letter, and this is what is illustrated.

Ephesians, fol. 491 (Fig. 80): Paul, seen from the exterior at the window of a crenellated building, hands a letter with 'Paulus' written on it to a youthful deacon on the outside. The prologue text specifies that Paul is in prison and is sending the letter through Titicus the deacon.[76]

[73] Abbot of St. Augustine, Canterbury, 1224–53.
[74] The Burney 3 prologues follow a variant tradition and differ in slight details from the De Bruyne ed., given in Appendix C.

[75] Stegmüller, *Initia*, 651; De Bruyne, *Préfaces*, 217–18. See below, Appendix E, for the text of the Pelagian prologue; the final sentence is lacking in the Burney 3 version.
[76] Rather than Tychicus, as in the De Bruyne ed.

Philippians, fol. 493 (Fig. 81): The scene is similar to Ephesians, but the building is of another type. It conforms to the prologue in Burney 3 itself, which uses the *de carcere* variant.[77] Paul is in prison and is sending the letter by means of Epaphroditus.

Colossians, fol. 494ᵛ (Fig. 82): Paul, in an interior, hands a scroll to a deacon on the right. A variant to De Bruyne's reading appears in the manuscript, which specifies that Paul is sending the letter 'by means of Titicus the deacon',[78] and it is this text that is illustrated.

I Thessalonians, fol. 496 (Fig. 83): Paul hands a letter to a messenger, watched by a second youth. Again, Burney 3 employs an alternate reading of the text of the prologue; the letter is sent via Titus and Onesimus and this is what we see in the picture.[79]

II Thessalonians, fol. 497 (Fig. 84): Paul is writing, watched by a tonsured youth. Again, the prologue text does not specify the sending of the letter by messenger, so the scene is restricted to writing only.

I Timothy, fol. 498 (Fig. 85): Paul, seated at the left, speaks to a youth reading at the right. According to the prologue, Paul instructs and teaches Timothy, but there is no mention of sending a letter, and the picture conforms to the description.[80]

II Timothy, fol. 499ᵛ (Fig. 86): Paul is seated alone in an interior, writing. The prologue text, including all its variations, makes no mention of a messenger and there is none here.[81]

Titus, fol. 500ᵛ (Fig. 87): Paul gestures at a youth and a bishop who are either clasping hands or exchanging a letter; a church is in the background. This is clearly an attempt to picture the beginning of the prologue: 'he warns and instructs Titus concerning the regulations in regard to elders.'

Philemon, fol. 501ᵛ (Fig. 88): Paul stands at the left, hands bound; a tonsured youth hands a letter to a man on the right. The scene is in agreement with the prologue text, which says that Paul is in prison, sending a letter to Philemon by Onesimus. The binding of the hands is another method of signifying imprisonment. It occurs less frequently than the architectural representation, but there are several other instances of it.

Hebrews, fol. 501ᵛ (Fig. 89): Paul stands at the left preaching to a crowd, composed of Jews for the most part, on the right. The usual prologue to Hebrews specifies that the letter is addressed to the Jews in the Hebrew language and that therefore it is different from the other Epistles.[82] No mention is made of the circumstances of sending the letter or of a messenger. Hebrews is the only

[77] 'Scribens eis a Roma de carcere per epafroditum.' The words of the prologue appear in Fig. 81.

[78] 'Scribit eis ab epheso per titicum diaconum.' See also De Bruyne, *Préfaces*, 237, n. 9, which notes other MSS using the Burney 3 variant.

[79] 'Scribens eis ab athenis per titum et onesimum.' See also De Bruyne, *Préfaces*, 237, n. 20, which lists other MSS with a similar variant.

[80] The Burney 3 variation of the prologue adds to the De Bruyne text, 'scribens ei ab urbe Roma.' See also, *Préfaces*, 237, n. 34.

[81] The variant text adds here, 'scribens ei ab urbe Roma.' See also, *Préfaces*, 238, n. 7.

[82] The prologue always was used alongside the Marcionite prologues; it is attributed by De Bruyne to Pelagius (253–4), and included here in Appendix E.

one of the Epistles to begin with a letter other than 'P' (in this case, 'M') and this circumstance too might have suggested a different treatment. In any case, what we see in Burney 3 is the standard illustration for Hebrews in most manuscripts. The fact that Paul is shown preaching and not sending a letter expresses the direct contact which is suggested by the words of the prologue.

The Bible of Robert de Bello faithfully reproduces the indications of the prologues regarding the transmission of the letters and the descriptions of the messengers, and, in the case of I Timothy, Titus, Philemon, and Hebrews, the recipients.[83] The singling out of certain of the letters as having been written in prison conforms to the Marcionite prologues, but not always to the suggestions in the Epistle texts themselves.

Many thirteenth-century manuscripts are variations of the type of which Burney 3 is an example. They include depictions of Paul in prison and as a writer sending a message but there are few in which the relationship to the text of the prologues is as clearly defined as in Burney 3. For example, in a Bible at Lyon (MS 421) of 1240–5, in which most of the illustrations follow the pattern of Burney 3, Paul gives a letter or speaks to two people in every scene except those illustrating the Pastoral Epistles, so that the pictorial cycle fails to reproduce as exactly as in Burney 3 the descriptions of the prologue text.

Another approach to the texts can be seen in a Bible in Oxford made *c.*1220, New College MS 7. In it the theme of Paul communicating with cities and individuals by means of letters delivered by messengers is elaborated further. This manuscript, unlike Burney 3, is dependent principally on the texts of the Epistles themselves, in particular the opening passages of each Epistle, but a minor note is sounded which comes from the Marcionite prologues. One key point indicating influence of the prologues is the omission of Philippians and Colossians as Imprisonment Letters, but there might be other examples of infiltration of ideas from the prologues as well.

Romans, fol. 264[v] (Fig. 90): Paul, seated at a desk, hands a scroll to a messenger. This is a non-specific statement that a letter is being sent, which cannot be identified with either the Bible or the prologue text.

I Corinthians, fol. 268 (Fig. 91): Paul and another man stand at the left, facing each other and holding a scroll between them. Two men in the centre, seated, face two standing men on the right. This scene probably represents the opening lines of the text of I Corinthians.[84] The letter comes from Paul and Sosthenes; they are together on the left, and the others are the congregation at Corinth (seated) together with all men who invoke the name of Christ (standing). An alternate interpretation is provided by the words of the prologue: Paul is giving the letter to Timothy, and the seated people are the Corinthians simultaneously hearing true and false doctrine from the two standing figures. No matter which interpretation is taken, it is still a fact that the scene goes beyond the notion of giving a letter to a messenger and incorporates a representation of the recipients as well. The former interpretation is more likely correct, since so many of the other scenes in this manuscript obviously depend on the Bible rather than the prologue text.

[83] The words of the prologues are illustrated in 12 of the 14 letters, Rom. (?) and II Cor. being the only exceptions.

[84] 'Paulus, vocatus apostolus Jesu Christi per voluntatem Dei, et Sosthenes frater, ecclesiae Dei quae est Corinthi, sanctificatis in Christo Jesu, vocatis sanctis, cum omnibus qui invocant nomen Domini nostri Jesu Christi, in omni loco ipsorum et nostro.'

II Corinthians, fol. 271 (Fig. 92): Paul gives a scroll to a messenger; a group of men on the right bow their heads, the foremost of them lifting his hands in prayer. The Epistle text specifies that the letter comes from Paul and Timothy to 'God's people',[85] depicted pictorially by the position of prayer.

Galatians, fol. 272ᵛ (Fig. 93): Christ (this is a mistake: it should be Paul) stands on the left with a letter, while a group of men on the right, two of them youths, stretch out their hands. The Bible states that the letter comes from Paul and a group of his friends,[86] and that is apparently what we see in the picture.

Ephesians, fol. 273ᵛ (Fig. 94): Paul, in prison on the left, gives a letter to a traveller. Both the Bible and the prologue texts specify that Paul is in prison and that Titicus (or Tychicus) is his messenger.[87]

Philippians, fol. 274ᵛ (Fig. 95): Paul gives a scroll to a group of people among whom are two bishops. This scene is one of the clearest examples of derivation from the Bible text, which states that the letter is going to God's people at Philippi, including their 'bishops and deacons,'[88] although, if conforming strictly to the text of Philippians, Paul should be in prison.

Colossians, fol. 275 (Fig. 96): Paul and another man, close together and moving in tandem, give a letter to a group of people. The scene is a graphic depiction of the Bible text which says that the letter comes from Paul and his 'brother' Timothy to God's people.[89] The absence of an indication of prison shows that the influence of the prologue is also at work here, since the text of Colossians mentions Paul's imprisonment, but the prologue does not.

I Thessalonians, fol. 275ᵛ (Fig. 97): A long scroll is given by Paul and two other men standing behind him on the left to three people on the right. The Bible text states that the letter comes from Paul, Silvanus, and Timothy to the Thessalonians,[90] and the artist has contrived an ingenious, if clumsy, method of depicting the joint sending of a letter.

II Thessalonians, fol. 276 (Fig. 98): Paul gives a scroll to two tonsured deacons. The letter is again supposed to come from Paul, Silvanus, and Timothy. The scene is probably a joint author portrait. Perhaps originally the recipients also were represented, as in the illustration for I Thessalonians, but the scene has been reduced in the process of transmission.

I Timothy, fol. 276ᵛ (Fig. 99): Paul gives a letter to a bishop, watched by two youths, in conformity to the beginning of the Bible text, which follows the ordinary salutation beginning

[85] 'Paulus, apostolus Jesu Christi per voluntatem Dei, et Timotheus frater, ecclesiae Dei quae est Corinthi.'

[86] 'Paulus apostolus, non ab hominibus, neque per hominem, sed per Jesum Christum, et Deum Patrem, qui suscitavit eum a mortuis; et qui mecum sunt omnes fratres, ecclesiis Galatiae.'

[87] Eph. 3:1: 'Hujus rei gratia, ego Paulus. vinctus Christi Jesu'; and Eph. 6:21-22: '. . . omnia vobis nota faciet Tychichus charissimus frater, et fidelis minister in Domino;

quem misi ad vos in hoc ipsum. . . .'

[88] Paulus et Timotheus, servi Jesu Christi, omnibus sanctis in Christo Jesu, qui sunt Philippis, cum episcopis, et diaconibus.'

[89] 'Paulus, apostolus Jesu Christi per voluntatem Dei, et Timotheus frater, eis qui sunt Colossis.'

[90] 'Paulus, et Silvanus, et Timotheus, ecclesiae Thessalonicensium.'

the letters written by Paul to an individual (in contrast to the scene in Burney 3 (Fig. 85), which illustrates the prologue text 'Paul instructs and teaches').

II Timothy, fol. 277ᵛ (Fig. 100): Paul is writing from prison to Timothy, a bishop, who holds out his hand to receive the letter; two other men turn their backs and lift their hands in prayers. This is one of the few representations of Paul writing II Timothy as a prisoner, and indicates that the planners of the scene looked at the Bible text independently of the prologues.[91] The two figures on the right are, perhaps, followers of Paul mourning his impending death which is foreseen in the letter.

Titus, fol. 278 (Fig. 101): Paul writes a letter in prison, while in the centre a bishop addresses a youth. It is difficult to account for the inclusion of the prison theme in this scene. The most likely explanation is that it is a mistaken repetition of II Timothy in the same manuscript.

Philemon, fol. 278ᵛ (Fig. 102): Paul in prison hands a letter to a youth kneeling on the outside; the three recipients of the letter are shown at the right. They are the correct number specified by the Bible—Philemon, Apphia, and Archippus—but they all seem to be men, and Apphia should be a woman (as she was in Ste. Geneviève 77 (Fig. 67)).[92]

Hebrews, fol. 279 (Fig. 103): The illustration is the usual scene of Paul with the Jews, but here the connection with the letter-writing cycle is made clear by the fact that Paul is sitting at his desk composing the letter to the Jews who gesture at him on the right.

New College MS 7 is by no means perfect in its system of imagery based on the Bible; it contains some obvious mistakes and cannot be trusted completely. But it must be fairly close to the original of this cycle, in that it reveals such close attention to the text at certain points. While it is mainly oriented to the Bible text for its inspiration, intrusions from the prologues make it clear that the influence of the latter was deep and far-reaching. A noteworthy aspect of New College 7 is the clear definition it gives to the role of the sender, the messenger, and the recipient.

In several manuscripts which are related to New College 7, the clarity of the distinction between the various elements in the scene has broken down.[93] The figures are no longer defined as sender, messenger, and recipient, and the illustrations tend to become simple preaching scenes. One example in which the distinction is maintained to some degree is in a manuscript in the library of Ste. Geneviève in Paris (MS 1185) which was made around the same time as New College 7 but is not nearly as clear and precise in its relation to the text. For example, in the illustration to Philemon, fol. 297 (Fig. 104), Paul, in prison, hands a letter to a Jewish youth on the outside; the ultimate recipients of the letter are not depicted, as they are in New College 7 (Fig. 102).

Most of the recipients of the letters in Ste. Geneviève 1185 are depicted as Jews. For example, in the illustration for Philippians, fol. 292ᵛ (Fig. 105), Paul is correctly shown in prison, with a group of companions (there should be only one, Timothy) addressing a group of Jews (that is, the Philippians) on the outside. In New College 7 there is a careful differentiation: only the

[91] II Tim. 1:8: 'Noli itaque erubescere testimonium Domini nostri, neque me vinctum ejus.'

[92] 'Paulus, vinctus Christi Jesu, et Timotheus frater,

Philemoni dilecto, et adjutori nostro, et Appiae, sorori charissimae, et Archippo, commilitoni nostro.'

[93] For example, in Paris, Arsenal 1170 and Lyon 421.

recipients of Hebrews are Jews. Other manuscripts of the thirteenth century exhibit the same inclination as Ste. Geneviève 1185 to turn Paul's audiences into Jews. This is a symptom of a growing interest in expressing the relation of Christianity to Judaism, not only in the illustrations of the Epistles, but in medieval art in general.[94]

It is evident that the 'epistolary' cycles—series of pictures depicting the writing, dispatch, and delivery of letters—in the initials of the Epistles are the products of careful consideration, not haphazard choices assigned at random to enliven the page. Sufficient examples survive of Bibles in which the images are quite literal interpretations of the prologues or of the epistolary indications in the text to show that the inventors of iconography were serious in their intention to recreate the exact circumstances by which the letter travelled from its author's desk to its destination. The Marcionite prologues played a key role in this activity, and the strength of their influence is particularly marked in the representations of Paul writing and sending his letters from prison.

Paul as a Preacher

Another way of depicting Paul disseminating his doctrine is to show him in personal contact with an audience of one person or a group. A scene of preaching or discussion is not the same as the depiction of an historical moment, as, for example, in the Acts cycle, where there are several scenes of preaching at definite times and places (Damascus, Athens, Jerusalem). To illustrate an Epistle with a preaching scene is to make a general statement as to the nature of Paul's relationship with the recipient(s) of the letter; it is not connected with an event. The pictorial representations, therefore, have a tendency to be general, and are more difficult to connect with texts, in contrast to those cycles in which the epistolary approach prevails. A certain psychological relationship underlies the depiction of the figures in the preaching scenes. Paul's authority and the subordination of the audience are emphasized in a variety of ways: by hierarchic scale, by spatial arrangements, by gestures. He is the master, the leader; they are the pupils, the followers.

Of the scenes showing Paul with a group there are three basic types, all to be found in the twelfth century and continuing without much change into the thirteenth century.

The first type depicts Paul at full length either seated or standing, while his audience appears at his feet. The Lombard Commentary in Paris, Ste. Geneviève 77, of the third quarter of the twelfth century, has several good examples of this type (Figs. 63, 65): it employs the hierarchic scale as well. The difference between Paul and his audience often is emphasized by depicting the latter in bust length, implying that Paul is on a platform and they are below him. This is the representation, for example, used several times in the Souvigny Bible, Moulins MS 1, fol. 365v (Rom. (Fig. 107)) and in a thirteenth-century Bible in Palermo (Fig. 110).[95]

Paul's separation from and superiority to his audience also can be conveyed by a different method, as exemplified by a manuscript in the Morgan Library in New York, c.1260–70 (Fig. 106),[96] in which the figures stand on Paul's level, but are differentiated from him by the spatial arrangement. They are crowded, but he is surrounded by space.

Finally, a third type shows Paul preaching to 'peopled' architecture, a graphic way of picturing a city. This is the method used in almost all the Epistle scenes in the Manerius Bible,

[94] See e.g. B. Blumenkranz, *Le juif médiéval au miroir de l'art chrétien* (Paris, 1966), who does not give specific examples from Epistle illustration, but these serve to support his general conclusions.

[95] Bibl. Naz. I.F.6–7, vol. II, fol. 339v (I Cor.).

[96] Morgan M. 109–11, vol. III, fol. 183v (Col.).

*c.*1200.[97] In the initial for Corinthians, for example (Fig. 108), Paul, holding a scroll, stands in the stem of the 'P' addressing the city of Corinth, whose citizens are seen in front of a building, with one man visible through a window. In later Bibles, the exciting composition which takes advantage of the historiated P will give way to more hackneyed designs, but the idea of the city as the recipient of Paul's message will continue (Figs. 109, 112). It is possible that the scene of Paul preaching to inhabited architecture (that is, to the community of Christians, or the Church) derives from the representations of St. John's letters to the seven churches of Asia. Such a suggestion could have come from the Pelagian preface to Romans, which ends with a parallel between John's and Paul's addresses, each to seven churches.[98]

Two thirteenth-century Bibles, which are virtually contemporaneous (1220–30), and also seem to be closely related—London BL Add. 15253, and Palermo, Bibl. Naz. 1.F.6–7—illustrate almost all of the Epistles by one or another kind of preaching scene. As is true of many other thirteenth-century Bibles, both of these reveal a preoccupation with the relations between Judaism and Christianity, since in every scene Paul's audience is clearly defined as Christians and Jews, or Jews alone. In Add. 15253 this point is strongly made, since the scroll Paul holds in each case is inscribed in pseudo-Hebrew.

These manuscripts differ from the Burney 3 and New College 7 'epistolary' types in that there is no messenger: Paul is in direct confrontation with his audience, gesturing and holding a book or scroll; there is no indication of writing or imprisonment.

All three ways of preaching are represented in the London and Palermo manuscripts:

Rom. Palermo	fol. 335	(Fig. 109): Paul addresses an inhabited city
London	fol. 294ᵛ	Conversion of Paul
I Cor. Palermo	fol. 339ᵛ	(Fig. 110): Paul presents a scroll to a group of Jews and Gentiles, shown bust-length before him
London	fol. 298	(Fig. 111): Paul presents a 'Hebrew' scroll to a group of Jews standing on the right
II Cor. Palermo	fol. 343ᵛ	(Fig. 112): Paul and a Jew, above a crenellated wall, speak to a group of Jews and non-Jews below; Paul's companion, according to the text, is Sosthenes
London	fol. 301ᵛ	Paul presents a 'Hebrew' scroll to a group of Jews and Gentiles, some standing, some sitting at his feet
I Thess. Palermo	fol. 351	(Fig. 113): Paul with a Jew and a bishop above a crenellated wall speak to a group of Jews and Gentiles below; Paul's companions, according to the text, must be Timothy (the bishop) and Silvanus (the Jew)
London	fol. 307ᵛ	(Fig. 114): Paul with two companions in hats—one pointed and the other round—above a crenellated wall hold a Hebrew scroll towards a group of praying men below; Timothy's mitre has turned into a pointed furred cap[99]

[97] Paris, Ste. Geneviève 8–10.

[98] See below, Appendix E. The Manerius Bible itself does not include the Pelagian preface, but might have belonged to a MS tradition that did include it.

[99] The illustrations continue in a similar vein, except that the London version treats I and II Tim. and Tit. as Pastoral letters (i.e. with a two-figure scene) while Palermo does so only in the case of Tit.

Heb. Palermo	fol. 353	In both manuscripts: Paul is in the centre of a
London	fol. 311	triangular space formed in a Roman capital 'M'

In both manuscripts: Paul is in the centre of a triangular space formed in a Roman capital 'M' (Fig. 115); an audience of Jews and Gentiles listens from the other two triangular sections of the 'M'

It can be seen that the designer of the iconography of this group has been influenced, to a degree, by the suggestions of authorship in the opening passages of the letters. For example, in the illustrations of I Thessalonians (Figs. 113, 114) all three senders—Paul, Silvanus, and Timothy—are shown. However, in comparison to New College 7, London and Palermo fail to demonstrate the process of writing, sending, and delivering the letter. It is clear, for example, that the scroll conveyed by hand to the Thessalonians by Paul and his companions in New College 7 is a letter (Fig. 97), since we have seen him writing in earlier scenes, but in London 15253 the pseudo-Hebrew scroll has become the text for a sermon (Fig. 114); it is spoken, not delivered. It is even omitted in Palermo 1.F.7 (Fig. 113), since it is not needed as a sign of speech. The artists of the latter two manuscripts, therefore, have a different understanding of what is taking place—an oral rather than a written communication.

Hebrews in the majority of manuscripts is illustrated with some variation of the preaching theme used in London 15253 and Palermo 1.F.7. The uncial M—more commonly used than the capital M of these two examples—creates two arched spaces and in most Bibles these are occupied by Paul on one side and a group of people on the other, depicting the recipients of Paul's message (often they are Jews). An early example can be seen in the mid twelfth-century Bible in the Bibl. Assemblée Nationale, MS 2 (Fig. 116), in which Paul, holding a book, talks to seven people, the most prominent of them a Jew. The Bible of Hugh of St. Cher in the Bibliothèque Nationale provides a good example of the continuation of this theme in the thirteenth century (Fig. 117).[100] Paul is shown talking to two Jews, and the notion of transmission of the letter as a verbal message is underlined by the scroll in Paul's hand, inscribed with the opening words of Hebrews: 'Multifariam multisque modis olim. . .'

Association of preaching scenes with the Epistle to the Hebrews can be seen in the University of Toronto *Corpus*, where seventy-nine manuscripts are to be found in which a preaching scene accompanies Hebrews,[101] together with another seventeen in which Paul appears with another figure, really a condensation of a preaching scene. There are only sixteen examples of all other representations. Evidently the fact that Hebrews does not begin with a salutation has influenced the iconography, with the result that only one Bible in the *Corpus* illustrates Hebrews with any kind of an epistolary scene.[102] We have seen as well that there is no Marcionite prologue to Hebrews and that the Pelagian prologue, unlike the former, does not emphasize the act of writing.

Paul as Apostle to the Heathen

Is Paul in these preaching scenes encouraging the faithful, exhorting the unconverted, or

[100] Paris, BN lat. 16719–22, vol. IV, fol. 163ᵛ.

[101] The total includes 12 MSS in the Prologue Cycle group and 6 of the 'unusual compositions'.

[102] Paris, BN lat. 167, fol. 326. See Appendix B for a summary of other subjects.

confronting the hostile? In the examples presented up to now, Paul, as teacher, definitely seemed to be in a position of authority and a relation of sympathy with his audiences, Jew and Gentile.

In other instances, he seems to be not so much preaching as arguing with antagonistic crowds. In an early tenth-century manuscript of the Pauline Epistles from St. Gall (Fig. 118),[103] for example, the illustration for Romans shows Paul debating or contending with a crowd of Jews and Gentiles, identified by inscriptions, who make rude gestures at him. This scene implies that the main emphasis of Paul's apostleship is one of confrontation with the unconvinced or the lapsed. In a late twelfth-century Bible at Oxford the tradition is continued (Fig. 119).[104] Paul, standing among a crowd of vulgar people, points at his mouth, as if to call attention to his words. The jeering attitude of the crowd is emphasized by their distorted, ugly features, a favourite medieval device to convey an impression of immoral behaviour and thought.

Justification for this attitude is provided by passages in the letters themselves and in the Marcionite prologues. The Epistles are full of strong language, resolute advocacy of Paul's outlook, and equally firm denunciation of that of his opponents, while the Marcionite prologues exaggerate this characteristic in the letters, isolating the controversial elements and placing the emphasis on Paul's denunciations of the false apostles.[105]

From the late twelfth century onward there was a tendency to define the opposition to Paul more specifically as Jewish, as in a twelfth-century Bible in Boulogne, where Paul stands on the shoulders of the blindfolded and defeated Synagogue (Fig. 120).[106] Vanquished Synagogue occasionally makes an appearance in Hebrews as well (Fig. 328).[107] This atmosphere of confrontation reveals an interpretation of the Epistles as arguments against the Jews and Jewish doctrine.

Preaching scenes in particular provide an opportunity to display Paul in situations of contention or triumph over his enemies. The illustration for Romans in a Bible in Baltimore of about 1235, for example, shows him preaching reproachfully to the Jews, who receive the message with sadness and humility (Fig. 121).[108]

The explanation for this phenomenon is many-sided. The crusading spirit of the thirteenth century found sympathy with texts which fulminated against the enemies of Christianity. Paul's writings themselves often drew a contrast between Jewish Law and Christian justification by faith, a contrast which was seized on by the medieval artist under the additional influence of the Marcionite prologues. In a general way, it had become common by then to identify the heathen as Jews, in art more exaggeratedly than in the written word.[109]

We have noted already the increasing inclination to regard Paul as an embodiment of militancy. One image which combines a reference to this characteristic and the theme of

[103] St. Gall, Stiftsbibl. 64, p. 12, early 10th-c. (Goldschmidt, *German Illum.*, I, pl. 78).

[104] Bodl. Laud Misc. 752, fol. 391ᵛ (Rom.).

[105] See, in particular, the prologues for Rom., I Cor., Gal., Phil., Col., I Thess.

[106] Boulogne MS 2, vol. II, fol. 231 (Rom.): Paul stands on vanquished Synagogue, who herself stands on a clovenhoofed monster, who in turn is simultaneously devouring a human figure and being bitten by a winged animal. It is possible that the monster is a personification of paganism. If so a hierarchy of values is depicted: paganism, Judaism, Christianity.

[107] See e.g. Besançon 4; and Paris, Ste. Geneviève 1180,

fol. 353ᵛ (see below, Chapter 4, for a discussion of Ste. Geneviève 1180).

[108] Baltimore, Walters MS 56, fol. 383ᵛ (Rom.).

[109] Blumenkranz, *Juif médiéval*, maintains that 'l'artiste du haut moyen âge a traduit souvent la confrontation de chrétiens et de Juifs par l'opposition du Bien et du Mal' (42); and 'toute opposition contre l'Église est ramenée à celle des Juifs: les hérétiques et les incroyants sont couramment représentés en Juifs' (77). Blumenkranz agrees that the visual medium often stated the opposition more blatantly and in more extreme terms than did literary sources (68, 135).

confrontation with the Jews can be seen in the illustration for Hebrews 4:12 in the *Bible Moralisée* in Toledo (Fig. 122) in which Paul is depicted addressing a group of remorseful Jews with both a sword and a book in his hands.[110]

After exhortation comes conversion. In the scenes of Paul converting the Jews, the latter are probably meant to represent heathendom in general, although there were actually campaigns to convert the Jews themselves in the thirteenth century.[111] The process of conversion is most commonly expressed by a scene showing Paul holding aloft a large processional cross in front of a group of Jews (Figs. 245–7).

Scenes of Paul addressing the Jews with a cross belong to Romans alone: there are only two instances in which this image appears with other letters, compared to the thirty-seven occurrences with Romans.[112] The iconography is peculiar to the thirteenth century, and there are no examples previous to about 1230. It figures in three types of manuscripts: (1) five Bibles in which a scene of Paul with a cross accompanying Romans is followed by a series of messenger and preaching scenes;[113] (2) a group of Bibles with simple scenes which I have called the 'Cross-and-Sword' cycle[114] (groups one and two are posterior to 1250); (3) the Prologue Cycle group (*c.*1230–60).[115]

All fifteen Bibles of the 'Cross-and-Sword' type follow a regular and simple pattern. In Romans, Paul is depicted holding aloft a cross preaching to one person or a group, usually Jews (Fig. 123). From I Corinthians to Philemon, there is some form of the attesting figure, most often Paul with a sword—combined occasionally with the book or scroll (Fig. 124)—or the figure without attributes, for the sake of variety. Finally in Hebrews (Fig. 125), there is the standard preaching scene, usually with one or a group of Jews. Vat. Reg. lat. 3, *c.*1250, is a typical example.

The cross as an attribute of St. Paul appears most rarely before the thirteenth century. Both of the earlier examples cited by Dobschütz[116] (a Gradual in the Biblioteca Angelica in Rome of the eleventh century and a jamb figure at Étampes, *c.*1150[117]) are tiny crosses held in one hand and clutched to the breast, unlike the large processional crosses held by Paul in the Romans illustrations in the thirteenth century, which convey an entirely different meaning.

Judging by the dates of the Cross-and-Sword manuscripts, the scene of Paul presenting a cross can best be explained by the enthusiasm for preaching and crusading characteristic of the thirteenth century, as expressed by the Fourth Lateran Council of 1215.[118] A principal concern of the period was not only the defeat of foreign adversaries through Crusades, but the conversion of the heathen and the suppression of domestic heresy as well. It is these ideas that we see at work in

[110] See above, n. 42.

[111] Synan, *Popes and Jews*, 99–102; Grayzel, *Church and Jews*, 13–21.

[112] The total includes 12 MSS in the Prologue Cycle group.

[113] Cambridge, Trin. 0.4.27, fol. 450[v], *c.*1250–60; Douai 18, vol. II, fol. 2, 1250–60; Lyon 409, fol. 498, *c.*1260; London, BL Royal 1.D.I., fol. 481[v], *c.*1250–60; Oxford, Bodl. Auct. D.1.17, fol. 344, *c.*1270.

[114] The Cross-and-Sword Cycle: Brussels 3939, *c.*1250; Cambridge, Emmanuel College II.1.6, *c.*1270; Cambridge, Mass., Houghton Typ. 414, *c.*1255; Dublin, Beatty 52, *c.*1260; London, BL Add. 16410, 1292 (dated); London, BL Stowe 1, 1260; Nantes, Dobrée VII, 1260–70; New York, Morgan M. 138, *c.*1260–70; Oxford, Corpus Christi 1, *c.*1260–70; Paris, BN lat. 17198, *c.*1250–60; Paris, Ste. Geneviève 1181, *c.*1260; Rome, Vat. Reg. lat. 3, *c.*1250;

Stockholm 166, *c.*1270–80; Stuttgart, Bibl. qu. 8, *c.*1270; Uppsala, C. 155, *c.*1260–70.

[115] The Prologue Cycle group precedes the others in time but, because of its importance, it is discussed separately in this study. The Cross-and-Sword iconography might be a condensation of that of the Prologue Cycle. See below, Ch. 4, particularly 'Romans' and 'Hebrews'; and Conclusions.

[116] Dobschütz, *Paulus*, 10, 61, n. 91.

[117] Porter, *Pilgrimage Roads*, vol. X, Fig. 1466.

[118] A. Luchaire, *Le Concile de Latran et la réforme de l'église*, vol. VI of *Innocent III* (Paris, 1908), especially 64–9, shows that in this period the campaign directed against the external enemies were matched by measures against the heretics at home, and that the rewards given to the Crusaders were the same in both cases. See also Synan, *Popes and Jews*, 66–82; and Grayzel, *Church and Jews*, 39–40.

the thirteenth-century Bibles which emphasize Paul as an apostle to the heathen. The type of cross held by Paul in the illustrations for Romans is no doubt similar to those used in preaching support of the Crusades. The Prologue Cycle manuscripts, *c.*1230–60 for the most part, are even more closely linked with this spirit than are the Cross-and-Sword group, which mainly date from *c.*1250 to 1270, but the whole question of Christianity's relations with heathendom remained important during the sixth, seventh, and eighth Crusades (1228–9, 1248–54, 1270), and these ideas continued to be a source of inspiration to Pauline iconography. The central concerns of the Cross-and-Sword group—conversion and militancy—are an accurate, perhaps oversimplified, summing up of the later crusading spirit.

It is clear that the inventors of Pauline iconography were looking closely at the texts of the books they were decorating. The words of the Epistles themselves and of their prologues as well were scrutinized afresh. This close attention to words was characteristic of Bible study in the twelfth and thirteenth centuries. Such an attitude is revealed, for example, in a poem included in the Stavelot Bible made in 1097.[119] Written by Abbot Wolfhelm, it advocates the reading of the entire Bible, concluding, interestingly enough, with the advice that the preface should never be omitted.[120]

Smalley informs us too that the prologues were read carefully; in fact, during the courses of lectures given by the masters of sacred scripture, a whole session would be devoted to the prologues of a particular Bible excerpt before proceeding to the explication of the text itself.[121]

The illustrations I have considered in this chapter tell the same story. Designers of Pauline imagery must have pored over the prologues and the opening passages in the Epistles with almost manic care, concentrating upon the rather prosaic information in them as if it were knowledge of the highest order, trying to re-create pictorially the circumstances under which the letters were written, sent, and delivered. This care for the word is consistent with the attitude of twelfth- and thirteenth-century exegetes towards Scripture, with their strong emphasis on the 'literal' and 'historical' sense of the text as the foundation of understanding.[122] Exact reconstruction of the Epistle as an object which once existed, with all its personal implications, was the way to begin to comprehend its message.

An interesting aspect of the search for the literal in the origins of the letters is the appearance of the theme of Judaism: sometimes Paul's message is written in 'Hebrew'; often his audience includes Jews. The awareness of the Jewish background to Scripture is also characteristic of the movement which sought to rediscover the literal meaning by investigating Jewish interpretations of the Bible in emulation of 'that modern pupil of the Synagogue, the base of all learning, Father Jerome'.[123] Another attitude towards Judaism also can be seen in the late twelfth century, one of antagonism, corresponding to the hostility towards Jews in the political and economic spheres in this period. It is in this context that the ideology of the Marcionite prologues began to affect the illustrations.

All of these pictures of Paul are lent deeper significance because they penetrate the words of the text. The historiated initial was a marvellous invention which gave play to the taste for

[119] London, BL Add. 28106–7, vol. II, fol. 3.
[120] Brieger, 'Bible Illustration', 163, n. 1. The poem begins: 'Late diffusus. sic ecclesiasticus usus./Se testamentis exercet? ?ii omnipotentis/Ut legat hec ambo. sed et omni compleat anno./Sicut in ebdomada. Psalmorum clauditur oda./Ast hinc psallendi cum stet status inde legendi./Lectio quo prosit.

nunquam prefatio desit.'
[121] *Study of the Bible,* 217–18.
[122] Ibid. 169–95.
[123] Ibid. 187, quoting Herbert of Bosham. On pp. 149 to 172 Smalley discusses the medieval notion that Jewish Bible studies were the key to the literal interpretation.

imagination and fantasy. At the same time it was a serious instrument in the search for an imagery that helped the reader to a better understanding of the written word.

The imagery discussed in this chapter associates the Epistles with Paul by showing his authorship in a variety of ways, from simple attesting figures to the complex epistolary cycles. In the next chapter a different type of subject-matter is examined. It too connects the writings with the author, but indirectly: scenes from Paul's life are combined with his writings. Sometimes the connection between Paul's experiences and the message of the letter is obscure; in other instances the reason for the combination is more apparent. In any case, the principle that the personal and the historical belong with the theoretical continues to be followed.

CHAPTER THREE

Scenes from Acts and the Apocrypha

I. THE APPLICATION OF ACTS ICONOGRAPHY TO THE EPISTLES IN BIBLES

In a number of medieval Bibles the Epistles are illustrated with scenes from Acts,[1] the precedent for this usage going back to Carolingian times. It should be noted that the designers of iconography have juxtaposed a non-narrative, hortatory, didactic text—the Epistles—with images from a narrative source—Acts—but the significance of such a confrontation of narrative and non-narrative has never been commented on. A parallel use of narrative scenes and non-narrative texts can be seen in the illustration of the Psalms with scenes from the life of David drawn from the text of Kings.[2]

The Middle Ages obviously saw a connection between Acts and the Pauline Epistles which was deeper than their mutual association with the person of Paul. In Chapter Two I described medieval attempts to combine data from the life of the author with the meaning of his written words. The illustrations dealt with in that context explored the biographical hints about the circumstances in which the letters were written. Use of scenes from Acts, considered in the present chapter, represents a more sophisticated attempt to reconstruct the historical context of the writing of the Epistles through juxtaposition of individual letters with seemingly unrelated episodes in the life of their author.

The Carolingian Pauline Cycle and Its Descendants

Pauline scenes in two Carolingian Bibles (Figs. 6, 7)[3] have been discussed in Chapter One in their relation to Western and Byzantine iconographic traditions. In the present chapter the interest lies in the connection of their imagery with the text of the Epistles. The Carolingian Bibles use one full-page illustration as an introduction to the Epistles as a whole; the Epistles thus are treated, not as fourteen (or fifteen) books, but as a distinct sub-section within the New Testament. A precedent was therefore established in that a single pictorial scheme introduced the Epistles as a whole.[4] (A related method of illustration was used in the precocious Moutier–Grandval Bible, c.834 (Fig. 23)[5] in which the initial 'P' of Romans is given an historiated scene as an introduction to the entire fourteen books.) There is a textual precedent, of course, in Pelagius' commentary on the Epistles which was used as a preface to the entire set of letters throughout the Middle Ages.[6]

[1] Fifteen 12th- and 13th-c. Bibles with numerous Pauline Acts scenes have been discovered in the course of this study.

[2] See e.g. Haseloff, *Psalterillustration*, 100–1.

[3] The Vivian Bible, Paris, BN lat. 1, and the Bible of San Paolo fuori le mura; see above, pp. 12–16.

[4] Three 9th-c. separate editions of the Epistles also use an illustration accompanying Romans as an introduction to the entire set of Epistles: Düsseldorf, Universitätsbibl. A. 14, fol. 120; Stuttgart, Landesbibl. HB II 54, fol. 25v; Munich, Clm 14345, fol. 7. See above, Ch. 2, n. 46, and Ch. 1, n. 72.

The use of one illustration as a preface to the entire set of Epistles can also be found in Byzantine art, e.g., Oxford, Bodl. Canon. Gr. 110, fol. 176 (10th-c.); Paris, BN gr. 224, fol. 6v; Paris, BN gr. 223, fol. 6v (both 11th-c.).

[5] London, BL Add. 10546, fol. 411v. It is precocious in the sense of using an historiated initial. See above, Ch. 1, n. 92.

[6] Wrongly ascribed to Jerome in the Middle Ages (e.g. by the editor of the *Glossa Ordinaria*), it appeared in some of the most ancient Bible texts. See De Bruyne, *Préfaces*, 213–15; Stegmüller, *Initia*, 670, and below, Appendix E.

As I have demonstrated earlier, the Carolingian full-page cycles are confined to scenes having to do with events leading up to and following the conversion of Paul, as described in Acts 9:1–25: Saul Receives Letters, the Conversion, Paul Led to Damascus, the Dream of Ananias, Paul Healed by Ananias, Paul Preaching in Damascus, and Paul's Escape from Damascus.

These subjects continued to supply the core of Acts illustration in twelfth and thirteenth century Bibles, augmented by two additional items: The Stoning of Stephen (Acts 7:60) and Paul Baptized by Ananias (9:19). Although the Carolingian Bibles themselves do not have the Stoning of Stephen in their Conversion cycles, its inclusion is appropriate, since it signifies Paul's persecution of the Christians previous to his Conversion; moreover, the Carolingian Epistles in Munich had a version of this scene (Fig. 135) in addition to two Paul episodes.[7] Paul's Baptism also obviously belongs in the cycle. The delayed appearance of this theme, and its absence in the Carolingian schemes, might have to do with changing concepts of the nature of the baptismal rite.[8]

Out of all the available details of the life of Paul it is of the greatest interest that those chosen for illustration should be confined to the Conversion events. The reason for the choice is twofold. It depended partly on what was available in the way of Pauline iconography: as has been pointed out above, the concept of Paul's Conversion as a unified series of episodes—including the Stoning of Stephen—probably originated in classical times.[9] It is generally agreed as well that the conversion was the most important single moment in Paul's career.[10] There is a connection with the Epistles as well. In addition to being the most colourful events recounted in the canonical life of Paul, the Conversion episodes are included among the few autobiographical details related by him in the Epistles. In Galatians 1:13–16 Paul gives a general account of the events which are described in such vivid detail in Acts 9:1–25. His reference in Galatians recounts the story beginning with his persecution of the Christians and the actual conversion itself up to his preaching in Damascus. In Paul's words:

You have heard what manner my life was when I was still a practising Jew; how savagely I persecuted the church of God, and tried to destroy it; and how in the practice of our national religion I was outstripping many of my Jewish contemporaries in my boundless devotion to the traditions of my ancestors. But then in his good pleasure God, who had set me apart from birth and called me through his grace, chose to reveal his son to me and through me, in order that I might proclaim him among the Gentiles . . .[11]

The Carolingian cycles are actually pictorial transcriptions of the statement in Galatians—in the specific images narrated in Acts, however, rather than in the vaguer terms of Galatians. Paul's persecution of the Christians is depicted by the scene of his receipt of letters; the general theme of Christ revealed to him is conveyed specifically by the scenes of Paul's actual conversion and by his being healed, and his proclamation of Christ by the preaching episode.

[7] See n. 4.

[8] See below, pp. 88–91.

[9] See above, p. 8. Dinkler-von Schubert, 'Per Murum', 89, n. 13, also accepts the notion that the series of events outlined here, including the Stoning of Stephen, formed a clearly defined cycle with a history of its own.

[10] Rigaux, *Paul et ses lettres*, 64: 'Les moments essentials de l'existence de l'Apôtre sont sa conversion et sa mission. C'est par ces actes de Dieu que Paul acquiert sa véritable transcendance. Ils constituent des points de départ pour sa pensée et son action. Connaître leur véritable nature et leur

répercussion sur la vie et le message apostolique apparaît à tout exégète une impérieuse et inéluctable nécessité.'

[11] Gal. 1:13–16: 'Audistis enim conversationem meam aliquando in Judaismo, quoniam supra modum persequebar ecclesiam Dei, et expugnabam illam. Et proficiebam in Judaismo supra multos coaetaneos meos in genere meo, abundantius aemulator existens paternarum mearum traditionum. Cum autem placuit ei, qui me segregavit ex utero matris meae, et vocavit per gratiam suam, ut revelaret Filium suum in me, ut evangelizarem illum in gentibus, . . .'

Furthermore, the representation of Paul escaping from the walls of Damascus, as it appears in the San Paolo Bible, has a textual basis in II Corinthians 11:33: 'I was let down in a basket, through a window in the wall, and so escaped his [King Aretus'] clutches.'[12] It is interesting to note that II Corinthians places an emphasis on Paul's achieving freedom and starting his life as a missionary as a consequence of his experience in the basket. This is what is shown in the San Paolo Bible when Paul walks away from the walls of Damascus. However, the Conversion cycle actually has a greater relevance to the Epistles than a connection with a passage in one of the letters. What better statement could there be of the dominant ideas in the Epistles—the relationship with Judaism, the revelation of Christ, missionary work—than a depiction of these very experiences in the life of the author of the letters?

The Acts scenes in the two Bibles, therefore, especially those of the San Paolo Bible, form a suitable introduction to the Pauline Epistles in a general way, in that they express certain central ideas in the Epistles text; they also conform, in a particular way, to autobiographical information in the text of the Epistles.

Principal inheritors of the Carolingian iconographic schemes were the German illuminators of the tenth to the twelfth centuries. A line of continuity from Carolingian art in choice of scene and details of iconography is to be observed, for example, in the illustrations of the Admont Bible of the twelfth century (Fig. 42),[13] in which scenes from Acts form a full-page preface to the Pauline Epistles consisting of two scenes, the Conversion and Paul Led to Damascus, with many details of composition and pose echoing the Carolingian imagery. In the Gumpert Bible, made in Salzburg in 1195 (Fig. 126), the scenes in the traditional preface to the Pauline Epistles are set up in a typical early Gothic manner. There are four roundels surrounding a quatrefoil, each space devoted to a scene from Acts. Three out of the five scenes are drawn from the Conversion sequence, which indicates that the emphasis is still in this direction.[14]

Also hearkening back to Carolingian precedent is the thirteenth-century Bible from the Cistercian Abbey of Heisterbach (Fig. 127).[15] Two types of Pauline illustrations—the author portrait and full-page preface—are combined on one page. The historiated initial 'P' of Romans contains a standard thirteenth-century type of author portrait, Paul with the sword and book; on the same page, within the columns of text, are a series of framed scenes drawn from the Conversion Cycle, including a Conversion with Paul tumbling from his horse. Thus, the Bible of Heisterbach continues the Carolingian emphasis on the Conversion Cycle as a suitable counterpart to the Epistles, and, at the same time, indicates its thirteenth-century origin by the use of the attribute of the sword in the author portrait and by the equestrian Conversion.

The Bible of Heisterbach is exceptional, because the sole use of the Conversion Cycle to illustrate the Epistles did not long survive the widening of Pauline iconography accompanied by the practice of historiating many or most of the initial letters which characterizes the later twelfth century. However, there is another example of a thirteenth-century Bible in which the Pauline

[12] II Cor. 11:33: 'Et per fenestram in sporta dimissus sum per murum, et sic effugi manus ejus.'

[13] Vienna, Nationalbibl. Cod. Ser. Nov. 2702, fol. 199ᵛ. See above, Ch. 1, n. 230.

[14] Erlangen, Univ. Bibl. MS 1, The Gumpert Bible, fol. 387ᵛ: see G. Swarzenski, *Salzburger Malerei*, I, 129–42. From the Conversion sequence: Saul Receives Letters, the Conversion, the Baptism; later episodes are the Blinding of Elymus (13:8–11) and the Miracle of the Lame Man

(14:7–10).

[15] Berlin, Staatsbibl. Theol. lat. fol. 379, 'The Bible of Heisterbach', fol. 467: see H. Swarzenski, *Die lateinischen illuminierten Handschriften des XIII. Jahrhunderts in den Ländern an Rhein, Main und Donau* (Berlin, 1936), 17–18, 91ff. pl. 15(61). The Acts scenes are: Saul Receives Letters, the Conversion, Paul Baptized by Ananias, Paul Preaching in Damascus (all in the full-page preface), and, accompanying the text of Eph. (fol. 481ᵛ), Paul's Escape from Damascus.

iconography is confined to the Conversion episodes, in this case distributed within the text as historiated initials. It is a French manuscript in the Morgan Library in New York (MS M. 163), made in 1229 in the north of France, possibly at Corbie. The initials of the Epistles are illustrated as follows:

Rom.	fol. 366[v]	Stoning of Stephen (Fig. 128)
I Cor.	fol. 371	Saul Receives Letters from the High Priest (Fig. 129)
II Cor.	fol. 375	Conversion of Paul, from a horse (Fig. 130)
Gal.	fol. 378	Paul Led Blind to Damascus (Fig. 131)
Eph.	fol. 379[v]	Healing of Paul by Ananias (Fig. 132)
Phil.	fol. 381	Ananias Baptizes Paul, in a font (Fig. 133)
Col.	fol. 382[v]	Paul seated with a scroll

All of the other initials are ornamental. The illuminator's source was probably a Conversion Cycle with only six scenes, together with the standard author portrait of Paul. When he had run out of scenes from his model he resorted to using ornamental initials for the remaining seven Epistles.

Systems of Combining Acts and the Epistles

Despite the lingering of past traditions which can be observed in such manuscripts as the Bible of Heisterbach and Morgan 163, a major innovation of the twelfth and thirteenth centuries is the extension of Pauline imagery to include events from the life of Paul drawn from wider sources than the Conversion Cycle.[16]

Evidence of Acts in twelfth-century Bibles is somewhat scanty. There are in the Toronto *Corpus* only two Bibles with historiated initials for the Epistles devoted solely to Acts subjects: Troyes, Bibl. Mun. MS 458, vol. II[17] (*c*.1140); Troyes, Bibl. Mun. MS 2391[18] (*c*.1140–50); and a late twelfth-century Bible includes scenes from Acts among those drawn from other types of imagery: Oxford, Bodl. Laud Misc. 752[19] (1175–1200).

In the thirteenth century, Bibles with elaborate Acts cycles became more common. The members of this group have obvious iconographic similarities, so that it is practical to consider them together, but there is little evidence of direct affiliation, except in the case of two of these manuscripts which will be discussed separately under the title, 'The Apostolic Cycle'.[20]

The following English and French thirteenth-century Bibles employ scenes from Acts in all or most of the historiated initials of the Pauline Epistles: Avranches, Bibl. Mun. 2–3 (*c*.1210),

[16] See Appendix B for the frequency of Acts subjects in the Bibles in the Toronto *Corpus*.

[17] The so-called 'Bible of St. Bernard' in 2 vols. from Clairvaux: on vol. I, fol. 1, is written 'pars prima biblie beati Bernardi abbatis clarevallis' in a 15th-c. hand. Only 3 Acts subjects are represented: Rom., fol. 196, Conversion; I Cor., fol. 201[v], Paul Led to Damascus; Eph., fol. 211[v], Miracle of the Viper. Phil., fol. 213, is illustrated with a single figure with a snake; the rest are ornamental.

[18] From the collegiate of S. Étienne at Troyes. A list of

subjects is given below, p. 79.

[19] Rom., fol. 391[v], Paul arguing; II Cor., fol. 399, Conversion; Gal., fol. 402, two saints; Eph., fol. 403[v], the Miracle of Eutychus; Col., fol. 405[v], Paul sends a book from prison; I Thess., fol. 406[v], Paul gives a scroll to 2 youths; I Tim., fol. 408, Paul and a bishop; Tit., fol. 410, Paul and a priest; the rest are ornamental.

[20] The 'Apostolic Cycle': London, BL Add. 27694; Paris, BN lat. 13142.

Boulogne, Bibl. Mun. 4 (*c.*1260), London, BL Add. 27694 (*c.*1260); New York, Morgan M. 163 (dated 1229), Oxford, Bodl. Auct. D.4.8 (*c.*1250), Paris, BN lat. 13142 (*c.*1260–70), Paris, Mazarine 15 (*c.*1260?), Rome, Vat. Urb. lat. 7 (*c.*1250).[21]

There are also fifteen additional manuscripts in which isolated episodes from Acts appear in the midst of other subjects.[22] With few exceptions, the scene chosen for illumination in these Bibles is the Conversion, always with Paul mounted on a horse.

Finally, I have found three more examples of full cycles appearing in historiated initials in separate commentaries on the Epistles, namely: New York, Morgan M. 939 (dated 1189),[23] Cambridge, Trin. Coll. B.4.1 (post-1250), Paris, BN lat. 670 (*c.*1250). These Epistle commentaries with scenes from Acts are different from the Bibles in that they are less clearly related to the Carolingian Acts tradition in manuscripts; they also contain a higher proportion of unidentifiable scenes, or of those stemming from other sources. This is particularly true of the one twelfth-century example in the Morgan Library which also happens to be Spanish.[24]

At this time the iconography of the Acts cycle was enriched with new scenes from the life of Paul. Since the Conversion episodes can be stretched to a maximum of about nine scenes, and there are fourteen Epistles (occasionally fifteen, with Laodicians), a minimum of five new episodes had to be found if each was to be illuminated, a point I shall consider in detail below. The question then arises as to the principle governing choice and distribution of scenes. The reason for the choice of a particular subject from Acts to accompany a given Epistle is most difficult to determine. In some cases they appear to be distributed almost at random; only occasionally is there an obvious indication that the artist has looked at the text of the Epistle for the message contained therein. In any case, the literal meanings of the scene and of the Epistle often seem to have little in common. (Notable exceptions to this statement are the two manuscripts of the Apostolic Cycle.)

There does not seem to have been a general rule applied regarding the allocation of scenes. One event appears as the illustration for a number of Epistles; for example, the scene of Paul escaping over the walls of Damascus in a basket—described in Acts 9:25 and II Corinthians 11:33—which should accompany II Corinthians, actually does so in only three instances. (Two of these examples are in the exceptional Apostolic Cycle.) In addition, the scene of Paul's escape is used as the illustration for I Corinthians, Galatians, Ephesians, Philippians, Colossians, II Thessalonians (three times), and II Timothy (twice).[25] Another example of the wide distribution of a particular episode can be seen in the depiction of Paul Healed by Ananias (Acts 9:17–18 and

[21] Several Bibles stemming from other national traditions use scenes from Acts, and are used for purposes of comparison in the course of this study: (ex) Dublin, Beatty 41, mid-13th-c. (German, probably Rhenish); Abbey 7345, *c.*1260 (Bolognese).

[22] MSS with isolated scenes from Acts: Amiens 23, 1200–15; Arras 3/1, *c.*1270–80; Boulogne 5, 1220–5; Cambridge, Trin. 0.5.1, 1210–40; Florence, Laur. Plut. XV.11, early 13th-c.; Lille 835–8, 1264; London, BL Add. 15253, *c.*1230; Oxford, Bodl. Lat. bib. e.7, *c.*1240?; Oxford, Bodl. Laud Misc. 752, late 12th-c.; Reims 34–6, first quarter 13th-c.; Rouen 11 (A. 69), *c.*1230; New York, Morgan Glazier 42, 1245–50; New York, Morgan M. 109–11, *c.*1260–70; Paris, BN lat. 11930–1, 1230–5; Oxford, Bodl. Auct. D.4.10, 1230–40; Douai 17, 1250–60.

[23] Spanish: a colophon gives the name of the donor,

Abbot Guterius, and the date of execution.

[24] The present study concentrates primarily on the illustrations in Bibles, referring to subjects which occur in the Epistle commentaries only when there is a parallel appearance in illuminated Epistle initials in Bibles. The occurrence of Acts iconography in Epistle commentaries, and a comparison of that use with the same subject-matter in Bibles, awaits a fuller consideration than is possible within the scope of this study.

[25] I Cor.: New York, Morgan M. 939, fol. 70. Gal.: Paris, BN lat. 670, fol. 140. Eph.: Abbey 7345, fol. 437^v. Phil.: Cambridge, Trin. B.4.1, fol. 186^v. Col.: Oxford, Bodl. Auct. D.4.8, fol. 657. II Thess.: Avranches 3, fol. 291^v; Paris, Mazarine 15, fol. 434; Troyes 2391, fol. 224^v. II Tim.: New York, Morgan Glazier 42, fol. 353; Rome, Vat. Urb. lat. 7, fol. 395^v.

22:12–13) which is used to illustrate Colossians twice, and once each with II Corinthians, Galatians, Ephesians, Philippians, and I Thessalonians.[26]

Such scattered distribution indicates that autobiographical data in the letter *per se* played little or no part in the choice of scenes to accompany each Epistle. However, the indirect autobiographical information supplied by the Marcionite prologues which determined that certain of the letters be understood as 'Prison' or 'Pastoral' Epistles does seem to have had a certain influence, even on the Acts cycle.

No doubt there was in some—or most—cases an intention to express an allegorical meaning in the combination of scene and Epistle, but this intention is most difficult to ascertain in instances where one scene accompanies a number of different Epistles. The allegorical interpretation probably could be revealed in a more intensive approach to individual motifs than is possible within the scope of the present study.

The problem of identifying individual scenes is great, particularly where there is no known model, and difficulty is compounded by the fact that, in the thirteenth century especially, many of the surviving books are of a low quality, in both style and iconographic exactitude; often the artist did not understand or could not convey the subject with which he was dealing.

Up to a certain point, an identification can be made by the order in which the scenes occur as it compares with the narrative sequence of the text of Acts. The Conversion Cycle is often rendered in sequential order, as in the example given above of the Bible in the Morgan Library. A typical specimen of sequential order going beyond the Conversion Cycle can be seen in Oxford, Bodl. Auct. D.4.8, an English manuscript made *c.*1250. The text order is maintained in this Bible up to the Pastoral Epistles. At this point another system takes over:

Rom.	fol. 634	Saul Receives Letters from the High Priest (Acts 9:2)
I Cor.	fol. 640ᵛ	Conversion of Paul, from a horse (9:3–4)
II Cor.	fol. 646ᵛ	Paul Led Blind to Damascus (9:8), (Fig. 150)
Gal.	fol. 651	Paul Fed by Ananias (9:17–18), (Fig. 155)
Eph.	fol. 653	Baptism of Paul (9:19)
Phil.	fol. 655ᵛ	Paul Preaching in Damascus (9:20–2)
Col.	fol. 657	Paul's Escape from Damascus (9:25), (Fig. 171)
I Thess.	fol. 658ᵛ	Paul Beaten at Philippi (16:22) or at Jerusalem (21:30, 22:25), (Fig. 185)
II Thess.	fol. 660	Miracle of the Viper (28:1–5)

The sequential system seems to break down when the Pastoral Epistles are illustrated:

| I Tim. | fol. 661 | Paul blesses a bishop |
| II Tim. | fol. 662ᵛ | Paul and a bishop |

[26] II Cor.: Troyes 2391, fol. 214ᵛ. Gal.: Oxford, Bodl. Auct. D.4.8, fol. 651. Eph.: New York, Morgan M. 163, fol. 379ᵛ. Phil.: Avranches 3, fol. 287ᵛ. Col.: Paris, Mazarine 15, fol. 432; Rome, Vat. Urb. lat. 7, fol. 392. I Thess.: Boulogne 4, fol. 201.

Tit.	fol. 664	Paul dictates to a man writing on a scroll
Phil.	fol. 664ᵛ	Paul addresses two men in hats like rounded mitres (possibly a scene of judgement)
Heb.	fol. 665	Execution of Paul (Apocryphal), (Fig. 208)

The illustrations for I and II Timothy derive from the concept of 'Pastoral Epistles', and Titus is illustrated by a scene of the common 'scribe' type. Philemon is more difficult to identify; it may be a reference to one of the episodes in which Paul was judged prior to imprisonment (that is, at Philippi, Jerusalem, Caesarea, or even Rome). If it is indeed related to the theme of imprisonment it is possible that here Philemon is regarded in its role of 'prison letter', as it is in the next manuscript I shall discuss.[27] Finally, a subject drawn from the Apocrypha, which might be considered part of a 'sequential' system since it fits into the chronology of Paul's life, terminates the series.

Frequent use of scenes of suffering and death with the 'Imprisonment Epistles' indicates that there is a consciousness of certain letters as embodiments of the prison theme, and that this interpretation has influenced the distribution of Acts imagery. A good example of this process can be seen in one of the twelfth-century Bibles in Troyes (MS 2391: the Imprisonment Epistles are starred):

Rom.	fol. 204	Conversion of Paul (Fig. 142)
I Cor.	fol. 209ᵛ	Paul Led Blind to Damascus (Fig. 148)
II Cor.	fol. 214ᵛ	Paul Healed by Ananias (Fig. 152)
Gal.	fol. 217ᵛ	Paul Baptized by Ananias (Fig. 158)
*Eph.	fol. 219ᵛ	Paul Judged by two men, one holding a sword (Fig. 187)
*Phil.	fol. 221ᵛ	Ornamental
*Col.	fol. 222ᵛ	Paul Beaten by two men (Fig. 190)
I Thess.	fol. 223ᵛ	Miracle of the Viper (Fig. 200)
II Thess.	fol. 224ᵛ	Paul's Escape from Damascus (Fig. 165)
I Tim.	fol. 225ᵛ	Paul Stoned by two men (Fig. 177)
II Tim.	fol. 226ᵛ	Ornamental
Tit.	fol. 227ᵛ	Ornamental
*Philem.	fol. 228ᵛ	Execution of Paul (Fig. 207)
Heb.	fol. 229	Ornamental

Ephesians and Philippians are specified to be Imprisonment Epistles in both their own texts and in the Marcionite prologues. Colossians can be called a Prison Letter because of evidence in its text. Philippians is an 'optional' Prison Letter because of a variant tradition in the Marcionite

[27] See above, Ch. 2 *The Imprisonment Theme*.

prologue;[28] therefore it is common practice to ignore its implications of captivity, as here in Troyes 2391. The designers of the Troyes iconography are following both the 'Marcionite' and the 'text' system in showing that certain of the Epistles can be comprehended through the knowledge that they were written from prison.[29]

In Troyes 2391 the imprisonment theme intruded into the sequential system, which was followed as far as Galatians (the Baptism of Paul). At this point in the sequence, Paul's Escape from Damascus should have been used, but its place was usurped because of other considerations, and it finally appears as an illustration to II Thessalonians, out of sequential order.

Scrambled order also can aggravate difficulties of interpretation. The most extreme example of disorder can be seen in a Bible now in Avranches (MSS 2 and 3), made *c*.1210.[30] This important manuscript, luckily, is of a high order of iconographic exactitude, so that the meaning of the individual scenes is conveyed clearly, in one case aided by an inscription. The Avranches Bible also includes as illustrations of certain Pauline Epistles the earliest and most complete set of scenes from the apocryphal Plautilla legend.[31]

The Pauline episodes in Avranches 3 are out of order, except for the first two scenes (the Conversion and Paul led Blind to Damascus) and the last (Plautilla Exhibits the Veil to Soldiers after Paul's execution), but there are several consecutive sets within the entire group. The representation of Paul Healed by Ananias (Philippians), for example, is followed by the Baptism of Paul (Colossians); similarly, the scene in II Thessalonians is in sequential order with I and II Timothy, and Galatians is followed by Ephesians. In the following table, the order of the scenes as they appear in the Avranches Bible is designated by Roman numerals, and the order of the sequence of events in the texts of Acts and the Apocrypha by Arabic numerals:

I	Rom.	fol. 269	Conversion of Paul (Fig. 143)	(1)
II	I Cor.	fol. 274[v]	Paul Led Blind to Damascus (Fig. 149)	(2)
III	II Cor.	fol. 280	Paul Before a King (probably Nero), (Fig. 202)	(9)
IV	Gal.	fol. 284	Paul Receives the Veil from Plautilla (Fig. 204)	(10)
V	Eph.	fol. 286	Execution of Paul (Fig. 205)	(11)
VI	Phil.	fol. 287[v]	Paul Healed by Ananias (Fig. 153)	(3)
VII	Col.	fol. 289	Baptism of Paul (Fig. 159)	(4)
VIII	I Thess.	fol. 290[v]	Miracle of the Viper (Fig. 197)	(8)
IX	II Thess.	fol. 291[v]	Paul's Escape From Damascus (Fig. 163)	(5)
X	I Tim.	fol. 292[v]	Miracle of the Lame Man (Fig. 175)	(6)
XI	II Tim.	fol. 294	Miracle of the Evil Spirit (Fig. 179)	(7)
XII	Tit.	fol. 295	Paul Returns the Veil to Plautilla (Fig. 209)	(12)

[28] De Bruyne, *Préfaces*, 236, n. 32.

[29] Strictly speaking, II Tim. should also be considered as an Imprisonment Epistle, according to the 'text' evidence.

[30] See Branner, *Manuscript Painting*, 201.

[31] Lipsius-Bonnet, *Acta Apostolorum*, I, 23–44: see above, Ch. 1, n. 106.

| XIII | Philem. | fol. 295ᵛ | Paul Before a King (probably Nero), (Fig. 210) | (13) |
| XIV | Heb. | fol. 296 | Plautilla Shows the Veil to Soldiers (Fig. 211) | (14) |

Presence of apocryphal scenes (subjects most frequently to be found in windows), together with the scrambled order, leads to the suspicion that the artist of this Bible might have been copying from a window or other monumental source. In Chapter One we have seen two examples of windows in which the canonical Acts cycle has been mixed with the apocryphal legend of Plautilla (Figs. 36, 37)[32] and noted the tendency of monumental ensembles to combine the canonical with the apocryphal. In addition, one of the canonical scenes in Avranches 3—Paul's Blindness Healed by Ananias—is depicted in a form which departs from precedent as far as Bible illumination is concerned, but which can also be found in window painting.[33]

At one time I thought that the confusion of scenes in this Bible resulted from the arbitrary copying of a window in the order of the arrangement of subjects in vertical rows rather than in the text order. The discovery, however, that three of the scenes might be interpreted typologically in relation to the Epistles they illustrate raises the possibility that this method was applied to the whole cycle. These scenes are Paul's Execution illustrating Ephesians, Paul Before a King with Philemon (both prison letters), and the Miracle of the Viper accompanying I Thessalonians, perhaps a reference to the Resurrection, a major theme in the letter. A separate study of Avranches 2–3 and two other manuscripts associated with it might reveal all or most of the scenes to have such typological connotations.

The two manuscripts in question are Paris, Mazarine 15 and Rome, Vat. Urb. lat. 7, both dating from *c.*1250–60. (These are the only other Bibles to include the Plautilla episodes in the events surrounding the Execution.) Although their sequences of scenes are by no means as jumbled as that of the Avranches manuscript, they coincide with it on a number of points. Mazarine 15 has a higher degree of concordance with Avranches 3 and therefore conforms less to the sequential principle than does Vat. Urb. lat. 7, the latter having only two departures from the order of the text. The following table summarizes the scenes in the two manuscripts (see p. 80 for a comparable table of subjects in Avranches 3):

Rome, Vat. Urb. lat. 7			Paris, Mazarine 15	
Rom.	fol. 377ᵛ	Saul Receives Letters	fol. 417ᵛ	Stoning of Stephen
I Cor.	fol. 382	Stoning of Stephen	fol. 421ᵛ	Saul Receives Letters
II Cor.	fol. 386	Conversion	fol. 425ᵛ	Conversion
Gal.	fol. 388ᵛ	Conversion (2nd episode)	fol. 428ᵛ	Paul Led to Damascus
Eph.	fol. 390	Paul Led to Damascus	fol. 429ᵛ	Paul Beaten
Phil.	fol. 391	Paul Fed by Ananias	fol. 431	Paul Led to a King

[32] Chartres, apse window; and Rouen, window of sacristy; see above, pp. 24–6.

[33] See below, *Paul Healed by Ananias*, pp. 89–90.

Col.	fol. 392	Paul Healed by Ananias	fol. 432	Paul Healed by an Angel
I Thess.	fol. 393	Paul Baptized by Ananias	fol. 433	Paul Preaching in Damascus
II Thess.	fol. 394	Paul Preaching in Damascus	fol. 434	Paul's Escape from Damascus
I Tim.	fol. 394v	Paul Led to a King	fol. 434v	Unidentified scene
II Tim.	fol. 395v	Paul's Escape from Damascus	fol. 435v	Paul Fed by Ananias
Tit.	fol. 396v	Paul Addressing two Jews (in Rome?)	fol. 436	Unidentified scene
Philem.	fol. 396v	Execution of Paul	fol. 436v	Execution of Paul
Heb.	fol. 397	Paul Returns Veil to Plautilla	fol. 437	Paul Returns Veil to Plautilla

Mazarine 15, a manuscript of inferior quality, exhibits certain anomalies which might derive from the use of a not completely understood model related to Avranches 3: for example, Ephesians is illustrated in Mazarine 15 with a scene of Paul beaten from behind (Fig. 189)—quite different from the usual beatings in the Epistles—which probably derives from a misunderstanding of a depiction of the Execution of Paul, used in Avranches 3 as an illustration for Ephesians (Fig. 205), but incomprehensible to the Mazarine artist in a place so early in the chronology.[34] Mazarine 15 also follows Avranches 3 in illustrating II Thessalonians with the scene of Paul's Escape from Damascus.

In addition to using differing methods of allocating subjects—whether by typology or place in the sequence—Avranches 3 and Vat. Urb. lat. 7 deal differently with the problem of finding enough scenes to fill fourteen spaces. In the former, five episodes from the Conversion Cycle are augmented by three representations of later passages in Acts, together with five apocryphal scenes. The artist of the latter manuscript uses only two (perhaps three) apocryphal episodes, and no later Acts scenes, but he stretches out the Conversion Cycle by adding 'fillers', as when he depicts Ananias in three separate episodes feeding, healing and baptizing Paul in Damascus. These systems of choice and allocation of subject-matter show some of the range of possibilities we shall be encountering in this chapter.

The sequential system, whereby subjects were combined with texts simply because they occur in a certain order, is an unusual but by no means unheard of method of illustration.[35] Like the Epistolary Cycle, it seems to be an attempt to reconstruct the historical circumstances surrounding the writing of the letters. It might even imply that the iconographers had a notion that the order in which the letters were always arranged was the result of a chronological

[34] See Branner, *Manuscript Painting*, 20, for an explanation of the workshop procedure followed in this MS, the illustrations of which have been elaborated from rough sketches in the margins.

[35] The method of illuminating a series of initials with a continuous narrative not necessarily related to the text is not unknown in medieval art. See, for example, the late 12th-c. commentary on the Psalms in the Morgan Library in New York (MS 336), in which the scene in the initial of each of the Psalms is taken from Genesis, running in sequence from the Creation to the Sacrifice of Isaac.

principle, and that they followed each other in time just as the events of Paul's life had a temporal logic.

Sequential arrangement is one aid to interpreting the meaning of the scenes in the Acts cycle. Identification also can be established by comparison with other monuments and manuscripts in which similar subject matter is securely identified, as well as by careful examination of the texts of Acts, the Epistles, and the Apocrypha. These aids prove helpful; surprisingly few scenes refuse to yield themselves to interpretation, except in the very worst manuscripts, full of obvious mistakes. In the following discussion, a distinction is made between the scenes drawn from the Conversion Cycle, in which a line of continuity from Carolingian sources can be traced, and those subjects which appear for the first time in Bible illumination in the twelfth and thirteenth centuries. These two categories will be examined in separate sections. A final section deals with the Apostolic Cycle, in which a special relationship between text and image determines the choice and iconography of the scenes.

II. THE CONVERSION CYCLE: VARIATIONS ON TRADITIONAL THEMES

The Conversion sequence continues to dominate the illustration of the Epistles, despite the introduction of other themes. As imagery, the Conversion scenes change remarkably little. However, they are subject to influences which reflect the twin poles of thirteenth-century artistic and intellectual life, naturalism and abstraction. In the manuscripts which show evidence of the former influence, the scenes are replete with convincing detail of setting, dress, and action, all of which emphasize the narrative, anecdotal content; they are recognizable moments in a human life. The editions which are subject to the latter influence, however, tend to eliminate extraneous detail, partly as a symptom of the tendency towards simplification, but also perhaps in an effort to create 'types' with an allegorical rather than a literal meaning.

There are other pressures in the twelfth and thirteenth centuries which affect traditional Acts iconography, such as the fact that cycles are broken up and distributed as initial letters within the text. This means that, in the case of the Pauline Acts scenes, they are not only completely divorced from their narrative source, Acts, as they were in the Carolingian Bibles, but each scene is also separated from its pictorial narrative context. As a result, certain episodes are eliminated, that is, those in which the basic connection of author–text cannot be made (for example, the Dream of Ananias, a scene in which Paul is not present). In a few instances, where the Acts narrative has a parallel text in the letter which is illustrated and the image can be related to a passage in the letter, the slightly different emphasis in the letter might influence the imagery of the picture. This happens very rarely.

The Stoning of Stephen[36]

French and English Bibles of the thirteenth century have representations of this scene, which, though abbreviated, are clearly derivative of a narrative Byzantine type. (No twelfth-century

[36] 13th-c. Bibles: Boulogne 4, fol. 199 (Phil.); Cambridge, Trin. 0.5.1, fol. 331 (Eph.); New York, Morgan 163, fol. 366ᵛ (Rom.); Paris, Mazarine 15, fol. 417ᵛ (Rom.); Rome, Vat. Urb. lat. 7, fol. 382 (I Cor.). Also in (ex) Dublin, Beatty 41, vol. II, fol. 236 (Gal.); Cambridge, Trin. B.4.1, fol. 218ᵛ (I Tim.); Chicago, Rockefeller-McCormick, fol. 114; Dečani; Mount Sinai 1186, fols. 127 and 128; Rome, Vat. gr. 699, fol. 82ᵛ; San Paolo frescoes. (See Eleen, 'Acts Illustration', Appendix, for details of this and other Acts subjects in Italian monuments.)

examples have come to light, but no doubt this lack is due to accidents of survival and discovery.)

Enough examples of a standard narrative iconography of the Stoning of Stephen exist in post-Iconoclastic Byzantine art that it is possible to be quite certain of its characteristics.[37] The tenth-century Menologion of Basil II (Fig. 134) is a representative example.[38] It shows Stephen at the right kneeling in prayer in a mountainous landscape, blessed by the hand of God, while Saul seated at the left directs a group of men who hurl stones at the martyr. (There are also alternative symbolic types to be found in Byzantium[39] but they do not concern us here.)

The narrative type possibly was similar to representations known in the West at an early date, as we recognize from Augustine's description;[40] but I have not discovered any examples having all of the details of the typical Eastern version before the twelfth century, at which time the Byzantine iconography became known to the West, probably via Italy (Fig. 136).[41] Although the pre-twelfth-century Western iconography of the Stoning of Stephen is by no means standardized, we can exemplify its disparity from the Byzantine with the scene in the Carolingian Epistles in Munich (Fig. 135), in which Saul is standing rather than seated and Stephen is not praying, is facing rather than turning away from his tormentors and is grasped by one of them.

After its importation to Western Europe, the Byzantine imagery gradually lost many of its circumstantial details yet remained recognizable. The depictions in the Italian manuscripts, for example (Fig. 136), retain all of the elements of the Byzantine figure composition, but flatten the design by elimination of the landscape. In squeezing these images into the loops of the historiated initials, the medieval artists have made additional reductions. In Morgan 163, for example (Fig. 128), Saul, Stephen, and two of his tormentors are confined by the contours of the circular space so that they appear to be touching. Some of the dramatic impact, therefore, is lost, a process carried further when the number of stoners is reduced to one, as in Mazarine 15 (Fig. 137).

A different approach is taken by the artists of three other manuscripts who reorganize the composition, making it suit the oval shape of the frame (Fig. 138). Saul disappears, and the figure of Stephen is centralized, surrounded by his tormentors. Anecdotal detail in costume has replaced the epic narrative of the Byzantine version, but the original inspiration of this type is still evident.

Saul Receives Letters from the High Priest[42]

Thirteenth-century examples of this scene reveal their dependence on a Carolingian model like that of the San Paolo Bible (Fig. 7), in which the High Priest, seated at the left with his court, reaches across to hand a letter to Paul approaching from the right. In the finely detailed mid-thirteenth-century Bible in the Vatican (Fig. 139), Saul and the High Priest are in a similar relation to each other as in the earlier examples but Saul is upright. As is common in the translation of rectangular scenes into small initials, the supernumeraries have disappeared; only Saul and the High Priest remain. Reflecting its manufacture in the thirteenth century, the Vatican manuscript also includes descriptive details. The High Priest wears a Jewish hat in addition to the

[37] See Kessler, 'Paris Gr. 102', 214–15, Figs. 1, 11, 13–14; and Eleen, 'Acts Illustration', 271–2, Fig. 52.

[38] See above, Ch. 1, n. 165.

[39] See e.g. the representations in the Rockefeller-McCormick New Testament, and the Vatican Cosmos (above, Ch. 1, nn. 151, 155).

[40] See above, Ch. 1, n. 35.

[41] See above, p. 29, Eleen, 'Acts Illustration', Figs. 47–51.

[42] 13th-c. Bibles: New York, Morgan 163, fol. 371 (I Cor.); Oxford, Bodl. Auct. D.4.8, fol. 634 (Rom.); Paris, Mazarine 15, fol. 421[v]; Rome, Vat. Urb. lat. 7, fol. 377[v] (Rom.). Also in Dečani; Mount Sinai 1186, fol. 128[v]; Italo-Byzantine cycle; San Paolo frescoes; Monreale mosaics.

patriarchal beard of the earlier versions; as signs of his high position he carries a staff terminating in a fleur-de-lis and crosses his legs in a typical medieval gesture of authority. Paul wears a *garde-corps*,[43] a garment suitable for a traveller in the thirteenth century. The letter is no longer in the form of a roll, as in the earlier manuscripts, but is a regular, folded missive with a clearly identifiable pendant seal. The version in Mazarine 15 (Fig. 140), a corrupt relative of the Vatican manuscript, gives evidence of the watering-down of precision and narrative exactitude in the hands of an inept copyist; here, the High Priest's Jewish hat has given way to an ambiguous crown-like headgear, and he is beardless. What is being exchanged by the two men cannot be ascertained. Thus the scene recedes into limbo, doubly divorced from the text which inspired it.

The Conversion of Paul[44]

As described in Chapter One, the twelfth century followed the Carolingian iconography of the Conversion of Paul, within the restrictions imposed by the confined space of the historiated initial and subject to the tendency of Romanesque art to exaggerate and distort. Two variations on the theme of Paul's reaction, traceable to Carolingian sources, can be seen in the twelfth-century Bibles in Troyes. In Troyes 458 (Fig. 141) he is depicted upright, about to collapse in response to the message sent by the hand of God, and in Troyes 2391 (Fig. 142), having fallen, he is shown at the next moment lying supine on the ground, his two companions registering amazement. If the two Troyes manuscripts both derive from a longer cycle of Pauline scenes, it is logical to assume that in the model the Conversion appeared as two moments in a continuous narrative, in the manner of the Vivian Bible (Fig. 6). Each of the twelfth-century artists has used a single moment in time for his one scene of Paul's Conversion, but the basic elements of the iconography are similar.

The version in the early thirteenth-century Bible in Avranches (Fig. 143) resembles this twelfth-century type. With some differences of gesture and dress, the scene is basically that of Troyes 2391 (Fig. 142), and both are within the traditions of the Carolingian Bibles—particularly the San Paolo Bible—in interpreting the experience as a personal one, and in their general tone and setting.

Avranches 3 is already somewhat old-fashioned in depicting Paul as a pedestrian. By this time the equestrian Conversion, as described in Chapter One, was firmly established. Although isolated examples of the scene of Paul converted while on foot continue to be found in the thirteenth century, the year 1200 can be put forward as the effective dividing line between the two conceptions. Many artists used the equestrian Conversion as a pretext for a vigorous, flamboyant design of stumbling horse, falling rider, and flying cloak, often combined with minute detail in the study of harness, dress, and facial expression (Figs. 145, 146).

Nevertheless, even in the midst of this innovative iconography, older habits also persist. Vat. Urb. lat. 7, for example, which I have cited in Chapter One to exemplify the typical thirteenth-

[43] M. Davenport, *The Book of Costume* (New York, 1948), 151, Figs. 477, 491.

[44] Conversion as a pedestrian: 12th-c.: New York, Morgan 939, fol. 2ᵛ (Rom.); Oxford, Bodl. Laud Misc. 752, fol. 399ᵛ (II Cor.); Troyes 458, vol. II, fol. 196 (Rom.); Troyes 2391, fol. 204 (Rom.). 13th-c.: Avranches 3, fol. 269 (Rom.). Also in Dečani; Vercelli Roll; San Paolo frescoes; Palermo; Monreale; Abbey Bible.
Conversion as an equestrian: 12th-c.: Erlangen MS 1, fol. 387ᵛ (Gumpert Bible); Vienna, Nationalbibl. Cod. Ser.

Nov. 2702, fol. 199ᵛ (Admont Bible). 13th-c.: Boulogne 4, fol. 200 (Col.); London, BL Add. 27694, fol. 407 (Rom.); New York, Morgan 163, fol. 375 (II Cor.); Oxford, Bodl. Auct. D.4.8, fol. 640ᵛ (I Cor.); Paris, BN lat. 13142, fol. 601ᵛ (Rom.); Paris, Mazarine 15, fol. 425ᵛ (II Cor.); Rome, Vat. Urb. lat. 7, fol. 386 (II Cor.). Also in the Italo-Byzantine cycle. The equestrian Conversion also occurs as an illustration to Rom. in 10 other Bibles and 2 Epistle-Commentaries, and with Col. in 2 Bibles.

century equestrian Conversion, includes as well a second episode, no doubt in perpetuation of the Carolingian tradition of continuous narrative for this scene: Paul tumbles from the horse in II Corinthians (Fig. 47) and in Galatians (Fig. 144) he lies unconscious, observed sympathetically by his two companions, as in the twelfth-century versions in Troyes and Avranches. It is noteworthy that one of the companions is a deacon, a reminder of the liturgical emphasis which underlies much of the imagery in this and other thirteenth-century Bibles.

The Conversion is popular as an illustration for Romans. It is pre-eminently suited to this position. First of all, in any parallel between the events of Paul's life and his teachings, the first moment of his life as a Christian missionary appropriately accompanies the first book of his writings. Furthermore, there is also a more exact point of agreement between the message of the text and the picture: at the beginning of the text of Romans there is a reference to Paul's conversion: 'Through him [that is, Christ] I received the privilege of a commission in his name to lead to faith and obedience men in all nations.'[45] Later in the same letter, he says, 'But I have something to say to you Gentiles. I am a missionary to the Gentiles, and as such I give all honour to that ministry'.[46] The position of the reference to apostleship at the beginning of the letter ensures that it is juxtaposed to the illustration in the large initial. Thus the scene of the Conversion of Paul, the moment at which he was made an apostle by Christ—a subject taken from the iconography of Acts—finds its logical place as a visual expression of the words of the letter to the Romans.

A final reason for the aptness of the conversion theme as an illustration for Romans is that the text of Romans, addressed to a mixed congregation of Jewish and Gentile Christians in Rome, is filled with references to Paul's peculiar status as a Jewish Christian. Books 9 and 11 concentrate on this theme, as for example, 9:1–4: 'I am speaking the truth as a Christian, and my own conscience, enlightened by the Holy Spirit, assures me it is no lie: in my heart there is great grief and unceasing sorrow. For I could even pray to be outcast from Christ myself for the sake of my brothers, my natural kinsfolk. They are Israelites'.[47] The theme of Paul's double nature is symbolized subtly and precisely by the image of his conversion—the moment at which he, a Jew by birth, became a Christian by revelation. The pictorial rendering of this scene, in the linear, exaggerated, yet naturalistic style of the thirteenth century renders the moment as one of great excitement, made more so by the violent motion of the tumbling horse and rider.

It should be noted in addition that at least four times the Conversion illustrates II Corinthians. The event is possibly regarded here in a typological sense, since this letter contains the celebrated reference to Paul's mystical elevation to the third heaven (II Corinthians 12:1–5).[48] We have seen in Chapter One that a twelfth-century English artist used a narrative representation of the Conversion to symbolize Paul's mystical experience (Fig. 27),[49] evidence that such an interpretation was known in the Middle Ages. In order for the Conversion to coincide with II Corinthians, it is necessary in those manuscripts following a sequential system to include two

[45] Rom. 1:5: 'Per quem accepimus gratiam et apostolatum, ad obediendum fidei in omnibus gentibus, pro nomine ejus.'

[46] Rom. 11:13: 'Vobis enim dico gentibus: quamdiu quidem ego sum gentium apostolus, ministerium meum honorificabo.'

[47] Rom. 9:1–4: 'Veritatem dico in Christo; non mentior, testimonium mihi perhibente conscientia mea in Spiritu Sancto: quoniam tristitia mihi magna est, et continuus dolor cordi meo. Optabam enim ego ipse anathema esse a Christo pro fratribus meis, qui sunt cognati mei secundum carnem, qui sunt Israelitae . . .'

[48] See below, p. 132, n. 67 for a discussion of the scene of Paul's elevation to the third heaven and its use as an illustration for II Cor.

[49] Oxford, Bodl. Auct. D.2.6, fol. 107ᵛ; see above, Ch. 1, n. 113.

prior episodes as illustrations for Romans and I Corinthians. This requirement probably accounts for the relative popularity of the scenes of the Stoning of Stephen and Saul Receiving Letters.

Paul Led Blind to Damascus[50]

In the initial letters of the twelfth- and thirteenth-century Bibles this scene easily lends itself to misinterpretation. The relationship between Paul and his helper, often in quasi-military dress, and of both men to the structure representing the city of Damascus, can give rise to the mistaken idea that Paul is being arrested; error is doubly possible when the manuscript is of a low quality. It is only when the scene is viewed within the context of the entire Acts cycle and when the better manuscripts are brought to light that the meaning becomes clear.

As noted in Chapter One the Carolingian method of illustrating this subject was to show Paul led forward by a disciple in a short tunic who precedes the blind apostle, reaching back to grasp his hand (Figs. 6, 7, 8). In the two Carolingian Bibles the assistant actually stands within the gate of Damascus to draw Paul in; the San Paolo Bible also includes two more companions who follow behind Paul. This type also is to be found in Byzantium[51] (Fig. 9), evidence, as I have pointed out, of a common early archetype for both traditions. In Byzantine art the entire city of Damascus usually is represented in the distance, unlike the Western interpretations, in which only a portion of the city is shown in the foreground.

Most manuscripts of the twelfth and thirteenth centuries follow the Carolingian precedent in that Paul is represented being led forward, clasping hands with a companion who precedes him, as in the two twelfth-century Bibles in Troyes (Figs. 147, 148). As is so often true of illustrations for the Conversion Cycle in Avranches 3, the scene of Paul Led Blind to Damascus (Fig. 149) in this manuscript is remarkably close to the Carolingian type: the assistant is shown within the gates of the city, reaching back to lead Paul in by the hand, and Paul is followed by two other companions (as in the San Paolo Bible) clad in military dress (as in the Vivian Bible). The mid thirteenth-century Bible in Oxford also has a scene of this type, much reduced (Fig. 150). The evidence of the Bibles in Troyes, Avranches, and Oxford therefore suggests continuity of the Carolingian iconography, relatively unchanged in the process of adaptation to the initial letter.

Related to the Avranches manuscript in many ways, the mid thirteenth-century Bible in the Vatican (Fig. 151) exemplifies the penchant of this period for elaboration of detail. The basic elements of the Carolingian design still underlie the representation in the Vatican manuscript—the blind Paul is led by the hand into the city gate by one disciple, followed by another—but here the approach is no longer narrative, but anecdotal as well. Paul is not only blind, but blindfolded, and he wears the up-to-date *garde-corps*, its characteristic features carefully delineated. His companion leads him by the hand and simultaneously caresses him tenderly.[52] Finally, the second disciple in the rear is depicted minutely as a deacon. The discursive spirit of this representation, together with the fact that it illustrates Ephesians, with which it has no apparent connection, either literal or allegorical, lends support to the notion that sequential arrangement was one of the determining factors in matching Acts scenes to the Epistles. The three earlier manuscripts

[50] 12th-c.: Troyes 458, vol. II, fol. 201ᵛ (I Cor.); Troyes 2391, fol. 209ᵛ (I Cor.). 13th-c.: Avranches 3, fol. 274ᵛ (I Cor.); New York, Morgan 163, fol. 378 (Gal.); Oxford, Bodl. Auct. D.4.8, fol. 646ᵛ (II Cor.); Paris, Mazarine 15, fol. 428ᵛ (Gal.); Rome, Vat. Urb. lat. 7, fol. 390 (Eph.). Also in Chicago, Rockefeller-McCormick, fol. 115; Mount Sinai 1186, fol. 128ᵛ; Rome, Vat. gr. 699, fol. 83ᵛ; Brussels 10752, fol. 6; Manchester, Rylands 7, fol. 133ᵛ; the Italo-Byzantine cycle; Dečani; San Paolo frescoes; Monreale; Palermo.

[51] See above, p. 28.

[52] The Italian artists adapted the San Paolo imagery in a similar way; see my Figs. 20–1

discussed above all used Paul Led to Damascus as an illustration for I Corinthians; in this case, too, there is no obvious connection with the text, so it is likely that it appears in this position simply because it is the second episode in these sequences.

Paul Healed by Ananias[53]

As noted in Chapter One, the theme of Ananias healing Paul's blindness seems to have been peculiar to Western imagery. In the Carolingian Bibles it was used instead of the scene of the Baptism of Paul by Ananias, the latter formula being characteristic of Byzantium. Although Paul's Baptism was added to the Western cycle from about the eleventh century onward,[54] it did not replace the healing scene (the Vercelli Rotulus includes both (Fig. 18)), and most Bibles which have one also include the other. If we refer to the text of Acts (9:17–19) we see that the two episodes are presented as separate events, close together in time:

So Ananias went. He entered the house, laid his hands on him and said, 'Saul my brother, the Lord Jesus, who appeared to you on your way here, has sent me to you so that you may recover your sight, and be filled with the Holy Spirit.' And immediately it seemed that the scales fell from his eyes, and he regained his sight. Thereupon he was baptized, and afterwards he took food and his strength returned.[55]

A certain ambiguity confuses interpretation of this text: the exact moment at which Paul receives the Holy Spirit cannot be ascertained. Is it at the moment of Conversion, when Ananias heals him, or when he baptizes him? According to the theology of baptism, the Holy Spirit descends at some time during the sacrament.[56] It is possible that in the Carolingian Bibles the healing by Ananias is meant to be interpreted as baptism,[57] but since there is no actual representation of the use of water, it is difficult to be sure. There is evidence that the signing of the cross on the forehead of the candidate 'often serves to denote Baptism as a whole' among the early Fathers.[58] The Carolingian scene might possibly be meant to represent the sealing with a cross, and, therefore, baptism. In the Brussels commentary on the Epistles[59] (Fig. 26), which obviously derives from Carolingian imagery, a healing scene based on a model similar to the Vivian Bible is expanded into a real baptism by the simple addition of a font; the parallel between the two supports the notion that the ninth-century iconography represents baptism. However, an examination of the scenes in both Carolingian Bibles reveals that Ananias seems to be blessing Paul's eyes, not his forehead; Paul is seated in profile, facing Ananias, both hands raised in prayer. It is possible that a double meaning was intended.

That the twelfth- and thirteenth-century Bibles used two scenes to represent these two separate moments shows that they meant the episode of Ananias blessing Paul to be understood

[53] 12th-c.: Troyes 2391, fol. 214v (II Cor.). 13th-c.: Avranches 3, fol. 287v (Phil.); Boulogne 4, fol. 201 (I Thess.); New York, Morgan 163, fol. 379v (Eph.); Oxford, Bodl. Auct. D.4.8, fol. 651 (Gal.); Paris, Mazarine 15, fol. 432 (Col.); Rome, Vat. Urb. lat. 7, fols. 391, 392 (Phil., Col.). Also in Vercelli Roll; San Paolo frescoes; Monreale.

[54] See above, Ch. 1, n. 112, for a list of monuments with both scenes.

[55] Acts 9:17–18: 'Et abiit Ananias; et introivit in domum, et imponens ei manus, dixit: Saule frater, Dominus misit me Jesus, qui apparuit tibi in via qua veniebas, ut videas, et implearis Spiritu Sancto. Et confestim ceciderunt ab oculis ejus tamquam squamae, et visum recepit; et surgens baptizatus est.'

[56] G. W. H. Lampe, *The Seal of the Spirit* (London, 1951), 50–63, 193–214; and J. D. C. Fisher, *Christian Initiation: Baptism in the Medieval West* (London, 1965), 14–15.

[57] Dinkler-von Schubert, 'Per Murum', 79, calls the scene of the healing by Ananias in the San Paolo Bible 'baptism'.

[58] J. Daniélou, *The Bible and the Liturgy* (London, 1956), 54. According to Lampe, *Seal*, 215, 'From the middle of the third century onwards this ceremony comes to be associated more and more frequently with the bestowal of the indwelling presence of the Spirit . . .' This belief was particularly strong in Carolingian times (ibid. 195–6).

[59] Brussels, Bibl. Royale 10752, fol. 6. See above, Ch. 2, *Paul as a Preacher*.

unambiguously as the healing of Paul's blindness, whatever the Carolingian attitude might have been.

As is often the case with the Conversion Cycle, the earlier High Medieval versions follow Carolingian precedent closely: in one of the twelfth-century Bibles in Troyes (Fig. 152), for example, the poses, gestures, and the relationship between the figures are similar to those of the San Paolo Bible (except that Ananias is touching but not blessing Paul). The Vercelli Rotulus (Fig. 18) and the Monreale mosaics (Fig. 19)[60] are also of this type.

In all of the thirteenth-century examples, however, another imagery seems to have intervened. Again, anecdotal elements become important: Paul is represented as a sick man reclining in bed, cured by Ananias' gesture. This version is to be found in Avranches 3, in the Bible in the Vatican, and in Mazarine 15 (Figs. 153, 156, 157).[61] The notion of Paul as not only blind but ill as well is related to yet another version of this scene which appears several times showing Paul, sick in bed, fed by his attendants. In the Bible in Oxford (Fig. 155) this scene replaces the scene of the healing by Ananias, but in the version in the Vatican (Fig. 156) it is added to the cycle, fitted in as an illustration for Philippians between Paul Led Blind to Damascus (Ephesians) and Paul Healed by Ananias (Colossians). Mazarine 15 also includes two separate scenes of healing and feeding (Colossians, II Timothy (Figs. 154, 157)). The scene of Paul being fed (out of sequence in the Vatican Bible, where it should come after the healing and the baptism) is a depiction of Acts 9:19: 'and afterwards he took food and his strength returned.'[62] He is shown in the Vatican manuscript in bed, eyes closed, drinking a liquid from a basin held by Ananias. Behind Ananias, the attendant deacon, who often appears in the illustrations of this particular manuscript, holds the elements of the Eucharist. Evidently a typological parallel is made here between the feeding of Paul and the sacrament of the Mass. The theme of heavenly salvation from starvation as a type of the sacrifice of Christ symbolized by the Eucharist is common in medieval Christian art.[63] It is evident that the illuminators of the Bible in the Vatican and of several other manuscripts[64] are interpreting the healing of the blind Paul by Ananias as a type of salvation. The use of food in the Oxford manuscript, and the more specific reference to the food of the Mass in the Vatican Bible takes the interpretation beyond the generalized one of salvation and gives it a more exact theological meaning, one suited to the interests of the mid-thirteenth century.

Because the Vatican manuscript includes themes drawn from the Apocrypha in addition to those from canonical texts, it is reasonable to suspect that the Eucharistic scene of feeding might derive from an apocryphal source which cannot be identified at this time. It is interesting to note that two of the other thirteenth-century manuscripts in which Paul is shown in bed in the healing scene (Avranches 3 and Mazarine 15) also combine apocryphal and canonical subjects. It is possible that the motif of Paul lying sick in bed derives from a popular legend retelling the canonical Conversion events, with elaborate descriptions of Paul's sickness in Damascus. It

[60] In Monreale, Ananias gestures at but does not touch Paul, no doubt a response to the problems caused by an intrusive window.

[61] The Mazarine artist has made a mistake and replaced Ananias with an angel.

[62] Acts 9:19: 'Et cum accepisset cibum, confortatus est.'

[63] e.g. in the Klosterneuburg Altarpiece, in which Melchizedek's serving of bread and wine (Gen. 14:18) and the gathering of manna (Ex. 16:14–17) are used as types of

the Last Supper. See *The Year 1200: I, Catalogue*, ed. K. Hoffmann, cat. 179, 171–5; also F. Röhrig, *Der Verduner Altar* (Vienna, 1959). Typological imagery is discussed by E. Mâle, 'La part de Suger dans le création de l'iconographie du Moyen-Age', *Revue de l'Art Ancien et Moderne*, 35 (1914), 91–102, 161–8, 253–62, 339–49.

[64] Mazarine 15; Oxford, Bodl. Auct. D.4.8. In Boulogne 4, fol. 201, Ananias extends a chalice and flask towards Paul, sick in bed.

should be noted that both the Chartres and Rouen windows (Figs. 36, 37) include scenes which might represent Paul in bed healed by Ananias. In the latter, where the patient can be more easily recognized as Paul, Ananias extends a chalice towards him, as in some of the thirteenth-century Bibles. That there is a type of healing imagery common to both Bibles and windows reinforces the hypothesis put forward above that Avranches 3 and the other Bibles with similar subject-matter have been influenced by the monumental designs.

The general conclusions that can be drawn from the evidence of the scene of Paul Healed by Ananias is that a Carolingian source was followed quite closely in the twelfth century, but that most of the thirteenth-century Bibles show an admixture of discursive detail, possibly linked to popular legend. This scene lends itself to anecdotal treatment, leading away from the simple narrative of earlier times.

The Baptism of Paul by Ananias[65]

The scene of Paul's Baptism, as noted above, appears in the Conversion Cycle in the West around the eleventh century. This subject probably was included in the San Paolo frescoes, but the present evidence for it is inconclusive. Even if the ruined scene identified as such by Waetzoldt is not the Baptism of Paul, it is likely that it would have been represented as occurring in the natural water of a spring or river in the usual mode of baptisms in the frescoes.[66] By the eleventh century, the baptism of a person other than Christ usually was depicted as taking place in a font, although most fonts were too small for adults.[67]

I have noted above the differences between the Byzantine (and Byzantine-inspired) type of the Baptism of Paul, with its cistern-like font and its single celebrant, and the Western type, which tends to have a chalice-shaped font and several celebrants, making for a centralized composition. Interest in liturgical details of dress, implements, and gesture also is a leitmotif running through Western interpretations.

Baptism as it was typically depicted in the twelfth century can be seen in one of the Troyes manuscripts (Fig. 158): Paul, nude, is immersed to the waist in a font; Ananias, tonsured and vested as a priest, officiates at the sacrament of baptism by laying his right hand on Paul's head and gesturing with his left. An assistant raises his hands in prayer. The early thirteenth-century version in Avranches (Fig. 159) reiterates the twelfth-century depiction of the sacrament of baptism, varying only in that Ananias, in ordinary dress, places both hands on Paul's shoulder.

In several Bibles of the later thirteenth century a distinction is made between baptism by immersion and by affusion. The clearest example of this distinction is in the Bible in the Vatican (Fig. 160), which basically repeats the design of the earlier iconography; Paul is still immersed in the font, but Ananias also pours water over his head from a ewer, attended by a deacon.

[65] Avranches 3, fol. 288 (Col.); London, BL Add. 27694, fol. 411v (I Cor.); New York, Morgan 163, fol. 381v (Phil.); Oxford, Bodl. Auct. D.4.8, fol. 653 (Eph.); Paris, BN lat. 13142, fol. 608v (I Cor.); Rome, Vat. Urb. lat. 7, fol. 393 (I Thess.); Troyes 2391, fol. 217v (Gal.). Also in Brussels 10752, fol. 6; Chicago, Rockefeller-McCormick, fol. 115v; Paris, BN lat. 670, fol. 63v (I Cor.); the Italo-Byzantine cycle; San Paolo frescoes; Monreale; Palermo.

[66] *Kopien*, cat. 634, Fig. 372. See L. de Bruyne, 'L'Imposition des mains dans l'art chrétien ancien', *Rivista di archeologia cristiana*, 20 (1943), 113–276, esp. 212–47, s.v., 'L'Imposition de la main: rite du Saint-Esprit', for a description and bibliography of baptism in Early Christian art. Although R. S. Bour, in 'Baptême d'après les monuments d'antiquité chrétienne', *Dictionnaire de Théologie Catholique* (hereafter, *DTC*), II, i, 3rd repr. (Paris, 1923), 233–44, points out that baptism by immersion and affusion are shown in Early Christian art, the former are by far the more numerous.

[67] Immersion in a font is probably a reflection of the medieval practice of baptizing infants by immersion; see J. Bellamy, 'Baptême dans l'église latine depuis la VIIIe siècle avant et après le concile de Trent', *DTC*, II, i, 250–96, particularly 254–5.

Baptism by immersion, by this time an outdated custom and impossible to carry out in the small fonts of the twelfth century, is employed because their intention was to picture baptism as a 'type' of sacrament, not as an historical moment. The later Bible in the Vatican, which displays an interest in the particular rather than the general, augments the symbolic scene of baptism (by immersion) with the details of baptism as it was actually practised in the thirteenth century (by affusion). A related approach can be seen in a Bible in London (Fig. 214): here Ananias holds a chrismatory, in reference to yet another procedure which was part of the rite of baptism, the annointing with chrism.[68]

It is difficult to comprehend the reasons for choosing Paul's Baptism as the illustration for Galatians, Ephesians, Philippians, Colossians, and I Thessalonians, with all of which it is paired. However, in the Apostolic Cycle the Baptism accompanies I Corinthians, a reasonable choice, since baptism is a theme dealt with in this text. In the other examples the choice of scene seems to be the result of a sequential arrangement.

Paul Preaches in Damascus[69]

Because Pauline imagery abounds in scenes of preaching, and there are few indications for differentiating the preaching in Damascus from other similar occasions, it is difficult to give firm identification to this scene. None of the twelfth- and thirteenth-century Bibles repeats the composition of the Carolingian versions (Figs. 6, 7), which is set within a building, Paul in the centre making an oratorical gesture as he addresses his audience arranged symmetrically around him.

The Bible of Heisterbach (Fig. 127), although different from the Carolingian, shows how it is possible to establish identity for this episode. The architecture has disappeared, as has the symmetrical design; Paul stands in profile on the left, talking to a group of Jews (the text of Acts 9:20 specifies that he preached in the synagogue). We know that the illustration intentionally represents Acts 9:20–1 because two scrolls are inscribed with phrases drawn from that text: 'Quoniam hic est filius Dei' and 'Nonne hic est qui expugnabat . . .'

Few Bibles include this scene in their Acts sequences, and in those that do there is nothing to tell us that it is specifically the preaching in Damascus that is represented. In the Vatican Bible, for example, we find Paul addressing the Jews with a cross (Fig. 161), the standard illustration for Romans in several of the cycles,[70] and in Mazarine 15 the depiction is of another common type of Paul lecturing to an audience seated at his feet.[71]

It is only the system of sequential arrangement that allows us to interpret these general statements as relating to a definite time in the life of the author.

Paul Escapes from the Walls of Damascus in a Basket[72]

This scene, its setting and action set forth precisely in the text, is easy to identify, and it does not

[68] See below, pp. 106–7.

[69] Oxford, Bodl. Auct. D.4.8, fol. 655ᵛ (Phil.); Paris, Mazarine 15, fol. 433 (I Thess.); Rome, Vat. Urb. lat. 7, fol. 394 (II Thess.) Also in the San Paolo frescoes; Monreale; Palermo; Berlin, Staatsbibl. theol. lat. fol. 379 (Bible of Heisterbach), fol. 467; Brussels 10752, fol. 6.

[70] See above, *Paul as Apostle to the Heathen.*

[71] See above, p. 66.

[72] Avranches 3, fol. 291ᵛ (II Thess.); Berlin, theol. lat. fol. 379, fol. 481ᵛ (Eph.); London, BL Add. 27694, fol. 415ᵛ

(II Cor.); New York, Morgan 111, fol. 170ᵛ (II Cor.); New York, Morgan Glazier 42, fol. 353 (II Tim.); Oxford, Bodl. Auct. D.4.8, fol. 657 (Col.); Paris, BN lat. 13142, fol. 615ᵛ (II Cor.); Paris, Mazarine 15, fol. 434 (II Thess.); Rome, Vat. Urb. lat. 7, fol. 395ᵛ (II Tim.); Troyes 2391, fol. 224ᵛ (II Thess.). Also in Abbey 7345, fol. 437ᵛ (Eph); New York, Morgan 939, fol. 70 (I Cor.); Manchester, Rylands 7, fol. 134; Cambridge, Trin. B.4.1, fol. 186ᵛ (Phil.); the San Paolo frescoes; Palermo; Monreale; enamel plaque in the Victoria and Albert Museum, London.

change very much during the period of its use in illustration.

Depictions of Paul's Escape fall into groups: the frontal, symmetric type introduced in Chapter One, and the side-viewed type. The first group perpetuates in the thirteenth century the iconography of the San Paolo Bible. Its characteristic features are: the symmetrical composition with Paul in a near-frontal pose inside the basket in the centre, and together with his two disciples forming an inverted triangle; the peculiar type of basket with three feet, obviously too small to contain a grown man—only Paul's head and shoulders are visible above its rim; and the elaborate three-dimensional view of an entire city, seen slightly from above, so that the entire space enclosed by the walls is visible, together with the varied architectural forms within. It is the text of Acts 9:25 that is illustrated here: 'But his converts took him one night and let him down by the wall, lowering him in a basket',[73] rather than Paul's own account in II Corinthians 11:33: 'and I was let down in a basket, through a window in the wall'.[74] There is usually no indication of a window in the scene as illustrated, but Paul is lowered from the top of a crenellated wall.

Avranches 3 (Fig. 163), repeating the Carolingian iconography (Fig. 7) in this, as in so many of the Conversion episodes, is in this group. The design of the three-footed basket, the position of Paul in the basket, and the gestures of his two aides are even closer to the Carolingian type than is the version in the earlier Pericopes of Prüm (Fig. 25), although, owing to the compressed space of the initial in the Avranches Bible, it has not been possible to present the full bird's-eye view of the fortified city; the architecture has been reduced to a few elements of wall, tower, and dome surrounding the main actors. It is an unsatisfactory solution, because the delineation of the figures in relation to a clearly defined interior and exterior space is essential for understanding the narrative. The problem of representing the assistants within a walled town together with Paul in front of the wall is partially solved in the mid thirteenth-century Epistle commentary in Cambridge (Fig. 164). Only a section of the wall is shown, but its continuity beyond the frame is implied. The disciples are made to appear within the walls by the addition of a second line of crenellations which passes behind them in another plane, creating, not an illusion, but a symbol of three-dimensional depth.

I have not discovered any examples of the side-viewed type of composition anterior to the twelfth century. The earliest twelfth-century example—in one of the Troyes Bibles (Fig. 165)—has many features in common with the Carolingian tradition, except that the disciples are turned sideways to lower Paul whose basket hangs free in space. The artist of the Troyes Bible has tried to represent an entire city, as in the earlier manuscripts of the symmetrical type, and to place one disciple behind the other, thus creating a design of great confusion. Another mid twelfth-century version in which similar elements are included can be seen in an enamel plaque in the Victoria and Albert Museum (Fig. 166):[75] but this time the action is easier to discern, since Paul is let down by one disciple and aided by two others on the ground. The Spanish Epistle commentary of 1189 (Fig. 168) additionally includes an evolved element in that most of the city has been eliminated, leaving only a wall.

In the thirteenth century the asymmetric type gradually replaced the symmetric, the complex design of city architecture giving way to the single tower, from which the disciples lower Paul, as in the Bible in the Vatican (Fig. 167). It is not difficult to understand how the process of reduction might have been at work, eliminating the difficult and confusing elements in the architectural

[73] 'Accipientes autem eum discipuli nocte, per murum dimiserunt eum, submittentes in sporta.'

[74] See above, n. 12.

[75] London, Victoria and Albert Museum, enamel plaque M. 312–1926; see Swarzenski, *Monuments*, Fig. 444.

setting, leaving only what is necessary to convey the meaning of the scene.

The increased popularity of the side-viewed composition at the expense of the frontal can probably be explained by the greater clarity of composition in the asymmetric design once the city architecture has been reduced to one tower: the wall becomes unmistakable when it is no longer obscured by the basket; the basket is seen clearly when it is outlined against empty space. The change to the initial letter from rectangular panels demanded such a solution.

What is the source of the side-viewed composition? Basing her argument mainly on examples in which this type of design prevailed, Dinkler-von Schubert has suggested a relationship between the image of Paul's escape in a basket and the Byzantine iconography of David's Flight from Saul[76] (I Samuel 11:12), a scene in which Michal, leaning out of the window of a single tower, lowers David on a rope.[77] The text of I Samuel determines several features of the imagery: namely, the action of escaping through a window and the use of a rope. In contrast, in the usual Western depictions of Paul's escape, his disciples are on top of a town or tower, there is no window, and he is in a basket. The text of II Corinthians should suggest a window, but because the scene is clearly derived from an Acts cycle, the text of Acts—omitting the window—is followed, and the basket is depicted descending from the walls. Given the textual justification for including a window, it would surely turn up earlier and more frequently in Pauline representations if a David scene were used as a model.[78] The asymmetric, side-viewed scene depicting the action as taking place outside a tower instead of a town, in which Dinkler-von Schubert sees the closest similarity to the David scene, could have been created by a natural process of evolution, the inevitable outcome of the change from larger rectangular panels to the small, circular spaces of the initial letter.

In the typical shorthand code of thirteenth-century initials, the process of reduction is added to the simplification which had already started in the twelfth century. In a side-viewed composition, the two helpers must be arranged one behind the other—a quite complex composition given the treatment of space in thirteenth-century painting. One solution, illustrating another aspect of the process of reduction, was to eliminate one of the disciples and to show Paul being lowered by only one man: unacceptable in terms of the technical action portrayed, but pictorially clear.

This explanation has shown that it was possible that the thirteenth-century depiction of Paul's escape could have developed out of the Carolingian iconography through a process of the solution of technical problems. There need not have been a special relationship of direct influence of the Byzantine scene of David's escape for artists to have invented images in which Paul escapes through a window. The illustration in the Bible of Heisterbach (Fig. 170), for example, is in a rectangular panel inserted into the columns of text, thus providing space for a more elaborate treatment; the traditional complete city view is presented, but here the single disciple leans out of a window of a house within the walls, lowering Paul in a basket. It is true that in this case there is a

[76] 'Per Murum', 86 ff.; most of the Byzantine examples of this scene are in psalters, where it appears as an illustration for Psalm 58: London BL Add. 40731, fol. 33 (The Bristol Psalter); Rome, Vat. Barb. gr. 372, fol. 97ᵛ (The Barberini Psalter); Rome, Vat. gr. 752, fol. 183. There is one Western example in the Byzantine-influenced psalter, Paris, BN lat. 8846. The scene also is used in a MS of John of Damascus, *Sacra Parallela*, Paris, BN gr. 923, fol. 107ᵛ (David is let down in a basket, rather than a rope).

[77] Ibid. Figs. 10–13.

[78] It is true that Dinkler-von Schubert does not insist on the scene of David's escape as a model for the Pauline scene, although she suggests the earlier invention of the former, basing her conclusions on the theory that the scene of David's escape is of the Old Testament, and belonged in the Septuagint; therefore it must ante-date New Testament iconography (ibid. 88).

similarity to the Byzantine scene of David's escape, particularly to the one example in which, contrary to the text of I Samuel 19:12, David is shown in a basket.[79] On the other hand, the Carolingian elements also are strong in the scene in the Bible of Heisterbach: in addition to the elaborate city architecture, there is the detailed picture of the basket with three legs, a feature of those representations with strong affinities to the Carolingian model. The same kind of basket is used in the Bible in Oxford (Fig. 171), but the scene is so reduced that only a tower with an open window shows the place where Paul has been; there are no disciples visible. It is possible that these depictions of Paul lowered from a window were inspired directly by the text of II Corinthians 11:33, but in both manuscripts, disappointingly, the scene accompanies books other than II Corinthians.[80]

Paul's Escape provides the illustration for a wide variety of Epistles,[81] the majority of these choices giving little indication of possible parallels of meaning between text and picture. In three manuscripts, however, the scene does accompany II Corinthians, bringing out an intrinsic connection between the author and his works. Nevertheless, all three examples follow the traditional form deriving from the text of Acts—the basket is lowered from a wall, not from a window—rather than that of II Corinthians 11:33.

It can be seen that the traditions of the Carolingian Bibles still persisted in the twelfth and thirteenth centuries, although several scenes were omitted from twelfth-century Bibles, namely Saul Receives Letters from the High Priest, Paul Preaches in Damascus, and the Dream of Ananias. The first two are found in the thirteenth century, and their previous omission might be an accident of survival; earlier examples could turn up in the future when more manuscripts are known. An important addition to Acts iconography at this time was the scene of Paul Baptized by Ananias, which had already appeared in the West in the eleventh century. The Bible in Avranches, remarkably close to Carolingian tradition in its depiction of the Conversion episodes, has proven to be of consequence for study of transmission of Acts iconography, an observation that will be reinforced in later sections of this chapter.

Many of the alterations of Carolingian imagery are in composition, not iconography, resulting partly from the adaptation of rectangular scenes into the smaller circular or oval shapes of the initial letters, but there are iconographic changes as well. One type of innovation is in the greater attention paid to anecdotal detail; the Bible in the Vatican of *c.*1250 is a good example of a manuscript in which almost every scene is elaborated in this way. Some of the changes which result from this anecdotal approach can be seen in such subjects as the Healing of Paul by Ananias, in which Paul is shown as a sick man in bed, and in the scene of Paul's Baptism, in which the two types of baptism are specified. Liturgical dress, implements, and practice are all stressed in this new emphasis on detail.

The other type of change is in the direction of simplification: extra figures are eliminated, and details are at a minimum, a process by which, for example, the town of Damascus is contracted to a single wall or tower and the number of participants is reduced. In neither of these approaches is

[79] Paris, BN gr. 923, fol. 107ᵛ (John of Damascus, *Sacra Parallela*). This is the version which Dinkler-von Schubert cites as possibly influenced by Pauline iconography.

[80] Eph. (Heisterbach Bible) and Col. (Bodl. Auct. D.4.8).

[81] Including both Bibles and Epistle commentaries, the scene is distributed in the following way: I Cor.: New York, Morgan 939. II Cor.: London, BL Add. 27694; New York,

Morgan 111; Paris, BN lat. 13142. Gal.: Paris, BN lat. 670. Eph.: Bible of Heisterbach; Abbey 7345. Phil.: Cambridge, Trin. B.4.1. Col.: Oxford, Bodl. Auct. D.4.8. II Thess.: Avranches 3; Paris, Mazarine 15; Troyes 2391. II Tim.: New York, Morgan Glazier 42; Rome, Vat. Urb. lat. 7.

there much evidence that the artists took a fresh look at the texts either of Acts or of the Epistles for iconographic inspiration, except perhaps in a few of the depictions of Paul's escape through a window.

III. THE ACTS SCENES: NEW THEMES IN THE TWELFTH AND THIRTEENTH CENTURIES

Invaluable tools in the identification of twelfth- and thirteenth-century Pauline iconography can be found in the narrative cycles, particularly the Byzantine and Italo-Byzantine sequences described in Chapter One, and, to a lesser extent because more controversial, the San Paolo frescoes.

Most of these innovative scenes from the life of Paul make their appearance as illustrations for the Epistles during the twelfth century. New subjects continue to appear in the thirteenth century, but, with several exceptions, these novelties are of a different type; they represent the absorption into the Acts Cycle of elements from the other systems of Pauline imagery introduced in Chapter Two.[82] In addition, in the thirteenth century, the narrative intention apparent in some of the earlier manuscripts is replaced by a more generalized symbolic approach, which seeks to represent types rather than particular situations.

The delayed appearance of certain themes until the thirteenth century (for example, the Miracle of the Evil Spirit: Acts 16:16–18) can possibly be accounted for by the scarcity of extant twelfth-century examples; the discovery of one or two early manuscripts may push these innovations back into the twelfth century. In fact, Avranches 3, made early in the thirteenth century with essentially twelfth-century iconography for the Conversion sequence, probably can be considered as belonging in spirit to the earlier period; inclusion of this manuscript among twelfth-century versions takes care of almost all of the innovations.

The new scenes are considered, in the following discussion, in their sequential order:

The Miracle of the Healing of the Lame Man at Lystra[83] (Acts 14:7–10)

In Avranches 3 this scene is clearly identified in the words written on a scroll held by Paul 'Dico: surge', a paraphrase of the Vulgate text 'Dixit magna voce: surge' (Fig. 175). Paul blesses a lame youth, who is crouched on the ground holding a small crutch, his legs twisted under him. In contrast, in the two Bibles of the Apostolic Cycle (Figs. 220, 221), Paul, in the company of one or two companions, heals the man by pulling him up by the hand. This action is contrary to the text, which specifies that the cure is accomplished by Paul's words alone.

Both of these interpretations have precedents in Byzantine and Byzantine-inspired art. The Rockefeller-McCormick New Testament (Fig. 172),[84] for example, like the Apostolic Cycle, shows the action of Paul pulling up the man, as does the Gumpert Bible (Fig. 126), known for its concurrence with Byzantine iconography.[85] In the majority of Italo-Byzantine works, on the other hand, care has been taken to differentiate this miracle from Peter's similar deed at the Beautiful Gate (Acts 3:1–8), so that Paul invariably heals with a gesture, Peter by physically raising the man. These versions also establish a point of difference in the poses, the lame man in

[82] See above, Oxford, Bodl. Auct. D.4.8., pp. 78–9.

[83] 12th-c.: Erlangen 1 (Gumpert Bible), fol. 387ᵛ. 13th-c.: Avranches 3, fol. 292ᵛ (I Tim.); London, BL Add. 27694, fol. 420 (Eph.); Paris, BN lat. 13142, fol. 622 (Eph.). Also in London, BL Harley 1527, fol. 72ᵛ (Bib. Mor.);

the Italo-Byzantine cycle; Chicago, Rockefeller-McCormick, fol. 122ᵛ.

[84] See above, p. 26, n. 151.

[85] See above, p. 75, n. 14.

Peter's miracle squatting in the manner of the Byzantine examples (Fig. 174), whereas the analogous figure in the Pauline scene (Fig. 173) is either seated on a low chair or supporting himself on a crutch.[86] It is probable that this distinction in pose is a late development, and that in the mainstream of transmitted imagery the poses of the lame men in the two scenes were similar, as in the extant Byzantine versions.

The iconography of the thirteenth-century French Bibles resembles both the Byzantine and Italo-Byzantine variations. In Avranches 3 (Fig. 175), as in the Italian manuscripts, Paul heals with a gesture, although the most marked analogy to the lame man's pose in the Avranches Bible is with a Peter scene in one of the Verona New Testaments (Fig. 174). The Apostolic Cycle versions—especially the one in London (Fig. 220)—resemble most closely the Byzantine example (Fig. 172) and the Gumpert Bible in the depiction of Paul's action and in the arrangement of the bystanders.

While the possibility of Byzantine inspiration for this scene is strong, therefore, it cannot be stated definitely whether the influence was direct or via an Italo-Byzantine intermediary, although the latter is a distinct possibility.

Paul Stoned At Lystra[87] (Acts 14:18)

This episode is seldom represented, but two Early Christian reliefs establish a basis of comparison. They provide differing interpretations: a fourth-century sarcophagus in Marseilles, in a typically symbolic representation, shows Paul standing between two of his attackers, one of them raising a stone above Paul's head; the ivory plaque of the fifth century in the British Museum (Fig. 176), in contrast, depicts the attacker on the left raising the stone in a vehement gesture; he holds a second stone in his other hand and Paul kneels at the right.[88]

The scene in Troyes 2391 (Fig. 177) has certain similarities to the fifth-century ivory: Paul crouches in front of the principal attacker who raises one stone and prepares a second; the hand of God in heaven suggests martyrdom. The imagery has few distinguishing features and it is possible that the iconography of the Stoning of Stephen has been followed here. We cannot be certain, therefore, that this scene formed part of a unified transmitted tradition.

The Miracle of the Evil Spirit[89] (Acts 16:16–18)

In the thirteenth-century Bible initials there are two ways of depicting this subject: in one the girl is seated on the ground, her pose similar to that of the lame man in the scene described above; in the other she is upright, as in the Vercelli Roll and the Verona New Testaments (Fig. 178). Every thirteenth-century example of this scene portrays the girl with a demon emerging from her mouth, a common medieval device to indicate exorcism.[90]

[86] Eleen, 'Acts Illustration', *passim*, and Appendix.

[87] 12th-c.: Troyes 2391, fol. 225ᵛ (I Tim.). Also in San Paolo frescoes (mutilated); sarcophagus in Marseilles (after 350); and in an ivory plaque in the British Museum. See above, p. 7, n. 33.

[88] His gesture is close enough to that of the most complete figure in the San Paolo scene (Waetzoldt, *Kopien*, cat. 650, fig. 388) that a kinship can be postulated between the fresco and the ivory. (The number of figures is reduced in the ivory, a not uncommon occurrence.) The attackers in the fresco look down, so that we can assume that Paul in the San Paolo scene was kneeling before his attackers, as he is in the ivory.

[89] 13th-c.: Avranches 3, fol. 294 (II Tim.); London, BL Add. 27694, fol. 423ᵛ (I Thess.); Paris, BN 13142, fol. 629ᵛ (II Thess.); Paris, Mazarine 15, fol. 435ᵛ (II Tim.). Also in London, BL Harley 1527, fol. 75 (Bib. Mor.); the Italo-Byzantine cycle.

[90] See, e.g., the representation of Christ Healing the Demoniac at Capurnaum (Mark 1:23–6) in the Manerius Bible (Paris, Ste. Geneviève 10), fol. 127ᵛ: the demoniac is seated on the ground, demons flying from his mouth (Grabar and Nordenfalk, *Romanesque Painting*, 174). The same scene in the Winchester Bible, illustrated in the upper portion of one of the Beatus Bs (fol. 218), also shows the demoniac

The possessed girl in Avranches 3 (Fig. 179) is shown on the ground, clad in a short-sleeved shift (perhaps as an indication of her moral as well as her social position), her hair wildly disarranged, the evil spirit in the form of a black, winged angel emerging from her mouth. The model for this scene might have been the Miracle of the Lame Man in the same Bible, in which the man is also seated on the ground (Fig. 175). The desire to present the two scenes in a visually uniform arrangement might have been the deciding factor in determining the seated position of the girl in Avranches 3, especially if, as has been suggested above, Avranches 3 was copied from a window in which all of the images would be visible simultaneously. (The two scenes are adjacent in the manuscript.) Alternatively, the composition with the girl seated might have derived from a Christological exorcism scene, like that in the Manerius Bible.[91]

In the manner of the Italo-Byzantine compositions, the Apostolic Cycle manuscripts show the spirit emerging from the mouth of a standing girl (Figs. 229, 230). Both of the latter represent the girl as wearing some kind of head-covering, so that the original intention of depicting her as undignified and out of control has been lost.

Although the evidence of a Byzantine or Italo-Byzantine lineage is not as strong as for the Miracle of the Lame Man, it is conceivable that the Apostolic Cycle manuscripts in particular were recipients of such an influence.

The two following scenes ought to be considered together:

Paul Judged (at Philippi?)[92] (Acts 16:19–21)

Paul Flogged (at Philippi or Jerusalem)[93] (Acts 16:22–3; 21:30–3)

The frequent appearance of the flogging theme probably results from an incursion of the imprisonment motif into the Acts cycle, so that a specific instance of beating, deriving from a narrative moment, comes to symbolize imprisonment in general, and is used as an illustration for the Epistles considered to fall into this category. It is significant that most occurrences of this subject in twelfth- and thirteenth-century Bibles are associated with 'Imprisonment Epistles'.

There are three episodes of flogging in the story of Paul's life in Acts: at Philippi he was flogged in company with Silas, following the exorcism of the evil spirit from the servant girl; this punishment was preceded by a trial before magistrates. If, in a manuscript following the sequential system, the beating follows either the Miracle of the Evil Spirit or a scene of judgement, it is probable that the flogging depicted is that at Philippi. At Jerusalem Paul is alone when he is beaten by the crowd; this scene is followed by his arrest, shackled by chains, and another flogging by soldiers in the barracks.

I have made the point in Chapter One that the depiction of flogging in the prone attitude in the San Paolo frescoes (Figs. 180, 183) might be evidence of antique origin, and that this tradition was continued in Carolingian times, as exemplified by the fresco at Malles (Fig. 181). The prone position also seems to have been the typical way of portraying flogging in Byzantium as well

crouching on the ground, the spirit emerging from his mouth. In the version of the scene in the Byzantine Rockefeller-McCormick New Testament, fol. 37ᵛ, the demoniac is nude, upright, and there is no personification of the evil spirit (Willoughby, 'Codex 2400', after p. 58).

[91] See previous note.

[92] 12th-c.: Troyes 2391, fol. 219ᵛ (Eph.). Also in London, BL Harley 1527, fol. 75 (Bib. Mor.).

[93] 12th-c.: Troyes 2391, fol. 222ᵛ (Col.). 13th-c.: New York, Morgan Glazier 42, fol. 354 (Philem.); Oxford, Bodl. Auct. D.4.8, fol. 658ᵛ (I Thess.); Paris, Mazarine 15, fol. 419ᵛ (Eph.); Reims 36, fol. 146 (Col.). Also in Cambridge, Trin. B.4.1, fol. 206ᵛ (I Thess.); Paris, BN lat. 670, fol. 194 (I Thess.); London, BL Harley 1527, fols. 84ᵛ, 85; the Italo-Byzantine cycle.

(Fig. 182). One of the hallmarks of the Italo-Byzantine iconography, by contrast, is the use of the upright pose for both victim and tormentor (Fig. 186).[94]

Both types occur in the twelfth- and thirteenth-century Bibles. Echoes of the antique–Byzantine tradition can be seen in two manuscripts of the thirteenth century, a Bible in Reims (Fig. 184) and one in the Bodleian Library at Oxford (Fig. 185). The scene in the Reims Bible is quite close to the San Paolo scene of Paul Beaten by the Jews (Fig. 183), with the composition reversed and compressed, as is usual in the process of change to an initial: in the thirteenth-century version Paul is prone, as if on a block, wearing drawers similar to those in the fresco, and beaten from behind by two men in short tunics, one of them portrayed in the midst of a backhand stroke; as in the San Paolo scene they wield switches made of twigs. The scene in the Bible in Oxford (Fig. 185) represents a further stage of reduction; only two of the figures present in the Reims Bible are depicted here—Paul and the torturer on the right—and Paul's position has been changed to one of prayer. In neither instance is there a sequential context, so it is not possible to say whether it is the beating at Philippi or at Jerusalem that is depicted,[95] only that it points to the continuity of the San Paolo type of prone flogging scene.

As for the upright type of flogging, it is represented in the twelfth-century Bible in Troyes where there are two episodes: in the first (Fig. 187), Paul, half-nude, is judged by two magistrates; in the second (Fig. 190), he is beaten, standing in the centre with his torturers on either side. It is probably the flogging at Philippi depicted here, since Paul is taken first to the magistrates and he is partially nude, both conditions specified in the text. The iconography of the Flagellation of Christ might have inspired the centralized composition of the Troyes version, so that the evidence linking this scene with the tradition of Italian Pauline iconography is slight.

Other thirteenth-century depictions of beating show some degree of corruption of the upright type. In these less precise derivatives, many of them linked to Imprisonment Epistles, we cannot discover whether their intention was to depict a specific instance of suffering. In the Epistles commentary in Cambridge, for example, Paul is shown kneeling, clothed, between the two torturers who wield clubs. In a Bible in the Morgan Library (Fig. 188), there is only one tormentor with a club, and Paul is standing, while in Mazarine 15 (Fig. 189), Paul kneels and prays facing away from the torturer with the stick who holds Paul's hair. (The Mazarine scene is similar to a representation of the Execution of Paul in the Avranches Bible (Fig. 205) and might be a corruption of a model similar to the latter.)

There were two traditions for the depiction of flogging, as shown at San Paolo and in Byzantium on the one hand, and in the Italo-Byzantine iconography on the other, and there is some evidence that both were known in the thirteenth century. However, the theme of beating is closely tied to the notion of imprisonment, so that it was easily corrupted when divorced from its traditional and textual inspirations. There is also the possibility of influence of the iconography of the Flagellation of Christ.

The Miracle of the Raising of Eutychus[96] (Acts 20:7–12)

The story, as told in Acts, is as follows: while Paul is speaking to a group of people in a lamp-lit

[94]For San Paolo and Malles, see above, pp. 10, 35; for Byzantine and Italo-Byzantine depictions of flogging, pp. 34–5.

[95] The shackled hands in the Reims Bible might stand for the Jerusalem episode.

[96] 12th-c.: Oxford, Bodl. Laud Misc. 752, fol. 403ᵛ (Eph.). 13th-c.: London, BL Add. 27694, fol. 426ᵛ (II Tim.); Paris, BN lat. 13142, fol. 632 (II Tim.). Also in Cambridge, Trin. B.4.1, fol. 230ᵛ (II Tim.); San Paolo frescoes; Vercelli Roll; Chartres and Rouen windows.

room, a youth, Eutychus, falls from a third-floor window and is assumed to be dead. Paul picks him up and says that there is life in him; later he is discovered to be alive. A similar story is told in the Apocrypha regarding a youth named Patroclus, a cup-bearer of Caesar, who likewise falls and is restored to life.[97] It is difficult to tell which of the two occasions is represented, except by the sequential context in which it is placed, whether canonical or apocryphal.

Although this subject appears in the Pauline windows in drawn-out sequences (Figs. 36, 37),[98] it is an infrequent choice for illustration. The few occurrences in Bible manuscripts have in common an outdoor setting, so that the drama of the fall centres on the exterior of a building with a high window, a device also used in the Vercelli Roll (Fig. 191). There are no repetitions of the continuous narrative of the Roll, but the picture in the Epistle commentary in Cambridge (Fig. 192) reiterates some of its features: Paul is shown preaching to a group outside a rusticated building with a rounded window in the upper storey, while the youth is depicted in mid-air tumbling head foremost. (The Vercelli Roll continues the story with episodes of the youth dead on the ground and then restored alive to his friends by Paul.) Although not an unarguable demonstration of a tradition of copying, there is a slight resemblance, especially when both are contrasted with the version in a Bible in Oxford (Fig. 193) which portrays graphically the words of the text 'Paul threw himself upon him'.[99] The scenes in the Apostolic Cycle (Fig. 232), on the other hand, symbolize rather than enact the event. Here, the boy sleeps in the window and is simultaneously saved by Paul's gesture.

We see at work, therefore, in our diverse examples a variety of principles by which book illustration is governed: perpetuation of a pictorial narrative tradition, new invention exploiting the dramatic essence of the story, and simplification for the purposes of symbolic statement.

The Miracle of the Viper[100] (Acts 28:3–6)

This scene depicts Paul's salvation from death after he and his companions are shipwrecked on the island of Malta. Paul is putting sticks on a fire when he is bitten by a viper; shaking it into the fire, he is miraculously unharmed.

Next to the Conversion Cycle, this subject is the most popular of all the canonical events from the life of Paul to be represented in Bibles of the Middle Ages, and is also one episode from Acts for which we have clear evidence of an Early Christian archetype. A fifth-century ivory diptych in the Bargello in Florence (Fig. 194) is decorated with a series of episodes from the experiences of Paul in Malta.[101] The centre register of the right wing depicts the Miracle of the Viper: Paul is at the left, his mantle draped over his left hand above the fire, the very realistic viper striking his right hand, which is extended as if to shake hands. Publius, the chief magistrate, reacts with astonishment as do the two men on the right.

Proof of the continuance of this imagery into the Middle Ages can be seen in two of the Italian

[97] Lipsius-Bonnet, *Acta Apostolorum*, I, 25–7.

[98] See above, pp. 24–6.

[99] The action of Paul in raising the youth was similar in the San Paolo frescoes (Waetzoldt, *Kopien*, cat. 639, fig. 377), but there it was part of a two-episode narrative.

[100] 12th-c.: Troyes 458, vol. II, fol. 211ᵛ (Eph.); Troyes 2391, fol. 223ᵛ (I Thess.). 13th-c.: Avranches 3, fol. 290ᵛ (I Thess.); London, BL 27694, fol. 428ᵛ (Heb.); Oxford, Bodl. Auct. D.4.8, fol. 660 (II Thess.); Paris, BN lat. 13142, fol. 634ᵛ (Heb.). Also in New York, Morgan 939, fol. 165ᵛ (Eph.); London, BL Harley 1527, fol. 92ᵛ (Bib. Mor.); ivory

diptych in Florence; Italo-Byzantine cycle; San Paolo frescoes; fresco in Canterbury Cathedral, St. Anselm's Chapel.

[101] The Carrand Ivory'; see W. F. Volbach, *Elfenbeinarbeiten der Spätantike und des frühen Mittelalters*, 3rd ed. (Mainz, 1976), no. 108; and Schnitzler, *Rheinische Schatzkammer*, II, pl. 30. The subject-matter of the right wing consists of Paul debating with the pagan philosophers in the upper register, the Miracle of the Viper in the centre, the afflicted of Malta waiting to be healed on the bottom. Left wing: Adam's Dominion over the Animals.

manuscripts, the Abbey Bible and the Giustiniani codex (Figs. 195, 196).[102] Both include the principal motifs present in the ivory: Paul stands beside the fire holding out his arm from which the snake is hanging while the Maltese recoil in alarm. The Abbey version repeats the placement of Paul on the left and even the bunched drapery hanging in the ivory from his left hand is matched by the long twisting snake with which the thirteenth-century artist has replaced the more zoologically correct fifth-century viper. This composition is reversed in the Giustiniani codex, perhaps to allow the snake to cling more obviously to Paul's right hand, but the main elements are the same, and there is an astonishing reminder of the ivory in the three witnesses, two of them looking at Paul and the one in the centre glancing away.

In the version in Avranches 3 (Fig. 197), the portrayal of Paul is quite similar to that in the ivory and the Italian manuscripts in pose, gesture, and drapery. In place of the folded mantle he holds a bunch of sticks in his left hand, but the viper hangs down from his right hand in a way that recalls the ivory. However, the number and arrangement of the bystanders is different, and the prow of a ship appears on the left.

There is a precedent for this motif in the San Paolo frescoes (Fig. 198),[103] which also has some features in common with the ivory. Here Paul stands at the right, facing the fire, the viper attached to his outstretched right hand, which is held over the flames. He is observed by three men seated on a rock at the left, two of them wearing only mantles to cover their naked bodies, each stretching forth his right hand. In the background, the location of the action and the circumstances of Paul's arrival are established by the careening masts and sails of a ship. This iconographic scheme is echoed in a Bible in Troyes (Fig. 199). Paul's pose in relation to the coiled snake resembles that in the fresco; three observers on the left make similar gestures. The main difference is that the ship is on the right and has been provided with an oarsman, rather than sails. A somewhat more distant, but still related, version can be seen in the other twelfth-century Bible in Troyes (Fig. 200), where the viper has turned into a lizard-like creature biting Paul's wrist; the number of bystanders has been cut down and they are placed conveniently in the ship. Most of these variations can be attributed to the distortions of the twelfth-century style and to the need for compression when the scene is translated into an initial.

There can be little doubt that the Italian artists were heirs to an Early Christian tradition, as exemplified by the ivory, for this scene, this tradition possibly handed down to them via Byzantium.[104] It is likely also that the imagery was transmitted to Northern Europe by the twelfth century. Correspondences between the San Paolo fresco and the northern representations are more difficult to explain. Rather than demonstrating the antiquity of the iconography, it might confirm Cavallini's use of contemporaneous pictorial language.[105] Possibly the truth lies between the two alternatives. The elements held in common by the fresco and the ivory—Paul's pose in relation to the snake, fire, and bystanders (as usual reversed in the fresco)—could go back to the fifth-century imagery, whereas the ships in the background, a more anecdotal detail, might be a contribution of the thirteenth-century restoration.

In the two Apostolic Cycle manuscripts (Figs. 236, 237), most of the discursive elements have been cut out: in one panel of the initial 'M' of Hebrews the viper is shown biting Paul's wrist; in

[102] Abbey Bible, fol. 423 (Rom.); and Giustiniani codex, fol. 143.

[103] Waetzoldt, *Kopien*, cat. 668, Fig. 406.

[104] Although there are no extant depictions in Byzantine art, the Miracle of the Viper was included in the 'Painter's Manual'; see above, Ch. 1, n. 161.

[105] See above, pp. 35–6, for other examples of medievalisms in the San Paolo frescoes. A 14th-c. Italian MS (Vienna Nationalbibl. 1191, fol. 444[v]) also uses the motif of a group of onlookers in a boat.

the other, the boat floats on water. As in almost every other facet of the iconography of this pair of Bibles, narrative is eschewed in favour of symbol. The two themes, given equal importance, refer to Paul's double salvation on the Island of Malta—from shipwreck and from the viper.

Models for these additional scenes from Acts cannot be identified as easily as those influencing the Conversion Cycle. We have encountered the possibility of descent from Byzantine or Italo-Byzantine sources in such representations as the Miracles of the Lame Man, the Evil Spirit, and Eutychus. The evidence, however, is inconclusive. The twelfth- and thirteenth-century imagery is not sufficiently precise, nor do we have enough examples, to establish whether it is the Byzantine or Italo-Byzantine variation with which we are dealing. There is little doubt that aspects of the Byzantine iconography were circulating in the North from the twelfth century, but whether as direct importations from Byzantium or via Italian intermediaries cannot at present be determined.

In one clear-cut instance (The Miracle of the Viper) and in one slightly less definite (the Flogging of Paul) there are examples of Acts imagery which might go back to antique archetypes, but again, by means of what stages they reached the North in the Middle Ages is not certain. The essential importance of the Italo-Byzantine cycle is apparent, but a charting of the process of transmission awaits thoroughgoing studies of the iconography of the acknowledged Byzantinizing monuments, such as the *Hortus Deliciarum*[106] and the Gumpert Bible, and also of related cycles such as the historiated windows and the *Bibles Moralisées*.

Passio Sancti Pauli Apostoli[107]

Departing from the strictly canonical, a number of Bibles include episodes from the Apocrypha in addition to using scenes from Acts as illustrations for the Epistles. Three of them have more or less complete sequences. I have observed above that the account of Paul's decapitation, as told in the *Acta Pauli*,[108] was a popular subject in Early Christian funerary art. The Execution of Paul furthermore was associated with the Epistles as early as the ninth century,[109] and was included in the Acts Cycle by the middle of the twelfth century. However, the depiction of the martyrdom of Paul in Avranches 3 and the two other manuscripts related to it is based not on the older apocryphal (but theologically orthodox) *Acta Pauli* but on the more romantic version of the events surrounding the Execution ascribed to Linus, the *Passio Sancti Pauli Apostoli*, which was influenced by gnosticism.[110] The latter account was also influential in the formation of popular legends dealing with Paul in the Middle Ages (the information about Paul in the *Legenda Aurea*, composed by Jacobus de Voragine in the late thirteenth century, follows this more colourful version of the martyrdom of Paul).[111] It also features a heroine, Plautilla, who appears in the pictorial versions.

According to Delaporte, readings from the *Passio Pauli* formed part of the ancient liturgy of

[106] Rosalie Green's forthcoming monograph on the *Hortus Deliciarum* will no doubt clarify some of these issues.

[107] Cycles of *Passio* scenes: Avranches 3, fols. 280, 284, 286, 295, 295ᵛ, 296 (II Cor., Gal., Eph., Tit., Philem., Heb.); Paris, Mazarine 15, fols. 431, 436, 436ᵛ, 437 (Phil., Tit., Philem., Heb.); Rome, Vat. Urb. lat. 7, fols. 394ᵛ, 396ᵛ, 397 (II Tim., Philem., Heb.). Also in Vienna, Nationalbibl. Ser. Nov. 2700, p. 368 (Salzburg Antiphonal); Chartres

window; Rouen window.

[108] See above, Ch. 1, n. 7.

[109] In the Moutier-Grandval Bible (London, BL Add. 10546), fol. 411ᵛ; see above, pp. 16–17.

[110] See above, Ch. 1, n. 106.

[111] Voragine, *Legenda Aurea*, Cap XC, 'De Sancto Paulo Apostolo', 380–96.

Chartres, where they can be found in lectionaries from the tenth century onwards;[112] this must be the source of the scenes in the window at Chartres based on the legend of Paul and Plautilla. The Chartres window dedicated to Paul (Fig. 36) and, presumably, the Chartres lectionary, combine scenes from the *Passio Pauli* with others from the *Passio Petri et Pauli*, a text involving both Peter and Paul, but the culminating point of the latter text is omitted: there is no scene of the crucifixion of Peter in the window; the entire upper portion is devoted to the legend of Paul and Plautilla. A similar combination of themes, including as well the emphasis on Paul, can be found in the Rouen window (Fig. 37), and, as we have seen, in the Avranches cycle.

There is a precedent to the use of the *Passio* as a subject for illumination to be found in the mid-twelfth-century Antiphonal from Salzburg (Fig. 201):[113] it depicts Plautilla inside a building handing her veil to Paul; the executioner stands in the centre, the sword over his shoulder; Paul is seen again at the right, his neck gashed, falling to the ground; there are three observers on the far right. As pointed out in Chapter One, from at least the ninth century, and probably before, the legends of the saints were read in the office. Apparently at Salzburg, as at Chartres, it was the Linus version of the *Passio* that was read on his feast day—30 June—and the illustration of the legend found its way, along with the text, into the local Antiphonal.

Turning now to the illustrated Bibles, we find that the legend of Paul and Plautilla is told in six scenes in Avranches 3, out of sequential order so that it is necessary to reconstruct the narrative order from hints given in details of dress and gesture. In the initial for II Corinthians (Fig. 202), Paul, carrying a scroll with his name inscribed, is propelled forward by a man in a short tunic toward a seated king—Nero—who holds a sword upright and gestures with a pointing finger. This is the scene of condemnation. The man behind Paul is his guard—his accusatory gesture becomes clear when we look at the same scene in the Bible in the Vatican (Fig. 203), in which the dramatic elements are emphasized by magnified gesticulations. It should be noted that Paul in the Avranches Bible is wearing a shift and overmantle; dress is one way of distinguishing this, the first appearance before Nero, from the other scenes in the *Passio*, since in the later five scenes he wears a shift only, appropriate costume for a condemned man.

Galatians (Fig. 204) is illustrated by a depiction of Paul, accompanied by the executioner with a sword, receiving the veil from Plautilla. Although she is a respectable, noble matron, Plautilla is depicted as bareheaded; she has taken the veil from her own head, as described in the text.

The representation of the Execution itself is in the initial for Ephesians (Fig. 205). Paul is shown kneeling, eyes bound with the veil, his hands raised in prayer, facing the executioner who brandishes a sword aloft.

In the illustration for Titus (Fig. 209), Paul returns the veil to Plautilla, who receives it with a gesture of excitement, and, in Philemon (Fig. 210) Paul makes his second visit to Nero. This scene differs from the first confrontation between the two: in the Philemon scene Paul is doing the talking, and Nero looks worried and unsure, as compared to his censorious mien in the earlier scene. Another feature linking the second scene to the post-execution events is that Paul is shown wearing the simple shift in which he was beheaded.

Finally, in the initial 'M' of Hebrews (Fig. 211) Plautilla shows the veil to two soldiers. An important element in all of these scenes is the pattern made by the veil: billowing into an arch, drooping, tied in a graceful knot. The emphasis on the repeated pattern of the veil is to be seen as

[112] Delaporte and Houvet, *Vitraux de Chartres*, 285, n. 4.
[113] Vienna, Nationalbibl. Ser. Nov. 2700 (formerly Salz-burg, Stiftsbibl. St. Peter A.XII.7), p. 368. See above, Ch. 1, n. 127.

well in the windows dedicated to Paul, which convey their message from a distance, so that the key element—the veil—must be exaggerated.

In the Bible in the Vatican, in contrast to Avranches 3, the Acts Cycle scenes are organized so that they are in almost sequential order: the two Plautilla scenes come at the end, although the previous episode of Paul with a king (Fig. 203) is used as the illustration for I Timothy and therefore separated from the conclusion of the story by two other scenes. The Execution is in the initial for Philemon (Fig. 206). Paul is kneeling, facing towards the executioner, his eyes bound with the veil. Finally, in the 'M' of Hebrews (Fig. 212), he returns the veil to Plautilla. Although the details of naturalistic and dramatic imagery are emphasized in the Vatican manuscript, the narrative purpose is not as clear-cut as in the Avranches Bible; for example, there is no modification in Paul's dress when he has been condemned, and Plautilla is not bareheaded when the veil is returned.

Mazarine 15, a pale reflection of Avranches 3, includes three episodes from the legend of Plautilla, also in correct sequential order (in this version, too, the scene of Paul arrested and brought to a king occurs much earlier, in Philippians). In the initial for Titus, Plautilla, her head still covered, gives Paul the veil. The Execution takes place in the initial for Philemon: the veil is nowhere in evidence. Finally, in the initial for Hebrews, as in the Vatican manuscript, Paul returns the veil to Plautilla; this scene is more carefully drawn and its meaning is obvious.

The presence of the Plautilla legend in thirteenth-century Bible illumination is a purely Western feature, having as its background popular legends and local variations in liturgical books. A precedent for these illustrations can be found in certain earlier manuscripts in which the legends themselves appear, but there is strong evidence—in the combinations of scenes chosen, in the order of these scenes and in the repetition of formal patterns—suggesting that window decoration was the immediate source for this group of Bibles.

The Execution of Paul[114]

In addition to the three manuscripts which portray the Plautilla legend, three more Bibles and one Epistle commentary add the single scene of the Execution of Paul to the Acts cycle. In almost all of the manuscripts except Avranches 3, this representation occurs as the illustration for either Philemon or Hebrews, exemplifying the operation of the sequential system, the last scene coming at the end (in two of the instances in which the Execution accompanies Philemon, the later episode of Paul returning the veil to Plautilla occupies the initial for Hebrews; in the third of these Bibles there is no illustration for Hebrews).

A group of manuscripts, mainly liturgical, in which the Execution of Paul was frequently illustrated, was described in Chapter One. The comparison was made between these versions and the Early Christian or Byzantine type which depicted the moment before the actual event. After the tenth century there was a tendency to represent the decapitation with increasingly gory detail (Figs. 34, 35). This emphasis on the moment of, or the moment after, the decapitation continued in liturgical manuscripts throughout the Middle Ages.

Bible illustration tells another tale: without exception, the scenes of martyrdom which complete the Acts cycles in twelfth- and thirteenth-century Bibles show Paul still alive (Figs. 205–8). In contrast to the gruesome depictions in many liturgical books, the Bible scenes of

[114] Avranches 3, fol. 286 (Eph.); Boulogne 4, fol. 205ᵛ (Philem.); Oxford, Bodl. Auct. D.4.8, fol. 655 (Heb.); Paris, Mazarine 15, fol. 436ᵛ (Philem.); Rome, Vat. Urb. lat. 7, fol. 396ᵛ (Philem.); Troyes 2391, fol. 228ᵛ (Philem.). Also in (ex) Dublin, Beatty 41, vol. II, fol. 244ᵛ (II Tim.); Cambridge, Trin. B.4.1, fol. 242ᵛ (Heb.).

execution are very restrained. They always represent Paul kneeling and praying, the executioner raising his sword aloft.

This type is similar to representations in earlier liturgical books (Figs. 32, 33). It differs slightly from the common depiction of the Execution in Byzantine art[115] showing Paul kneeling in prayer and the executioner raising his sword behind Paul's back (Figs. 14, 31). In the Western tradition Paul invariably faces the executioner, who clutches the top of his head as if to gain purchase for the blow (Figs. 205–8).[116] The windows at Chartres and Rouen have similar representations (Figs. 36, 37).

Decapitations are common in Bible imagery, but an examination of two other examples in the Avranches manuscript provides evidence that the Pauline beheading scenes fall into a special category. In the initial for the prologue to the book of Judith (fol. 244[v]) Judith, facing Holofernes, holds him by the hair as in the Pauline scene. Unlike the depiction in the latter, however, the sword is shown slicing into the neck of the victim. The details of death are emphasized too in the initial for I Maccabees (fol. 258) in the same Bible, the executioner standing behind the victim and driving the sword into his skull.[117] It seems, therefore, that there was not a standard form for the representation of capital punishment in the artistic sphere of the Avranches Bible. The identity of the depictions of the Execution of Paul in a number of Bibles and in the windows as well suggests that this scene was transmitted with a cycle of Pauline iconography and was not simply a routine treatment of a standard type of beheading.

Before summing up the evidence of Acts and apocryphal scenes used as Epistle illustration, a separate group displaying a special relationship to the text must be taken into consideration:

IV. THE APOSTOLIC CYCLE

In the majority of medieval Bibles with Acts illustrations, the narrative scene from Acts often seems to have little or no relevance to the literal meaning of the Epistle it accompanies. Occasionally it can be demonstrated that the allegorical or typological meaning of a particular scene is intended to be interpreted as a comment on the message of the Epistle it accompanies, but the lack of consistent evidence places a detailed investigation of this possibility outside the scope of the present study.

The principle of sequential arrangement, however, often seems to have had a determining influence on the choice of scene; nevertheless, the Bibles which carry the narrative beyond the Conversion sequence and discussed by me up to this point never follow the sequential method absolutely, without rearrangements. In contrast to these, two manuscripts form a group which is of interest in that they are almost identical in iconography (the only occurrence of a recension within the entire body of Bibles using Acts scenes), and also because they use an almost perfect sequential system. Even more importantly, there seems to have been a deliberate choice of each

[115] e.g. Phillipps 7681, fol. 121[v]; Jerusalem, Gr. Patr. Saba 208, fol. 87[v] (Menologion); Paris, BN gr. 510, fol. 87[v] (Homilies of Gregory Nazianzen). See above, Chapter 1, nn. 152, 156, 157.

[116] In two Bibles the executioner is standing behind Paul, as in the Byzantine MSS, but in both instances he is clutching Paul's hair in the manner of all the Western examples:

Boulogne 4 (Philem.); Mazarine 15; both of these Bibles are eccentric, the latter because of its many errors, the former because it includes many undecipherable scenes, possibly apocryphal.

[117] A similar type of Execution is used in Rome, Vat. Urb. lat. 7, fol. 67[v] (Joshua).

scene in that it conveys a central theme of the literal and/or the spiritual meaning of the text of the Epistle it accompanies.

Unfortunately, the two Bibles—London, BL Add. 27694 and Paris, BN lat. 13142—are of low quality, in artistic standard and in iconographic clarity. Both can be dated—by style— between 1260 and 1270 so it can be assumed that their archetype, not necessarily a Bible, was illustrated somewhat earlier. The relationship of picture to text in the two Bibles reflects a highly sophisticated milieu of biblical scholarship similar to that of Paris in the 1230s and 40s. A span of thirty or forty years between the invention of the iconography and the illumination of these manuscripts could explain their perfunctory and almost corrupt treatment of subject-matter; nevertheless, much of the original intention is still evident.

The subjects in the historiated initials appear more or less in their sequential order in the text of Acts, although there are several exceptions to this rule. Each scene simultaneously illustrates a passage in the particular Epistle it accompanies, as demonstrated by the following chart:

Scene	*Acts*	*Epistle*
Conversion of Paul	9:3–7	Rom. 1:5–6
Baptism of Paul	9:18	I Cor. 1:13, 1:14, 1:16, 1:17, 10:2, 12:13, 15:29
Paul's Escape from Damascus	9:25	II Cor. 11:33
Paul with Peter	9:26–8	Gal. 2:2–8
Miracle of the Lame Man	14:8–10	Eph. 4:17–24
Paul Accepts Timothy	16:1–3	Phil. 3:1–5
Miracle of the Macedonian (?)	16:9–10	Col. (?)
Raising of the Dead[118]	17:31	I Thess. 4:15–18
Miracle of the Evil Spirit	16:16–18	II Thess. 2:3–4
Paul with a Bishop	21:18	I Tim. 3:2–7
Miracle of Eutychus	20:9–12	II Tim. 1:6–8
Paul with the High Priest (?)	23:1–5	Tit. 3:1–2
Paul's Visit from His Nephew (?)	23:16	Phil. 11–14
Miracle of the Viper	28:1–5	Heb. 7:15–19

It can be seen that certain subjects chosen for illustration also appear elsewhere, and have already been discussed. However, the choice of scenes reflects a more exact deliberation and is quite at variance with that of the other Bibles. Only three scenes from the Conversion sequence occur, for example, in the London and Paris Bibles, in comparison to five in Avranches and nine in the Vatican versions. A number of episodes appear only in the London and Paris Bibles and not in the other Acts cycles, such as the Raising of the Dead. Several scenes are most enigmatic and

[118] Only the Paris MS uses this sequence of I and II Thess. London reverses the order.

difficult to interpret; conjectural explanations are offered here based on the hypothesis that a sequential scheme has been followed and that the text of the Epistle is significant for an understanding of the illustration. My method of interpretation, therefore, has been to find an event which fits between the preceding and succeeding episodes and at the same time can be explained by a passage within the text of the Epistle itself.

Underlying the planning of iconography in these two manuscripts is the premiss that there is an identical pattern running through the events of the life of Paul and the text of his letters. The logic of the pattern lies in its arrangement as a series of events taking place in time. Themes common to Paul's life and his works link the two spheres, so that the truth of the letters can be understood better by looking at them in terms of the pattern of the life of their author.

Conversely, the passages in the letters serve as explanations, even moralizations, of the factual accounts in the pictures. In several instances the chosen text from the Epistle itself matches a medieval exegesis of the section in Acts which is portrayed in the picture. The picture draws together the parallel texts—that is, from Acts and the Epistles—so that each enriches understanding of the other.

One unifying ideological theme runs through the interpretation of the Epistles which is brought out by the illustrations in the two Bibles—an emphasis on Paul's ministry to the Gentiles and on justification by faith, in contrast to Jewish justification by law. Not all of the scenes fall into this category, but there are enough of them to make acceptable the title 'Apostolic Cycle' I have given to the imagery of these Bibles.[119]

The Conversion of Paul[120] (Acts 9:3–7; Romans 1:5–6 (Fig. 213))

While it is impossible to sum up this complex letter in one image, the fact that Paul 'writes as one conscious of his Apostolic commission from Christ'[121] is an important starting-point, and the scene of Paul's Conversion conveys this idea succinctly and dramatically.

The use of the Conversion as a suitable accompaniment to Romans has been discussed above. It is a frequent choice of the illuminators, and in this respect the Apostolic Cycle follows the practice of the majority of Bibles with Acts imagery. Both manuscripts are illustrated with commonplace Conversion scenes, in which Paul is struck down by the hand of God while on a horse.

Paul Baptized by Ananias[122] (Acts 9:18, I Corinthians 1:13, 1:4, 1:16, 1:17, 10:2, 12:13, 15:29 (Figs. 214, 215))

Baptism is not usually considered to be an important topic in I Corinthians. Most authors single out the Eucharist and Love as the most important theological questions discussed in it.[123] Yet, if we look at the text of the letter, we find that the word 'baptism' (in one form or another) is mentioned seven times, exceeding the occurrence of the term in all the other Epistles put together.

Strangely, some of Paul's references to baptism in the letter are almost derogatory. In I Corinthians 1:17 he insists 'Christ did not send me to baptize, but to proclaim the Gospel.'[124] The

[119] Where the iconography of the two MSS is identical, or nearly so, only one illustration is reproduced, but both are provided where there are important differences.

[120] London, BL Add. 27694, fol. 407 (Rom.); Paris, BN lat. 13142, fol. 601ᵛ (Rom.).

[121] *ODCC*, s.v., 'Romans, Epistle to the', 1175.

[122] London, BL Add. 27694, fol. 111ᵛ (I Cor.); Paris, BN lat. 13142, fol. 608ᵛ (I Cor.).

[123] e.g. the *ODCC*, s.v., 'Corinthians, Epistles to the', 343; and T. W. Manson, 'The Message of the Epistles: I Corinthians', *ET*, 44 (1932–33), 500–4.

[124] I Cor. 1:17: 'Non enim misit me Christus baptizare, sed evangelizare.'

reason for these negative remarks is that he is emphasizing the spiritual side of Christianity, not the ritual, and criticizing the uses to which baptism was put in the primitive Christian communities. His most positive reference to baptism in I Corinthians is to its spiritual nature: 'For indeed we were all brought into one body by baptism, in the one Spirit, whether we are Jews or Greeks, whether slaves or free men, and that one Holy Spirit was poured out for us all to drink.'[125]

An important aspect of the theology of baptism is the notion that the Holy Spirit descends to the baptized at some moment during the ceremony;[126] there has not always been general agreement as to the exact point at which this descent occurs—that is, whether the Holy Spirit is conferred by the water during affusion or immersion, during the annointing with chrism, or by the laying on of hands,[127] although anointing was always stressed. The representation of baptism in the London Bible is an appropriate accompaniment to Paul's text in I Corinthians, since he emphasizes the role of the Holy Spirit. In the London version Ananias is shown holding a chrismatory; this is a reference to the very process by which the Holy Spirit was invoked at that time. This is the only Bible illustrated with scenes from Acts in which the moment of anointing with chrism is depicted in the baptism scene.

The illustration directs the reader's attention to the theme of baptism in the Epistle; in perusing the text, he will find a number of references to corrupt practices and beliefs connected with baptism, as well as to the passage cited above (12:13) which emphasizes that 'baptism is generation of the spirit'.[128] Therefore, the use of the scene of Paul's baptism, particularly in the London Bible, reinforces the text in a subtle way. It also conforms to the principal theme of the Apostolic Cycle: Paul's mission to the Gentiles is directed to change man's spiritual condition, not to teach him laws and procedures.

Paul's Escape from the Walls of Damascus[129] (Acts 9:25, II Corinthians 11:33 (Figs. 216, 217))

The Apostolic Cycle manuscripts are the only Bibles with complete Acts sequences in which this popular scene is used to illustrate the very Epistle in which it is described. An important theme in II Corinthians is Paul's justification of his actions as an apostle (especially in Chapter Three), his relations with his flock, and his sufferings for them. The episode of Paul's salvation through the help of his friends is a good visual summary of many of these ideas. Augustine compared Paul to Christ himself in his flight from Damascus, and to the Church, whereas the assistants who let the basket down are those who work for the salvation of the Church: 'Let the minister of Christ flee, as Christ himself fled into Egypt: whosoever flees is sought for spiritually, while the salvation of the church is assured through others.'[130]

Not only, therefore, has the scene of Paul's Escape from Damascus a literal parallel in the text of the letter, but it also directs attention to the wider implications of the message. It functions as a demonstration of an aspect of Paul's apostlehood.

[125] I Cor. 12:13–14: 'Etenim in uno Spiritu omnes nos in unum corpus baptizati sumus, sive Judaei, sive gentiles, sive servi, sive liberi; et omnes in uno Spiritu potati sumus.'

[126] Lampe, *Seal*, 50–63, 193–214.

[127] Ibid. 194–7, 215–31, and Fisher, *Christian Initiation*, 15, 34–5, 44–5.

[128] *Biblicum Sacrorum cum Glossa Ordinaria*, ed. Franciscus Fevardentius, 6 vols. (Paris, 1590), (hereafter *Gl. Ord.*), VI, 305–6, *I ad Cor. 12:13:* 'Qui baptismus est spiritualis generatio.' For the place of the *Gl. Ord.* in medieval Bible scholarship, see below n. 171.

[129] London, BL Add. 27694, fol. 415ᵛ (II Cor.); Paris, BN lat. 13142, fol. 615ᵛ (II Cor.).

[130] *Gl. Ord.*, VI, 446, Augustinus, *II ad Cor. 11:33:* 'Fugiat Minister Christi, sicut ipse Christus in Aegyptum fugit: fugiat et quia spiritualiter quaeritur dum per alios firma est ecclesie salus.'

Paul and Peter in Jerusalem[131] (Acts 9:26–8, Galatians 1:18, 2:7–8 (Figs. 218, 219))

This scene, used as an illustration for Galatians in the Apostolic Cycle, does not occur in any of the other Bibles, yet it fits quite clearly into the double scheme of the chronology of Paul's life combined with the message of the Epistles. The main emphasis in the letter is on justification by faith, in contrast to the Jewish belief in justification by law, through an examination of the Jewish background to Christianity. In Galatians 2:2–8 Paul describes a visit to Jerusalem during which the leaders of the church recognized his mission to the Gentiles as surely as Peter had been entrusted with the Gospel for the Jews.[132] Equality and reciprocal division of duties between Peter and Paul are emphasized. In Acts 9:26–8 the story is retold more anecdotally of Paul's visit to the apostles in Jerusalem, but Peter is not mentioned. However, it was probably a common interpretation of this event that Paul did meet Peter on his visit to Jerusalem, because a commentary by John Chrysostom on this passage in Acts specifies that Paul did see Peter: 'When he was baptized he did not go immediately to Jerusalem to see the apostles, but (*as he wrote to the Galatians*), first he went to Arabia, thence back to Damascus, from where, after three years, he went to Jerusalem to see Peter.'[133]

It is noteworthy that this commentary on Acts points out the parallel between the two passages in Acts and Galatians, thus serving as a verbal equivalent to the scene in the initial.

The version in the London Bible is closer to the description of the event in both texts, since it shows Peter and Paul seated, each holding his special attribute, among a group of other men. The initial in the Paris Bible has no narrative connotations: the two men merely stand together in isolation. It is possible that the depiction of the two apostles seated together derives from the iconography of the Pentecost.

The Miracle of the Heaing of the Lame Man[134] (Acts 14:8–10, Ephesians 4:17–24 (Figs. 220, 221))

Ephesians also deals with missionary questions and with Paul's position as apostle to the Gentiles (especially 3:1–13). At first sight the scene of the Healing of the Lame Man appears to be an inappropriate choice as illustration for this letter. However, a commentary by Bede on the episode of Healing of the Lame Man in Acts helps to point out a parallel in the Epistle text. Bede compares the lame man to the Gentiles won away from their pagan religion: 'Just as the lame man whom Peter and John cured at the door of the temple prefigures the salvation of the Jews, so this sick Lichaeonius represents the Gentiles removed from the law of the temple, but assembled by Paul's preaching.'[135] Similar ideas are repeated in the Epistle itself: Paul urges the Ephesians to

Give up living like pagans with their good-for-nothing notions . . . leaving your former way of life, you must lay aside that old human nature which, deluded by its lusts, is sinking towards death. You must be

[131] London, BL Add. 27694, fol. 418ᵛ (Gal.); Paris, BN lat. 13142, fol. 620 (Gal.).

[132] Gal. 2:7–8: '. . . mihi evangelium praeputii, sicut et Petro circumcisionis. . .'

[133] *Gl. Ord.*, VI, 1085–6, Chrysostom, *ad Act. Apost. 9:26–8*: 'Non quam cito baptizatus est venit in Jerusalem ad apostolos sed (*sicut Galathis scribit*) primo abiit in Arabiam, et inde reversus est Damascum, deinde post annos tres venit Jerusalem videre Petrum. . .' [My italics: L.E.]

[134] London, BL Add. 27694, fol. 420 (Eph.); Paris, BN lat. 13142, fol. 622 (Eph.).

[135] *Gl. Ord.*, VI, 1140, Beda, *ad Act. Apost. 14:8–10*: 'Sicut claudus ille quem Petrus et Johannes ad portam templi curavit praefigurat Judaeorum salutem, ita hic Lichaeonius aeger Gentes a legis templi religione remotas, sed Pauli praedicatione collectas.' See above, p. 95, for a comparison of the iconography of the Peter and Paul scenes (my Figs. 172–5).

made new in mind and spirit, and put on the new nature of God's creating, which shows itself in the just and devout life called for by the truth.[136]

In both passages, the pagan religion is equated with illness and deformity; Christianity means healing and a new life.

By combining the scene of the Miracle of the Lame Man with the Epistle to the Ephesians, the designers of the iconography have given new insight into the allegorical meaning of the event in Acts and at the same time have commented on the letter by visual means.

Paul Takes Timothy as His Helper[137] (Acts 16:1–3, Philippians 3:1–5 (Figs. 222, 223))

The illustration for Philippians in the Apostolic Cycle is most difficult to interpret, and the two versions are not quite identical: common to both are depictions of Paul and another man—two men in Paris—who present(s) a child to Paul with a caressing gesture; in both there is a second child present. Paul walks away to the left with the second child in the Paris version, but in the London Bible the second child goes off alone to the right. Because of the low calibre of these manuscripts, such a rarely occurring episode, having only an allegorical relation to the text, can lose its clarity easily.

Light is cast on the mystery of this scene by a similar representation in the thirteenth-century Bolognese Bible where it illustrates II Timothy (Fig. 224).[138] Son of a Jewish mother and a Greek father, Timothy in this Bible is a shoulder-high boy, given by his father to Paul who kneels to receive him. The affectionate gesture made by Timothy's father in the Italian version is similar to that of the adult offering the child in the illustration for Philippians in the Apostolic Cycle. Thus, through the person of Timothy himself, the scene is linked to the episode described in Acts 16:1–3 in which Paul accepts Timothy as his helper and circumcizes him. This oblique reference to the ritual of circumcision, disparaged by Paul in the letter, is the bond uniting picture and text.

There are several feasible explanations for the presence of the two children in the Philippians illustration. One is that the scene represents two consecutive episodes conflated from a fuller narrative. Timothy is represented twice—being given to Paul and taken away by him (this interpretation would mean that the Paris version is more accurate). Another explanation is that the Apostolic Cycle scenes are erroneous copies of a very bad model in which there was a kneeling figure of Paul, as in the Italian Bible. The copyist mistook the kneeling figure for a second child, and reproduced the rhythm of larger and smaller figures without fully comprehending their meaning.

The introduction of Timothy, of mixed Jewish and Gentile origin, again raises the central question of Paul's ministry, that is, justification by faith or by law. In connection with the latter, Paul is described in Acts 16:1–3 as having circumcized Timothy as a concession to Jewish opinion, and in the Middle Ages many commentators argued the reasons for Paul's action. It is noteworthy that much of the controversy regarding circumcision as a symbol of Jewish law centres around the passage in Acts describing Timothy's circumcision,[139] but there is also

[136] Eph. 4:17, 22–4: '. . . non ambuletis sicut et gentes ambulant in vanitate sensus sui . . . deponere vos secundum pristinam conversationem veterem hominem, qui corrumpitur secundum desideria erroris. Renovamini autem spiritu mentis vestrae, et induite novum hominem, qui secundum Deum creatus est in justitia, et sanctitate veritatis.'

[137] London, BL Add. 27694, fol. 421ᵛ (Phil.); Paris, BN lat. 13142, fol. 624ᵛ (Phil.).

[138] Abbey 7345, fol. 444ᵛ (II Tim.). Timothy was traditionally depicted (in writing as well as pictorially) as a youth. The identification of the scene in the Abbey Bible partly rests on its occurrence with II Tim.

[139] *Gl. Ord.*, VI, 1159–60, *ad Act. Apost. 16:1–3.*

considerable commentary on the passage in Philippians, in which Paul himself mentions and castigates circumcision.[140] For example, Tertullian used the theme as a point of departure for speculation on the relative role of Jews and Gentiles within Christianity:

Not that the figures of the law have any use after the truth of the Gospels, but in order that the Jews might not retreat from the faith through the agency of the Gentiles, [the Jews] from whom the old shadow gradually had lifted just as idolatry had lifted from the Gentiles. These legal shadows instituted by the Lord were used from time to time by the apostles, and in that time were taken over to avoid the treachery of the Jews.[141]

Another commentator on the same passage observes that Titus, unlike Timothy, was not circumcized.[142] The notion of a comparison of the initiations of Timothy and Titus suggests a third possible interpretation of the second child in the illustration: Timothy is taken by Paul to be circumcized, while Titus is absolved from the necessity of the ritual. In this case the scene would not be a narrative record of a certain event in the life of Paul, but an abstract scheme symbolizing the parallel between, and opposition of, two ideas.

Whatever the exact meaning of the scene, it is safe to assume that it refers to the initiation of Timothy, and, by implication, to the rite of circumcision. Thus it falls into the larger context of Paul's apostleship to the Gentiles. In both its narrower and wider senses it is suitable as an accompaniment to Philippians, which deals with the relations between Paul and the community converted by him. In Philippians 3:2–6 Paul makes a comparison between physical circumcision and the condition of being a Christian: 'Beware of those dogs and their malpractices. Beware of those who insist on mutilation—'circumcision' I will not call it; we are the circumcised, we whose worship is spiritual, whose pride is in Christ Jesus, and who put no confidence in anything external.'[143] In other words, circumcision of the spirit is inward faith, not requiring an outward sign.

Like the use of the scene of baptism illustrating I Corinthians, which contrasts mechanical with spiritual baptism, the scene of the initiation of Timothy—and, by implication, of his circumcision—emphasizes the contrast between outward and inward circumcision.

Unidentified Scene[144] (Perhaps The Miracle of the Appearance of the Macedonian: Acts 16:9–10 (Figs. 225, 226))

The illustration for Colossians is an enigmatic scene of Paul standing with a youth (nimbed in the Paris version). Possibly it depicts an episode in Paul's journey in the Middle East when he was stopped by a man—thought by some to have been an angel[145]—who appealed to him to come and

[140] *Gl. Ord.*, VI, 591, *ad Phil. 3:1–5.*

[141] *Gl. Ord.*, VI, 1159, Tertullian, *ad Act. Apost. 16:1–3:* 'Non quod figurae legis post veritatem evangelii aliquid utilitatis afferrent, sed ne per occasionem Gentium Judaei a fide recederent, quibus umbra vetus paulatim tollenda erat, sicut Gentibus idololatria. Legales vero umbrae quia a domino institutae interdum ab apostolis illo tempore sunt usurpatae pro declinanda Judaeorum perfidia.'

[142] *Gl. Ord.*, VI, 1160, Rabanus Maurus, *ad Act. Apost. 16:1–3:* 'Timotheum circuncidit pro scandalo Judaeorum, ne legem Moysi videretur damnare, sed eam quasi non necessarium Gentibus non imponere Titum non circuncidit. . .'

[143] Phil. 3:2–6: 'Videte canes, videte malos operarios, videte concisionem. Nos enim sumus circumcisio, qui spiritu servimus Deo, et gloriamur in Christo Jesu, et non in carnem fiduciam haventes.'

[144] London, BL Add. 27694, fol. 422v (Col.); Paris, BN lat. 13142, fol. 626 (Col.). Possibly also in the San Paolo frescoes (*Kopien*, cat. 637, Fig. 375): Paul, reclining, has a vision of the Macedonian in his sleep; Vercelli Roll: a man in a doorway talks to Paul.

[145] *Gl. Ord.*, VI, 1161, Rabanus Maurus, *ad Act. Apost. 16:9–10:* 'Angelus illius gentis assimilatus viro Macedoni proprietate linguae, vel forma speciali, vel iudicio verbi.'

preach in Macedonia. The gestures of Paul and the man in the Colossians initials are quite unusual, unlike frequently occurring scenes of the apostle addressing or listening to another figure. In both depictions Paul registers surprise, his hands raised with spread fingers; the young man holds his hands cupped together in the London version, cupped but facing upwards in the Paris Bible. These very specific hand signs are perhaps intended to convey that the man is 'beseeching' Paul to come to Macedonia.

If the scene is indeed that of the appearance of the Macedonian to Paul it fits into the sequential scheme. It also fits into the general theme of the Apostolic Cycle, since it is a key moment in Paul's mission, a proof of contact with God through a mediator who redirects his missionary journey. However, there is no direct parallel in the text of Colossians itself, other than the passing derogatory reference to 'angel-worship' among a list of heresies to be avoided (2:18). The ambiguous nature of the illustrations in the two available manuscripts prevents a more exact identification at the present time.

The Raising of the Dead[146] (Acts 17:31, I Thessalonians 4:16–18 (Figs. 227, 228))

At this point the two manuscripts part company. The Paris version, eschewing sequential order in favour of the appropriate text, illustrates I Thessalonians with a scene depicting the Resurrection of the Dead, but the London Bible uses this scene for II Thessalonians. The Paris version is probably more accurate in respect to the model, since there is an important passage in the first letter to the Thessalonians devoted to this central aspect of Paul's theology.

In contrast to the other scenes in this cycle, Paul does not appear in the depiction of the Raising of the Dead, which derives from a section of the traditional scene of the Last Judgement. Christ is shown floating on clouds, blessing three naked dead arising from their tombs below. The image is clearly a visual translation of the words of Paul in the Epistle: 'because at the word of command, at the sound of the archangel's voice and God's trumpet-call, the Lord himself will descend from heaven; first the Christian dead will rise; then we who are left alive shall join them, caught up in clouds to meet the Lord in the air.'[147] This passage often has been singled out as the most important in the whole letter; for example, according to the *ODCC*, 'The main purpose of the first Epistle ... is to set their minds at rest on the fate of the dead members of the community.'[148] The inventor of the Apostolic Cycle follows the usual interpretation in this regard.[149]

The imagery of the Raising of the Dead differs from the rest of the cycle in that it does not derive from a narrative source, but is purely doctrinal, representing Paul's words rather than actions or experiences of his which find a parallel in a theoretical statement. There is, however, a matching text in Acts, slightly out of sequential order, in which Paul is described as preaching about the Last Judgement (17:31), so that the principle of following the events of Paul's career has not been abandoned.

[146] Paris, BN lat. 13142, fol. 628 (I Thess.); London, BL Add. 27694, fol. 424[v] (II Thess.). See below, Ch. 4, 'I Thessalonians' for a discussion of other examples of representations of the Raising of the Dead.

[147] I Thess. 4:16–18: 'Quoniam ipse Dominus in jussu, et in voce archangeli, et in tuba Dei descendet de caelo; et mortui qui in Christo sunt resurgent primi. Deinde nos, qui vivimus, qui relinquimur, simul repiemur cum illis in nubibus obviam Christo in aera.'

[148] s.v., 'Thessalonians, Epistles to', 1346–7; see also W. F.

Howard, 'The Message of the Epistles: I Thessalonians', *ET*, 44 (1932–3), 357–62; and P. M. Magnien, 'La resurrection des morts d'après la première épitre aux Thessaloniciens', *Revue Biblique*, NS 4 (1907), 349–82: 'La première épitre aux Thessaloniciens est aussi le premier document où l'on puisse étudier la conception paulinienne du dogme chrétien de la résurrection des morts' (349).

[149] The Toledo *Bible Moralisée*, III, fol. 139 (Fig. 295), uses a similar segment of the conventional Last Judgement as the 'moralization' to the scene illustrating I Thess. 4:14–15.

I Thessalonians in the London Bible is illustrated with the scene of the Miracle of the Evil Spirit, which sequentially precedes the episode of Paul preaching about the Last Judgement, but more suitably accompanies the text of II Thessalonians, as it does in the Paris Bible.

The Miracle of the Evil Spirit[150] (Acts 16:16–18, II Thessalonians 2:3–4 (Figs. 229, 230))

II Thessalonians is also on an eschatological theme, but of a different sort. In a mysterious passage which has given rise to much speculation, Paul describes the final rising which will take place against God: the Day of Judgement will not come, 'unless there comes first that rebellion when the man of sin will be revealed, the son of perditu, who opposes and raises himself against everything which is called God, and against what is worshipped.'[151] There is no doubt that the Middle Ages regarded this evil figure as 'Antichrist'.[152] Paul's version of the ultimate end of this enemy is similar to that described in Revelation 20:10. After his final rebellion, in Paul's words, 'Lord Jesus will destroy [him] with the breath of his mouth and annihilate [him] by the radiance of his coming.'[153]

The Paris Bible uses an event from Paul's life as a parable of the confrontation of Christ and the force of evil. Paul exorcizes the evil spirit from the possessed servant girl just as the *filius perditionis* will be exorcized by Christ.

Although in other instances the London Bible seems to be more faithful to the principle of matching scene and doctrine, the Paris version makes better sense in the episodes chosen for illustration of I and II Thessalonians, since the scenes of the Raising of the Dead and the Miracle of the Evil Spirit, in that order as they appear in the Paris version, are more appropriate to the meaning of the texts. The artist of the London Bible corrected the sequential order, combining the Miracle of the Evil Spirit with I Thessalonians, where it is out of place. The juxtaposition of the Raising of the Dead with II Thessalonians, as it occurs in the London Bible, is not inappropriate, since the letter does have an eschatological emphasis, but the combination of picture and letter is not as exact as in the Paris version where there is a textual basis for the use of both scenes.

Paul with a Bishop[154] (Acts 21:18, I Timothy 3:2–7 (Fig. 231))

The suitability of a scene of Paul and a Bishop as an illustration for I Timothy has been discussed in Chapter Two in connection with the Pastoral Epistles. Timothy was generally recognized to have been a bishop,[155] and there is a section in the first letter to him (3:1–17) dealing with the responsibilities demanded of a bishop, and the character becoming to him.

In the context of the Apostolic Cycle, the scene of Paul and a Bishop also fits into the sequence of Paul's life. During his last visit to Jerusalem Paul paid a visit to James to whom he described 'all that God had done among the Gentiles through his ministry.'[156] This passage is interesting

[150] Paris, BN lat. 13142, fol. 629 (II Thess.); London, BL Add. 27694, fol. 423ᵛ (I Thess.). See below, Ch. 4, 'II Thessalonians', for other representations of the eschatological theme in this letter.

[151] II Thess. 2:3–4: 'Quoniam nisi venerit discessio primum, et revelatus fuerit homo peccati, filius perditionis, qui adversatur et extollitur supra omne quod dicitur Deus, aut quod colitur. . .'

[152] *Gl. Ord.*, VI, 671, Augustinus, *ad II Thess. 2:3*: 'filius perditionis, antichristus, non per naturam, sed per imi-

tationem.'

[153] II Thess. 2:8: '. . . quem dominus Jesus interficiet spiritu oris sui, et destruet illustratione adventus sui eum.'

[154] London, BL Add. 27694, fol. 425 (I Tim.); Paris, BN lat. 13142, fol. 630 (I Tim.).

[155] See above, Ch. 2, n. 58.

[156] Acts 21:18–19: 'Sequenti autem die introibat Paulus nobiscum ad Jacobum . . . narrabat per singula quae Deus fecisset in gentibus per ministerium ipsius.'

because, as well as placing Paul in company with a bishop (James), it also includes a reference to his ministry to the Gentiles, a constant theme in the Apostolic Cycle. That James was considered to be a bishop is attested by Bede: 'That very James, the brother of the Lord, the son of the sister of Mary mother of the Lord, was he who immediately after the passion was ordained bishop by the apostles.'[157]

The Miracle of the Raising of Eutychus[158] (Acts 20:9–12, II Timothy 1:6–8 (Fig. 232))

Here again the sequential order of Acts has been disrupted slightly in order to fit the preceding episode of Paul with a Bishop into the initial of I Timothy. In both Bibles, the scene of the Raising of Eutychus is reduced to its minimum components: Paul is shown touching a youth sleeping in a tower. The fall of Eutychus and his restoration to life are compressed into one static image, the artist ignoring the event as a series of episodes taking place in time.

The general tone of the letter provides the reason for the inclusion of this scene. II Timothy is imbued with the premonition of approaching death, yet with confidence in the ultimate victory over death. Paul exhorts Timothy not to be ashamed of the imprisonment of his leader, but to continue to labour with the Gospel, because of the 'gift of God which is within you through the laying on of my [Paul's] hands.'[159] Although these words do not give us a literal connection with the theme of the Miracle of Eutychus—except for the notion of the laying on of hands, a feature of ordination as well as of Paul's miraculous restoration of the youth—the over-all message is one of victory over death: 'And now there is laid up for me the crown of righteousness which the Lord, the all-just Judge, will award me on that day.'[160]

II Timothy adds courage in the face of death to the demands made on a Christian minister in I Timothy, and therefore amplifies further the concept of apostleship.

Unidentified Scene[161] (Perhaps Paul with the High Priest: Acts 23:1–5, Titus 3:1–2 (Figs. 233, 234))

The information provided by the illustrations for Titus in the two manuscripts is too inexact for a clear identification to be put forward. In the London Bible, Paul is shown standing before a seated man who wears a rounded hat (a Jew's hat?), while the man is also standing in the Paris version and his hat is of gold.

Assuming that the sequential method has been followed, a suggestion might be made that this scene represents Paul before Ananias, the High Priest of the Council of Jews in Jerusalem. One of the points made by Paul in his speech before the Council was acceptance of constituted authority: 'It is written, "You must not speak evil of the ruler of your people." '[162] Obedience to authority is also emphasized in the letter to Titus: 'Remind them to be submissive to the government and the authorities, to obey them'.[163] Thus, the two parallel texts bring out an important aspect of Paul's pastoral message, one that might have had contemporary application in the second quarter of the thirteenth century.

[157] *Gl. Ord.,* VI, 1208, Beda, *ad Act. Apost. 21:18:* 'Jacob iste frater domini, filius Mariae sororis matris domini fuit qui post passionem statim ab apostolis Episcopus ordinatus.'

[158] London, BL Add. 27694, fol. 426ᵛ (II Tim.); Paris, BN lat. 13142, fol. 632 (II Tim.).

[159] II Tim. 1:6–7: '. . . gratiam Dei, quae est in te per impositionem manuum mearum.'

[160] II Tim. 4:8: 'In reliquo reposita est mihi corona justitiae, quam reddet mihi Dominus in illa die justus judex.'

[161] London, BL Add. 27694, fol. 427 (Tit.); Paris, BN lat. 13142, fol. 633ᵛ (Tit.).

[162] Acts 23:5: 'Scriptum est enim: Principem populi tui non maledices.'

[163] Tit. 3:1: 'Admone illos principibus et potestatibus subditos esse, dicto obedire . . .'

Paul's Nephew Visits Him in the Barracks(?)[164] (Acts 23:16, Philemon 11–14 (Fig. 235))

A scene familiar from the discussion of the Prison Epistles in Chapter Two illustrates Philemon: Paul, reaching through a prison window, shakes hands with (Paris), or hands a scroll to (London) a youth on the outside. That the youth is meant to be Philemon, whom Paul is sending to his former masters, is clear from the text of the letter.

The story of Paul, as told in Acts, includes a parallel incident which fits into the sequential scheme, when his sister's son visits him in the barracks to which he is confined in Jerusalem (23:16), following the judgement scene depicted in the Titus initial.

In addition to the motif of Paul in prison which unites the two texts, both express very clearly another side of the prison theme: solicitude is exchanged mutually between those on the outside and those inside. Paul, in prison, is concerned about the slave Onesimus; Jerome, for example, expressed admiration for Paul on this point.[165] The nephew also shows solicitude in his bold investigation of the plot against Paul.

The simultaneous reference to the two texts, which emphasizes an interpretation of Philemon as a Prison Epistle, also brings out a more general message of ideal relations between members of the church in times of suffering, underlined by Jerome's commentary.

The Miracle of the Viper[166] (Acts 28:1–5, Hebrews 7:15–19 (Figs. 236, 237))

Again, all anecdotal elements have been avoided in the illustrations for Hebrews in the two Bibles; they concentrate on a point of doctrine; that is, salvation through faith. On one side of the initial 'M' is the ship floating on water, on the other Paul and the viper, representing his two miraculous escapes from death on Malta.

The underlying message of the Acts–Epistles confrontation in the illustration for Hebrews takes us back to the common theme of the first six Epistles, that of Paul's ministry to the Gentiles as proof of the efficacy of reliance on faith in contrast to the Jewish reliance on law. This is the reiterated message of Hebrews which 'asserts with emphasis the finality of the Christian dispensation and its superiority to that of the Old Covenant, as a dissuasive from any return to Judaism.'[167] A companion theme is that of Paul's role as priest, not through tribal heredity, as practised by the Jews, but through the will of God:

The argument becomes still clearer, if the new priest who arises is one like Melchizedek, owing his priesthood not to a system of earth-bound rules but to the power of a life that cannot be destroyed. For here is the testimony: 'Thou art a priest for ever, in the succession of Melchizedek.' The earlier rules are cancelled as impotent and useless, since the Law brought nothing to perfection; and a better hope is introduced, through which we draw near to God.[168]

The Miracle of the Viper is a good demonstration of these ideas, because ordinary laws would require Paul to die by the venom of the serpent, but he is saved because of his faith and because, as

[164] London, BL Add. 27694, fol. 428 (Philem.); Paris, BN lat. 13142, fol. 634 (Philem.).

[165] *Gl. Ord.*, VI, 779–80, Hieronymus, *ad Philem. 11:14*: 'Simul autem admirandum de magnanimitate apostoli, et in Christum mente serventis.'

[166] London, BL Add. 27694, fol. 428ᵛ (Heb.); Paris, BN lat. 13142, fol. 634ᵛ (Heb.).

[167] *ODCC*, s.v., 'Hebrews, Epistle to the', 614–15.

[168] Heb. 7:15–19: 'Et amplius adhuc manifestum est, si secundum similitudinem Melchisedech exsurgat alius sacerdos, qui non secundum legem mandati carnalis factus est, sed secundum virtutem vitae insolubilis. Contestatur enim: Quoniam tu es sacerdos in aeternum secundum ordinem Melchisedech. Reprobatio quidem fit praecedentis mandati, propter infirmitatem ejus et inutilitatem: nihil enim ad perfectum adduxit lex; introductio vero melioris spei, per quam proximamus ad Deum.'

Christ's representative, he exercises divine powers. Paul's double escape on Malta is a prototype of freedom from death.

Significantly, the culminating scene of the Apostolic Cycle is based on a canonical text. Most of the other Bibles illustrated with many scenes from Acts also include apocryphal episodes. The fact that the Apostolic Cycle is confined to subjects drawn from the Bible itself is a consequence of its strict, ordered, minute examination of parallel texts in Acts and the Epistles.

In these two Bibles, pictorial images acting as commentaries on the texts of the letters point to parallel passages in Acts and thus reveal a particular interpretation of each letter. At least seven of these interpretations can be considered to fall into the category of arguments in favour of justification by faith,[169] based on stringent, almost acrimonious comparisons between Paul's appeal to faith and Jewish reliance on law. A related underlying theme is Paul's personal role as apostle of Christ, and his relations with his own disciples.[170] Hence, the title 'Apostolic Cycle' can be considered appropriate. Two of the Epistles—I and II Thessalonians—concentrate on Paul's theology of Last Things, and three—the Pastoral Epistles—on his theories regarding the role of the minister and bishop (several letters including in other categories could be cross-listed in this last group), one letter (Philemon) is treated as a Prison Epistle and one is doubtful.

The majority of scenes derive from the common thirteenth-century pool of imagery depicting events from the life of Paul, but it is noteworthy that the process of reduction takes an extreme form in this cycle, because the narrative function no longer applies. The pictures are used in a purely allegorical or symbolic sense, without any intention of 'telling a story'; a good example is the Miracle of Eutychus, in which the depiction of a series of events is squeezed into one composite image which does not reproduce a definite moment of time, but only conveys the core of meaning of the scene. In at least one instance the traditional iconography is changed, reflecting influence of the Epistle text. Use of the chrismatory in the baptism scene brings out an interpretation of baptism unique to I Corinthians.

Three scenes appear only in this cycle, and might have been specially contrived or adapted for the purpose. The depiction of Paul and Peter with the other apostles used as an illustration for Galatians is very simple and could derive from a scene of the Pentecost. The Raising of the Dead is an adaptation of a Last Judgement. Finally, the most complex of the new scenes is that depicting Paul accepting Timothy; there is evidence that this image, too, is a modification of a then-existing iconographic type. The two unidentified subjects are simple in the extreme, consisting of Paul in conversation with another figure.

The illuminators of the Apostolic Cycle do not win laurels for their great powers of pictorial invention. They attract our interest by their remarkable ability to probe beneath the surface, revealing hidden relationships between the author's life and doctrine. Frequent occurrences of matching subjects in the *Glossa Ordinaria* and the picture sequence suggest that there is a more than accidental link between them. It is possible that the Apostolic Cycle was devised to accompany an edition of the Gloss, or at any rate that it was made for and by scholars for whom the approach to the Bible in the Gloss—a collection of parallel texts and commentaries—was a feature of everyday life.[171]

[169] Rom., I Cor., II Cor., Gal., Eph., Phil., Heb.

[170] II Cor., Eph., Heb.

[171] B. Smalley, 'Les commentaires bibliques à l'époque romane: glose ordinaire et gloses perimées', *Cahiers de Civilization Médiévale*, 4 (1961), 15–22, has shown that the *Glossa Ordinaria* had been standardized by about 1200, in both content and appearance as a planned design, and that it continued to serve as the compulsory textbook for Bible studies. I am grateful to Dr. Smalley for discussing this matter with me.

This chapter has demonstrated that Pauline imagery deriving from Acts was by no means a neglected subject in medieval Bible illustration. The Conversion Cycle had a continuous history of transmission, beginning with the Carolingian Bibles and surviving into the High Middle Ages with little change. In the twelfth and the thirteenth centuries certain modifications were introduced, partly as a result of accomodation to the problems posed by the historiated initial, partly because of new uses to which the imagery was put. One important change is in the Conversion of Paul itself, which became an equestrian scene, influenced by the warrior ethic of the Middle Ages.

Scenes from the life of Paul which are innovations in the twelfth- and thirteenth-century Bibles have a different history. Very few of them are new inventions as subjects, and we have looked at the possiblity of the influence of Byzantine or Italo-Byzantine models, although a scarcity of examples prevents final conclusions at the present time.

The full-cycle Bibles which display affinity with Carolingian tradition also emphasize the Conversion sequence by devoting a disproportionate number of illustrations to this short period in Paul's career. Included in this group are the two Bibles in Troyes, Avranches 3, and the two manuscripts related to it—Mazarine 15 and Vat. Urb. lat. 7—Oxford Bodl. Auct. D.4.8, and Morgan 163. Apocryphal scenes depicting the legend of Paul and Plautilla also found in this group (with the exception of Morgan 163) most probably derive from windows. These apocryphal subjects go back in part to illustrated service books, but the extensive cycles of scenes and their combination with the canonical sequences probably were devised for windows, eventually finding their way into Bibles of which Avranches 3 is the outstanding example. Certain idiosyncratic features of iconography occur in these manuscripts and the windows as well.

The Apostolic Cycle, on the other hand, with its delicately balanced references to Paul's life and writings, departs more from tradition, not only in the alteration of customary imagery, but also in its reduced reliance on the Conversion sequence. Furthermore it does not include Apocrypha and its innovative scenes are more identifiably in the Byzantine or Italo-Byzantine mode.

What principle determined the selection of new scenes from the later career of Paul? With the exception of the two Bibles in the Apostolic Cycle, it is difficult to find explanations in the Epistles themselves for the choice of scene. There is, however, a documentary source which might help to answer the question. It is the description of the career of Paul in a work of Isidore of Seville.[172] His summary of the life of the apostle corresponds to the information about Paul in the

[172] Isidore, *De Ortu et Obitu Patrum qui in Scriptura Laudibus Efferentur*, in *Opera Omnia*, V (Rome, 1802), 152–89. The section devoted to Paul is Chapter 69, 181–2. See also De Bruyne, *Préfaces*, 220: 'Paulus, qui ante saulus, apostolus gentium, aduocatus iudaeorum, a christo de caelo in terra prostratus, oculatus cecidit, caecatus surrexit, ex persecutore effectus uas electionis, ex lupo ouis, inter apostolos vocatione nouissimus, praedicatione uero primus, in lege gamalielis discipulus in euangelio christi seruus, ex tribu beniamin ortus. Hic secundo post ascensionem domini anno baptizatus, dignitatem meruit apostolatus, atque plus omnibus laborans, multo latius inter ceteros uerbi gratiam seminauit, atque doctrinam euangelicam sua praedicatione conpleuit; incipiens enim ab hierosolymis, usque illyricum, et italiam spaniasque processit ac lumen christi multarum manifestauit obtutibus gentium, quibus ante non fuerat declaratum, cuius miracula ista esse noscuntur. Raptus sursum tertium caelum conscendit, demersus deorsum nocte et die in profundum maris fuit, seducentem pythonis spiritum imperata discessione damnauit, patrem publii dissenteria et febribus orando sanauit, adolescenti mortuo uitalem reddidit spiritum, caecitate percussit magum, claudum in proprium reformauit incessum; diri quoque sepentis nec sensit nec horruit morsum, sed igni dedit arsurum. Hic ob amorem christi multas passiones grauiaque corporis sustinuit tormenta, ad ultimum a nerone eo die quo petrus crucifigitur, hic gladio caeditur. Sepultus est uia hostensi romae anno post passionem domini XXVIII.'

Bible illustrations. The topics mentioned by Isidore are Paul's Jewish origins; his Conversion; the curing of his blindness; his preaching; his baptism; his travels; his elevation to the third heaven; his shipwreck; his exorcism of a 'python';[173] the curing of the father of Publius; the reviving of Eutychus (or Patroclus); the blinding of the magician Elymas; the healing of the lame man; the miracle of the viper; Paul's sufferings; his final passion and death. Almost all of Isidore's subjects are included, directly or by inference,[174] in the French and English Bibles discussed here. Only one is totally lacking, and its absence might be an accident of survival.[175] Contrariwise, the Bible illustrations go beyond Isidore's list only in one episode: Paul's Escape from Damascus. The departures from Isidore can be attributed for the most part to the processes of contraction or elaboration of episodes. One example of the former, in which several moments are compressed into one scene, can be found in the Miracle of the Viper, where there is a reference to, but not a depiction of, the shipwreck. The second process—expansion of Isidore's theme— can be seen in the cycle of Plautilla scenes.

It should be noted that Isidore has not drawn his narrative only from Acts, but that at least one episode described only in the Epistles—Paul Raised to the Third Heaven—has been included, as well as apocryphal material. This indicates that the author conceived of Paul's life and career as set forth in Acts, Epistles, and Apocrypha as a totality. It is not surprising that Isidore's summary occasionally came to be used as a preface to the Epistles, and is included by De Bruyne and Stegmüller among their lists of prefaces.[176] This usage was rare, however, and has not been discovered in any of the examples of Bibles with Acts illustrations. One particularly significant occurrence of the Isidore summary as a preface is in the eleventh-century Roda Bible, from San Pedro de Roda in Catalonia.[177] The Roda Bible itself lacks Acts or Pauline illustrations, but a lost Catalonian Bible might have included them.[178]

There is no evidence at the present time to suggest that Spanish iconography was copied in French and English Bibles, but it is possible that Isidore's text was itself influential in determining the choice of subjects. The notion that there is an intrinsic unity between Acts, Epistles, and Apocrypha is epitomized by Isidore's use of themes drawn from all three. The application of this principle of unity in Bible illustration, together with the use of a particular range of subjects, reflects a similar habit of mind, suggesting that Isidore's method might underlie the imagery.

[173] i.e. the Miracle of the Evil Spirit, Acts 16:16: '... puellam quandam habentem spiritum pythonem. . . .'

[174] e.g. the combination of the Conversion with II Cor. is probably a reference to Paul's elevation to the third heaven; see above, p. 21.

[175] The Blinding of Elymas (Acts 13:10–11) is in the Gumpert Bible, Erlangen, Univ. Bibl. MS 1, fol. 387ᵛ (my Fig. 126) and could be expected to make its appearance in future discoveries.

[176] De Bruyne, 220; Stegmüller, no. 665.

[177] Paris, BN lat. 6; see Berger, 'Préfaces de la Vulgate', 63, no. 266; and W. Neuss, *Die katalanische Bibelillustration um die Wende des ersten Jahrtausends und die altspanische Buchmalerei* (Bonn-Leipzig, 1922), 12.

[178] See above, p. 23, and nn. 130–2, for a discussion of the sculptures of Ripoll, thought to have been copied from a Catalonian Bible, and my observation that the mutilated initials of the Pauline Epistles in the Roda Bible might once have had historiated scenes.

CHAPTER FOUR

The Prologue Cycle

Like the Bibles dealt with in the previous chapter, those that remain to be discussed are illustrated with scenes showing Paul engaged in various activities. In the former the series of events from Paul's life form a coherent sequence in time, but the actions depicted in the manuscripts studied now do not represent individual moments. Despite their deceptive resemblance to episodes in a narrative sequence, they are symbolic acts, dramatizing aspects of the author's teachings, each picture chosen to emphasize an outstanding point of doctrine in a particular letter. These images stand in a delicate and complex relationship to the text of the Epistles.

The name I have proposed for the Bibles discussed in this chapter—the 'Prologue Cycle'—derives from the influence on their iconography of a rare set of prologues, given by De Bruyne the collective title *It 1*.[1] Dependence on the Marcionite prologues can be detected as well.

This group of manuscripts has never been fully identified and described, although Erbach-Fürstenau, in 1910, isolated a few of the less important examples and discussed them in another context—that of French influence on Italian iconography—without understanding the meaning of their enigmatic scenes.[2] He very correctly pointed out, however, the rapidity with which the copyists could lose the sense of the original in illustrations which are difficult to understand. Despite deliberate changes and erroneous copying, however, the entire group of Bibles is remarkably uniform in its iconography. Recently Robert Branner has repeated Erbach-Fürstenau's discovery by noting the iconography of several more members of this group,[3] a by-product of his study of workshop groupings of thirteenth-century Paris manuscripts.

Because of their uniformity of iconography, it is possible to evaluate the individual scenes and entire manuscripts that depart from the norm. Undoubtedly in some instances this variance is deliberate, an attempt by the artist to improve the clarity of the image or to express an idea in his own way. The very complexity of the imagery, however, often leads the illustrators astray: they copy without comprehending and the result is increasing obscurity. We can, therefore, begin to speak within broad limits of a scene being 'correct' or 'mistaken'. Distance from the original invention of the iconography is partly a product of time, so that manuscripts that are early in date—as evinced by 'early' style—often but not always are more 'correct'. As in all efforts of edition, however, we shall encounter later examples for which the illuminators had access to

[1] *Préfaces*, 239–42; see below, n. 25; and see Appendix D for all references to the *It 1* prologues.

[2] Erbach-Fürstenau, *Die Manfredbibel*, 34–5. The manuscripts described by Erbach-Fürstenau were: Bologna, Bibl. Universitaria 297; Cava, Bibl. Monumenta Nazionale 33; Dijon, Bibl. Mun. 4; Munich, Clm 11318; Paris, BN 14397.

[3] Branner, *Manuscript Painting*, appeared too late for his discoveries to be incorporated into my study. On pp. 194–5 he lists the iconography of the Epistles' illustrations in a

number of Bibles, of which 6 belong to the Prologue Cycle; 3 of these are included in the present study (nos. 7, 8, and 9 on my list), and 3 were previously unknown to me: Brussels IV–499; Holkham Hall 13; and Milan, Ambrosiana, Q 34 Sup. From Branner's brief descriptions, the Brussels MS has a complete cycle, and the others only partial cycles. Branner, unfamiliar with the earlier and better members of the Prologue Cycle group, associated this iconography with the 'Gautier Lebaube' atelier, active *c.* 1240 (ibid. 19).

good models and which consequently belie their late date in the accuracy of their imagery.

The earliest of the Bibles were made in Paris probably in the late 1220s in ateliers that were simultaneously at work on the *Bibles Moralisées*,[4] a concentrated effort of Parisian biblical scholarship and manuscript painting that continued throughout the second quarter of the century. Our early Prologue Cycle Bibles have both a stylistic and iconographic kinship with the earliest portions of the *Bibles Moralisées*, and this affiliation with Paris illumination continues throughout the period of production, but included in the group are Bibles made in other parts of France, especially in the north, in England, and even in Italy, one as late as 1300.

I. THE MANUSCRIPTS

1. *Bologna, Biblioteca Universitaria No. 297*,[5] 2 vols. (225 mm × 165mm; 79 historiated initials). According to Erbach-Fürstenau, this Bible comes from France and was produced in the mid-thirteenth century.[6] Although the Bologna catalogue lists it as a monument of the fourteenth century, the style of the illuminations supports the earlier date. At one time it was in the possession of Pope Benedict XIV.

2. *Cava dei Tirreni, Biblioteca Monumenta Nazionale, MS 33*[7] (370 mm × 265 mm; ff. 519; 85 historiated initials). A colophon on fol. 484 indicates that this book was written by the scribe Guido, otherwise unknown. Decorated with the arms of Abbot Philipp della Haya, it is ascribed by the Cava catalogue to his incumbency (1316–31). Erbach-Fürstenau observes, however, that the heraldic emblems seem to have been added later, and dates it as 'shortly before 1300', a reasonable contention from the viewpoint of style. It is included in this study since its iconography manifestly derives from French models and helps to cast light on the process of copying.

3. *Dijon, Bibl. Mun. MS. 4*[8] (260 mm × 175 mm; ff. 440; 79 historiated initials). Dated *c*.1240–50 by style, this Bible comes from Cîteaux. (On fol. 4 appears the notation, in a thirteenth-century hand: 'Liber Cistercii'.) The quality of the illuminations is low, and there are a number of errors in copying.

4. *Göttweig, Stiftsbibliothek Cod. 55* (565 mm × 350 mm, ff. 291; 74 historiated initials). The provenance and origin of this interesting and previously unpublished manuscript are unknown, but on the evidence of the present study it promises to become a central monument in the study of Bible iconography in the thirteenth century, and possibly of Bible text scholarship as well. It is a manuscript of fairly high quality and is closely related to the earlier *Bibles Moralisées* in style. The illuminations can be dated *c*.1225–35 on stylistic grounds and the place of origin is probably Paris.

[4] There are 2 three-volume *Bibles Moralisées* covering both Old and New Testaments, one in the Toledo Cath. Lib. (the last gathering is in the Morgan Lib. in New York, MS M.240); the other is divided among 3 libraries: Oxford, Bodley 270b, Paris, BN lat. 11560, London, BL Harley 1526–7 (A. de Laborde, *La Bible Moralisée illustrée* (Paris, 1911–27), 4 vols.). In addition there are 2 one-volume editions in the Vienna Nationalbibl.: MS 2554 (the only *Bib. Mor.* in French, ending with Kings); and MS 1179 (containing the historical books of the Old Testament, Job, Daniel, Apocalypse).

[5] L. Frati, *Indice dei codici latini conservati nella R. Biblioteca Universitaria di Bologna* (Florence, 1909), 190, No. 199. Erbach-Fürstenau (p. 34) confused this MS with another Bible, now MS 298 in the Biblioteca Universitaria.

[6] All references to the dating and places of origin of MSS refer to the illuminations only, and not to the script, unless otherwise stated.

[7] *Codices Cavenses*, ed. L. Mattei-Cerasoli (Cava, 1935), 60–5.

[8] *Catalogue Général des Manuscrits des bibliothèques publiques de France*, V (Paris, 1889), 2–3.

5. *Madrid, Fundación Lázaro Galdiano 15289*[9] (330 mm × 215 mm; ff. 333; 68 historiated initials). This Bible of high quality on stylistic evidence can be assigned to France, *c*.1225–35. The provenance is unknown. The illustrations of the Pauline Epistles are precise and detailed and are somewhat unusual in comparison with the other manuscripts in this group. It contains several anomalies in the combination of scene and letter, which is surprising in view of the accuracy of the rest of the illustrations. The last three Epistles have been removed from the text.

6. *Munich, Staatsbibl. Clm 11318*[10] (265 mm × 172 mm; ff. 532; 80 historiated initials). Also described by Erbach-Fürstenau, this manuscript is of poor quality, although accurate in its iconography. It is related to Dijon 4, and so a date of *c*.1250 is acceptable.

7. *Nantes, Musée Dobrée VIII,*[11] 2 vols. (270 mm × 180 mm; vol. I, ff. 865; vol. II, ff. 694 and 3; 79 historiated initials). This elegant, richly decorated Bible glossed with the commentary of Hugh of St Cher at one time belonged to the Royal Library ('ad usum domini regis'). It was given by Charles VI to his confessor, Renaud des Fontaines, later bishop of Soissons, and from the early fifteenth century was in the possession of Soissons Cathedral. It was acquired by T. Dobrée in 1849 in Paris. On stylistic grounds it can be assigned to France (probably Paris), *c*.1260.

8. *Oxford, Brasenose College MS 1*[12] (390 mm × 248 mm; ff. 514; 73 extant historiated initials). For reasons of style, this book can be regarded as French, *c*.1280. At one time it belonged to William Smith, Bishop of Lincoln, founder of Brasenose College. Despite its relatively late date, this manuscript is fairly exact in iconography.

9. *Paris, BN lat. 14397: 'The Bible of Blanche'*[13] (350 mm × 230 mm; ff. A and 397; 81 historiated initials). This Bible can be dated by a *terminus ante quem*. It was presented by Blanche of Castile to St. Victor in Paris before her death in 1252. A contemporary hand was written on folio A: 'hanc bibliothecam dedit ecclesie sancti victoris parisiensis Blancha illustris regina francie mater regis ludovici.' By style it can be dated *c*.1245 and its place of origin was probably Paris.

10. *Paris, Bibliothèque Ste. Geneviève, MS 1180: 'The Maugier Bible'*[14] (221 mm × 150 mm; ff. A and 377; 81 historiated initials). The tiny illuminations of this book appear to be rather coarse when enlarged, but they are executed with care and an obvious understanding of the subject-matter. It is assigned by style to Paris, *c*.1225–35 and, again, a kinship with the earlier *Bibles Moralisées* is apparent. On folio A a seventeenth-century hand has noted: 'La bible appartenant a maistre Mace, marchand notaire et secrétaire du roy et de la royne', and also on folio A, in a seventeenth-century hand: 'Collegii Flexiensis [i.e., La Flèche] societatis Jesu catalogo adscriptus' . . . 'Donnée par le R. Père de la Fare [or de la Treve] recteur du collège des Jesuites de la Flèche le . . . septembre 1706.' On fol. 1: 'Ex libris S. Genovefae Paris, 1753.'

11. *Rome, Vatican Library, Rossiana 314*[15] (175 mm × 115 mm; ff. 534; 70 extant historiated initials). This is a Bible of good, but not outstanding quality, which can be localized and dated by

[9] J. Domínguez Bordona, *Manuscritos con pinturas: notas para un inventario de los conservados en colecciones públicas y particulares de España*, 2 vols. (Madrid, 1933), I, 512, No. 1221 and Fig. 430. Between fol. 300 and fol. 301 pages are missing. There is a resulting gap in the text from II Tim. 4:2 to Heb. 2:7.

[10] *Catalogus Codicum Latinorum Bibliothecae Regiae Monacensis*, eds. C. Halm, F. Keinz, G. Meyer, G. Thomas (Munich, 1876, repr. Wiesbaden, 1968), II, ii, 13, no. 178.

[11] G. Durville, *Catalogue de la bibliothèque du Musée Thomas Dobrée*, I (Nantes, 1904), 291–311; and G. Durville, *Les 2 MSS royaux du Musée Dobrée* (Paris, 1905); Branner, *Manuscript Painting*, 232.

[12] Branner, *Manuscript Painting*, 236.

[13] L. Delisle, 'Inventaire des manuscrits latins de Saint-Victor conservés à la Bibliothèque Impériale sous les numéros 14232–15175', *Bibliothèque de l'école des Chartes*, 30 (1869), 12; Branner, *Manuscript Painting*, 213.

[14] *Cat. Gén.*, I, Bibliothèque Ste. Geneviève, I (Paris, 1898), 541–2; Branner, *Manuscript Painting*, 206.

[15] H. Tietze, *Die illuminierten Handschriften der Rossiana in Wien-Lainz* (Leipzig, 1911), 28–9.

style as North French, *c.*1245–50. There is evidence of iconographic and stylistic affinity with the Bible in Bologna.

In addition to these eleven examples of Bibles with complete cycles, there is an additional one which has disappeared and is known only by fourteen photographs made in the first decade of this century:

12. *(Ex) Florence, Olschki.* Only four photographs remain for the Pauline Epistles,[16] but these are most interesting and show an obvious kinship with the Bible in Ste. Geneviève, although they are not identical.

There are also seven Bibles with partial or defective versions of the cycle:

13. *Cambridge, Fitzwilliam Museum, I*[17] (382 mm × 247 mm; ff. 478; 61 historiated initials). A *de luxe* book in the style of the illuminated Life of S. Denis,[18] it can be assigned by style to Paris, *c.*1250–60. On folio 3ᵛ in a fifteenth-century hand is a partly erased mark of provenance: 'Ista biblia est de domo vallis viridis prope parisius [Vauvert in Paris] ordinis cartusiensis.' The Pauline cycle has been simplified here by replacing many of the subjects with single figure or preaching scenes. Only four recognizable scenes are drawn from the cycle.

14. *Cambridge, University Library, Gg.6.15*[19] (191 mm × 153 mm; ff. 504 and 2; 80 historiated initials). This is a fine Bible, dated and localized by style as *c.*1260 from France (probably Paris), of unknown provenance. Its Pauline cycle is reduced, only seven of the fourteen scenes being represented.

15. *London, British Library Add. 38114–15,*[20] 2 vols. (285 mm × 200 mm; vol. I, ff. ii and 328; vol. II, ff. 422; 81 historiated initials). A relatively late Bible, it is dated and localized by style as *c.*1275 from North or North-East France. The Pauline cycle is altered in a number of ways by what are probably errors. On vol. I, fol. ii, in an eighteenth-century hand is written: 'Monasterii sancti Michaelis [i.e., St. Mihiel in the diocese of Verdun] de sancto Michaele congregationis sanctorum Vitoni et Hydulphi.' It was given to the British Museum in 1912 by A. H. Huth.

16. *London, British Library Add. 52778: the 'York Bible'*[21] (240 mm × 140 mm; ff. 427; 51 historiated initials). This Bible is considered on stylistic grounds to be English, *c.*1250–75, and to have been made at York. It came to the British Museum from the collection of E. G. Millar, and contains a simplified version of the Pauline cycle.

17. *New York, Pierpont Morgan Library, M.269*[22] (222 mm × 159 mm; ff. 425; 70 historiated initials). Made about 1245–50, it contains a much simplified version of the cycle (the scenes common to the other manuscripts in this group are used for only Rom., I Cor., and II Cor. The other Epistles are illustrated with the single figure of Paul). It is related to the Bible in Ste. Geneviève.

18. *Rouen, Bibliothèque Municipale, 10 (A.32)*[23] (290 mm × 195 mm; ff. 374; 81 historiated initials). This is a rather crude manuscript, the style suggesting a date of *c.*1240–50; Paris as a

[16] The 4 photographs are of Eph., Col., I Thess., II Tim. (mistaken use of the scene for I Tim.).

[17] M. R. James, *A Descriptive Catalogue of the Manuscripts in the Fitzwilliam Museum* (Cambridge, 1895), 1–6; Branner, *Manuscript Painting*, 224.

[18] Paris, BN Nouv. Acq. fr. 1908.

[19] *A Catalogue of the Manuscripts Preserved in the Library of the University of Cambridge*, 6 vols., eds. C. Hardwick and H. R.

Luard, III (Cambridge, 1858), 221.

[20] *Catalogue of Additions to the Manuscripts in the British Museum in the Years MDCCCCXI–MDCCCCXV* (London, 1925), 13–14.

[21] D. H. Turner, 'From the Library of Eric George Millar', *British Museum Quarterly*, 30 (1965–6), 80–7.

[22] Branner, *Manuscript Painting*, 207.

[23] *Cat. Gén.*, I (Paris, 1886), 3–4.

place of origin is indicated by the Calendar on folios 159ᵛ–161ᵛ. It was given to the Capuchins of Mortagne in 1675, and contains simplifications of the cycle as well as a number of errors.

These eighteen manuscripts (twenty-one with Branner's additions) represent a fairly large segment among the thirteenth-century Bibles that were illustrated with complex scenes for the Epistles. Their histories, moreover, as far as they are known, indicate a strong concentration of distinguished owners: royal (Nantes, Dobrée VIII, and Paris, BN lat. 14397); high ecclesiastical (Brasenose 1, Cava, and Bologna); scholarly (Göttweig 55 might have been a scholar's book). Several more are of the highest quality, obviously intended for important patrons, particularly the Bible in Madrid, the two in Cambridge, and the one in New York. Notable also are the large dimensions of a number of these books: five are over three hundred millimetres in height and two of these are over five hundred, a grand scale indeed in the thirteenth century.

It is likely that special care was taken in the illustration of these manuscripts, and that the scenes depicted in them conceivably represent advanced ideas and might reflect the guidance of scholars in their invention. Certainly this new cycle, invented in the thirteenth century, is not merely a rubber stamp of traditional schemes.

Although consideration of the Old Testament is outside the scope of the present study, a rapid perusal suggests that the iconographic unity to be observed in the Epistle illustrations is also to be found elsewhere. Until the publication of the Toronto *Corpus of Bible Illustrations* we cannot know whether the originality of the iconography of the Pauline Epistles is also characteristic of the remaining portions of these Bibles.[24]

The Prologues

As I have already mentioned, De Bruyne's '*It 1*' prologues are influential in determining aspects of the iconography. There are eleven of these lengthy prefaces, introducing all of the Epistles except Romans, Philemon, and Hebrews. Virtually unknown and seeming to go back no earlier than the eleventh century, they differ from the Marcionite prologues in that they are more balanced in doctrine, acting as summaries of the texts of the Epistles, although the contrast between law and faith is a prominent theme in them as well.

Evidence for a link between the illustrations and the prologues rests mainly on one Bible, Göttweig 55. All of the *It 1* prologues can be found in Göttweig 55, thus adding a fourth *exemplum* to the three edited by De Bruyne.[25] The arrangement of the page in Göttweig 55 is noteworthy, since it has a bearing on the visual interpretation of the written word. The *It 1* prologues are always on the same page as the initial beginning the text of the Epistle (Figs. 238–40); usually the whole prologue or, at the very least, its *explicit* is in the same column as the initial. Immediately between the *It 1* prologue and the initial is the Marcionite prologue.[26]

[24] P. H. Brieger has remarked the unity of Old Testament iconography of many of the members of the group (oral communication).

[25] The 3 Bibles cited by De Bruyne, *Préfaces*, 239, are: (1) Rome, Bibl. Nazionale Centrale Vittorio Emanuele II, Sess. 3 (SSVII), Tuscan, of the second quarter of the 12th c., with purely ornamental initials; see K. Berg, *Studies in Tuscan Twelfth-Century Illumination* (Oslo–Bergen–Tromsö, 1968), 34, 38, 308. (2) In the same library, MS Sess. 34 (1269), an eleventh-century Bible which came from the Abbey of Nonantola, and also has purely ornamental initials. (3) Rome,

Bibl. Casanatense 723, Florentine, of the fourth quarter of the 12th c. Five of the Epistles are illustrated with bust-portraits of Paul (Rom., fol. 219ᵛ; I Cor., fol. 225ᵛ; Gal., fol. 235; I Thess., fol. 242ᵛ; Tit., fol. 248). See Berg, *Studies*, 143–5, 305–6, Figs. 237–9. The Italian origins of De Bruyne's *exempla* probably suggested the title '*It*'.

[26] The Marcionite prologue for Eph. (fol. 267) is omitted. Göttweig 55 also has an elaborate series of prologues for Rom., a most unusual occurrence at this date: Pelagius' prologue to all the Epistles (Stegmüller 670, De Bruyne, 213–15); Pelagius' prologue to Rom. (Stegmüller 670, De

Three elements, therefore—the *It 1* prologue, the Marcionite prologue, and the initial—are in close proximity to each other and are visible simultaneously, an arrangement that has important consequences for the subject matter of the illustrations.

In Göttweig 55 the *It 1* prologues are all titled 'prologus' and the Marcionite prologues are called 'argumentum'. The Guido Bible in Cava, the only other manuscript in the Prologue Cycle group to include any of the *It 1* prologues—in only one place, as a preface to I Corinthians—also labels it 'prologus'. As in Göttweig 55, each of the Marcionite prologues is called 'argumentum'. It should be noted that the Marcionite prologues usually are labelled 'prologus' when they are alone (Figs. 261, 272).

This nomenclature is echoed in the few published occurrences of any of the *It 1* texts. The edition of Bruno's commentary on the Epistles, for example, includes the *It 1* prologues for I and II Corinthians which are called 'prologus' whereas the Marcionite prologues are 'argumentum', whether they are used along with the *It 1* texts or alone.[27] The same system is followed in the *Glossa Ordinaria*: the *It 1* prologues are labelled 'prologus' and are used for I and II Corinthians, and the Marcionite prologues are called 'argumentum' and accompany every Epistle.[28] J. Wordsworth's edition of the New Testament follows the same practice: only the *It 1* prologues for I and II Corinthians are included, labelled 'prologus', as against 'argumentum' for the Marcionite prologues.[29] As proof of the rarity of the *It 1* prologues, Wordsworth based his edition of the two prologues on a single fourteenth-century manuscript and on early printed Bibles, in contrast to most of his *exempla*, drawn from the sixth to the ninth centuries.[30]

The importance to the present study of the *It 1* prologues lies in their influence on the pictures. Since the prologues are physically present in Göttweig 55, one of the earliest and most accurate of the whole group of manuscripts, the hypothesis can be advanced that the original illustrated manuscript, from which all the others descend, also included the *It 1* prologues. In addition, it is certain that the Marcionite prologues also were in the original, since there are very few medieval Bibles or commentaries from which they have been excluded.

The Styles of the Prologue Cycle Manuscripts

If the subject-matter of the illustrations derives in part from the prologues, it will also become clear in the following discussion that the imagery frequently seems to come from the *Bibles Moralisées*.[31] Often the Prologue Cycle illustrations are similar to those in corresponding portions of the *Bibles Moralisées*, but occasionally the former appear to be based on completely unrelated representations in the latter. The proposal can therefore be put forward that a *Bible Moralisée*, or a manuscript like it, served as a pictorial model book from which the original Prologue Cycle artist was free to draw, amend, and rearrange at will. The Epistle illustrations in the *Bibles Moralisées* themselves have no apparent connection with the influence of *It 1* prologues since they are for the most part simple preaching scenes. The two projects—*Bible Moralisée* and Prologue Cycle—although perhaps products of a single workshop, or of several closely related ones, were independent of one another.

Bruyne, 215–17); Marcion's prologue to Rom. (Stegmüller, 677, De Bruyne, 235); Pelagius' Concordance to the Epistles (De Bruyne, 220–3). See my Figs. 238–40 for samples of first pages of Göttweig 55.

[27] *Expositio in Omnes Epistolas Pauli, PL* 153:121–2, 217–18.

[28] *GL. Ord.*, VI, *I ad Cor.*, 193–4; *II ad Cor.*, 355–6.
[29] Wordsworth-White, *Novum Testamentum*, II, 154, 281.
[30] The 14th c. MS source is London, BL Add. 18720, which has the *It 1* prologues for I and II Cor. only.
[31] See above, n. 4.

Consideration of the styles of the Prologue Cycle manuscripts is appropriate here, since it is helpful to establish them in chronological order and to view them in their relationship to the *Bibles Moralisées*. Recent scholarship concering the latter—notably the contributions of Reiner Haussherr and Robert Branner—has expressed general agreement on their dating; a number of other manuscripts, including several prominent in the present study, have been cited in association with them.[32] There are four principal manuscripts of the *Bible Moralisée*: two in Vienna containing parts of the Old Testament, ÖNB 1179 and ÖNB 2554, and two three-volume editions of the entire Bible, one in the Toledo Cathedral Library and the other divided among three libraries: the Bodleian in Oxford, the Bibliothèque Nationale in Paris, and the British Library.[33] Together they cover the entire range of Paris styles practised between *c.*1220 and 1250. The Prologue Cycle Bibles march in step with them.

It is generally accepted that the *Muldenfaltenstil* (literally, 'depressed-fold style')—a system of modelling that reveals form through softly clinging drapery arranged in folds with hairpin-like terminations—came into being, flourished, declined, and was replaced by a more abstract style during the first half of the thirteenth century, although complete agreement is still lacking on the dating of individual monuments.[34] Several phases of this development are to be found in the products of the *Bible Moralisée* workshops. The earliest, the two manuscripts in Vienna and the first sixty-four folios of the third volume of the Toledo manuscript, probably made in the 1220s, incorporate the efforts of artists who use the *Muldenfaltenstil* to good advantage in defining the fullness of form (Fig. 241) although for the most part the folds are less tense and less sharply defined than in the best works in this style.[35] The depressed folds have become more pointed in another section of the New Testament in the manuscript in Toledo (Fig. 242), possibly of the late 1220s. Haussherr characterizes this style as the 'declining' phase of the *Muldenfaltenstil*. A later stylistic development belonging to the 1230s is represented by much of the remainder of the Toledo manuscript—that is, additional sections of the New Testament and the entire Old Testament—and by most of the other three-volume version (Figs. 243, 309), probably produced between 1235 and 1245. Here, the *Muldenfalten* have disappeared. The folds are stiff, disguising rather than revealing form and tending to be arranged in abstract panels. Finally, there is a style of 'big folds' (Fig. 244) related to the elegant style of massive-folded impressive draperies worn by graceful figures in the sculpture made for the court of St. Louis in the 1240s.[36]

[32] R. Haussherr, 'Christus-Johannes-Gruppen in der Bible moralisée', *Zeitschrift für Kunstgeschichte*, 27 (1964), 133–52, esp. 147; idem., 'Beobachtungen an den Illustrationen zum Buche Genesis in der Bible moralisée', *Kunstchronik*, 19 (1966), 313–14; idem., 'Templum Salomonis und Ecclesia Christi—Zu einem Bildvergleich der Bible moralisée', *Zeitschrift f. Kunstg.*, 31 (1968), 101–21; idem., 'Bible moralisée', *Lexikon der christlichen Ikonographie*, I (1968), cols. 289–93; idem., 'Sensus litteralis und sensus spiritualis in der Bible moralisée', *Frühmittelalterliche Studien*, 6 (1972), 356–80, esp. 357; idem., 'Ein Pariser martyrologischer Kalender aus der ersten Hälfte des 13. Jahrhunderts', *Festschrift Matthias Zender* (Bonn, 1972), II, 1076–103, esp. 1101–3; idem., *Bible moralisée, Faksimile Ausgabe in Originalformat des Codex Vindobonensis 2554 der österreichischen National-bibliothek*, 2 vols. (Graz, 1973); idem., 'Eine Warnung von dem Studium von zivilem und kanonischem Recht in der Bible moralisée', *Frühm. Stud.*, 9 (1975), 390–404, esp. 390. R. Branner, *Manuscript Painting*, 32–65. See also, G. Schmidt, *Die Gotik in Niederösterreich* (Vienna, 1963), p. 112; and A. Stones, 'The Earliest Prose Lancelot Manuscript?', *Reading Medieval Studies*, 3 (1977), 12–44, esp. 17–18. I am grateful to Dr Stones for discussing this question with me and for calling my attention to several important articles.

[33] See n. 4 and Haussherr, *Bible moralisée, Faksimile* (n. 32).

[34] In addition to the works cited in n. 32, a brief definition of the style and a summary of its development is given by K. Hoffmann in *The Year 1200*, I, XXXIV. Hoffmann's dating coincides with Haussherr's, but somewhat later dates are given in a review of the same monuments in W. Sauerländer, *Gotische Skulptur in Frankreich 1140–1270* (Munich, 1970), 48–54.

[35] e.g. the Death of the Virgin Tympanum at Strasbourg (Sauerländer, *Gotische Skulptur*, Fig. 131) dated by Haussherr as *c.*1220.

[36] Sauerländer, *Gotische Skulptur*, Figs. 184–5.

The French Bibles of the Prologue Cycle group undergo a style development parallel to that of the *Bibles Moralisées*, although perhaps practised by inferior masters. The distinction between earlier and later stylistic tendencies is important, because style seems to coincide with iconographic 'correctness' or 'error'. As I have already noted, it is possible to speak of the imagery being 'right' or 'wrong' because it is so patently derived from a textual source, and, in many cases, from an indentifiable pictorial model in the *Bible Moralisée* as well. There are enough examples in the Prologue Cycle group that it is possible to attempt a standard summary of a given scene based on the elements common to most of the manuscripts. Using these shared features as a point of departure a hypothesis concerning the 'original' is attempted. The scenes are so detailed and so particular in their references that they cannot have descended from more than one original. In other words, the Prologue Cycle was only invented once.

The earliest manifestations of the *Muldenfaltenstil* as found in the *Bibles Moralisées* are lacking in the Prologue Cycle group, although a few echoes of it can probably be found in the Madrid Bible (Fig. 301). The next phase, that of the declining *Muldenfaltenstil*, characterized by sharpened folds, is represented by three Bibles with full cycles: Göttweig, Madrid, and Ste. Geneviève. In Göttweig the drapery still appears soft, and the folds are functional in defining volume, although outline of the silhouette is more important than in earlier phases of the style (Figs. 285, 310). The same is true of the Ste. Geneviève Bible (Figs. 280, 297). In both of these manuscripts, each depressed fold is made by a single tapering brush-stroke, in comparison with the earlier style in which the edges of the folds are carefully drawn then filled in with tonally shaded colour, resulting in a distinction between highlight and shadow and aiding the effect of plasticity. In contrast to the Göttweig and Ste. Geneviève versions, the Bible in Madrid has more carefully drawn folds, conveying the impression that the manuscript is somewhat earlier than the two others (Figs. 281, 301). On the other hand, in the Madrid Bible the tendency towards stiffening is more in evidence than in the other two. Most likely all three are contemporaneous, falling within a ten-year span (1225–35).

These three Bibles are about equal in their achievement of accuracy. On the whole, Göttweig is the most reliable in respect to the illustrated manuscript model. As I have shown, Göttweig is provided with the prologues which play a part in determining the subject-matter of the illuminations. The eye of the beholder sees the words and the image simultaneously (Figs. 238, 239, 240). Therefore, as one would expect, the Göttweig Bible is relatively free from the tendency characteristic of so many of the manuscripts to wander from the original interpretation. The Göttweig manuscript has one trait, however, which indicates that it is not itself the original from which the others were copied. Its individual scenes compared to corresponding scenes in the *Bible Moralisée* usually have been reduced by the elimination of supernumerary figures, a not illogical improvement.[37] That originally the cycle must have retained some of these figures is often revealed by other manuscripts in which they persist.[38] In reducing the number of figures, the artists of the Göttweig Bible occasionally also rearranged the compositions. The iconography, however, usually was not seriously distorted.

Despite its closer resemblance to the *Bible Moralisée* in a number of illustrations the Madrid Bible is more eccentric than the others.[39] Resemblance to the *Bible Moralisée* is based partly on the inclination of the Madrid manuscript to retain more figures in its scenes. On the other hand,

[37] See e.g. below, I Cor., Figs. 250 and 255.
[38] The Madrid, Olschki, and Bologna Bibles share this tendency.

[39] See e.g. below, II Tim., Figs. 314, 316.

certain of the Madrid scenes seem to be unique, perhaps personal, interpretations of the subject.[40] Madrid also contains two downright departures from the norm: the usual scene for I Corinthians in the cycle is used for Romans, and I Corinthians is changed into an ordinary messenger scene.[41] The artist of the Madrid Bible reveals himself to be an original creative personality in a number of ways. He seems always to be thinking of the aesthetic effect of his composition, often rearranging scenes to give a more balanced harmony. He manages to convey the vehemence of the text by means of the strength of his linear patterns. It is reasonable to suppose that he also might have introduced improvisations in iconography, instead of copying passively, so one must be cautious in using this manuscript in an attempt to reconstruct the original, however much one admires it.

Least like the *Bible Moralisée* in its external aspects, the Ste. Geneviève Bible is closest to the *It 1* text in its accuracy of interpretation. Perhaps because it is quite a small manuscript, it tends not only to eliminate extra figures, but also to do away with almost all material properties such as buildings and furniture. Yet the intended meaning usually is made quite clear, sometimes in a more imaginative way than in the other manuscripts.[42] The artist understood what he was doing. Stylistic and iconographic similarities link the partial cycles in the lost Olschki manuscript and the Bible in the Morgan Library with the Ste. Geneviève Bible. Because their scenes usually are less reduced than those of Ste. Geneviève, they help to put the latter into the context of the other manuscripts in the group.[43]

The more abstract, flat style of the three-volume *Bibles Moralisées* is preceded in the Prologue Cycle by a further group of manuscripts representing moments in the decline of the *Muldenfaltenstil*. The more important members of this group are Vatican Rossiana 314, Bologna 297, and the Bible of Blanche (Paris, BN lat. 14397).

Retaining vestiges of the depressed folds in the drapery, the artist of the Rossiana Bible relies more on a strong, emphatic outline to convey his idea of form, so that the folds become decorations in the broad areas defined by the lines as in the illustrations for I Corinthians and Philippians (Figs. 251, 282). This tendency can also be observed in the related, but inferior, manuscript in Bologna (Fig. 307). The Rossiana and Bologna Bibles have many iconographic features in common with the Göttweig manuscript, but they share one distinct mistake in the illustration for Philippians (Figs. 282, 283) which separates them into a sub-category of their own. It is evident that they do not descend from Göttweig itself, but from a model higher up in the redaction, since, as already pointed out above, the Bologna Bible tends to include some of the figures absent in Göttweig.

A few decorative remnants of the *Muldenfaltenstil* persist in the Bible of Queen Blanche, submerged in the hastily sketched and insubstantial forms and vague imagery: even Paul cannot always be identified, most of the figures are handsome and too youthful, and there are obvious mistakes, as in the illustration for I Thessalonians (Fig. 294).

The later phase, in which form becomes less sculptural and is outlined by flat, stiff, thickly outlined panels, is represented by the Bible in the Fitzwilliam Museum in Cambridge. A comparison of the illustration for I Corinthians in the Fitzwilliam Bible with a similar scene in the London section of the *Bible Moralisée* brings out the similarity, although the leaning toward

[40] See below, II Cor., Phil., Figs. 262, 281.

[41] The confusion in iconography might be connected with the fact that the Madrid Bible also uses unusual prologues for Rom.—in addition to Stegmüller No. 670, which is commonly found in most Bibles, it has No. 674 (as does Göttweig)—and for I Cor. Stegmüller 654, usually found as a prologue to Rom.

[42] See, for example, the illustrations for Rom. and Heb., Figs. 248, 328.

[43] See below, Col., Fig. 289.

abstraction of form is more pronounced in the Fitzwilliam manuscript, since it is at least ten years later than the *Bible Moralisée* (Figs. 254, 255). The passage of time is shown as well by the dissipation of the unity of the cycle in the Fitzwilliam manuscript. Those scenes that remain are not incorrect in their iconography—although they lack the precision of the earliest group—but only four of the original fourteen scenes remain.[44] The rest have lost their narrative content, and have declined into preaching and messenger scenes.

The final stage of the style sequence is marked by the Nantes Bible, in which the forms are built of massive, elegant folds modelled in highlight and shadow (Fig. 300), in contrast to the linear modelling of the earlier styles. Within these large folds exist puny, childlike human figures. This style lends itself to elegance and charm, characteristics which tend to have a distorting effect on the original subject matter. In general, the Nantes Bible adheres to the iconography of the early cycle, but the strength and vehemence present in the first members of the group is contradicted by the frail physiques, the charming heads, and self-conscious poses of the figures. A comparison of the roughly vigorous illustration for II Timothy in the Ste. Geneviève Bible with the same scene in the Nantes manuscript (Figs. 311, 312) reveals how the message of the earlier— conveyed by the artist's gesture as well as by iconography—is muted in the later style.

Painted in the Italian classicizing style of the late thirteenth or early fourteenth century, the Cava Bible stands apart from the sequence of style development. It is quite exact in its iconography, but here too, the lack of vehemence lowers the emotional tone considerably (Figs. 267, 271). The fact that the Cava Bible retains one *It 1* prologue is an indication that it had an accurate manuscript as its model. Undoubtedly the meaning of the image was still understood by the artist of this Bible.

It is clear, therefore, that in the earlier versions of the Prologue group, the *Muldenfaltenstil*— corresponding to the earlier stages of the *Bibles Moralisées*—functions as an adjunct to the expressiveness of the imagery. The style development taking place over several decades is accompanied by dilution and loss of accuracy in the iconography.

Existence of most of the styles of the *Bibles Moralisées* in the Prologue Cycle manuscripts provides strong evidence that they are products of the same stylistic milieu. It is noteworthy that the earliest and most accurate of the Prologue Cycle Bibles seem to antedate the corresponding portions of extant *Bibles Moralisées*, and therefore it is unlikely that any of the latter served as the model. Conversely, the Prologue Cycle Bibles may themselves prove helpful in future attempts to reconstruct the history of the *Bibles Moralisées*, since they might go back to a lost portion of the New Testament in one of the earlier style phases.

The following book-by-book examination of the Prologue Cycle manuscripts reveals the way in which they relate to each other as well as to the *Bibles Moralisées*. In addition, an unusual text/picture relationship, of the utmost complexity and subtlety, is brought to light.

II. THE EPISTLE SCENES

Romans (Figs. 245–248, 256)[45]

A scene of Paul raising a large cross towards a group of three Jews is common to the majority of

[44] Rom., I Cor., Col., Heb.

[45] Paul preaching to the Jews with a cross (or a recognizable variant): Bologna, fol. 42; Camb., Fitzwilliam, fol. 392; Camb., University, fol. 423; Cava, fol. 434; Dijon, fol. 365ᵛ; Göttweig, fol. 257ᵛ; London, BL 52778, fol. 387; Munich, fol. 438ᵛ; Nantes, fol. 414; New York, Morgan, fol. 384;

manuscripts in the group. Some of the later manuscripts introduce variations in the pose, or they reduce the number of figures or confuse their actions slightly,[46] but the collective evidence of the older and better manuscripts is unmistakable. This image emphasizes the confrontation between Christianity and its opponents as the principal message of Romans. Depiction of Paul's adversaries as Jews probably has a three-fold function: they represent simultaneously the Old Law (stigmatized by Paul in the letter), the contemporary Jewish community, against which there was strong feeling in the thirteenth century, and the infidel in general.[47]

An interpretation of the Epistles that stresses those aspects of Paul's teachings standing in opposition to the Old Law—and, by extension, to all the ways of unbelief—is also typical of the *Bible Moralisée*.[48] The Toledo version, for example, in which some of the prologues to the Epistles are written as if part of the text, signalizes with Romans the attitude that will be taken in its text and pictures. It starts with a short prologue informing us that 'This is the beginning of the letters of Paul, of which the first is to the Romans, showing that virtue and salvation are achieved not through the law, but through faith in Jesus Christ.'[49]

Although the 'literal' illustration for Romans 1:1 in the Toledo manuscript is a preaching scene, a representation of Paul confronting the Jews with a cross not unlike the Prologue Cycle depictions appears as the 'moralization' to this text (Fig. 249), but incorporating as well certain features absent in most of the Prologue Cycle Bibles: Paul, in front of a group of adherents, holds toward three Jews a large cross supporting the *corpus* of the crucified Christ. The Jews bear aloft a small tabernacle containing a graven image of a male figure holding a shield. The picture is accompanied by a text which makes the meaning explicit: 'In dispute, the apostle writes to the Romans, refuting both Gentiles and Jews, teaching them to humble themselves, that they might attribute all things to grace.'[50] The iconographers are making double use of the image of Jews as infidels by portraying them at the moment of worship of an idol. The obvious inference is that the cross triumphs over the graven image through Paul's teachings.

Images of Paul preaching to the Jews are too commonplace for us to establish the *Bible Moralisée* representation beyond doubt as the model for the Prologue Cycle scene, but this possibility is not to be excluded. Certainly the two projects are similar in outlook and imagery. As usual, the Prologue Cycle interpretation, confined to small initials, is more succinct than the comparable scene in the larger roundels of the *Bible Moralisée*.

In the majority of manuscripts in the cycle, the usual reduction is apparent: Paul is alone,

Brasenose, fol. 416; Paris, BN 14397, fol. 327ᵛ; Ste. Geneviève, fol. 334ᵛ; Vat. Rossiana, fol. 444; Rouen, fol. 308ᵛ. Other: London, 38115, fol. 281 (single figure with sword and cross); Madrid, fol. 287 (Eucharistic scene).

[46] e.g. in Dijon and BN 14397, Paul addresses only one man; in the latter he has lost his cross, and in Nantes, Brasenose and BL Add. 52778, all the figures are seated.

[47] See above, Ch. 2, n. 109.

[48] Blumenkranz, *Juif médiévale*, s.v., 'Les thèmes de la polémique antijuive', 50–77, draws many of his examples from the *Bible Moralisée*. Haussherr, *Faksimile*, II, 33 has also noted this attitude.

[49] Toledo, III, fol. 127: 'Incipiunt epistole pauli quarum prima est ad romanos in quo ostendit virtutiam et salutatem non per legem esse sed per fidem Jesu Christi.' This prologue

has not been noted elsewhere. There are 4 other prologues included in the Toledo MS, always the Marcionite version, or a paraphrase of it. The prologue for I Cor. (fol. 129) is treated as a prologue: i.e. it is written in smaller script. The rest—I Tim. (fol. 143), II Tim. (fol. 146), Philem. (fol. 149)—are written as if part of the text.

[50] Toledo, *Bible Moralisée*, III, fol. 127: 'pro [?] altercatione scribit Romanis apostolus confutans modo gentiles iudeos docens eos humiliari ut omnia attribuant gratie.' The upper of every pair of roundels in the 3-volume *Bibles Moralisées* is a 'literal' depiction of the accompanying Scripture text. Below it is the 'moralization', giving an allegorical or moral interpretation of the same episode, together with a verbal commentary on the text. There are 4 pairs of roundels to each page, arranged in 2 columns and intended to be read vertically.

rather than accompanied, and there is no tabernacle. The Ste. Geneviève Bible (Fig. 248), despite even greater condensation, reminds us not of the form but of the content of the *Bible Moralisée* iconography. Paul and a Jew are engaged in altercation. Paul has lost his cross, but carries a small panel with an image on it, no doubt meant to represent an icon of Christ. The Jew carries a contrasting image, the Golden Calf. This exceptional Bible thus exhibits features which are probably closest to the original core of meaning, but are lacking in any of the other examples.

There is no *It 1* prologue for Romans, so that we cannot submit the picture to that test. The Marcionite prologue, of course, is present, and the illustration is very much in accord with its doctrine, which emphasizes confrontation between Paul's teachings and the Law. It also provides a verbal image of Paul personally communicating with the Romans and in strong terms calling them back to the evangelical faith.

The illustration for Romans is an effective introduction to the whole Prologue Cycle, in which Paul's doctrine is displayed as a force at the service of an embattled church. The rest of the illustrations—like Romans—will be 'preaching' scenes, but of a special kind. Paul's message is on the page, and we also see him delivering it. Such a juxtaposition of a picture showing the communication of a letter along with the letter itself is related to some of the methods of depicting the epistolary or preaching nature of the Epistle, as discussed in Chapter Two.[51] But here something new has been added in that we are shown the meaning of the message as well as the act of transmission.

I Corinthians (Figs. 250, 254, 257)[52]

Most of the Prologue Cycle Bibles use a mystifyingly specific scene as the illustration for I Corinthians. Paul, as a priest, celebrates the Eucharist by placing the Host in the mouth of a man kneeling at the left, his hands lifted in prayer. Behind the man in a kneeling woman wearing a barbette and cap, her hands raised high.

As a depiction of the rite, the eucharistic iconography in the Prologue Cycle is traditional. A comparison with a scene from the *Vita Benedicti* of the second half of the eleventh century shows that the main components of the thirteenth-century version are all present: the priest is behind the draped altar, facing forward, and the communicant is shown on the left; in the *Vita Benedicti* the priest is provided with an assistant, who holds the chalice behind the altar.[53]

Peculiar, however, to the Prologue Cycle Bibles is the repetition in all of the manuscripts of the man and the woman in their particular poses and the careful depiction of the details of the woman's dress. A similar scene used as the moralization to Mark 16: 1–3 in the Harley portion of the divided *Bible Moralisée* provides a parallel (Fig. 255).[54] A cleric behind a draped altar, holding

[51] See above, Ch. 2, *Paul as Preacher*. The cross-and-sword group and several other MSS (Ch. 2, n. 114) use the scene of Paul preaching to the Jews with a cross, but these examples are all later than the early group of the Prologue Cycle MSS, and probably represent a simplified form of the latter.

[52] Paul as a priest communicating a man while a woman waits: Bologna, fol. 46; Camb., Fitz., fol. 396ᵛ; Camb., University, fol. 427ᵛ; Cava, fol. 439; Dijon, fol. 369ᵛ; Göttweig, fol. 260ᵛ; Nantes, fol. 443ᵛ; New York, Morgan, fol. 388ᵛ; Brasenose, fol. 421ᵛ; Paris 14397, fol. 331; Ste. Geneviève, fol. 338ᵛ; Rossiana, fol. 449; Rouen, fol. 312. Other: London, BL 38115, fol. 288 (Paul in mass vestments prays at altar with covered elements; 2 or 3 men

behind him); Madrid, fol. 290 (messenger scene); Munich, fol. 443ᵛ (Paul in bed, visited by an angel; see below, n. 63); London, BL 52778, fol. 391 (orn.).

[53] Rome, Vat. lat. 1202, fol. 62. The scene appears among a series of sacraments. See also M. Vloberg, *L'Eucharistie dans l'art* (Grenoble–Paris, 1946), s.v., 'L'illustration de la liturgie eucharistique en occident', 55–70; and K. Lankheit, 'Eucharistie', in *Reallexikon zur deutschen Kunstgeschichte*, VI (Stuttgart, 1971), cols. 154–254. Unfortunately, neither author cites many medieval examples of actual liturgical representations.

[54] London, BL Harley 1526–7, II, fol. 59ᵛ.

a chalice in his left hand, gives the Host to a man wearing a *garde-corps*, who kneels, as does the woman behind him, in the pose of the couple in the Prologue Cycle Bibles. The woman is dressed and coiffed in similar fashion to the woman in the Bibles as well. Three people wait their turn on the left.

The representations in the Prologue Cycle Bibles and the *Bible Moralisée* are so similar that it can be assumed that there was a common model. The former can be broken down into subordinate groups, each of which shares certain features of the *Bible Moralisée* scene. In the Göttweig sub-group (Figs. 250, 251),[55] Paul has replaced the priest, and wears the priest's vestments. The kneeling man is variously clothed among the members of the sub-group, but in none of them does he wear the *garde-corps*. He is clad only in a tunic in the Göttweig Bible itself (Fig. 250), and in the Bologna and Rossiana (Fig. 251) versions he wears a long gown and cape or *chlamys*. The most important alteration in all members of this category is that no chalice is visible.

In the second sub-group, the Ste. Geneviève and Morgan Bibles (Figs. 252, 253), both the man and the woman wear the dress of the *Bible Moralisée*—that is, the man wears the *garde-corps*—but Paul wears his traditional garment instead of priest's vestments. As in the Göttweig type, there is no chalice. The altar has been eliminated as well.[56]

Typified by the Fitzwilliam and Nantes Bibles (Figs. 254, 257), the third sub-group, produced after 1250, has certain similarities to the first. Paul is dressed as a priest, and the man does not wear a *garde-corps*. The main difference is that the chalice has been added, or retained.[57]

An explanation for these differences emerges when we attempt to reconstruct the history of the iconography. Reasons for choosing the eucharistic scene as the illustration for I Corinthians are not difficult to find. I Corinthians 10:16 and 11:23–6 are among the most prominent scriptural accounts of the institution of the Eucharist.[58] The designers of the Prologue Cycle iconography were making a standard judgement in deciding upon the eucharistic theme as the message of I Corinthians. The question may be asked, however, as to why the particular details of this scene were chosen and why the dress of the participants was asserted so emphatically. The answer might lie in the text of the *It 1* prologue for I Corinthians. The prologue is a summary of the contents of the Epistle. Toward the end of a systematic enumeration of the points in the letter, two items are juxtaposed: '. . . advice is given concerning the head, which ought to be shorn by men and covered by women, and also concerning the mutual sharing of the sacraments.'[59] The combination of a woman wearing a hat and together with a bareheaded, short-haired man participating in the sacrament might have been suggested by the fortuitous combination of words in the prologue text. In view of the tendency of this cycle to draw contrasts between the people of the Law and the people of faith, emphasis on dress and style of hair is an interesting theme. Jews were required by their own law not to cut their hair short or to shave their beards, and they prayed with covered heads.[60] Furthermore, by this time, they were forced by civil and church authorities to adopt special dress.

If a book similar to the extant *Bibles Moralisées* did indeed serve as a model for the cycle,

[55] The group includes Göttweig, Bologna, Rossiana, BN 14397, Dijon, Cava.

[56] Rouen is also of this type.

[57] Cambridge, Fitzwilliam; Cambridge Univ. Lib.; Nantes; Brasenose.

[58] J. Daniélou, *The Bible and the Liturgy* (Notre Dame, 1956), 170; J. A. Jungmann, *The Early Liturgy: To the Time of*

Gregory the Great (Notre Dame, 1959), p. 30; *ODCC*, s.v., 'Eucharist', 468.

[59] See Appendix D for all references to the text of the *It 1* prologues.

[60] Grayzel, *Church and Jews*, 66, n. 112, quotes a rabbinical synod of the year 1220: 'A Jew shall not cut his hair or shave his beard after the manner of Gentiles.'

depictions of the Eucharist would be in plentiful supply and the designers of iconography for the cycle would have been able to find a model for the scene which fitted the strange requirements of the prologue text.

Comparison of the scene in the Harley *Bible Moralisée* (Fig. 256) with the three variations in the Prologue Cycle helps to explain the process by which the imagery was transmitted. In all of the sub-groups, Paul is substituted for the priest in the *Bible Moralisée* scene. The three bystanders on the left probably were not present in the original of the Prologue Cycle, since its scenes tend to be more sparsely populated than those of the *Bibles Moralisées*. Otherwise, the scene might have looked much like that in the Harley manuscript. The predecessor of the Göttweig group altered the dress of the man, and that of the Ste. Geneviève group changed Paul's priestly garb and eliminated the altar, rather unimportant modifications, but useful to us for reconstructing the process of copying.

The most significant alteration, however, is this: both the Göttweig and Ste. Geneviève versions also have done away with the chalice. The absence of the chalice may not be an oversight, since these manuscripts are meticulous in the details of iconography, but is possibly a reference to the growing disinclination in the thirteenth century to permit the laity to drink from the chalice.[61] Whether the original manuscript of the cycle made the distinction is difficult to decide, since the chalice appears again after the mid-century in the Fitzwilliam sub-group (Fig. 254). The Madrid Bible, one of the earliest of the books, has a chalice in its eucharistic depiction (Fig. 255). This scene, however, is out of place in the sequence of the cycle, and therefore suspect as evidence. The Madrid chalice, moreover, is clumsily drawn and ill-adapted both to the definition of space and to the design, so that it is possible that it was added later by a critic who did not understand or disagreed with its omission.[62] The much later Fitzwilliam sub-group tends in general to be not as accurate as the Göttweig. Thus it seems likely that the testimony of the latter is correct and that the original scene lacked the chalice, but in other respects was similar to the model in the *Bible Moralisée* on which it was based.

The approach to narrative used for I Corinthians is similar to that of Romans, in that Paul himself 'acts out' the doctrinal point in the letter. The reader, in seeing the picture at the head of the text, and simultaneously reading the summary in the prologue, is therefore advised by a memorable and appropriate image as to what he must look for in reading the letter.

II Corinthians (Figs. 258, 259, 261, 262, 263)[63]

The standard illustration for II Corinthians shows Paul sleeping in a bed, his head to the left. Behind the bed stands a nimbed angel pointing upwards at a fiery cloud.

Again, it is not difficult to find in a *Bible Moralisée* a scene so similar that it is obvious that it

[61] E. Dublanchy, 'Communion dans les deux espèces,' in *DTC*, III (1908, repr. 1923), 552–72, especially 565: 'Le désuétude du calice, surtout après l'entière suppression de l'*intinctio*, se généralise de plus dans le courant du XIIIe siècle.' The prohibition was summed up by Thomas Aquinas, *Summa Theologica*, ed. J. Pecci, 5 vols. (Paris, 1925), IV, 531: Part IIIa, Ques. LXXX, Art. 12, '... ideo provide in quibusdam ecclesiis observatur ut populo sanguis sumendus non detur sed solum a sacerdote sumatur.' According to Lankheit, 'Eucharistie', col. 196, 'Seit den 2. Viertel des 14. Jh. ist nur noch die Spendung allein des Brotes dargestellt worden.' The evidence of the present study suggests that this had already been the practice for 100 years.

[62] The illustration for Gal. (Fig. 267) provides additional evidence that the Madrid Bible was altered in later years.

[63] Paul in bed, visited by an angel: Bologna, fol. 51; Cava, fol. 443; Göttweig, fol. 363v; London, BL 38115, fol. 295v; Madrid, fol. 293; Munich, fol. 448; Nantes, fol. 474; New York, Morgan, fol. 392v; Brasenose, fol. 426v; Paris, BN 14397, fol. 334v; Ste. Geneviève, fol. 342; Rossiana, fol. 454; Rouen, fol. 315. Single figure with sword: Camb., Fitz., fol. 400v; Camb. University, fol. 432; Dijon, fol. 373. Other: London, BL 52778, fol. 395 (orn.).

descends from the same model.[64] In the depiction of the Dream of Cornelius (Acts 10:3–6) in the Harley manuscript (Fig. 260), for example, Cornelius is shown asleep, his right hand under his ear, his left hand drooping, in the identical pose to Paul in the Göttweig Bible (Fig. 258). The angel, too, makes similar gestures in both representations.[65] This is a common depiction in the *Bible Moralisée* and it is not proposed that the Cornelius scene itself served as the model for the cycle.

What is suggested by the use of this scene in the context of II Corinthians? We must first consider the possibility that what is represented is Paul being taken up to the third heaven. The Middle Ages understood the strange passage in II Corinthians 12:2–5,[66] 'I know a man . . . who was caught up to the third heaven', as referring to Paul himself. Evidence as to one way in which this episode was pictured is provided by a twelfth-century edition of Anselm's prayers and meditations which illustrates the prayer to Paul with a specific scene showing Christ drawing Paul up through the three arcs of heaven (Fig. 264).[67] The same event is depicted only slightly differently in the Toledo manuscript, where it is accompanied by an identifying inscription (Fig. 265).[68] The Toledo scene shows Paul standing in an oval of fire being pulled up to Christ in heaven by two angels, in front of an audience. These two examples suggest that in the Middle Ages the usual pictorial interpretation of Paul's experience showed him awake and consciously participating. Unlike Cornelius he was not dreaming. The presence of Christ as an actor in the scene is an important element.

Another suggestion for interpreting the scene in our cycle is provided by the *It 1* prologue to II Corinthians which ends with a reference to the nefarious activities of the pseudo-apostles, calling them 'treacherous henchmen who change themselves into apostles of Christ in imitation of Satan, pursuing profit, money and gain under the appearance of preaching.' This is a paraphrase of a passage in the text of the letter (11:13–15), ending, 'Satan transforms himself into an angel of light.'[69] The possibility that the angel in the Bible scene is really a pseudo-apostle, or even Satan in disguise, is supported by a comment of Peter Lombard on the text in question: 'He showed himself as a sort of angel of God, evidently [as] Christ or some kind of heavenly angel, that he might deceive.'[70]

Paul himself makes further reference to the angel of Satan in the letter, when he observes that he was given the angel of Satan as a goad to bruise his flesh, to keep him from being over-elated by the revelation shown him.[71] The last reference is helpful as an aid in understanding how the general references to the angel of Satan in the text have been transformed into a narrative scene, taking place as if at one point of time. What we see depicted could be the false angel who has come to goad Paul after the latter's vision of God. This might be why the angel is making such a stern commanding gesture. Identification of the scene as the particular moment when Paul, returned

[64] London, BL Harley 1526–7, II, fol. 66v.

[65] A similar scene depicts e.g. the vision of Joseph in Matt. 1:20 (BL Harley 1526–7, II, fol. 8v).

[66] II Cor. 12:2–5: 'Scio hominem in Christi ante annos quatuordecim (sive in corpore, nescio, sive extra corpus, nescio Deus scit) raptum hujusmodi usque ad tertium coelum. Et scio hujusmodi hominem (sive in corpore, sive extra corpus, nescio, Deus scit) quoniam raptus est in Paradisum, et audivit arcana verba, quae non licet homini loqui.'

[67] Admont, Stiftsbibl., MS 289, fol. 44v. In a German Bible of the 13th c.—(ex) Dublin, Beatty MS 41, fol. 233—a similar

scene illustrates II Cor. itself.

[68] Toledo, III, fol. 132, 'hoc potest significari per verba apostoli ubi ait se raptum fuisse usque ad tercium celum et audisse ibi archana verba que non licet homini loqui.'

[69] II Cor. 11:14: 'Et non mirum, ipse enim Satanas transfigurat se in angelum lucis.'

[70] P. Lombard, *Collectaneorum in Epistolas S. Pauli*, PL 192:74, II ad. Cor. 11:13–15: 'Ostendit de quasi angelum Dei, scilicet Christum vel aliquem coelestum angelum, ut decipiat.'

[71] II Cor. 12:7–8: 'Datus est mihi stimulus carnis meae, angelus Satanae, qui me colaphizet.'

from heaven, is accosted by the false angel, also helps to explain the insistence on the glowing clouds above. It has been suggested that Paul's suffering took the form of an illness, and therefore it is suitable that he should be shown in bed.[72]

Aside from the distortions usual in the later stages of the transmission of an iconographic scheme—such as Paul facing in the opposite direction (Nantes) or only the angel's head appearing, rather than his full figure (Cava, London BL 38115)—there are two manuscripts with variant scenes which merit individual consideration. The first is the Madrid Bible (Fig. 262) in which Paul is shown with the angel between two bands of fiery clouds, the angel pointing with both forefingers in an emphatic, almost ferocious way, up at heaven and down at Paul's empty bed. The interpretation of II Corinthians in Madrid, although it is different than the other manuscripts, supports the supposition that what is being portrayed is the goading by Satan as an angel.

The other variation, in the Ste. Geneviève Bible (Fig. 263), is like that of Madrid in some ways, and it is easier to understand. This manuscript follows its habitual practice of eliminating extra properties, in this case the bed. We are left with a scene of Paul, seated, addressed by a bearded man who makes the usual pointing gesture at a fiery cloud above.[73] It is like the Madrid version in that Paul is awake and in communication with his visitor. The substitution of a man for the angel is an interesting phenomenon in this manuscript, which is often closer to the sense of the *It 1* text. Probably the standard scene—similar to the Cornelius depiction in the *Bible Moralisée*—was used in the original manuscript of the cycle. The Ste. Geneviève artist might have made a deliberate choice in changing the angel into a man because of the ambiguous and misleading connotations of the former in the role of Satan or Satan's agent.

Like the first two scenes in the cycle, II Corinthians conveys its message by placing Paul as a participant in the action, probably taking as a model and adapting a standard narrative motif.

Galatians (Figs. 266, 267, 269–272)[74]

Galatians provides another instance in which the contrast between Christianity and Judaism is stressed in both the illustrations and the prologues.

Paul propels a man forward by pushing his shoulder in the standard scene. The man in turn pushes a woman who forces a child forward toward the border of the picture. It is not difficult to identify this scene as the Expulstion of Hagar (Genesis 21:10–14). The text of Galatians provides the reason why an episode from the Old Testament was chosen:

Abraham had two sons, one by his slave and the other by his free-born wife. . . . The two women stand for two covenants. The one bearing children into slavery is the covenant that comes from Mount Sinai: that is Hagar. Sinai is a mountain in Arabia and it represents the Jerusalem of today, for she and her children are in slavery. But the Heavenly Jerusalem is the free woman; she is our mother. . . . And you, my brothers, like Isaac, are children of [God's] promise. But just as in those days the natural-born son persecuted the spiritual son, so it is today. But what does scripture say? 'Drive out the slave-woman and her son . . .'[75]

[72] See J. Knox, *Chapters in a Life of Paul* (New York-Nashville, 1950), 91.

[73] The Morgan Bible is similar, but the man is nimbed.

[74] The Expulsion of Hagar, or some recognizable variant: Bologna, fol. 54; Cava, fol. 446ᵛ; Dijon, fol. 376 (the child is missing); Göttweig, fol. 266; Madrid, fol. 295; Munich, fol. 451ᵛ (the child is missing); Nantes, fol. 492; Brasenose, fol. 430; Paris, BN 14397, fol. 337 (the child is missing); Ste.

Geneviève, fol. 345; Rossiana, fol. 457. Single figure with a sword: Camb. University, fol. 435; London, BL 38115, fol. 300ᵛ; New York, Morgan, fol. 395 (no sword). Other: Camb., Fitz., fol. 403ᵛ (Paul talks to 2 Jews); London, BL 52778, fol. 397ᵛ (messenger scene); Rouen, fol. 317ᵛ (Paul talks to a man and a woman).

[75] Gal. 4:22–30: 'Scriptum est enim quoniam Abraham duous filios habuit, unum de ancilla, et unum de libera . . .

Paul's metaphor of Hagar and Sarah as representing two opposite natures—Synagogue and Church or Law and Grace—was popular in medieval imagery, verbal and visual.[76] Innocent III, for example, often seems to have employed the phrase.[77]

Confirmation that the Expulsion of Hagar is in fact the subject of this scene is provided by an illustration in a Psalter in Philadelphia which might have been made in the same workshop as the Göttweig and Ste. Geneviève Bibles (Fig. 268).[78] The Psalter scene, close to the Göttweig interpretation in composition and style, shows Abraham expelling Hagar and Ismael to the left, watched by the jealous Sarah with her son Isaac; above is a *titulus* reading 'Abraham iecit Agar cum filio suo.' Reversed from left to right, the versions in the Ste. Geneviève and Madrid Bibles (Figs. 267, 269) are similar. It should be noted that Göttweig and Madrid include another male figure, a feature I shall explain below.

Another occurrence of this episode in the circle that produced these manuscripts is in the Oxford portion of the divided *Bible Moralisée* (Fig. 273)[79] in which Sarah is depicted complaining to Abraham, who in turn gives a judgement against Hagar, seen departing in sorrow with Ismael on the right. The two women are contrasted in their postures—Sarah upright, as Church is often represented, Hagar drooping like Synagogue—and in their head coverings; Sarah wears a barbette and cap, as is proper for a respectable matron, Hagar the slave wears her hair long and uncovered.

Making clear that this theme is meant to represent the victory of Church over Synagogue, the moralized scene of the same Old Testament text in the Oxford *Bible Moralisée* shows a nimbed saint gesturing at figures who perform contrasting actions, a priest elevating the Host and two Jews dropping the tablets of the Law.

In translating the narrative scene into the Bible cycle, certain innovations have been introduced. Paul has been a participant in the action in the three subjects examined up to this point. If the intention were similar in the case of Galatians, Paul should replace Abraham and himself expel the servant-girl and her child. This he does in only one example, the Ste. Geneviève Bible (Fig. 269) in which, as usual, uniqueness results in greater clarity. If, on the other hand, it is intended that Paul act in the role of exponent of doctrine, standing aside and observing the protagonists enforce his ideas, as is true of several of the illustrations for other Epistles,[80] Abraham should be in the scene, pushing out his handmaiden. It is likely, I think, that this was the way the scene appeared in the original version. Strangely, the only example in which Abraham

Haec enim sunt duo testamenta: unum quidem in monte Sina, in servitutem generans, quae est Agar. Sina enim mons est in Arabia, qui conjunctus est ei quae nunc est Jerusalem, et servit cum filiis suis. Illa autem quae sursum est Jerusalem, libera est; quae est mater nostra . . .

Nos autem, fratres, secundum Isaac promissionis filii sumus. Sed quomodo tunc is qui secundum carnem natus fuerat, persequebatur um qui secundum spiritum, ita et nunc. Sed quid dicit Scriptura? Ejice ancillam, et filium ejus.'

[76] Grayzel, *Church and Jews*, 10. In the Toledo *Bib. Mor.*, the moralization for the scene of the expulsion of Hagar begins, 'Agar legem sara gratiam significant' (I, fol. 13).

[77] e.g. in his letter to the king of France, he castigates those who believe that 'ancillae filius cum filio liberae possit et debeat haeres esse, Judaicam servitutem illorum libertati praeponunt, quos Filius liberavit,' *PL* 215, 501, cited by

Synan, *Popes and Jews*, 93 and Appendix IV.

[78] Philadelphia Free Library, Lewis Coll. MS 185; see E. Wolf, *A Descriptive Catalogue of the John Frederick Lewis Collection of European Manuscripts in the Free Library of Philadelphia* (Philadelphia, 1937), 200–4. Schmidt, *Die Gotik*, 112, and Stones, 'Prose Lancelot', 18, have noted the similarity between Göttweig and the Philadelphia Psalter, and Haussherr has mentioned the latter in connection with the Vienna *Bibles Moralisées* ('Kalender', 1101–3); *Faksimile*, 29. Branner, *Manuscript Painting*, connects the Philadelphia manuscript with the Toledo rather than the Vienna *Bible Moralisée* workshop, but he lists Ste. Geneviève 1180 together with the Vienna manuscript.

[79] Oxford, Bodley 270b, fol. 13ᵛ.

[80] See below e.g. I and II Thess.

the patriarch actually appears is in the very late Guido Bible in Cava (Fig. 271). The majority of manuscripts—including the usually reliable Göttweig (Fig. 226)—confuse the situation by substituting a young man in place of Abraham, and representing Paul as expelling him as well. Therefore, Paul seems to be pushing out a whole family. In the Rossiana manuscript, the man is represented as a Jew (Fig. 270).

The physical condition of the scene in the Madrid Bible (Fig. 267) provides an interesting comment on the understanding of this imagery on the part of later readers. The paint has been removed in certain key areas: the point at which Paul's hand might touch the man's shoulder and around the head and chin of the latter. It is possible that a later critic, realizing the ambiguity in Paul's gesture and in the man's youthful appearance, partially altered the picture so that it could be read as Paul advocating that Abraham oust the servant-girl. Conversely, if the Madrid scene originally showed Paul advising Abraham to expel Hagar, it has been changed to make it more like the illustrations in the other manuscripts.

Another uncertain element in the representations in almost all of the Bibles is that Hagar has her head covered. With Sarah absent from the scene it is not possible to contrast the two women, but the lowly status of Hagar should require that she be bareheaded. Since the choice is so widespread it is likely that it was made at an early stage in the process of transmission. Strangely, two manuscripts that usually are quite incorrect represent Hagar as bareheaded—Paris, BN 14397 (Fig. 272) and Dijon—but they share an additional emendation in the omission of Ismael.

There is no mention of Hagar by name in the *It 1* prologue, but the final portions are relevant in that they deal with a comparison between justification by law and by faith. Abraham appears prominently in the prologue as a figure of justification by faith. In view of the fact that Hagar was a frequently used metaphor of justification by law, it is reasonable to assume that the peroration of the prologue corresponds to the meaning of the scene in the initial: 'I, Paul, say to you that if you receive circumcision Christ will do you no good at all; you will fall from grace who be justified in law.'

Ephesians (Figs. 274–278)[81]

At first sight the illustration appears familiar because it is similar to the many versions of Ephesians as a Prison Epistle.[82] The majority of manuscripts in the Prologue Cycle are illustrated in a relatively simple way with a scene of Paul in prison gesturing at one or two armed knights on the outside. It is evident that, whatever else is intended, the Marcionite prologue's suggestion of Ephesians as a Prison Epistle is being followed. There are two main differences, however, between the Prologue Cycle scenes and the more common type of imprisonment representation discussed in Chapter Two. The first is that there is in the former no indication of a letter being written or transmitted. Secondly, as in the rest of the cycle, the deceptive ordinariness of the illustration enwraps a statement concerning a principal point of doctrine within the letter.

In each example, except for a few of the later, more evolved manuscripts, Paul's companion outside the prison is a fully equipped soldier, an image epitomizing a section in the letter pervaded with military metaphor:

[81] Paul, in prison, addresses an armed knight on the outside: Bologna, fol. 55ᵛ; Cava, fol. 448; Dijon, fol. 377; Olschki, fol. 368 (no prison, 2 knights); Göttweig, fol. 267; London, BL 38115, fol. 303; Munich, fol. 453; Madrid, fol. 296 (2 knights); Nantes, fol. 503; Brasenose, fol. 431ᵛ; Paris, BN 14397, fol. 338ᵛ; Ste. Geneviève, fol. 346 (no prison, 2 knights); Rossiana, fol. 459. Single figure with sword: Camb., Fitz., fol. 405; Camb. University, fol. 436ᵛ; New York, Morgan, fol. 396ᵛ. Other: London, BL 52778, fol. 399 (Paul writes a letter watched by a boy); Rouen, fol. 318ᵛ (Paul preaches to a man and a woman).

[82] See Ch. 2, *The Imprisonment Theme*, and Appendix C.

Finally then find your strength in the Lord, in his mighty power. Put on all the armour which God provides, so that you may be able to stand firm against the devices of the devil. For our fight is not against human foes, but against cosmic powers, against the authorities and potentates of this dark world, against the superhuman forces of evil in the heavens. Therefore, take up God's armour.[83]

This exhortation is followed by a list of arms which the Christian soldier is urged to wear, most of them represented in the illustration: the belt of truth, the coat of mail of integrity, the shoes of peace, the shield of faith, the helmet of salvation, the sword of the words of God.

The final passage in the *It 1* prologue also calls attention to the theme of militant knighthood: 'He [Paul] provides the kinds of arms with which they might be strong enough to struggle against the spiritual enemies.'

As usual, the Ste. Geneviève Bible (Fig. 277) reveals greater sensitivity to the text–picture interplay than do most of the other manuscripts. The 'stage property'—the prison—that was probably in the original has been deleted from this version, but the message has not been distorted. It is even enhanced. By eliminating the prison theme, the Ste. Geneviève artist is able to concentrate on the core of the message. Here Paul is shown seated, facing two knights; one is ready for battle, his sword held aloft, and the other is putting on his armour in obedience to the command given twice in the letter to put on God's armour. The Ste. Geneviève interpretation is repeated in the lost Olschki Bible (Fig. 278). In the latter Paul is helping the knight to put on his armour, his gesture remarkably close to that of a bishop vesting a priest (Fig. 306). What is portrayed is a moment of action—the donning of armour—in keeping with most of the other scenes in the cycle, rather than a timeless state of being.

Ephesians is the only Epistle lacking a Marcionite prologue in the Göttweig Bible—the omission probably due to an error in spacing—so that the last words of the *It 1* prologue appear in immediate juxtaposition to the picture (Fig. 274). The striking image of a knight ready to fight therefore appears next to the words which might have been quoted in a sermon sending him off to do battle. The Ephesians page provides an outstanding example of the efficacy of medieval illumination in conveying meaning in resonance with the written word. Like the prologue itself, the picture functions to direct the reader to a definite attitude to the text even before he has read it, which lingers in his mind during the perusal.

Philippians (Figs. 279–284)[84]

The illustrations for Philippians maintain the theme of struggle against the enemies of the church, although not in a military sense this time. Paul is shown praying while another man beats a Jew. In the Ste. Geneviève Bible (Fig. 280) the act is carried out in a particularly offensive way: Paul's agent pinches his victim's nose while raising a cudgel, humiliating as well as hurting him. The gesture of indignity is muted, or misinterpreted, in the Göttweig version (Fig. 279), as well

[83] Eph. 6:10–13: 'De cetero, fratres, confortamini in Domino, et in potentia virtutis ejus. Induite vos armaturam Dei, ut possitis stare adversus insidias diaboli. Quoniam non est nobis collectatio adversus carnem et sanguinem, sed adversus principes et potestes, adversus mundi rectores tenebrarum harum, contra spiritualia nequitiae, in caelestibus. Propterea accipite armaturam Dei.'

[84] Paul praying while a man beats another man, usually a Jew: Göttweig, fol. 268; Nantes, fol. 511; Paris, BN lat. 14397, fol. 339ᵛ; Ste. Geneviève, fol. 347ᵛ. Paul watches an execution: Camb. University, fol. 438; Cava, fol. 449ᵛ; Dijon, fol. 378ᵛ; London, BL 38115, fol. 305; Munich, fol. 455; Brasenose, fol. 433. Paul, kneeling, is beaten: Bologna, fol. 57; Rossiana, fol. 460ᵛ. Paul, in prison, watches the expulsion of a group of Jews: Madrid, fol. 297. Single figure: Camb., Fitz., fol. 406 (with a sword); Morgan, fol. 398. Other: Rouen, fol. 319ᵛ (Paul blesses a kneeling youth); London, BL 52778, fol. 400ᵛ (orn.).

as in most of the other manuscripts. Madrid, however, has an elaborate depiction of four Jews being expelled, with similar offensive gestures (Fig. 281).[85]

Either through misunderstanding of the model, or because of a desire to render Philippians as a prison Epistle, the artists of the Rossiana and Bologna Bibles (Figs. 282, 283) have converted this scene into one of Paul being beaten.[86] This deviation from the norm, shared by the two Bibles in Italian libraries, is evidence that they are members of a separate redaction, possibly imported to Italy where one of them may have been made. The Cava manuscript, on the other hand, is remarkably true to the intention of the original, despite its late date (Fig. 284). It evidently derives from a stream separate from that of the Rossiana and Bologna versions. Cava does not repeat exactly the earliest illustrations for Philippians, however, since it has changed it from a beating into an execution, as have four of the other later manuscripts.

The text of Philippians includes warnings to the Christians about their enemies, as well as prophetic forecasts as to the dire fate awaiting the latter: 'Be frightened in nothing by your adversaries, which to them is a token of perdition, but to you of salvation, and comes from God,' and also, 'There are many enemies of the cross of Christ going around, as I have often told you and now, however, say with tears, whose final end is destruction.'[87] There is little doubt that the enemies of the cross to whom Paul refers are the Judaizers, since this passage follows closely a castigation of those who would revert to Jewish practices.[88] The *It 1* prologue is specific in naming these enemies as pseudo-apostles: 'He warns them, however, that they should beware of the pseudo-apostles, who preach the keeping of the tenets of the old laws, to the detriment of grace.'

The illustrations for Philippians make the most extreme statement up to this point in identifying as Jews the pseudo-apostles, enemies of the Church, and in depicting violence against them. Romans showed Church and Synagogue in confrontation, Galatians showed Synagogue abased, now Philippians shows the Jew as the enemy doomed to perdition. Unlike these two previous depictions, the Philippians illustration does not show Paul participating in the act of punishment. Instead, he stands apart from what is happening prophesying a future which takes place before our eyes in the scene of action.

Colossians (Figs. 285–289)[89]

Rejection of the Old Law continues in the representations of Colossians. Most of the manuscripts are illustrated with a scene showing Paul standing with Moses, the broken tablets of the Law lying between them.

It is possible to build up a picture of what the original must have looked like with the help of two of the Bibles in the group that have somewhat fuller representations. In the Olschki version

[85] Madrid is also the only one of the group to follow the variant tradition of the Marcionite prologues in treating Phil. as a prison Epistle, in both the prologue text and the pictorial imagery, see above, pp. 59–60.

[86] Bologna and Rossiana 314 both have 'de carcere' in their Marcionite prologues.

[87] Phil. 1:28: 'et in nullo terreamini ab adversariis, quae illis est causa perditionis, vobis autem salutis, et hoc a Deo'; and Phil. 3:18–19: 'Multi enim ambulant, quos saepe dicebam vobis, nunc autem et flens dico, inimicos crucis Christi; quorum finis interitus.'

[88] Phil. 3:2–6; see above, Chapter 3, n. 143.

[89] Paul watches Moses break the tablets of the law: Bologna, fol. 58; Camb., Fitz., fol. 407[v]; Cava, fol. 450[v]; Göttweig, fol. 269; Nantes, fol. 518[v]; Munich, fol. 456; Brasenose, fol. 434[v]; Paris, BN 14397, fol. 340[v]; Ste. Geneviève, fol. 348[v]; Rossiana, fol. 462 (Christ is substituted for Paul); Rouen, fol. 320[v]. Paul watches Moses break the tablets while a priest raises a chalice: Olschki, fol. 371[v]; Madrid, fol. 297[v]. Single figure: Camb. University, fol. 439 (with a sword); Morgan, fol. 399. Other: Dijon, fol. 379[v] (2 figures conversing); London, BL 38115, fol. 307 (Paul with a sword between two seated groups); London, BL 52778, fol. 401[v] (messenger scene).

(Fig. 289) Paul is shown in the role of instructor or advocate, as in the illustrations for Philippians. In the centre a priest holds aloft a chalice towards Moses, who is collapsing as if humiliated, dropping the tablets to one side. At the same time Moses seems to be fleeing from Paul. Like Church triumphant over Synagogue, the priest is shown in a position of victory over Moses. The Ste. Geneviève scene (Fig. 287) is similar to that in the Olschki version, but the priest has been omitted. Paul himself has become the victorious protagonist. Another example of the Ste. Geneviève type occurs in the Guido Bible from Cava. Although Moses—represented here as a youth with horns—does not appear to be collapsing, he does look as if he were fleeing from Paul.

In the Madrid Bible (Fig. 288) the three figures of the Olschki scene also appear but their individual roles are not defined as clearly as in the latter. In the interests of balance, the Madrid artist has rearranged the composition, so that both Paul and Moses face towards the centre. The narrative impact of the Olschki scene, representing actions taking place in time, has been turned into a timeless *schema*.

The majority of manuscripts are illustrated with a scene which is really a reduction of the Madrid design (Figs. 285, 286). What remains is a symmetrical arrangement of Paul, Moses and the tablets of the Law, but they have lost the suggestions of victory and defeat that were probably features of the original.

Breaking of the tablets of the Law in the Prologue Cycle no doubt stands for the victory of Christianity. Similar imagery occurs in the *Bible Moralisée* in Oxford (Fig. 273), where accompanying the previously discussed scene of the Expulsion of Hagar is an illustration of a priest elevating the Host while two Jews (one of them possibly Moses) depart in shame, dropping the broken tablets.[90] It should be noted that the perception of Moses in the Prologue Cycle as the defeated adversary of Christianity is contrary to the usual typological approach, which regards Moses as the prefiguration of Christ.[91]

Both the Bible text and the *It 1* prologue provide suggestions to help us understand the meaning of this scene. The reference at the end of the prologue to Colossians is oblique, in that the specific act of smashing the tablets is not mentioned, but it is a warning against Jewish observances and against the subtleties of the philosophers as well. Again, as in the illustrations of earlier letters, if the historiated scene is indeed meant to relate to the prologue, Jewish Law is being made to stand for all systems of unbelief.

A short passage in the text of Colossians is more directly applicable to the picture. In it, Paul describes Christ as 'cancelling the charter of the decree that was against us.'[92] It is interesting that the artist of the Rossiana manuscript, possibly wondering what Paul was doing in the scene, replaced him with Christ, a closer interpretation of the Colossians text.

The illustrations of the first four letters in the cycle, and, to some extent, the fifth (Ephesians), can be read as 'events'. Colossians falls into another category in that Paul is shown as the advocate of a doctrine which is typified before our eyes in a timeless statement.

I Thessalonians (Figs. 290–294)[93]

Like the Apostolic Cycle, the Prologue Cycle illustrates I Thessalonians with a depiction of the

[90] Oxford, Bodley 270b, fol. 13ᵛ.

[91] The *Bible Moralisée* is inconsistent in its outlook since the Oxford manuscript also uses the typological method elsewhere: Oxford, Bodley 270b, fol. 55ᵛ: 'Moyses qui tabulas priores confregit et alias loco illarum recuperavit significat jesum qui veterem legem destruxit et sua passione novam reparavit.'

[92] Col. 2:14: '. . . delens quod adversus nos erat chirographum decreti . . .'

[93] Paul preaching about the raising of the dead: Bologna,

Raising of the Dead, regarded by many commentators as the most important subject dealt with by Paul in the letter.[94] The author of the *It 1* prologue, too, closes his introduction to I Thessalonians with a summary of Paul's references to resurrection:

. . . he removes, finally, their sadness which arose in the loss of their dear ones, through the hope of resurrection. Concerning the order of this very resurrection, and its kind, or the uncertain end of time, he teaches concerning this, that because of the uncertainty of the resurrection, he says that they ought to be vigilant in spirit and free from vice and they ought to prepare with greater zeal.

Each cycle interprets the theme of resurrection in its own way. In the Apostolic Cycle (Figs. 227, 228) the Resurrection of the Dead is depicted in the terms of the text of I Thessalonians: we are given a picture of the dead arising and of Christ coming to judge them. Paul is not in the scene. In contrast, the Prologue Cycle in fact illustrates the words of the prologue. Paul is shown speaking about the raising of the dead; he stands, gesturing while the naked dead arise from their tombs, their hands raised in thankful prayer. This scene is in the same pictorial mode as Colossians in that we see simultaneously Paul preaching and the image evoked by his words.

Parallels for both types can be found in the Toledo *Bible Moralisée* (Fig. 295).[95] The literal illustration for I Thessalonians 4:14–15 shows Paul preaching about the raising of the dead. He gestures towards Christ who is represented twice—crucified and rising from his tomb. On the lower right the dead rise, giving thanks to Christ. An audience—no doubt the living who are raised to heaven to join the dead—watches on the upper right. Paul is present, as in the Prologue Cycle. Immediately below the resurrection scene in the same *Bible Moralisée* is the moralization, which, like the Apostolic Cycle scene, is a depiction of the rising dead giving thanks to Christ above them in heaven. Paul is absent.

Comparison with the literal interpretation of the *Bible Moralisée* helps to explain a peculiarity in the versions in the Prologue Cycle. The grateful dead either appear to be praying to Paul, as in the Ste. Geneviève and Madrid Bibles (Figs. 291, 292), or facing away from Paul into empty space as in the Göttweig Bible (Fig. 290). All of them need the image of Christ to complete the picture. The Madrid manuscript is illustrated with a fuller design, suggesting that the original of the cycle scene might have looked more like the *Bible Moralisée*. Madrid includes an audience on the right and an angel blowing the last trumpet, mentioned in I Thessalonians 4:16.

A bishop appears in the scene in some of the Bibles, standing behind or across from Paul (Fig. 293).[96] This figure can be explained as a vestige of the group of living men who appear in the *Bible Moralisée* and also in the Madrid manuscript. The artist, possibly misunderstanding the purpose of these figures, has turned one of them into Timothy, described in the opening passages of the letter as Paul's co-author, and occasionally represented in that role in historiated initials.[97]

In three of the manuscripts the original meaning of the illustration has been misinterpreted and it has been changed into a scene of baptism (Fig. 294).[98] This would have been an easy

fol. 59; Camb. University, fol. 440; Cava, fol. 452; Olschki, fol. 370ᵛ; Göttweig, fol. 270; Madrid, fol. 298ᵛ; Munich, fol. 457 (only 1 of the rising dead is shown); Nantes, fol. 523ᵛ; Brasenose, fol. 436; Ste. Geneviève, fol. 349ᵛ; Rossiana, fol. 363; Rouen, fol. 321ᵛ. Paul baptizing 1 or more figures: Dijon, fol. 380; London, BL 38115, fol. 398ᵛ; Paris, BN 14397, fol. 341. Single figure: Camb., Fitz., fol. 408ᵛ (with

a sword); Morgan, fol. 399ᵛ. Other: London, BL 52778, fol. 402 (orn.).

[94] See above, Ch. 3, *The Raising of the Dead*, and nn. 147, 148.
[95] Toledo, III, fol. 139.
[96] The bishop appears in Rossiana, Bologna, and Olschki.
[97] See above, Ch. 2, *The Cycles of Epistolary Scenes*.
[98] Dijon; London, BL 38115; Paris, BN 14397.

mistake to make if the model(s) for these Bibles had featured a poorly drawn representation of Paul and several half-nude figures in their tombs. This ready tendency for the illustrations to fall away from the primary intention demonstrates the lack of understanding of the relation of picture and text by the artists of some of the poorer and later manuscripts.

II Thessalonians (Figs. 296–301)[99]

The Prologue Cycle, again like the Apostolic Cycle, employs a depiction of the defeat of the 'son of perdition' (II Thessalonians 2:8)[100] as the illustration for II Thessalonians. In this instance too, a passage near the end of the prologue directs attention to the relevant section of the letter: 'Thereupon, with an entreaty, since some among them insisted the end of the world and the advent of the Lord were near, which could be a grave occasion of error, he warns them not to believe easily and he predicts certain signs, which would precede the advent of the Lord.' The sign, as Augustine among others has observed, would be the revolt of Antichrist, followed by his destruction.[101]

In most of the Prologue Cycle illustrations Paul is shown predicting the downfall of the rebel against Christ and at the same time the event itself is also pictured. The 'son of perdition', or Antichrist, is represented sometimes as a Jew (Figs. 296, 298),[102] or as a crowned king (Figs. 297, 299).[103] Some of the versions provide him with ugly, distorted features and in the Nantes Bible (Fig. 300) he is depicted as a demon.[104] In each instance he is struck down by pointed cone-shaped bolts, usually sent down by the hand of God from heaven.

The scene in the Prologue Cycle is related to the illustration of Psalm 52 in the Paris portion of the divided *Bible Moralisée* (Fig. 302), showing Christ descending from heaven to strike down a group of figures including Jews and kings who are described as 'Antichrist and his friends.'[105] The representation in the Prologue Cycle is a reduction of the one in the *Bible Moralisée* except that the hand, rather than the half-figure of Christ appears in heaven and Antichrist is alone. Most of the Antichrist figures in the Prologue Cycle echo in their poses one or another of the figures in the more complex composition. In those manuscripts in which Antichrist is represented as a Jew (Figs. 296, 298), he is in the upright position of the Jew to the right of centre in the *Bible Moralisée*; where he is a king (this group includes the demon in the Nantes Bible (Figs. 297, 299, 300)) he is in the more horizontal pose of the king in the multi-figure scene. (The Madrid Bible (Fig. 301), as is often the case, proves an exception. Antichrist, pierced by multiple missiles, here falls to the left.) One explanation for the variety of poses taken by the figures of Antichrist in the Bibles, most having counterparts in the single picture in the *Bible Moralisée*, is that the original probably looked more like the *Bible Moralisée* scene, with at least three enemies of Christ struck down by

[99] Paul predicts the destruction of Antichrist: Bologna, fol. 60v; Cava, fol. 453; Dijon, fol. 381; Göttweig, fol. 270v; London, BL 52778, fol. 403; Madrid, fol. 299; Munich, fol. 458; Nantes, fol. 527v; Brasenose, fol. 437 (the Antichrist figure is replaced by a queen); Paris, BN 14397, fol. 342; Ste. Geneviève, fol. 350v; Rossiana, fol. 464. Single figure: Camb., Fitz., fol. 409 (with a sword); Camb. University, fol. 441 (with a sword); Morgan, fol. 400v. Other: London, BL 38115, fol. 310 (Paul, with a sword, addresses a group of Jews); Rouen, fol. 322 (Paul addresses a bishop).

[100] See above, Ch. 3, *The Miracle of the Evil Spirit* and n. 151.

[101] See above, Ch. 3, n. 152.

[102] Göttweig (?), Madrid, BN 14397, Camb. University, Dijon, Munich.

[103] Ste. Geneviève, Rossiana, Bologna, BL 52778, Cava, Brasenose.

[104] Innocent III provides a figure of speech linking Jews, kings and demons: 'Herodes diabolus, Judaei daemones; ille rex Judaeorum, iste rex daemonum. . . .' (*PL* 217, 561). Quoted by Synan in *Popes and Jews*, 89, n. 29.

[105] Paris BN lat. 11560, fol. 15v (the moralization for Psalm 52): 'Illi . . . significat antichristum et sui amantes; terrena sunt illi qui in fine mundi per vires suas vastabunt ecclesiam.'

pointed rays, in the presence of Paul. The various transmitted streams simplified the scene, each in its own way.

I Timothy (Figs. 303–307)[106]

The illustration for I Timothy depicts an Ordination, probably of a priest. Paul stands at the left gesturing while his words are enacted by a bishop who invests with a chasuble a tonsured youth, clad either in an alb[107] or in a dalmatic over an alb.[108]

There are several themes in the letter relating to its 'pastoral' character which are relevant to the illustration. The first is a section dealing wtih the responsibilities and character of an 'episcopus' (3:1–7).[109] Whatever this term meant to the early church, the Middle Ages undoubtedly recognized the office as that of the highest order of ministers; that is, those having the power to confer Holy Orders and to administer Confirmation. Therefore the picture of a bishop in the act of ordaining a priest can be said to have a threefold meaning in relation to the text: it is a reference to the sacerdotal nature of the priesthood, to the relationship between bishops and priests, and to Ordination, the rite that symbolizes both former points.

I Timothy is in fact regarded as one of the main sources for reconstructing the scriptural understanding of the sacrament of Ordination.[110] Although the term 'Ordination' does not appear in the letter, there are two references to the laying on of hands: the spiritual endowment given by the elders to Timothy himself is mentioned at 4:14 and Timothy's responsibility as a bishop in creating other ministers is referred to in 5:22.[111] The final passages of the *It 1* prologue also are devoted to this theme: 'After this he instructs the new bishop in church teachings and he prescribes what ought to be sought in Ordinations.' The Marcionite prologue also refers to Ordination, and to the other disciplines of the church.

In the Prologue Cycle illustrations it is not Ordination in general which is depicted, but Ordination of a priest, a minister of the sacerdotal class, who wears a chasuble, as opposed to one of the minor orders.[112] In combination with the adjacent prologues the illustration serves to isolate this theme for the reader to concentrate on in reading the letter. Neither the prologue nor the Epistle itself makes specific reference to the ceremony of investing with a chasuble, but undoubtedly the clear indication in the letter that it is the priesthood that is in question, not one of the minor orders, has had an influential effect on the image.

The early church followed a distinct rite of Ordination for each of the gradations of the ministry,[113] a practice continued in the Middle Ages. For example, the tenth-century Pontifical of

[106] Paul watches a bishop invest a priest with a chasuble: Bologna, fol. 61; Cava, fol. 453[v]; Göttweig, fol. 271; Madrid, fol. 299[v]; Munich, fol. 459. A bishop invests a priest with a chasuble (Paul is absent): Dijon, fol. 381[v]; Nantes, fol. 530; Brasenose, fol. 437[v]; Paris, BN 14397, fol. 342 (there are 2 priests); Ste. Geneviève, fol. 351; Rossiana, fol. 465. Other: Camb., Fitz., fol. 409[v] (Paul talks to a Jew); Camb. University, fol. 441[v] (Paul blesses a warrior); London, BL 38115, fol. 311 (bishop with a sword, youth kneels before him); London, BL 52778, fol. 403[v] (orn.); New York, Morgan, fol. 401 (single figure); Rouen, fol. 322[v] (Paul with a youth).

[107] Göttweig, Madrid, Olschki (erroneously used as an illustration for II Tim. See below, n. 117), Cava (?), Ste. Geneviève, Brasenose.

[108] Rossiana, Bologna, Nantes, BN 14397, Dijon, Munich

(?). For ecclesiastical dress see J. Braun, *Die liturgische Gewandung* (Freiburg im Breisgau, 1907), s.v., 'Die Albe', 57–101; 'Die Kasel', 149–247; and 'Dalmatik und Tunicella', 247–305.

[109] In the New Testament the term might merely have referred to ministers permanently established in one place; see *ODCC*, s.v., 'Orders and Ordination', 987–9.

[110] See n. 109; and J. Bligh, *Ordination to the Priesthood* (London–New York, 1956), 31.

[111] I Tim. 4:14: 'Noli negligere gratiam quae in te est, quae data est tibi per prophetiam, cum impositione manum presbyterii'; and I Tim. 5:22: 'Manus cito nemini imposueris'.

[112] Braun, *Gewandung*, 149; and Bligh, *Ordination*, 114–20.

[113] Jungmann, *Early Liturgy*, 62–4.

Landulfus records—and illustrates with pictures—the rites of Ordination of seven grades.[114] Although the laying on of hands is common to all grades, each also has its particular form; thus, the porter is given a key, the exorcist a book of exorcisms. Investing with a chasuble is particular to the Ordination of the priest, since it is the garment worn in the celebration of the Eucharist. The illustration of the imposition of this garment in the Pontifical of Landulfus (Fig. 308) shows a bishop placing the chasuble over the head of a candidate, uttering the words, 'Receive the priestly chasuble through which charity is symbolized. . . .'[115]

Ceremonial vestings occur frequently as symbolic images in the *Bibles Moralisées*, although not in connection with I Timothy. These representations often denote a change from one condition to another, as in the illustration for Ephesians 4:22–4 (Fig. 309), where it stands for man's complete moral change into a new nature, in this case symbolized by the putting on of a religious habit.[116] The *It 1* prologue echoes this theme in the sentence immediately preceding the mention of Ordination cited above: 'The coming of Christ, however, completes his intention who comes to make sinners healthy, because he ought to be heard by these sinners with willing spirits who need a healer of their conscious weakness.' The juxtaposition of the two topics in the prologue might have suggested the image of the imposition of the chasuble, a representation which stood simultaneously for the change into a new nature, of general application, and for the spiritual endowment given to the priest in Ordination.

II Timothy (Figs. 310–315)[117]

II Timothy returns us once again to military imagery. In most of the manuscripts the scene is of the type in which Paul himself functions as a participant in the action, rather than as an advocate or onlooker. He is shown with an armed knight, to whom he offers a crown, or on whose head he places or blesses a crown.

An illustration occurring in both *Bibles Moralisées* with New Testament texts helps to explain the representation in the Prologue Cycle (Fig. 316).[118] In the literal interpretation of II Timothy 2:3–5, Paul and a bishop are shown blessing a Christian soldier. The latter, bearing a cross on his shield, is engaged in battle with the infidel who wears a pointed—that is, a foreign—helmet, and carries a shield decorated with a pagan device. In the London manuscript the device is a horned animal head, and in the Toledo version it is an eight-pointed star, possibly a misapprehended star of David. Christ is in heaven, holding out two crowns, one over the head of the bishop, the other over the Christian soldier. The text explicitly tells what is being rewarded: Paul adjures Timothy as a church leader to 'suffer like a good soldier of Christ . . .

[114] Rome, Bibl. Casanatense 724.B.I.13 (957–84). The grades of the ministry are: minor orders—porter, lector, exorcist, acolyte; major orders—sub-deacon, deacon, priest.

[115] The entire inscription reads: 'Accipe casulam sacerdotalem per quam caritas intelligitur; potens est enim deus ut augeat tibi caritatem et opus perfectum qui vivit et regnat deus per omnia secula seculorum.'

[116] London, BL Harley 1526–7, II, fol. 107 (Eph. 4:22–4): 'Deponere vos secundum pristinam conversationem veterem hominem, qui corrumpitur secundum desideria erroris. Renovamini autem spiritu mentis vestrae et induite novum hominem, qui secundum Deum creatus est.' In the Toledo *Bib. Mor.* a vesting scene appears in vol. I, fol. 3 (Moralization of Gen. 1:11); vol. III, fol. 30 (Moralization of John 5:28,

29); vol. III, fol. 95 (Moralization of Acts 9:25).

[117] Paul crowning a warrior, or blessing the crown on a warrior: Bologna, fol. 62 (a bishop is present); Cava, fol. 454; Dijon, fol. 382ᵛ; Göttweig, fol. 272; London, BL 38115, fol. 313; London, BL 52778, fol. 404ᵛ; Madrid, fol. 300ᵛ (a bishop is present); Munich, fol. 460; Nantes, fol. 536ᵛ; Brasenose, fol. 439; Paris, BN 14397, fol. 343ᵛ; Ste. Geneviève, fol. 352; Rossiana, fol. 466; Rouen, fol. 323ᵛ. Single figure: Camb., Fitz., fol. 411 (with sword); Camb. University, fol. 443 (with sword); Morgan, fol. 402. Other: Olschki, fol. 373ᵛ (mistaken illustration for I Tim. See n. 117).

[118] London, BL Harley 1526–7, II, fol. 112ᵛ; Toledo, III, fol. 147.

For whosoever enters a contest: he will not be crowned unless he keeps the rules.'[119]

Christ holds two crowns, one for the bishop, the other for the Christian soldier. The analogy is obvious. Timothy, to whom the letter is addressed, is compared to a fighting man. Crowns await them both, rewards for their labour and suffering in the cause of God.

Paul also suggests in the letter that he himself merits a crown: 'I have run the great race, I have finished my course, I have kept faith. And now the prize awaits me, the garland of righteousness, which the Lord, the all-just Judge, will award me on that great day . . .'[120] The crown stands not only for victory, but for martyrdom as well.

Two of the Bibles in the Prologue group include a bishop as a third figure. In the Madrid version (Fig. 314)—closest to the sense of the *Bible Moralisée* scene—Paul, standing between the bishop and the soldier, gestures at a crown hovering in mid-air. It is possibly intended for Paul, awaiting death, but available also to the bishop and the soldier. The Madrid representation is no longer a scene of action, rooted in place and time, but a *schema* expressing meaning through an arrangement of images. Similar to the Madrid in some ways, the Bologna Bible (Fig. 315) shows Paul as an active participant. He holds the crown, personally offering it to the soldier and the bishop, as he does to the former alone in the Ste. Geneviève manuscript (Fig. 311).

In two of the Bibles—Madrid (Fig. 314) and Göttweig (Fig. 310)—the figure of the warrior is a repetition in careful detail, even in pose, of the selfsame figure in Ephesians (Figs. 275, 274), the knight who is told to take up the armour of God. It might be argued that the repetition is a product of reliance on standard models, called into use when a military image was required. These two manuscripts, however, happen to be those in which the most care is paid to detail. It is in the more careless manuscripts that the artist fails to stress the resemblance. The recurrence of the figure of the warrior helps to give unity to the cycle, to enhance the impression that the ideas depicted have an inner coherence.

As is also true of the illustration for I Timothy, the II Timothy picture seems to be influenced by both the *It 1* and the Marcionite prologues. The latter notes that Paul writes to Timothy about 'exhortation to martyrdom'. The *It 1* prologue also deals with the theme of martyrdom. It specifies that Paul encouraged Timothy by enumerating his own sufferings at Antioch, Iconium, and Lystra, and 'he fills him with hope of the help that was always available, by saying: "And the Lord rescued me out of everything." He wishes, finally, there to be a universal witnessing of the good life; if one meets with the hatred of evil men, that he might be elevated by this very thing with a good conscience if he is pressed by a burden of tribulations.'

Use of a crown as a sign of martyrdom is not unusual. The singularity of the representation in the Prologue Cycle is the juxtaposition of the crown with the military image. Both prologue texts refer to martyrdom, calling attention to the sections of the letter which combine military metaphor with premonitions of death and its rewards.

Titus (Figs. 317–320)[121]

A scene of chastisement introduces Titus. Paul watches a Jew seated on a bench beat with a club a crouching boy clad in drawers. A woman watches on the right. The *It 1* prologue provides a

[119] II Tim. 2:3–5: 'Labora sicut bonus miles christi . . . Nam et qui certat in agone: non coronabitur nisi legitime certaverit.' The Toledo text is shorter; only the last sentence appears.

[120] II Tim. 4:7–8: 'Bonum certamen certavi, cursum consummavi, fidem servavi. In reliquo reposita est mihi corona justitiae, quam reddet mihi Dominus in illa die justus judex. . . .'

[121] Paul and a woman watch a seated Jewish man beat a half-naked boy: Bologna, fol. 63; Cava, fol. 455ᵛ; Dijon, fol.

suggestion as to the meaning of what is portrayed: 'Finally, what should be taught to the differing age groups, in what way those who come from a mean condition to the reception of the faith, having been made better, bear testimony of the Christian doctrine, through which they learned to be better.' By means of the prologue, attention is directed to the passage in the letter in which Paul tells Titus, as a religious leader, to teach in special ways the various age and social groups: older men, older women, younger men, younger women, masters, and slaves (2:1–9). Each category has a special path to follow on the way to salvation.

The illustrations include a cross-section of the various types mentioned in the letter. We see represented a man—who is simultaneously a master—a woman, and a boy who is also probably a slave. The Bologna Bible (Fig. 319) adds the bishop—Titus—himself. The age groups and social classes are assembled in a composition which might be an interpretation of Paul's advice to slaves in the letter: 'Tell slaves to be obedient to their masters, pleasing them in all things, not answering back, not pilfering, but showing good faith in everything that they might embellish the doctrine of God our saviour in all things.'[122] In accordance with this admonition, passive submission to the master's will is displayed by the young slave in the picture.

In the Toledo *Bible Moralisée* there is a scene of penance used as the moralization to Mark 5:15–18 (Fig. 321),[123] which is similar in many ways to the Titus initial and helps us to understand it. A bishop flogs a half-naked youth, evidently a penitent, whose head he holds with his left hand.[124] Such an image of a bishop or leader administering a flogging might have two connotations, both of which are touched on in the *It 1* prologue. Flogging as an aspect of penance represents the way in which people are 'made better'. It is, moreover, suggestive of teaching, since we know from the representations of the personification of Grammar with a rod or switch that flogging was a standard teaching method in the Middle Ages.[125] The illustration, therefore, is a synthesis, referring simultaneously to a number of points in both prologue and Epistle.

Two questions, however, remain unanswered. Why is the man—evidently representing the people of Crete to whom Titus ministered—depicted as a Jew? The fact that Paul has replaced the man in the Ste. Geneviève manuscript (Fig. 320)—often to be relied on as a guide, because it eliminates ambiguities in its simplified scenes—suggests that there might be something wrong in giving the latter a Jew's hat. Perhaps, as in the *Bible Moralisée* scene, he was originally a bishop, his mitre changing through the process of transmission to a Jew's hat. There are precedents for this mistake.[126]

The woman's action prompts the second question. In three of the versions she appears to be

383[v] (Paul and the woman are absent); Göttweig, fol. 272[v]; Munich, fol. 461; Nantes, fol. 540; Brasenose, fol. 440 (Paul beats the boy); Paris, BN 14397, fol. 344 (the woman is absent); Ste. Geneviève, fol. 353 (Paul beats the boy, the man is absent); Rossiana, fol. 467. Single figure: Camb. University, fol. 444 (with a sword); London, BL 38115, fol. 314[v] (with a sword); Morgan, fol. 402[v]. Other: Camb., Fitz., fol. 412 (Paul preaches to a group); London, BL 52778, fol. 405[v] (orn.); Rouen, fol. 324 (Paul holding a sword, with a youth).

[122] Tit. 2:9–10: 'Servos dominis suis subditos esse, in omnibus placentes, non contradicentes, non fraudantes, sed in omnibus fidem bonam ostendentes, ut doctrinam sal-

vatoris nostri Dei ornent in omnibus.'

[123] Toledo, III, fol. 25.

[124] Flagellation, praised by Peter Damian in 'De laude flagellolum et, ut loquuntur, disciplinae' (*PL* 145, 679–86), was practised as a means of satisfaction of penance; see E. Amann, 'Pénitence, solutions définitives, la pratique', in *DTC*, XII, i, cols. 918–31. On col. 927, Amann observes that 'ces flagellations, le pénitent se les administre lui-même; on voit très souvent, surtout à partir de la fin du XIIe siècle, la discipline donnée par le confesseur.'

[125] Male, *Art religieux*, 82–3, Fig. 44.

[126] See above, London, BL Add. 15253, fol. 307[v] (I Thess.) (my Fig. 114).

staying the hand that is wielding the club, or shielding the boy in some way (Figs. 318–20).[127] It is difficult to find an explanation for her act, since Paul himself is either condoning or carrying out the punishment. Perhaps the gesture is meant as a depiction of Paul's advice to women to be kind (2:5).

The illustration for Titus with its varied cast of characters represents simultaneously several ideas in both prologue and text, the scene emerging as an apt summation of both.

Philemon (Figs. 322–324; 326)[128]

Like the illustration for Ephesians, the Philemon scene combines the imprisonment theme with a doctrinal formula. Paul is depicted in prison, gesturing toward two figures on the outside: a bishop who gives a large round object, undoubtedly the bread of charity, to a kneeling youth.

A similar image of charity occurs in the Toledo *Bible Moralisée* (Fig. 326), but as an illustration for I Timothy 6:11 rather than Philemon: 'But thou, man of God, flee from avarice and pursue justice, piety, fidelity, patience and gentleness.'[129] The picture is similar to the Philemon initial in the cycle: Paul—not in prison, of course—gestures toward a bishop giving the bread of charity to a kneeling youth. A fourth figure, no doubt the avaricious rich man guarding his money-bags, can be seen at the right. This theme is stressed as well in the letter to Philemon where, in a key passage Paul commends Philemon's former charity, and calls on him to grant further charity to Onesimus, his former slave and Paul's 'adopted son'.[130] (There is no *It 1* prologue.)

Medieval art commonly represented charity as the act of giving to a kneeling recipient a loaf, symbolizing the bread of charity. A good example can be seen in a thirteenth-century bronze font cover in Hildesheim Cathedral which depicts Caritas, crowned as queen, handing bread to a hungry man kneeling in front of her.[131] They are surrounded by illustrations of other acts of mercy.[132]

It can be seen therefore, that the type of representation of charity used in the Prologue Cycle was not unusual for its time, nor was it an exceptional scene in the milieu of the *Bible Moralisée*. Its innovative aspect was in its combination with the letter to Philemon. It has already been pointed out that there was a textual basis in Philemon for the emphasis on charity. Therefore, it is possible to suppose that there once existed a prologue comparable to the others in the *It 1* group, which summarized the main points in the Epistle, ending with an exhortation to Philemon to practise charity. The prologue probably was quite brief in keeping with the brevity of the letter. Another possibility is that in the absence of any Philemon *It 1* prologue the originator of the series had to

[127] Bologna, Ste. Geneviève, Rossiana.

[128] Paul, in prison, directs a bishop to give the bread of charity to a boy: Bologna, fol. 63ᵛ; Camb. University, fol. 444ᵛ; Cava, fol. 456; Göttweig, fol. 273; London, BL 52778, fol. 406; Munich, fol. 461ᵛ; Nantes, fol. 542ᵛ; Brasenose, fol. 440ᵛ; Paris, BN 14397, fol. 344ᵛ; Ste. Geneviève, fol. 353ᵛ (no prison); Rossiana, fol. 468 (no prison). Single figure: Camb., Fitz., fol. 412ᵛ (with a sword); Dijon, fol. 383ᵛ; Morgan, fol. 403. Other: London, BL 38115, fol. 315 (Paul in prison with a sword, second figure outside); Rouen, fol. 324ᵛ (Paul and a saint).

[129] Toledo, III, fol. 146 (I Tim. 6:11): 'Tu autem homo dei fuge avariciam sectare vero iusticiam pietatem fidem et caritatem, patientiam mansuetudinem.' The words are a slight variation on the Vulgate text. Similar representations of charity appear frequently in the pages of the *Bibles Moralisées*, e.g., Oxford, Bodley 270b, fol. 57ᵛ (the moralization of Exodus 35:8, 23).

[130] Philem. 5: 'Audiens charitatem tuam et fidem'; and Philem. 9: 'propter charitatem magis obsecro.'

[131] Künstle, *Ikonographie*, I, 194.

[132] The needy requiring attention from Caritas, reading clockwise from the right, are: the pilgrim, the hungry, the prisoner, the sick, the thirsty, the naked. Up to the 13th century, it was common that only 6 Acts of Mercy be listed. In the 13th-century theological tracts, 7 Acts begin to be mentioned, but the greater number was not used in works of art until later (Künstle, op. cit.).

fall back on the text itself. The illustration for Philemon also reflects the influence of the Marcionite prologue in its setting of the scene in a prison context.

Hebrews (Figs. 327–331)[331]

Following the example of the majority of medieval Bibles the Prologue Cycle illustrates Hebrews with a scene of Paul preaching to a group of people, usually Jews.[134] In several of the Prologue Cycle Bibles the scene becomes an ambiguous one of two saints or other individuals facing each other (Figs. 329–30). The weight of the evidence favours the earlier manuscripts: the original intention must have been to show Paul facing the Jews. The Ste. Geneviève version (Fig. 328) makes this point strongly, by showing Paul holding aloft a cross, facing vanquished Synagogue, who is collapsing, her crown falling from her head. Unfortunately the initials for Hebrews in the Madrid and Olschki Bibles which might have been similar do not survive to help reconstruct the early stage of the cycle.

There is no *It 1* prologue to Hebrews. The Pelagian preface, used along with the Marcionite prologues to the first thirteen Epistles, calls attention to the differences between Hebrews and the other letters. It says that Paul writes differently here because the recipients are Jews—those believers who are members of the circumcision. Furthermore, he is writing humbly, in their own language. The majority of illustrations for Hebrews derive from the words of this prologue. They simply record the direct communication between Paul and his audience, depicted as Jewish in a number of manuscripts, including Göttweig 55 (Fig. 327). These examples of simple preaching scenes do not go beyond the limits of the imagery discussed in Chapter Two, in that they merely record the circumstances under which the letter was transmitted.

In contrast, the Ste. Geneviève manuscript (Fig. 328) does exceed the range of the other versions, proving itself truer to the general pattern of the cycle in that it includes a reference to the doctrine of the letter. A long passage in Hebrews (8:1–10:18) compares the ministry of Christ as high priest with the covenant of the Jews, showing Christ's way to be superior: 'But in fact the ministry which has fallen to Jesus is as far superior to theirs as are the covenant he mediates and the promises upon which it is legally secured.' The covenant of Christ puts aside the first law to establish its successor.[135] The Ste. Geneviève illustration, showing Paul holding a cross triumphantly over defeated Synagogue, seems to be an interpretation of the sense of this text. In the absence of corroborating evidence it is difficult to tell whether or not the Ste. Geneviève version represents an earlier, fuller stage of the cycle, or whether the scene is an invention of the artist.[136]

One characteristic shared by most of the Bibles in the cycle is that the Hebrew illustration contributes to the sense of an underlying unity or rhythm in the treatment of all the Epistles. The individuals who first appear in the initial for Romans (Figs. 245–8) are seen again in Hebrews. Although the Ste. Geneviève version does not feature the identical characters in the two

[133] Paul addressing 1 or more Jews: Camb. University, fol. 444ᵛ; Göttweig, fol. 273ᵛ; London, BL 38115, fol. 315ᵛ (Paul holds a sword); Nantes, fol. 543ᵛ. Paul addressing 1 or more men: Camb., Fitz., fol. 412ᵛ; Munich, fol. 462; Morgan, fol. 403; Brasenose, fol. 441; Rossiana, fol. 468. Other: Bologna, fol. 64 (Christ and a saint); Cava, fol. 456 (2 saints); Dijon, fol. 384 (2 youths); Paris, BN 14397, fol. 345 (2 men on either side); Ste. Geneviève, fol. 353ᵛ (Paul holds a cross towards vanquished Synagogue); Rouen, fol. 324ᵛ

(Paul and a saint).

[134] See above, p. 68, and Appendix B.

[135] Heb. 8:6–7: 'Nunc autem melius sortitus est ministerium, quanto et melioris testamenti mediator est, quod in melioribus repromissionibus sanctitum est'; and Heb. 10:9–10: 'Aufert primum, ut sequens statuat.'

[136] Neither of the 3-volume *Bibles Moralisées* goes beyond Heb. 5:1 in its Epistle scenes.

illustrations (Figs. 248, 328), it does display a repetition of theme which is even more suggestive of interior logic than are the preaching scenes. Paul argues with the Jew in the illustration for Romans. After a series of confrontations of the two opposing ideologies, and of demonstrations of Christian doctrine, Synagogue is defeated.

The Prologue Cycle is held together by an inner unity effective on many levels. The first is that of ideology. Running like a thread through the entire series of illustrations is the notion that the principal message of the Epistles is struggle against the enemies of Christendom. The concept of struggle is examined in several ways. On the positive side, there is revealed an admiration of military virtue, as can be seen in the illustration for Ephesians, depicting the armour of the perfect knight, and II Timothy, in which the armed warrior is used as the type of the Christian martyr. The other side can be seen in the preoccupation with the enemies of Christianity, often depicted as Jews. Not only is confrontation represented, as in Romans, but the enemies are driven out (Galatians), beaten (Philippians), humbled (Colossians), destroyed (II Thessalonians), and finally shown to be defeated (the scene for Hebrews in the Ste. Geneviève Bible).

Extremist attitudes toward Judaism are apparent. Contrary to the customary approach of medieval iconography, the Prologue Cycle seems not to have followed a typological method, that is, the interpretation of persons and events in the Old Testament as portents of the New. One point of contrast can be seen in the treatment of Moses, ordinarily depicted as a forerunner of Christ in typological schemes. The events of his life—the Return from Egypt, Crossing the Red Sea, Gathering of Manna—usually are seen as foreshadowing episodes in the life of Christ. In the Prologue Cycle illustration for Colossians, in contrast, Moses is shown as shamed and humiliated. His Law is not a prefiguration of the New Dispensation but its opposite. Some of the Bibles examined above in Chapter Two revealed an attitude of acceptance of the Jewish heritage of Christianity. The ideology of the Prologue Cycle, on the other hand, corresponds to a change in the climate of opinion typical of the mid-thirteenth century. It is possible that the outlook of the patrons who purchased these Bibles was influential in this regard.

Contention and struggle, however, were not the only subjects which interested the designers of the iconography. They also reveal a broader objectivity as exegetes, possibly reflecting the objective attitude of the *It 1* prologues. Several important doctrinal points are brought out where these are emphasized in the texts. Two of the letters generally regarded as sources for the understanding of sacraments are so treated: I Corinthians depicts the Eucharist and I Timothy Ordination, both representations circumstantial in their details, so that the inspiration of the *It 1* prologue can be inferred.

Like many Bibles of more commonplace imagery, the Prologue Cycle manuscripts present I and II Timothy and Titus as Pastoral Epistles, and Ephesians and Philemon are dealt with as Prison Letters. Both Pastoral and Prison representations differ from the ordinary illustrations for these books in that they have multiple meanings. They not only show Paul sending a message from prison or talking to a bishop, but they simultaneously communicate the main point of his teachings in the letter.

The traditional treatment of these categories of Epistles reveals that the Prologue Cycle has its roots in twelfth-century Bible illustration. It is radical, however, in its doctrine and also in its mode of expression, which can best be defined by examining its relation to the *Bible Moralisée* and to the *It 1* prologues.

Analogies with the *Bible Moralisée* are obvious. Nine of the fourteen Prologue Cycle scenes have been shown to have parallels in the *Bibles Moralisées*.[137] Of these, only three are illustrations to the same Epistle in both projects.[138] The rest are drawn from the whole pictorial range of the *Bible Moralisée*, both literal and moralized scenes being represented, and from both Old and New Testaments. It is evident that the designers have used the *Bible Moralisée* as a model book, drawing subjects from all parts of it according to their suitability.[139] One interesting by-product of the comparison of the two projects lies in the fact that the style of the Prologue Cycle tends to be 'earlier' than the corresponding illustrations in the *Bibles Moralisées*. This suggests that the model for the cycle might have been a lost *Bible Moralisée* with both Old and New Testament scenes in the earlier *Muldenfaltenstil*, a conjecture which might prove useful to students of the *Bible Moralisée*.

Stylistic correspondences to the *Bible Moralisée* have been dealt with in the introduction to this chapter. One theme remains to be mentioned: the similar ideology revealed in the two projects. Like the Prologue Cycle, the *Bible Moralisée* tends to emphasize contrasts between Christianity and Jewish Law.[140] There is also an obvious interest in relating the sacraments to Bible exegesis. Thus the content points to common habits of mind in addition to the similar treatment of style.

Influence of the *It 1* prologues is more difficult to establish. The prologues are primarily summaries of the texts of the Epistles, and depart very little from the content of the latter. The illustration therefore corresponds to sections within both the Epistle and the prologue. In some instances, however, it is possible to point to a more definite relation between prologue and picture. The illustration for I Corinthians (Figs. 250–7), for example, represents in a single image several ideas which are juxtaposed in the prologue but not in the text, and the I Timothy scene (Figs. 303–7) depicts Ordination, mentioned by name in the prologue, but not in the text.

There are eleven *It 1* prologues, and in seven instances it is the words at or near the end which seem to be pictured.[141] The effect of the proximity of word and illustration is particularly striking in the initial for Ephesians in Göttweig 55 (Fig. 274), where there are no intervening texts.

Two modes of expression are evident in the Prologue Cycle. Either Paul is shown as the advocate of a doctrine which is exemplified in a scene or situation, or as a participant in the action. By comparing the extant versions with each other and with parallels in the *Bibles Moralisées*, it has been possible to propose reconstructions of some of the originals and to demonstrate that in several of the illustrations a modification has taken place whereby as a result of the processes of transmission and conflation Paul as advocate has been replaced by Paul as participant. It is reasonable to assume that the majority of scenes were of the former type in the earliest stages of the cycle.[143] If we take as an example the illustration for I Thessalonians—the Resurrection of the Dead (Figs. 290–4)—we see that two elements are present: the dead rising from their tombs and Paul talking about what is happening. This image corresponds to the twofold inspiration for the picture, the Bible text describing the rising of the dead, and the prologue referring to Paul in the third person as speaking about and promising resurrection. A comparison of this illustration

[137] I Cor., II Cor., Gal., Col., I Thess., II Thess., II Tim., Tit., Philem.

[138] I Thess., II Thess., II Tim.

[139] Another possible interpretation is that both projects had a common model-book, consisting of motifs. While some of the illustrations might bear out this suggestion (II Cor.), others are so specific and detailed that they must derive from fully realized scenes not motifs.

[140] See above, n. 48.

[141] II Cor., Eph., I Thess., II Thess., I Tim., II Tim., Tit. In 3 other instances, indirect references at the end of the prologue seem to point to the illustration: Gal., Phil., Col.

[142] In all except 2 of the Epistles with *It 1* prologues (I and II Cor.), there is some evidence that the original scene was one in which Paul functioned as an advocate or bystander, but not as a participant.

with that in the Apostolic Cycle (Figs. 227–8) in which a similar scene appears reveals that the latter—depending directly on the Epistle text—is a straightforward depiction of the Resurrection of the Dead. Paul is not present. It is the influence of the prologue that introduces the complication, the double way of seeing, the double way of speaking, in both first and third persons.

The prologue, the picture, and the passage in the text work together to strike the reader with an image that tells him how to think about the Epistle even before he begins his reading.

Conclusions

When, toward the end of the twelfth century, the planners of Bible iconography were faced with the necessity of illustrating all of the Pauline Epistles, they found a variety of ready sources upon which to draw. The first was the early medieval tradition of narrative Acts scenes which had been associated with the Epistles in Bibles from Carolingian times. From this point onward the continuity of one part of the Acts narrative—the Conversion Cycle—can be easily traced. There are some indications that additional Acts scenes—that is, those depicting Paul's career up to his martyrdom in Rome—also were products of a tradition going back to late classical times, but the evidence is not as conclusive as for the Conversion Cycle. The association of episodes from the entire career of Paul with the Epistles was established in written sources by the Middle Ages,[1] and the pictorial iconography existed in illustrated Acts manuscripts from at least the eleventh century. Use of scenes from Acts to illustrate the Epistles suggests that there was a conception of underlying harmony in the writings and life of the apostle. The combination of the two themes might possibly represent an attempt to reconstruct the historical setting of the letters, an expression of the desire of the Middle Ages understand Bible texts in their literal and historical senses.

A similar desire to define the literal provided the basis for another type of iconography which emphasized the epistolary nature of the letters with variations on the theme of Paul writing and sending letters delivered to the recipients by messengers. This type emerges from the author portrait, a traditional and commonplace method of illustrating texts. Thus a specifically Pauline imagery is created out of the ordinary author portrait.

The most original approach to the problem of illustrating the Epistles can be seen in the Prologue Cycle. In this group of Bibles the pictures illustrate meaningful themes in the letters through narrative scenes, some newly invented, others drawn from a wide range of models. A second mode of expression operates simultaneously, deriving from the 'epistolary' type, so that Paul is portrayed delivering his message while it is enacted. Thus the chosen passages in the text and the words of the prologues are shown in one composite image.

Important motifs from the text also are brought out in the Apostolic Cycle, but in a different way. Here, episodes from Paul's life are used as types, analogous to references in the letters but not direct images based on the text itself.

These remarkable series of images arranged in sequential order have certain unique characteristics as illustration, the study of which can give insight into wider aspects of medieval iconography and into the kind of reasoning that determined the use of pictures accompanying texts.

One aspect of their singularity is that they reveal that the epistolary nature of the text was

[1] See above, p. 116, n. 172, for Isidore's summary of the life of Paul, sometimes used as a prologue to the Epistles.

appreciated and exploited by medieval iconographers. There seems to have been, for example, an attempt to find visual equivalents for ideas expressed verbally in the third person (the prologue), as opposed to the first person (the letter itself). This distinction might have application to other illustrated books, not only of letters, but also of any texts in which prologues or commentaries seem to influence the imagery.

Another distinctive feature of the Epistles is that there are fourteen of them, a relatively large block of related but discrete writings. This provides an opportunity for examining text and image on a fairly broad scale. It also means that the illustrations, when they depart from the repetitive, often are of a serial nature or have a unifying rhythm. They invite speculation as to the relationship between them. The sequential allocation of Acts scenes, for example, implies that their arrangement might be based on a theory of chronology.

Imagery which is expressive of the ideology of the Epistles raises many questions. It has been suggested above that the picture chosen for the initial letter acted as a kind of commentary on the text, a hint to the reader to watch for the important passages. Such a use of images, verbal and pictorial, as a means of introducing and clarifying texts was not foreign to the medieval mind. Beryl Smalley, describing Hugh of St. Victor's use of images as explicatory devices, observes, 'You begin with your picture, to which the text is a commentary and illustration. The most abstract teaching must take its starting point from some concrete shape which the pupil can have visibly depicted for him.'[2] The illustrations of the Prologue Cycle fulfil this function admirably.

A related possibility ought to be considered, which again might prove useful to the understanding of other texts illustrated with a variegated series of images: could the pictures have been intended as aids to memorizing the texts? Frances Yates has described the ways in which artificial memorization was practised in the Middle Ages as well as in classical antiquity and the Renaissance.[3] She suggests that certain categories of medieval art might have been used in the process of deliberate systematic memorizing of texts and concepts.[4] Several authorities reveal that systems of memory images were used in the Middle Ages. Aquinas, for instance, maintained, 'and thus it is that we remember less easily those things which are of subtle and spiritual import; and we remember more easily those things which are gross and sensible. And if we wish to remember intelligible notions more easily, we should link them with some kind of phantasms, as Tullius teaches in his Rhetoric.'[5]

Illustrations linked to the message of the text fit into this structure, the more so because they represent definite, clearly delineated actions, each one quite different from the others, thus providing 'gross and sensible . . . phantasms'. The memorizing of the image fixes in the mind one or more noteworthy aspects of the text and, by association, leads to the mastering of the entire text. Scenes that are sequentially arranged but are not necessarily expressive of the message also conceivably could form part of a system of memorizing by images, in this instance by odd and striking but illogical ones. Yates's rediscovery of the methods of artificial memory opens a world of possibilities to the student of imagery, particularly of images related to texts. The suggestions put forward here merely touch on what could prove to be a fruitful area of exploration.

[2] *Study of the Bible*, 95.

[3] F. A. Yates, *The Art of Memory* (Chicago, 1966).

[4] Ibid., Chapter IV, 'Mediaeval Memory and the Formation of Imagery', 82–104.

[5] T. Aquinas, *In Aristotelis libros, De sensu et sensato; De memoria et reminiscentia, commentarium*, ed. R. M. Spiazzi (Turin-Rome, 1949), 93: 'Et inde est quod ea quae habent subtilem et spiritualem considerationem, minus possumus memorari. Magis autem sunt memorabilia quae sunt grossa et sensibilia. Et oportet, si aliquas intelligibiles rationes volumus memorari facilius, quod eas alligemus quasi quibusdam aliis phantasmatibus, ut docet *Tullius* in sua *Rhetorica*.' Cited by Yates, *Art of Memory*, 71.

The search for appropriate illustrations for the Epistles began at a propitious moment. Book illustration was still in a stage of rich development and at the same time scholarly interest in the Bible had reached a high point, the writings of St. Paul occupying a special place. It is possible to attempt to explain and analyze the medieval imagery, but to understand it fully is probably beyond the capacities of the contemporary mind. One can only end on a note of admiration and surprise at the astonishing product resulting from the meeting of creativity and intellect.

APPENDIX A

Comparison of the Acts Iconography in Early Christian, Byzantine, and Medieval Monuments[1]

	San Paolo fuori le mura[2]	Carolingian Acts Cycles	Byzantine Acts Cycles[3]	Italian Acts Cycles	Initials of the Pauline Epistles in 12th- & 13th-century Bibles	Other occurrences in Bibles
(1) Ascension (Acts 1:9–10)			probable	*		common as an illustration for Acts
(2) Peter and the Jerusalem leaders (1:15)			*			
(3) Election of Matthias (1:23–6)			*			
(4) Pentecost (2:1–4)			*	*		common as an illustration for Acts
(5) Miracle of the Beautiful Gate (3:1–8)			*	*		Gumpert Bible
(6) Peter and John at the Sanhedrin (4:5–13)			*			
(7) Castigation of Ananias and Saphira (5:1–8)			*	*		
(8) Peter and John Heal with their Shadows (5:15–16)			*			
(9) Peter and John before the Sanhedrin (5:27–32)			*			
(10) Peter and John Flogged (5:40)			*			
(11) Election of Deacons (6:1–6)	*(W366)					

[1] This chart provides a general summary. For a more detailed listing of subjects in Byzantine and Italian monuments, see Eleen, 'Acts Illustrations', Appendix.

[2] W = Waetzoldt, *Kopien* (fig. no.). I am in agreement with most of Waetzoldt's interpretations, the important exceptions being his Figs. 370, 382, 385–7, and 407 (see items 21–4, 52–4, 63, and 77), but obviously not a few of these identifications are tentative, and many problems remain to be solved.

[3] In addition to the subjects found in extant Byzantine art, proposals are made here for several subjects which, in my opinion, probably occurred at one time in Eastern Acts illustration; these probably were included in the missing portions of the Rockefeller-McCormick New Testament, the lacunae of which provide the basis for my suggestions. This MS probably had in it at one time scenes of Philip and the Eunuch and the Conversion of Paul, both of which occur elsewhere in Byzantine Acts cycles. I suggest additionally that there were illustrations for the Ascension, Paul's Debate with the Stoics and Epicureans and the Raising of Eutychus.

	San Paolo fuori le mura	Carolingian Acts Cycles	Byzantine Acts Cycles	Italian Acts Cycles	Initials of the Pauline Epistles in 12th- & 13th-century Bibles	Other occurrences in Bibles
(12) Stephen before the Council (6:12–13)	*(W367)					
(13) Stoning of Stephen (7:55–60)	*(W368)	*	*	*	*	
(14) Burial of Stephen (8:2)			*			
(15) Saul Persecutes the Christians (8:3)	*(W369)					Pommersfelden Bible
(16) Simon Magus Rebuked by Peter (8:18–24)				*		
(17) An Angel Appears to Philip (8:26)				*		
(18) Philip Encounters the Eunuch (8:27–30)				*		
(19) Philip Instructs the Eunuch (8:34–35)			*	*		
(20) Philip Baptizes the Eunuch (8:38)			*	*		
(21) Saul Receives Letters (9:1–2)	*(W370)[4]	*	*	*	*	
(22) Conversion of Paul (9:3–5)	*(W370)	*	*	*	*	common as an illustration for Romans
(23) Paul Led to Damascus (9:8)	*(W370)	*	*	*	*	
(24) Vision of Ananias (9:10–16)	*(W370)	*		*		Gumpert Bible
(25) Paul Healed by Ananias (9:17–18)	*(W371)	*		*	*	
(26) Baptism of Paul (9:19)	*(W372)		*	*	*	Gumpert Bible
(27) Paul Preaching in Damascus (9:20)	*(W373)	*		*	*	
(28) Paul's Escape from Damascus (9:25)	*(W374)	*	*[5]	*	*	
(29) Peter Heals Aeneas (9:33–5)				*		
(30) Raising of Tabitha (9:36–41)			*	*		Gumpert Bible
(31) Vision of Cornelius (10:1–5)				*		Gumpert Bible
(32) Cornelius Sends Ambassadors (10:7–8)						Gumpert Bible
(33) Vision of Peter (10:10–16)			*	*	*	Gumpert Bible

[4] See above, p. 8.
[5] This subject is extremely rare in Byzantine and Italian imagery.

	San Paolo fuori le mura	Carolingian Acts Cycles	Byzantine Acts Cycles	Italian Acts Cycles	Initials of the Pauline Epistles in 12th- & 13th-century Bibles	Other occurences in Bibles
(34) Peter Receives Ambassadors (10:17–22)				*		
(35) Cornelius Greets Peter (10:24–5)				*		
(36) Peter Baptizes the Converts (10:47–8)			*	*		Gumpert Bible
(37) Beheading of James (12:2)			*	*		
(38) Arrest and Release of Peter (12:3–7)			*	*		*(II Peter)
(39) Herod Struck Down (12:21–3)				*		
(40) Barnabas Called by the Holy Spirit (13:1)	*(W392)					
(41) Blinding of Elymas (13:10–11)	*(W393)		*			Gumpert Bible
(42) Paul Preaches in the Synagogue (13:14–16)				*		
(43) Miracle of the Lame Man (14:8–10)	*(W394)		*	*	*	Gumpert Bible
(44) Flight from Apotheosis (14:11–15)	*(W395)			*		
(45) Paul Stoned at Lystra (14:19)	*(W388)				*	
(46) Council of the Apostles (15:6)	*(W389)				*	
(47) Paul Takes Timothy (16:1–3)	*(W390)				*	
(48) Paul Preaches in Asia (16:4–8)	*(W391)					
(49) Miracle of the Macedonian (16:9)	*(W375)		*	*?	*?	
(50) Journey to Macedonia (16:11)	*(W376)					*
(51) Lydia Listens to Paul (16:14)	*(W396)					
(52) Baptism of Lydia's Family (16:15)	*(W385)[6]					
(53) Miracle of the Evil Spirit (16:16–18)	*(W386)		*	*	*	
(54) Arrest of Paul and Silas (16:19–21)	*(W387)					

[6] I have identified this scene and the two that follow differently from Waetzoldt (cat. 647–9). My interpretation is based partly on the principle that related scenes often occur together in the Barberini drawings and partly on the identification of the half-obliterated central figure of a woman in no. 53 (W386) as the possessed girl in the Miracle of the Evil Spirit; it is unlikely that such an important episode would have been omitted from the cycle.

	San Paolo fuori le mura	Carolingian Acts Cycles	Byzantine Acts Cycles	Italian Acts Cycles	Initials of the Pauline Epistles in 12th- & 13th-century Bibles	Other occurrences in Bibles
(55) Paul and Silas Beaten and Imprisoned (16:22–3)	*(W378)	*	*	*	*	
(56) Paul and Silas in the Stocks (16:24)	*(W397)			*		
(57) Baptism of the Jailer's Family (16:33–4)	*(W398)			*		
(58) Paul Debates with the Stoics and Epicureans (18:12–16)	*(W399)		probable	*		
(59) Paul Judged by Gallio (18:12–16)				*		
(60) Sea Journey (18:18)				*		
(61) Miracle of the Raising of Eutychus (20:9–12)	*(W377)		probable	*	*	
(62) Prophecy of Agabus (21:10–13)	*(W379)			*		
(63) Paul Flogged by the Jews (21:30–3)	*(W382)[7]					
(64) Paul Arrested in Jerusalem (21:34)	*(W380)					
(65) Paul Preaching on the Stairs (21:40)	*(W400)					
(66) Paul Beaten in Jerusalem (21:26–22:25)	*(W381)			*	*?	
(67) The Lord Appears to Paul (23:11)	*(W402)					
(68) Paul Sent to Felix (23:23)	*(W403)					
(69) Paul Taken to Caesarea (23:33)	*(W383)					
(70) Paul before Felix (23:33)	*(W404)					
(71) Paul Accused by the High Priest (24:1–22)				*		
(72) Paul before Agrippa (25:23)	*(W401)				*?	
(73) Sea Trip to Sidon (27:1)	*(W384)			*		
(74) Shipwreck (27:41)	*(W405)			*	*	
(75) Miracle of the Viper (28:3)	*(W406)			*	*	

[7] See above, p. 35, n. 199.

	San Paolo fuori le mura	Carolingian Acts Cycles	Byzantine Acts Cycles	Italian Acts Cycles	Initials of the Pauline Epistles in 12th- & 13th-century Bibles	Other occurrences in Bibles
(76) Healing of the Father of Publius (28:7–9)				*		
(77) Arrival in Rome (28:15)	*(W407)[8]					

[8] Waetzoldt, cat. 668, interprets this scene as the apocryphal meeting of Peter and Paul in Rome, but an identification of it as the culminating episode in the canonical Acts is more consistent with the emphasis of the entire cycle. See above, p. 5.

Iconography of the Historiated Initials of the Pauline Epistles in the University of Toronto
Corpus of Bible Illustrations

	Paul Alone Gesturing	Paul with Book or Scroll	Paul with Book & Sword	Paul with Sword	Paul Writing	Paul Writing Inspired by Dove	Paul Writing Inspired by Head of God
Rom.	3	13	4	19	9	4	1
I Cor.	8	9	16	30	2	1	1
II Cor.	11	14	20	28	5	2	1
Gal.	13	5	14	30	5	1	1
Eph.	11	8	15	33	4	2	1
Phil.	12	9	12	31	6	1	2
Col.	10	14	11	27	2	1	
I Thess.	12	14	10	30	2	1	
II Thess.	9	9	9	33	4	2	1
I Tim.	10	11	10	31	3	1	
II Tim.	13	10	13	30	4	2	1
Tit.	16	12	9	28	6	1	
Philem.	13	9	9	36		2	
Heb.	2	1		2		1	
Laod.			2	4	1		
Total	143	138	154	392	53	22	9

	Paul Giving Letter or Scroll to a Man	Paul in Prison Giving Letter or Scroll to a Man[1]	Paul Addressing Single Figure (Man or Youth)	Paul Preaching to a Group	Paul Preaching to a City	Paul Preaching and Presenting a Cross to a Group
Rom.	4	1	5	16	2	24
I Cor.	13		14	12		
II Cor.	14		12	8	1	
Gal.	9	3	12	18		
Eph.	4	13	6	8	1	
Phil.	4	5	11	11	2	
Col.	11	3	10	12	3	
I Thess.	9		8	14	3	
II Thess.	6		12	11	1	
I Tim.	6	2	23	7		
II Tim.	12		16	3	1	
Tit.	6		20	8	1	
Philem.	4	8	9	10		
Heb.	2		17	59		2
Laod.				2		
Total	104	35	175	199	15	26

	Unusual Compositions	Scenes from Acts	Prologue Cycle	Total Number of Historiated Initials	Total Number of Occurrences of Texts
Rom.	5	18	16	144	205
I Cor.	4	9	14	133	185
II Cor.	2	10	13	141	188
Gal.	4	8	11	134	183
Eph.	4	11	13	133	186
Phil.	1	8	13	128	182
Col.	1	11	13	129	184
I Thess.	3	8	15	129	183
II Thess.	4	8	12	121	183
I Tim.	6	7	12	127	181
II Tim.		6	14	127	178
Tit.	4	5	10	126	171
Philem.	3	8	11	122	185
Heb.	8	6	15	115	185
Laod.	1			10	26
Total	50	123	182	1820	2810

[1] See also the illustrations for Eph. and Philem. in the Prologue Cycle.

APPENDIX C

The Marcionite Prologues to the Pauline Epistles[*]

A C D E F L O P Q R S T V W Y Z
Γ Δ Θ Σ (*pro* Phil. I. Thess.) Ψ *Y* Φ Ω
B F H K M m k q

Romans

om CY , W *habet* 37ª, Θ *habet* Pel [1]

Romani [1] sunt ' in partibus ' [2] italiae. Hi praeuenti sunt [3] a falsis apostolis et sub nomine domini nostri [4] iesu christi in legem et prophetas [5] erant [6] inducti [7]. Hos reuocat apostolus [8] ad ueram euangelicam [9] fidem [10] scribens eis a corintho [11].

[1] + ergo RΨ² [2] *sic* AFΩ¹D , in partes Q¹TΔRΨ² , in parte Q²L , partes FH¹Ψ¹Z , partis OESΩ²H²Bm [3] *om* E [4] *om* Ω¹OZ [5] in lege et prophetas Rm , in legem et prophetis Ω , (+ et L) in lege et (+ in L) prophetis LQ¹HΔ [6] *om* Q¹Δ [7] indocti P [8] ~ ap. r. Ω [9] *sic*

A¹F¹Ψ¹Ω¹ , u. et eu. LQTΔRΩ²H , u. eu. que EΨ¹F [10] sapientiam m [11] ab athenis Ψ¹ELS , ab ath. eis P , + bene relegas in christo semper frater carissime Δ , habet apostolus uersus ⍼dcccclxviii (+ GL) in opere (-ra L) legis carnalis (-lia L) qui spiritaliter intelligendi sunt LP*m*

[*] From D. De Bruyne, *Préfaces de la Bible latine* (Namur, 1920), 235–8. I have followed De Bruyne's text, retaining the medieval spelling—e.g. *persteterunt* for *perstiterunt*—but have made changes where there were obvious typographical errors: e.g. *virum* for *verum* and *has* for *hos*. De Bruyne's *sigla* represent the following manuscripts, insofar as I have been able to trace them:

A	Florence, Bibl. Laurenziana, Amiat. 1 (Codex Amiatinus)		Toletanus)		(Freising Fragments)
B	Bamberg, Staatsbibl., Bibl. 1	V	Rome, Bibl. Vallicelliana, B.VI	Φ	Einsiedeln, Stiftsbibl., 6
C	Colmar, Bibliothèque, 15 (38)	W	Stuttgart, Landesbibl., HB II 54	Ψ	Munich, Staatsbibl., Clm 4577
D	Dublin, Trinity Col. Lib., 52 (Book of Armagh)	Y	Wroclaw, Bibl. Uniwersytecka, R 163	Ω	St. Gall, Stiftsbibl., 70
		Z	London, BL, Harl. 1772	*Y*	Munich, Staatsbibl., Clm 18140
E	Munich, Staatsbibl., Clm 14345	*B*	Munich, Staatsbibl., Clm 14179	a	Munich, Staatsbibl., Clm 6236
F	Fulda, Landesbibl. (Codex Fuldensis)	*F*	Munich, Staatsbibl., Clm 6229	d	Monte Cassino, Bibl. dell' Abbazia, 35
H	London, BL, Add. 24142	*H*	Cologne, Cathedral, 1	k	Vienna, Nationalbibl., 1247
I	Paris, BN, lat. 250	*K*	Munich, Staatsbibl., Clm 9545	m	Berlin, Staatsbibl., Phillipps 5 (1659)
K	London, BL, Add. 10546 (Grandval Bible)	*L*	St. Gall, Stiftsbibl. 83		
		M	Würzburg, Universitätsbibl., M. th. f. 12	q	Engelberg, Stiftsbibl., 5
O	Oxford, Bodl. Lib., Laud Lat. 108			t	Munich, Staatsbibl., Clm 17040
P	Munich, Staatsbibl., Clm 17043	Γ	Madrid, Academia de la Historia, Bible of San-Millán	v	Chiari
Q	Paris, BN, lat. 93	Δ	Vienna, Nationalbibl., 1190	*e*	Rome, Bibl. Casanatense, 723
R	Vatican Lib., Reg. 9	Θ	Paris, BN, lat. 9380 (Bible of Theodulf)	*f*	Rome, Bibl. Nazionale, Sessor. 34
S	Stuttgart, Landesbibl., Bibl. fol.80			*g*	Rome, Bibl. Nazionale, Sessor. 3
T	Madrid, BN, Vitr. 13–1 (Codex	Σ	Munich, Staatsbibl., Clm 6436	*x*	Bamberg, Staatsbibl., Bibl. 10
				y	Bamberg, Staatsbibl., Bibl. 6

I Corinthians

Corinthii sunt achaei [1]. Et [2] hi similiter ab apostolis [3] audierunt uerbum ueritatis et subuersi [4] multifarie a falsis apostolis [5], quidam a [6] philosophiae [7] uerbosa [8] eloquentia [9], alii a secta [10] legis iudaicae inducti [11]. Hos reuocat apostolus [12] ad ueram et [13] euangelicam sapientiam [14] scribens eis ab epheso 'per timotheum' [15].

[1] achaei AL , achaethi *FΨ* , achai CDB*Δ* , acai F , acei T , acahii *Γ* , (+ populi P) achaici PY*ΘH* , achiui ES*K* , achaiae *MR* achaiae *Ω*[1] (?) [2] *om* DF*Ψ* [3] apostulo *BFKΨY* , -los F [4] + sunt VY*Hm* , + quidam D [5] fratribus V [6] *om* A [7] philosophia S [8] uerbo F*B* [9] ad ph. uerbosam eloquentiam *MK*[2] [10] *sic* AR*F* , alia secta F*BΩΨ* , alii secta L , alii

ad (in E) sectam C[2]EH*Mk* [11] indocti PW[1] , inducit *B* , + sunt DEPFR*Ψkq* , ~ fuerunt (-rant q) i. H*q* [12] *om* ELSB*Mm* [13] *om* F [14] fidem *ΦM* [15] *om* LPWT*ΘΦ* , + discipulum suum V*kmq* , + scripta de chorintho uersos DCCCCXI L , + haec epistola per timotheum corinthios ab apostolo missa est *Θ* , + cohortans et corripiens ut salui fiant in christo iesu domino nostro D*M*

II Corinthians

Post actam [1] paenitentiam consolatoriam [2] scribit [3] eis [4] a troade [5] et [6] conlaudans [7] eos [8] hortatur ad meliora [9].

[1] acceptam CBFMR*Ψm* , hanc V , + a (+ eisdem D) corintheis D*k* [2] consolatorias FLR , -ria *M* + epistolam CEK*mΩ* [3] scripsit D*MΘYk* , scribens S [4] *om* SFC , + litteras *Φ*[2] , + epistolam apostolus D*Mk* [5] macedonia D

, + per titum A[2]VH*Yk* , per tychicum *M*[2] [6] *om* F [7] conlaudat *Ω* [8] *om* AC[1] [9] meliorem Y , + per tychicum D , + contristatos quidem eos (*om* E , ~ e.a. *BYΩ*) sed emendatos ostendens (-dit EPSB*YΩ*) EPSVY*BHYΩmk*

Galatians

Galatae sunt graeci. Hi uerbum ueritatis primum [1] ab apostolo [2] acceperunt [3], sed post discessum [4] eius temptati sunt a falsis apostolis, ut in legem et [5] circumcisionem [6] uerterentur [7]. Hos apostolus reuocat [8] ad fidem ueritatis [9] scribens eis [10] ab epheso [11].

[1] primus A[1] , prius A[2] [2] apostolis *Ω*[1] (?) [3] susceperunt S*K* [4] + a doctrina W[1] [5] + in DM*k* [6] circumcisione R , lege et circumcisione

C[1]FLQ*BKFΨΔΩ* [7] reuerterentur *SK* [8] ~ reu. a Y [9] *om* C[1] [10] *om* F [11] W[2] , ab urbe roma W[1] , + per tytum FR

Ephesians

in Ψ folium excidit

Ephesii sunt asiani [1]. Hi accepto uerbo [2] ueritatis persteterunt [3] in fide. Hos conlaudat apostolus scribens eis 'ab urbe roma' [4] de carcere per tychicum [5] diaconum [6].

[1] asini Y[2] , + et S [2] *om* C[1] [3] perstiterunt FY*FΘΩ*[2] [4] *om* Y Y , a roma ADLTP*FKMΘΩ*[2]*kq* [5] titicum E*WBYm* , titum *Δ* [6] *om* diac. k , *om* tych. d. TL*Θ*[2] , add. C[2]E[2]W[marg] *ABΦΩ*adqu : (+ amen C) sciendum sane quia haec (in hac W)

epistola (hanc epistotam a), quam nos ad ephesios (ab ephesiis W) scriptam habemus, haeretici et (*om* W) maxime marcionistae (-to et W) ad laudicenos (-censes a) adtitulant (scribant W)

Philippians

Philippenses [2] sunt machedones [2]. Hi accepto uerbo ueritatis persteterunt [3] 'in fide' [4] nec receperunt falsos apostolos. Hos apostolus conlaudat [5] scribens eis a roma 'de carcere' [6] 'per epaphroditum' [7].

[1] + ipsi *ΦΩ*[1] [2] *sic* FR , machedonas *ΨF* , macedones ALPQY*HΔΩ* [3] perstiterunt LY*Θ*[2]*Ω*[2]*Σ* [4] *om* D [5] ~ conl. ap. ACQSV*HΔΩ* , hoc

secundum laudat ap. Y [6] *om* *ΣR* [7] phaproditum PF , *om* LT*Θ*[1]*Σ*

Colossians

Colosenses et hi sicut laudicenses [1] sunt asiani. Et ipsi [2] praeuenti erant a pseudoapostolis [3] nec ad hos accessit ipse apostolus [4], sed 'et hos' [5] per epistolam recorrigit [6]. Audierant [7] enim uerbum ab archippo qui et ministerium in eos accepit [8]. Ergo apostolus iam ligatus [9] scribit [10] eis [11] ab epheso [12].

[1] laudienses *B* , laodicenses FC , laodicenses L⊖ DTV⊖mk [8] accipit D*M*k , ~ acc. in e. ΔQ
[2] + enim C Ω[1] [3] pseudoapostolus ΨF , [9] legatus F [10] scripsit ⊖ΓW , scribens S
falsis apostolis D [4] ~ ap. i. ⊖ , i. acc. ap. Y [11] *om* ΔQ [12] + per tychicum diaconum (-nem Y⊖[2])
om ipse T Y [5] *om* Y , *om* et SY [6] recorriget C VYH⊖[2]m , + per ticticum (tychicum C K) dia-
, corrigit V *Y*m , -gat ΨF [7] audierunt conum et honesimum acolytum CDPW*BKM*ΩkqΦ

I Thessalonians

Thessalonicenses sunt machedones [1], qui [2] accepto uerbo ueritatis [3] persteterunt [4] in fide etiam in persecutione ciuium suorum [5], praeterea [6] nec [7] receperunt [8] eq quae a falsis apostolis dicebantur [9]. Hos conlaudat apostolus scribens [10] ab athenis [11].

[1] macedones LF , + in christo iesu A[1]FLCPVS*HM*k [9] + refutantes D [10] *om* PΨ [11] *sine addito*
, *om* A[2]QTBFΓΔΨΣΩ [2] hii *FM*Ψk APΨFLR , + per timotheum diaconum CF*B*[1]*K*Ω ,
[3] caritatis D , + in christo iesu DRq + per tychicum q , + per tychicum (thitycum m) et
[4] perstiterunt ALYΨΣΩ [5] ipsorum Γ , + con- onesimum VY⊖[2]*H*m , + per tychicum (timotheum
stantes fuerunt in fide *H*m [6] *om* Y , propterea D *B*W[in ras.] , tithicum ΔQ) diaconum et honesimum
[7] non C [8] + falsos apostolos nec VY*H*mq acolytum DPQW*B*[2]*M*Δk

II Thessalonians

'Ad thessalonicenses [1] secundam' [2] scribit [3] et notum facit [4] eis de temporibus nouissimis et de [5] aduersarii detectione [6]. Scribit [7] ab athenis [8].

[1] thessalonicensibus D , *om* Y [2] *om* WR , , scribens et hanc epistolam TW*M*⊖ΦkΔQ , scribit
, + et epistolam [3] scripsit DTW*M* , + epistolam (+ autem CΩq) hanc ep. ACLPY*BH*YΩΓmq [8] de
ACD*H*ΩKMmkq , + apostolus PQTW*KM*Δ⊖k , + athenis TW , + per titum et onesimum VYHK⊖[2]m
ep. ap. Y [4] fecit F [5] *om* R [6] deiectione , + per titum (tychicum PD*M*k , tithycum R) dia-
*K*Hm*R Y*ΦΘΩ[2] , deceptione DVkP [7] scripsit *M* conum et onesimum acolytum DPV*H*MkRΔQ

I Timothy

'Timotheum instruit [1] et docet' [2] de ordinatione episcopatus [3] et [4] diaconii [5] et omnis ecclesiasticae disciplinae [6].

[1] instruet F[2]SFΨ , instruxit D*M*k , instituit F[1] + ei WΩ) de laodicia E[2]FW[in ras.]·*B*FHΦΨΩC[2] , scribens
[2] *om* B [3] episcopi D [4] + de E[1]F[1]FΨ ei ab urbe roma ⊖ Y , sc. ei ab urbe Γ[2] , sc. ei ab urbe
[5] diaconi CDSW[1]T*M*kq , -nibus Γ [6] omni laudicie T , sc. ei a machedonia AD , sc. ei a nicopoli
ecclesiastica disciplina & *sine addito* QLPΓ[1]RΔC[1] , per tichicum diaconum P
+ per tychicum D , + scribens (scribet *HC* ,

II Timothy

'Item [1] timotheo' [2] scribit [3] de exhortatione martyrii [4] et omnis regulae [5] ueritatis [6] et quid futurum sit temporibus nouissimis et de sua passione [7].

[1] *om* R [2] *om* Y [3] scribet W , scripsit D*M*k [7] ~ pass. s. D*M*k , *sine addito* A⊖LΓ[1]Ω , +
, + secundam *M* [4] martyrum ΔQ [5] *sic* scribit (-bens YS*YH*) ei ab urbe roma FPQΔΨYF ,
ATΓRΩBHC , et de omnis regulae W , et omnes scribens ei a roma W[2] , scribit autem ei a roma de carcere
regulae L , (+ et F) de omnes regulas FΨF , et de CB , scribit ei ab urbe R , scribens ei a laudicia WΓ[2]T
omni regula *KME* , omnis regula Y [6] ueritate TW

Titus

Titum commonefacit [1] et instruit de constitutione [2] presbyterii et de spiritali conuersatione [3] et hereticis uitandis qui in [4] scripturis iudaicis [5] credunt [6].

[1] communem facit Γ , argumentum ad titum discipulum suum quem monet D [2] + maiorem natu M [3] ~ c. sp. D*M*k [4] *om* T [5] iudaicis fabulis RΦ , traditionibus iudaicis D*M*k [6] *om* uit. — cred. Y , *sine addito* CAΘ¹LRΔQ , + scribit (+ ei F) a

nicopoli F*F*KΨΩ , ~ a nic. sc. PVYΘ²m , scr. ei ab athenis D*M* , scr. ei de laodicia H , scribens ei de (a W) nicopoli W*q*Γ² , scripta nicopoli S*B* , scribens ei ab urbe roma Γ¹ , scr. ei de nicopoli ab urbe roma T

Philemon

Philemoni familiares litteras facit [1] pro onesimo seruo [2] eius. Scribit [3] autem [4] ei a roma [5] de carcere [6].

[1] fecit M , mittit TΓ*Y*Θ , facit W*in ras.* [2] fratre Θ [3] scripsit M , scribens D [4] *om* D*M*k [5] ab urbe roma Y*H*mP [6] *sine addito*

CFLPT*B*FΓΘΨΩΔQ , + per onesimum acolitum (-otum A) AD*M* , p. eundem on. *K*R , p. supradictum on. (+ acol. k) *H*k

APPENDIX D

The *It 1* Prologues to the Pauline Epistles[*]

e f g (pro 1 Cor. Philipp.)

I Corinthians

Epistola prima ad corinthios multas diuersasque complectitur, quarum partem [1] relatione [2] fratrum cognouit apostolus, partem [3] ipsorum corinthiorum sunt litteris indicata [4], nonnullas uero pro officii sui cura aut ordinat aut emendat et uariis curationibus medetur diuersas inifirmitates languentium [5]. Nam primum apud eos curat [6] dissensionis uitium, quod multi pseudo apostolorum intulerant [7] unitatem scindentes ecclesiae ut proprii nominis facerent sectatores, quos his exprobrat [8] uerbis apostolus : hoc autem dico quod unusquisque uestrum dicit : ego quidem sum pauli, ego autem apollo, ego uero cephae, ego autem christi. Et oblique [9] horum se dicit facere nominum mentionem ut multo magis erubescant id se facere sub falsorum apostolorum nominibus, quod etiam si sub pauli et petri fieret nomine displiceret. Secundo [10] causa eius inducitur, qui paternae oblitus reuerentiae uxorem sibi non erubuit facere de nouerca ; quod facinus licet fornicationem appellauerit apostolus, tamen ita condempnauit, ut in ultionem facti auctorem talis operis diabolo iudicauerit deputandum, interposita iudiciorum et litium tertia quaestione. Quarto loco matrimonii curae [11] tractantur. His quinto loco uirginitatis consilium uelut [12] uicino subiungitur [13]. Sexto loco de escarum licentia disputatur. Septimo atque octauo loco de adtondendo uiris et mulieribus uelando capite et [14] sacramentorum communione praecipitur. Nono loco aemulatio quae de [15] diuersitate donorum spiritalium nascebatur sub exemplo membrorum et corporis castigatur. Decimo resurrectionis spes multis [16] argumentis et rationibus approbatur. Ultima de colligendis [17] ad necessitates [18] sanctorum nummis [19] caritatis cura uel aedificationis [20] culmen imponitur. Inseruntur [21] his paucae quae aut, ut [22] quibusdam uidetur, pendent ex superioribus aut habent licet proprias tamen paruulas actiones.

[1] partim *e* [2] reuelatione *g* [3] partim *e* , -tes *f²* [4] indicatē *fg* [5] diuersa infirmitate languentibus *fg* [6] curatur *fg* [7] intulerunt *fg* [8] exprobatur *fg* [9] obliqui *f* [10] secunda *fg* [11] matrimoniorum iura *fg* [12] et *e* [13] subiungit *f* [14] a *fg* [15] *om e* [16] +et *g* [17] collectis *f²* [18] necessitatem *fg* [19] nomini *fg* [20] aedificatio *g* , -ficii *f¹* , -io *f²* [21] interseruntur *fg* [22] in *g*

II Corinthians

In secunda ad corinthios epistola quasi in parte superiori [1], post tribulationum suarum relationem [2] reddit causas, quare ad eos secundo non ierit, quod non leui mutatione consilii fecisse se asserit, sed ne aduentu suo tristitiam incurreret, cum in peccato permanere discipulos repperisset. Deinde agnito fructu paenitentiae reconciliat eum ecclesiae quem in prima propter fornicationem a consortio sanctorum iusserat amoueri. Et [3] tertio contra pseudo apostolos officii sui dignitatem tuetur et noui testamenti ministros tanto anteire [4] gratia ostendit, quanto euangelium est lege praestantius. Inmoratur etiam in causa illa plurimum quam breuiter in prima contigerat, ut prompto ac libenti animo necessaria praesentis uitae non habentibus largiantur et utilitate spiritalis commercii commutent praesentia cum futuris atque abundantia sua sanctorum inopiam suppleant, ut uicissim ipsorum inopia sanctorum abundantia

[*] From De Bruyne, *Préfaces*, 239–42. For *sigla* see above, p. 160.

suppleatur. In fine repetit quod superius contra pseudo apostolos egerat et iactationem eorum praedicationesque de se gloriosas uel collata antiquitate generis uel catalogo iniuriarum ac periculorum suorum euacuat, dicitque eos operarios subdolos qui ad imitationem satanae transfigurentur in apostolos christi sub praedicationis specie lucra pecuniaria questusque sectantes.

[1] superioris *f* [2] relationes *f* [3] *om f* [4] ire *f*[1]

Galatians

Galatas post susceptionem euangelii quidam ad obseruationem legis ueteris [1] compulerunt, unde et hebionitarum heresis nata est [2], quae et christo credit [3] et obseruatione [4] circumcisionis et sabbati iudaizat ac similium mandatorum. Hos apostolus exemplis, ratione, auctoritate reuocat ab errore. Nam primum personam suam eis obicit, ut in ipso recognoscant, quid sibi facere conueniat et dicit se in iudaismo super coaetaneos suos habuisse studium et aemulatorem fuisse paternarum traditionum, ita ut christi persequeretur ecclesiam, post susceptionem tamen fidei ita credidisse christo et cruci eius adfixum esse, ut uideretur mortuus legi. Deinde alio quodam exemplo [5] proficeret, etiam petrum a se correptum [6] indicat, quare metu iudaeorum in conuentu [7] eorum, qui ex gentibus crediderant non tenuerit libertatem, cum utique sub euangelio par esset omnium credentium atque una conditio. Affert et exemplum abrahae ' qui ante ' [8] legem factorum fide iustificatus sit, quique benedictionem ob hoc acceperit, ut iam tunc ostenderetur neminem ad iustitiam posse aliter peruenire, nisi fidem abrahae fuisset imitatus. Argumentatur etiam quoniam in lege iustificari nemo iam possit, sub qua utique dictum erat : Iustus autem ex fide uiuit. Ex ratione [9] colligit si tantum fides potest, ut et ante legem abraham et sub lege nonnisi ipsa iustificet stultum esse [10] eam tempore suo ad iustificandum non putare solam posse sufficere. Ad postremum exerit auctoritatem apostolicam et pronuntiat: Ecce ego paulus dico vobis: quia si circumcidamini, christus uobis nihil proderit; a gratia excidistis qui in lege iustificamini.

[1] uet. *om f*[1] [2] + eis *f* [3] credidit *f*[1] [4] in obseruationem *f* [5] aliud (alium *e*) quod exemplum *ef* [6] correctum *f*[1]
[7] conuictu *f* [8] quia non *e* [9] Et rationem *f* [10] est *f*

Ephesians

in e iungitur cum Ma

Tam [1] deuotionem ephesiorum quam et fidem [2] et sanctorum dilectionem [3] uelut duobus idoneis testibus approbat [4] miris magister gentium exhortationibus incitat. Primo quod dicit eos ante constitutionem mundi electos et in adoptionem filiorum uocatos, ut ipsa electio et adoptio conuersationis in [5] bono [6] collocatae [7] eos respondere faciat dignitati. Deinde mysterium incarnationis dominicae quod superioribus ignotum fuerat generationibus per euangelium suum illis reuelatum dicit, ut in eo honorem suae conditionis agnoscerent, quoniam eiusdem naturae a mortuis suscitatus [8] homo christus iesus transcenderit honore principatus et nirtutes et dominationes et sic [9] in dei dextera in quo insigne [10] dignitatis ostenditur collocatus. Reuocantur etiam in memoriam superioris uitae quod est efficacissimum exhortationis genus, ut dum se abiectos et uiles reminiscuntur [11], crescat apud eos praesentis cumulus dignitatis, nam inter saxa idolorum et ligna inpingendo dei ueri notitiam non habebant. Agebant etiam extranei [12] non solum a promissionum [13] spe, uerum etiam a conuersatione israhel, cui promissio debebatur. Sanguine itaque christi amotum est legis obstaculum, quod iudaeos a gentibus dirimebat et iudaei nomine gentilisque deposito [14] unus ex duobus nouus homo factus est christianus. His ergo praemissis beneficiis ammonet eos, ut uicem referant et digne ambulent uocatione, qua uocati sunt cum omni humilitate et mansuetudine. Deinde ut optimus morum magister uitiorum omnium imperat cautionem, officia inter affectus ordinat, uxoris in uirum, uiri in uxorem, filiorum in parentes, parentum in filios, praecipit seruis,

ut fideliter seruiant, ammonet dominos, ut clementer imperent. Ad postremum [15] omnibus genera armorum suggerit quibus contra spiritales hostes ualeant dimicare.

[1] *om f* [2] fide *f* [3] dilectione *f* [4] adprobabat *f* [5] *om f* [6] bone *f* [7] collate *f²* [8] suscitatos *f* [9] sit *f* [10] insignet *e* [11] recognoscuntur, alii remin. *f* [12] extraneos *f* , -ea *e¹* [13] promissione *f* [14] disposito *f* [15] + in commune *f*

Philippians

Philippis [1] machedioniae ciuitas est, in qua apostolus post uisionem quae ei ostensa fuerat, sicut in actibus apostolorum refertur [2], uisio per noctem paulo ostensa est : uir macedo quidam erat stans et deprecans eum et [3] dicens : transiens in [4] macedoniam adiuua nos, primum euangelium praedicauit, quod tanta fide susceperunt, ut non solum ipsi crederent, uerum id quod audierant etiam aliis praedicarent et [5] feruore spiritus rudimenta discipulorum ponentes susciperent officia ministrorum. Quibus congaudet apostolus dicens : Obsecrationem faciens super communicatione uestra [6] in euangelio. Horum itaque cursum fauore suo incitat et catenas suas dicit ad profectum [7] euangelii pertinere, quia dum quaerentibus reddit causas uinculorum suorum, christi nescientibus nomen insinuat, cuius uoluntati et uitae suae tempus profitetur et mortis impendere, dum aut annuntiat [8] fidem eius aut pro fide eius mori non timet.

Hortatur autem [9] philippenses, ut digne [10] evangelio [11] christi conuersentur, hoc est ut fidem praedicationis conuersationis bonae [12] et operis [13] testimonio prosequantur nec metu [14] aduersariorum deducantur ab euangelizandi studio. Inter quorum tenebras faciendo [15] omnia sine murmurationibus et haesitationibus debent vitae suae splendore radiare. Admonet etiam ut caueant a pseudo apostolis, qui in [16] iniuriam gratiae custodiendas obseruationes legis ueteris praedicabant. Congratulatur [17] in fine oblationibus eorum, non ob hoc quia ipse aliquid acciperet, sed quia talibus eos uelit fructibus abundare.

[1] Philippi *g* [2] refert *e* [3] *om e* [4] *om e* [5] ut *e* [6] communicationem uestram *e* [7] prouectum *e g* [8] + per *g* [9] ergo *e g* [10] + in *e* [11] euangelium *f g* [12] bono *g f* [13] opere *f g* [14] metum *g* [15] facienda *e* [16] *om f g* [17] congratulatus *g*

Colossians

Prima apud colosenses [1] epaphrae uerbo fidei iacta [2] sunt fundamenta, ut testis est ipse apostolus dicens : Sicut didicistis ab epaphra carissimo conseruo nostro. His ergo scribens magister gentium uelut surgenti fabricae manum super aedificationis admouit [3] et incipiens a laude fidei, quam dilectionis operibus conprobabant [4] consummationibus eorum tam uotis quam adhortatione prosequitur et quod unum ad omnem perfectionem eorum [5] erat necessarium optat, ut impleantur [6] agnitione [7] uoluntatis dei, ex qua uelut fonte [8] ad omnium uirtutum nutrienda semina sapientiae [9] intellectus spiritalis possit abundans riuos [10] influere, cuius austu [11] gaudeant se auulsos de ariditate gentilium et in iriguo quasi uiua plantaria [12] collocatos. Iubet itaque eos agere gratias patri, qui eripuit eos de potestate tenebrarum et transtulit in regnum filii dilectionis suae [13], ut aut [14] ad profectum eorum proficiat beneficii memoria, aut certe ut non relabantur [15] eo [16], unde se gratulantur ' ereptos in regnum ' [17] filii dilectionis suae, et quid sit hic filius docet in quo et deitatis per imaginem dei et humanitatis [18] dicendo primogenitus omnis creaturae uoluit iudicare [19] substantiam. Nam omnia per ipsum et in ipso creata sunt, soli deo competit; primogenitus uero cum dicitur ex mortuis, homo uerus ostenditur. Et ideo pacificauit quae in caelis sunt et quae in terra [20], quia utrisque [21] elementis [22] fuit habitator et dominus ; et ut angelicas uirtutes humilitatem exemplo suo, ita homines docuit sanctitatem. Quorum omnium ideo se dicit facere mentionem ne obliti tantorum beneficiorum, illiciantur a terrena sapientia et magisteria humana sectentur id est aut philosophorum capiantur subtilitatibus, aut iudaicis obseruationibus implicentur.

[1] + ab *e* [2] iactata *e* [3] ammonuit *g* [4] conprobant *e¹g* [5] *om ef²g* , erant *g* [6] impleatur *f²eg* [7] agnitionem *e* [8] forte *g* [9] sapientia *eg* [10] riuus *e* [11] austo *g* [12] planta *e* , -tari *g* [13] + ita *e* [14] *om e* [15] reuelabantur *g* , elementur *e* [16] *om eg* [17] om *e¹* [18] humilitatis *g* [19] indagare *g* [20] terris *e²* [21] utriusq. *e* [22] elementi *e^marg. g* , testamenti *e*

I Thessalonians

Grande fidei testimonium thessalonicensibus ab apostolo perhibetur cum dicitur : Uos enim fratres imitatores nostri facti estis et domini nihilque illis deesse ad perfectionem testatur illa sententia qua dicitur: Sufficit discipulo, ut sit sicut magister eius et seruus sicut dominus eius. Nec tantum uerbo praedicasse id apostolo sufficit [1], ipsa opera profert in medium, per quae ad uirtutem imitationis ascenderant. Tantoque namque feruore spiritus et gaudio praedicationem euangelii susceperunt, ut tribulationibus, quae obuiabant auditui eorum, minime frangerentur, se in occasionem [2] laetitiae ducerent [3] quicquid ' propter hoc ' [4] aduersi paterentur. Quae constantia eorum uicinis quoque regionibus, id es machedoniae et achaiae exemplo suo magistra fuit qua animae fidem deberent uirtutes [5] suscipere. Tantam [6] uero annuntiationi suae dicit eos praebuisse reuerentiam, ut sibi non apostoli, sed dei crederent praesentis uerba resonare. Cui rei [7] documentum fuit, quod persecutiones a contribulibus suscitatas ad imitationem earum, quae in iudaea erant ecclesiarum aequo animo susceperunt. De quibus ad hebraeos dicit : Nam et uinctis compassi estis et rapinam bonorum uestrorum cum gaudio suscepistis. Hos ergo consequenter obtestans ammonet, ut partas iam uirtutes non solum sollicite custodiant, sed etiam cotidianis accessibus in cumulum [8] perducant. Per praeteritionem etiam caritatis eis studia commendat eo attentius, quo dicit eos [9] ut [10] a deo [11] edoctos, extraneo magisterio non egere. Amouet in fine tristitiam per spem resurrectionis, quae de carorum amissionibus nascebatur. De ipsius quoque resurrectionis uel ordine uel genere uel de [12] incerto fine temporum docet [13] ob quod incertam [14] uigilantes spiritu et sobrios a uitiis maiore [15] eos dicit debere [16] sollicitudine [17] praeparare [18].

[1] + sed et *e* [2] occasione *e* [3] ducerentur *e* [4] prophetae *f* [5] uirtute *e* [6] tantum *e* [7] *om e*[1]
[8] colomem *f* [9] eis *f*[1] [10] *om e* [11] adeo *e* [12] *om e* [13] *om e*[1] [14] incerto *e* [15] maiorem *e*
[16] *om e*[1] [17] sollicitudinem *e* [18] + debere *e*[2]

II Thessalonians

Seruatur in secunda epistola eadem praedicatio fidei thessalonicensium quae primae uolumen impleuerat, immo quod ad augmentum laudis pertinet supercrescere et abundare caritate dicuntur, ita ut plenitudinis suae praedicatorem per alias ecclesias apostolum habere mereantur. Quorum patientiam in persecutionibus tantam fuisse dicit, ut futurum, quo [1] in [2] impios et peccatores animaduertendum est iam tunc iustum dei iudicium comprobaret. Quoniam uel apud aequissimum iudicem quae seminauerit homo haec et metet et fructus operanti pro operum qualitate respondit uel certe quod exemplum [3] uirtutis eorum etiam hii qui persequebantur potuerunt [4] intellegere neminem [5] sanae mentis nisi ob certam spem talia sustinere. Deinde cum obtestatione quoniam aliqui apud eos finem mundi et aduentus dominici instare iactauerant [6] per quae esse poterat non parua erroris occasio monet, ne credant facile, et praedicit certa signa, quae sint aduentum domini praecessura. Addit praeterea praecepta, quibus et indisciplinate ambulantium inquietudo frenetur et otii amicis per negationem [7] cibi operandi aliquid necessitas imponatur et humanitatis, ne restricta uideretur iugis consuetudo seruetur.

[1] quod *e* [2] *om e* [3] exemplo *e* [4] potuerant *e* [5] nemo *f* [6] iactauerat *f* [7] necationem *f*

I Timothy

Quae proficiscens in macedoniam apostolus timotheo apud ephesum agenda mandauerat, ne minus ponderis sermone proficisentis tradita habere uiderentur, scripto [1] repetuntur, id est ut praedicatores obseruationum legalium qui documentum peritiae suae credebant esse, si generationum antiquarum gradus et seriem priscorum nominum decantarent, interdicto cohiberet, praesertim cum per caritatem et bonam conscientiam et fidem non fictam uelut in compendium redacta mandatorum multiplicatio seruaretur nec praedicatio fidei in iniuriam legis proficeret quae iustis non erat posita, quorum praeueniebat uoluntaria deuotio iussionem ab iniustis non impetrabat obsequium et ita erat apud

utramque partem otiosa². Cuius tamen intentionem christi aduentus impleuit, qui peccatores uenit saluos facere, quod libentibus animis ab his audiri debet, qui langoris conscii curatore indigent ³; instituit post haec ⁴ nouum episcopum ecclesiasticis disciplinis et quae sint ⁵ in ordinationibus quaerenda praescribit. Recessuros quosdam a fide ultimis temporibus et in manichaei blasphemias dilapsuros spiritu reuelante denuntiat. Praecipit ut det operam ⁶ lectioni, cuius instructione et ipse et audientes prouectum capiant sanctitatis.

¹ scripta *e* ² pretiosa ³ curatoris indigent (indegetur *e*¹) medicina *e* ⁴ +ut *e* ⁵ sunt *e* ⁶ opera *f*

II Timothy

Inter initia episcopatus sui deterrito ab annuntiatione euangeli timotheo ¹ ad uitae ² fidei quam ab auia ac matre didicerat commemorationem ³ conformat ⁴ et ad feruoris sui eum memoriam remittit dum uult eum resuscitare quod calens primo⁵ fuerat tepefactum⁶. Et ammonet, ne obprobria crucis christi et pauli uincula aestimet causam ⁷ pudoris. Exemplo etiam suo omnium tribulationum ei demit trepidationem, dum dicit illum scire, qualia illi facta sint ⁸ antiochiae, ichonio ⁹, lystris et spem illi ingerit parati semper auxilii dicendo : Et ex omnibus me eripuit dominus. Uult postremo bonae uitae esse generale testimonium, si malorum hominum odia incurrat, ut hoc ipso attollatur bona conscientia si tribulationum onere prematur.

¹ deterritum . . . timotheum *e* ² uitam *e* ³ commemoratione *e* ⁴ confortat *e* ⁵ primum *e*
⁶ tepefactus *e* ⁷ *om f* ⁸ factae sunt *e* ⁹ ichoniae *f*

Titus

Breuis numero uersuum ad titum epistola est ¹, sed multa complectitur, primo qualis ² ecclesiis praefici conueniat et quibus uirtutibus plenus, qui inter reliqua morum ornamenta studio habendi sermonis et copia possit ³ implere exhortationis officium et ⁴ contradicentium uel imperitiam uel inpudentiam confutare. Deinde quid specialiter conueniat diuersarum aetatum gradibus inculcari ⁵, qualiter etiam qui a uilitate ⁶ conditionis ad susceptionem fidei ueniunt, probabiliores facti ferant doctrinae testimonium christianae, per quam meliores esse didicerant ⁷.

¹ *om f* ² quales ³ possint ⁴ *om e* ⁵ conculcari *e* ⁶ ab utilitate *e* ⁷ didicerunt *e*

APPENDIX E

The Pelagian Prologues to the Pauline Epistles*

I *The Pelagian Prologue to all the Epistles**

B L a Ψ = H T Θ x y φ = D I R W λ (= B K V) d m v

1. [1] Epistolae [2] pauli [3] ad romanos causa haec est. Ecclesiam e [4] duobus populis, id est de [5] iudaeis et gentilibus [6], congregatam exaequat meritis, ut causas ei [7] auferat simultatis [8] quae de uoluntate [9] praelationis mutuae [10] nascebantur. Ergo ut pace inter se et caritate iungantur, ostendit [11] pares conditione dum peccatis fuisse obnoxii conprobantur [12] qui [13] aeque [14] salutem per fidem christi sint [15] et gratiam [16] consecuti. Nam neque [17] iudaeis profuisse legem incustoditam [18] docet, nec gentiles posse legis ignoratione [19] defendi; quos ratio et [20] ad dei notitiam ' perducere poterat, et ab omni uitae prauitate ' [21] reuocare.

2. Scito qui legis, non expositionem continuam esse dictorum sed subnotationes breues singulis [22] uersibus ac uerbis [23] appositas [24].

3. [25] Pauli apostoli epistulae [26] numero [27] XIIII [28], ad romanos I [29], ad corinthios II, ad galatas I, ad ephesios I, ' ad philippenses I ' [30], ad colosenses I, ad thessalonicenses II, ad timotheum II, ad titum I, ad philemonem I, ad hebraeos I.

4. Omnis [31] textus uel numerus epistularum ad unius [32] hominis perfectionem [33] proficiunt [34]. Cum romanis ita agit apostolus paulus quasi cum incipientibus [35] qui

Ψ	φ
adhuc perfectae fidei rationem nescirent, sub nomine enim saluatoris in legem fuerant inducti, ut christum profitentes legem tamen seruarent, ideoque apostolus his quae sit uera et spiritalis fides exponit, ut a lege eos eruens in sola fide christi illos constituat, unde [36] aliqua	post gentilitatem ut initia fidei sortiantur et perueniant ad spem uitae aeternae multa

de physicis [37] rationibus insinuat, multa de scripturis diuinis [38]. Ad corinthios prima consecutos [39] iam fidem

obliquos et minus non

1–2 *om* Ψ , 3 *om* Θ H x y , 1–3 *om* D , 2–4 *om* B , 1–2. 4 *om* L , ~ 3. 4. 1. 2. d , 3–4 *om* Wᵃ

[1] + argumentum a [2] epistola m [3] *om* K B a [4] de B R [5] *om* B [6] gentibus R W B I a d [7] eis d [8] simulatis Bᴵ aᴵ [9] uoluptate Rᴵ d [10] ~ m. pr. d [11] ostendens Wᴵ , ostenduntur B [12] conprobatur Wᴵ aᴵ [13] quia B [14] quique m [15] sunt R , *om* a [16] + sunt a² [17] et Bᴵ [18] in custodiam v [19] ignorantia v

[20] + mens a² [21] per (post a²) prauitatem (+ possent a²) a [22] singularis (-iter a²) a [23] acerbis B a [24] apposita Iᴵ λ R aᴵ [25] + Haec sunt T , + Hae insunt epistolae L [26] + sunt Θ R [27] + sunt d [28] + sunt v [29] unam R *semper in accusatiuo* [30] *om* v [31] + autem T [32] noui Ψ [33] perfectionem T [34] proficit T B V d [35] insipient. d [36] + de T , aliquos y [37] typicis Θ H x , deceptos y , ins. D [38] ~ multa de scr. d. [39] consecutus Θ Iᴵ

*From De Bruyne, *Préfaces*, 217–18. For *sigla* see above, p. 160.

recte conseruantes [40] obiurgat. Secunda ad corinthios [41] contristatos quidem, sed emendatos [42] ostendit. Galatas in fide ipsa peccantes et ad iudaismum declinantes exponit. Ephesios quia incipiunt et custodiunt laudat, quod [43] ea quae acceperant [44] seruauerunt [45]. Pilippenses quod [46] id quod [47] crediderunt seruantes [48] ad fructum peruenerunt. Colosenses conlaudat [49] quia uelut [50] ignotis scripsit [51] et accepto nuntio ab epaphra [52] custodisse euangelium gratulatur. Thessalonicenses [53] in opere et fide [54] creuisse gloriatur [55], in secunda praeterea quod [56] et [57] persecutionem [58] passi [59] ' in fide perseuerauerint [60], quos [61] et sanctos [62] appellat ' [63] ut illos [64], qui in iudaea christum confessi [65] persecutiones [66] fortiter tolerarunt [67]. ' Ad hebraeos, ad quorum similitudinem passi sunt thessalonicenses [68], ut in mandatis [69] perseuerantes [70] persecutiones promptissime [71] patiantur ' [72].

Omnes ergo epistulae pauli sunt numero XIIII [73] : ad romanos [74] ad corinthios II, ad galatas, ad ephesios, ad philippenses, ad colosenses, ad thessalonicenses II [75], ad hebraeos, quos hortatur ad similitudinem thessalonicensium, haec in canone non [76] habetur [77] reliquae ad timotheum prima, quemadmodum agat ecclesiam [78], ad timotheum [79] secunda, quemadmodum [80] seipsum agat, ad titum [81], ut creditam sibi ecclesiam cretae [82] ordinet, ad philemonem de onesimo seruo, qui emendatus melior [83] factus est.

'Septem ergo ecclesiis scripsit sicut et iohannes apostolus propter numerum septenarium ' [84].

[40] conuersantes ΘHd [41] Ad eosdem in secunda D [42] emendatis T [43] *om* m [44] acceperunt *y*d , -rint D [45] seruauerant λd [46] *om* D [47] in quo λmvd [48] seruant v [49] laudat ΘH*x* [50] colosensibus uelud D [51] scribit ΘHλdv*y* [52] ephara T [53] + prima v [54] ~ f. et op. D [55] gratulatur D [56] quia Ψ [57] *om* T [58] tribulationem D [59] ~ passi p. d. [60] perseuerauerunt Rd , -uerant ΘH*xy* [62] quod v [62] + apostolos m [63] *om* D [64] hii D , et illos *x*

[65] + sunt v [66] persecutores D [67] tolerauerunt T , -rarent *xy* [68] Ad heb. quos hortatur ad similitudinem thessalonicensium D [69] + dei D [70] *om* D [71] promptissimi T [72] *om* ΘH*xy* [73] + sed ad aecclesias quidem scripsit id est D [74] + unam D *et ita deinceps* [75] duas R [76] *om* D [77] habentur D [78] + dei D [79] eundum DR [80] *om* *y* , quomodo *x* [81] + unam D [82] recte Ψ [83] melius D [84] *habetur et in* v

II *The Pelagian Prologue to Hebrews**

A B C D E I P S Y Z *M* Ω m t

In primis dicendum est, cur [1] apostolus paulus in hac [2] epistula [3] non seruauerit morem suum [4] ut uel [5] uocabulum nominis sui uel ordinis [6] scriberet dignitatem [7]. Haec causa est, quod [8] ad eos scribens [9] qui ex circumcisione crediderant [10] quasi gentium apostolus et non hebraeorum; sciens quoque eorum superbiam suamque [11] humilitatem ipse demonstrans, meritum officii sui noluit anteferre. Nam simili modo [12] etiam [13] iohannes apostolus propter humilitatem in epistola sua nomen suum eadem ratione non praetulit. Hanc [14] epistolam fertur apostolus [15] ad hebreos conscriptam [16] hebraica [17] lingua misisse, cuius sensum et ordinem retinens lucas euangelista [18] post excessum beati apostoli pauli [19] graeco sermone conposuit [20].

[1] quare Ω [2] *om* Ω , prima D [3] +scribendo (-di B) *omnes exc.* CD*M* [4] ~ m. s. n. seru. C [5] ut uelud *M* B , uel ut D , et uel Z [6] ordinans D [7] scriberit Ω , -re B , adscriberet C , describeret IYm , ~ dig. scriberit D*M* [8] *om* Z [9] scribebat I [10] crediderunt DEt

[11] *om* D [12] similitudo BT [13] iam A [14] haec C[1] , + ergo CIΩm A [15] apostolum BDPS*M*Z [16] scriptam C [17] hebreica C , hebrice Ω [18] ~ eu. I. ES [19] ~ p. a. CS , *om* pauli A [20] conscripsit Y

*From De Bruyne, *Préfaces*, 253–4. For *sigla* see above, p. 160.

Selected Bibliography

Acta Apostolorum Apocrypha, eds. R. A. Lipsius and M. Bonnet, 3 vols., Leipzig, 1891; rpt. Darmstadt, 1959.

The Apocryphal New Testament, trans. M. R. James, Oxford, 1924; rev. ed. 1953.

Augustine, *Sermo 189*, PL 39, 2098–100.

—— *Sermo 315*, PL 38, 1434.

Berger, S., *Histoire de la Vulgate*, Paris, 1893; rpt. New York, n.d.

—— 'Les Préfaces jointes aux livres de la Bible dans les manuscrits de la Vulgate', *Mémoires présentés par divers savants à l'Académie des Inscriptions et Belles-Lettres*, 1st ser., 11, Paris, 1904, vol. II, pp. 1–78.

La Bibbia nell'alto medioevo, Settimane di studio del centro italiano di studi sull' alto medioevo, No. 10, Spoleto, 1963.

Biblia Sacra, Rome–Tournai–Paris, 1938.

Bibl Moralisée, Faksimile Ausgabe in Originalformat des Codex Vindobonensis 2554 der österreichisches Nationalbibliothek, ed. R. Haussherr, 2 vols., Graz, 1973.

Biblicum Sacrorum cum Glossa Ordinaria (abbreviated as *Gl. Ord.*), ed. F. Fevardentius, 6 vols. and index, Paris, 1590.

Blumenkranz, B., *Le Juif médiéval au miroir de l'art chrétien*, Paris, 1966.

Branner, R., *Manuscript Painting in Paris during the Reign of Saint Louis*, Berkeley, Los Angeles, London, 1977.

Brieger, P. H., 'Bible Illustration and Gregorian Reform', *Studies in Church History*, 2 (1965), 154–64.

Bruyne, D. De, *Préfaces de la Bible Latine*, Namur, 1920.

—— *Sommaires, divisions et rubriques de la Bible latine*, Namur, 1914.

Buchthal, H., 'Some Representations from the Life of St. Paul in Byzantine and Carolingian Art', *Tortulae: Studien zu altchristlichen und byzantinischen Monumenten*, ed. W. N. Schumacher, Freiburg im Breisgau, 1966.

The Cambridge History of the Bible, 3 vols., Cambridge, 1963–70.

Chartularium Universitatis Parisiensis, I, eds. H. Denefle, E. Chatelain, Paris, 1889.

Cipolla, C., 'La pergamena rappresentate le antiche pittura della basilica di S. Eusebio in Vercelli', *R. Deputazione Sovra gli Studi di Storia Patria per il Antiche Provincie e la Lombardia. Miscellanea di Storia Italiana*, 3rd ser., VI, Turin, 1901.

Daniélou, J., *The Bible and the Liturgy*, Notre Dame, 1956; trans. of *Bible et liturgie*, Rev. ed., Paris, 1951.

Demus, O., *The Mosaics of Norman Sicily*, London, 1949.

—— *Romanische Wandmalerei*, Munich, 1968.

Dictionnaire d'archéologie chrétienne et de liturgie (abbreviated as *DACL*), eds. F. Cabrol and H. Leclerq, 15 vols., Paris, 1907–53.

Dictionnaire de Théologie Catholique (abbreviated as *DTC*), eds. A. Vacant, E. Mangenot, and E. Amann, 15 vols., Paris, 1903–50; rpt. 1923.

Dinkler-von Schubert, E., '"Per Murum Dimiserunt Eum": zur Ikonographie von Acta IX, 25 und 2 Cor. XI, 33', *Studien zur Buchmalerei und Goldschmiedekunst des Mittelalters*, Festschrift für Karl Hermann Usener zum 60. Geburtstag am 19. August, 1965, Marburg, 1967.

Dobschütz, E. von, *Der Apostel Paulus*, Halle, 1928: Part II, *Seine Stellung in der Kunst*.

—— 'Die Bekehrung des Paulus'. *Repertorium für Kunstwissenschaft*, 50 (1929), 87–111.

Duncan, G. S., 'Some Outstanding N. T. Problems: VI, The Epistles of the Imprisonment in Recent Discussion', *Expository Times*, 46 (1934–5), 293–8.

—— 'Important Hypotheses Reconsidered: VI, Were Paul's Imprisonment Epistles Written from Ephesus?' *Expository Times*, 67 (1955–6), 163–6.

—— *St. Paul's Ephesian Ministry*, New York, 1930.

Eleen, L., 'Acts Illustration in Italy and Byzantium', *Dumbarton Oaks Papers*, 31 (1977), 253–78.

—— 'The Illumination of the Pauline Epistles in French and English Bibles of the Twelfth and Thirteenth Centuries', Diss., University of Toronto, 1972.

Erbach-Fürstenau, A., *Die Manfredbibel*, Kunstgeschichtliche Forschungen herausgegeben vom königlich preussischen historischen Institut in Rom, vol. I, Leipzig, 1910.

Gaehde, J. E., 'The Turonian Sources of the Bible of San Paolo Fuori Le Mura in Rome', *Frühmittelalterliche Studien*, 5 (1971), 359–400.

Garber, J., *Wirkungen der frühchristlichen Gemäldezyklen der alten Peters-und Pauls-Basiliken in Rom*, Berlin-Vienna, 1918.

Glass, D., 'The Archivolt Sculpture at Sessa Aurunca', *Art Bulletin*, 52 (1970), 119–31.

Grabar, A. and Nordenfalk, C., *Romanesque Painting*, The Great Centuries of Painting, n.p., 1958.

Grayzel, S., *The Church and the Jews in the XIIIth Century*, rev. ed., New York, 1966.

Gregory I, *Moralia in Job*, Ch. 24, PL 76,597.

Haseloff, G., *Die Psalterillustration im 13. Jahrhundert: Studien zur Geschichte der Buchmalerei in England, Frankreich und Niederlanden*, Kiel, 1938.

Haussherr, R., 'Bible moralisée', *lci*, I, 289–93.

—— 'Christus-Johannes-Gruppen in der Bible moralisée', *Zeitschrift für Kunstgeschichte*, 27 (1964), 133–52.

—— 'Ein pariser martyrologischer Kalendar aus der ersten Hälfte des 13. Jahrhunderts', *Festschrift Matthias Zender*, II, Bonn, 1972, 1076–103.

Hennecke, E., *New Testament Apocrypha*, ed. W. Schneemelcher, trans. R. McL. Wilson, Philadelphia, 1965.

Hetherington, P., *The 'Painter's Manual' of Dionysius of Fourna*, London, 1974.

Index to Periodical Literature on the Apostle Paul, ed. B. M. Metzger, vol. 1 of *New Testament Tools and Studies*, Grand Rapids, 1960.

Jungmann, J. A., *The Early Liturgy to the Time of Gregory the Great*, trans. F. A. Brunner, Notre Dame, 1959.

Kasser, R., 'Acta Pauli 1951', *Revue d'Histoire et de Philosophie Religieuses*, 40 (1960), 45–57.

Kennedy, V. L., *The Saints of the Canon of the Mass*, Studi di antichità cristiana pubblicati per cura del Pontificio Istituto di Archaeologia Cristiana, XIV, Vatican City, 1938.

Kessler, H. L., *The Illustrated Bibles from Tours*, Princeton, 1977.

—— 'Paris. Gr. 102: A Rare Illustrated Acts of the Apostles', *Dumbarton Oaks Papers*, 27 (1973), 211–16.

Kitzinger, E., *I Mosaici di Monreale*, Palermo, 1960.

Knox, J., *Chapters in a Life of Paul*, New York–Nashville, 1950.

Koehler, W., *Die karolingischen Miniaturen*, 4 vols. in 9 parts, Berlin, 1930–71: vols. I, *Die Schule von Tours*, 1930–3; III, ii, *Die Metzer Handschriften*, 1960.

Kristeller, P. O., *Latin Manuscript Books before 1600*, rev. ed., New York, 1960; first published in *Traditio*, 6 (1948), 227–317; 9 (1953), 393–418.

Künstle, K., *Ikonographie der christlichen Kunst*, 2 vols., Freiburg im Breisgau, 1926–8.

Laborde, A. de, *La Bible moralisée illustrée*, 4 vols., Paris, 1911–28.

Leclerq, H., 'Paul (Saint)', *DACL*, XIII, ii, 1938, cols. 2694–9.

Lexicon der christlichen Ikonographie (abbreviated as *LCI*), eds. E. Kirschbaum *et al.*, Freiburg im Breisgau, 1968–76.

Mâle, E., 'Les Apôtres Pierre et Paul', *Revue des Deux Mondes*, 15 July, 1 August, 1955, 193–208, 385–97.

—— *L'Art religieux du XIIIe siècle en France*, rev. ed., Paris, 1923.

Mangenot, E., 'Hughes de Saint-Cher', *DTC* VII, 221–39.

Novum Testamentum Domini Nostri Jesu Christi Latine, eds. J. Wordsworth and H. J. White, 3 vols., Oxford, 1913–54.

The Oxford Dictionary of the Christian Church (abbreviated as *ODCC*), ed. F. L. Cross, London, 1957; rpt. 1963.

The New English Bible, Oxford and Cambridge, 1970.[1]

Patrologia Latina (abbreviated as *PL*), ed. J. P. Migne, 221 vols., Paris, 1844–64.

Peter Lombard, *Collectanea in Omnes d. Pauli Epistolas*, PL 191, 1297–192, 520.

Prudentius, *Tituli Historiarum (Dittochaeon)*, In *Prudentius*, trans. H. J. Thompson, 2 vols., Cambridge, Mass., 1953.

Reallexikon zur deutschen Kunstgeschichte (abbreviated as *RDK*), vols. I– , eds. O. Schmitt, E. Gall, L. H. Heydenreich, Stuttgart, 1937– .

Rigaux, B., *Saint Paul et ses lettres: état de la question*, Paris–Bruges, 1962.

The Rockefeller–McCormick New Testament, eds. E. J. Goodspeed, D. W. Riddle, H. R. Willoughby, 3 vols., Chicago, 1932.

Sauerländer, W., *Gotische Skulptur in Frankreich, 1140–1270*, Munich, 1970.

Schneemelcher, W., 'Die Acta Pauli: Neue Funde und neue Aufgaben', *Theologische Literaturzeitung*, 89 (1964), 241–54.

Schumacher, W. N., 'Dominus Legem Dat', *Römische Quartalschrift*, 54 (1959), 1–39.

Smalley, B., 'Les Commentaires bibliques à l'époque romaine: glose ordinaire et gloses périmées', *Cahiers de civilization médiévale*, 4 (1961), 15–22.

——'Gilbertus Universalis, Bishop of London (1128–1134) and the Problem of the "Glossa Ordinaria"', *Recherches de théologie ancienne et médiévale*, 7 (1935), 235–62; 8 (1936), 24–60.

—— *The Study of the Bible in the Middle Ages*, 2nd ed., Oxford, 1952.

Stegmüller, F., *Repertorium Biblicum Medii Aevi*, Consejo Superior de Investigaciones Cientificas, Istituto Francisco Suárez, 7 vols., Madrid, 1940–61: vol. I, *Initia Biblica, Apocrypha, Prologi*, 1940; vols. II–VII, *Commentaria: Auctores*, 1950–61.

Testini, P., 'L'iconographia degli apostoli Pietro e Paolo nelle considette "arti minori"', *Saecularia Petri et Pauli*, Studi di antichità cristiana, XXVIII, Vatican City, 1969.

The Text, Canon and Principal Versions of the Bible, ed. E. E. Flack and B. M. Metzger, Schaff-Herzog Encyclopedia, Grand Rapids, 1956.

Waetzoldt, S., *Die Kopien des 17. Jahrhunderts nach Mosaiken und Wandmalereien in Rom*, Römische Forschungen der Biblioteca Hertziana, No. 18, Vienna–Munich, 1964.

Weitzmann, K., *Die byzantinische Buchmalerei des 9. und 10. Jahrhunderts*, Archäologisches Institut des deutschen Reiches, Abteilung Istanbul, Berlin, 1935.

—— *Illustrations in Roll and Codex*, Studies in Manuscript Illumination, No. 2, Princeton, 1947.

White, J., 'Cavallini and the Lost Frescoes in San Paolo', *Journal of the Warburg and Courtauld Institutes*, 19 (1956), 84–95.

Wilpert, J., *Die römischen Mosaiken und Malerien der kirchlichen Bauten vom IV. bis XIII. Jahrhunderts*, 4 vols., Freiburg im Breisgau, 1916.

—— *I sarcophagi cristiani antichi*, 3 vols., Rome, 1929–36.

Wollesen, J. T., *Die Fresken von San Piero a Grado bei Pisa*, Bad Oeynhausen, 1977.

The Year 1200: A Centennial Exhibition at the Metropolitan Museum of Art, The Cloisters Studies in Medieval Art, Nos. 1 and 2, vol. I, *Catalogue*, ed. K. Hoffmann; vol. II, *A Background Survey*, ed. F. Deuchler, New York, 1970.

[1] The English translations from the Bible in this book are from *The New English Bible*, with the exception of those on pp. 2, 112, 113, 132, 137, 138, 142–3, 144.

Index of Manuscripts

Numbers in italics refer to illustrations. The popular names of manuscripts are listed in the General Index, with a cross-reference to this index.

General Index

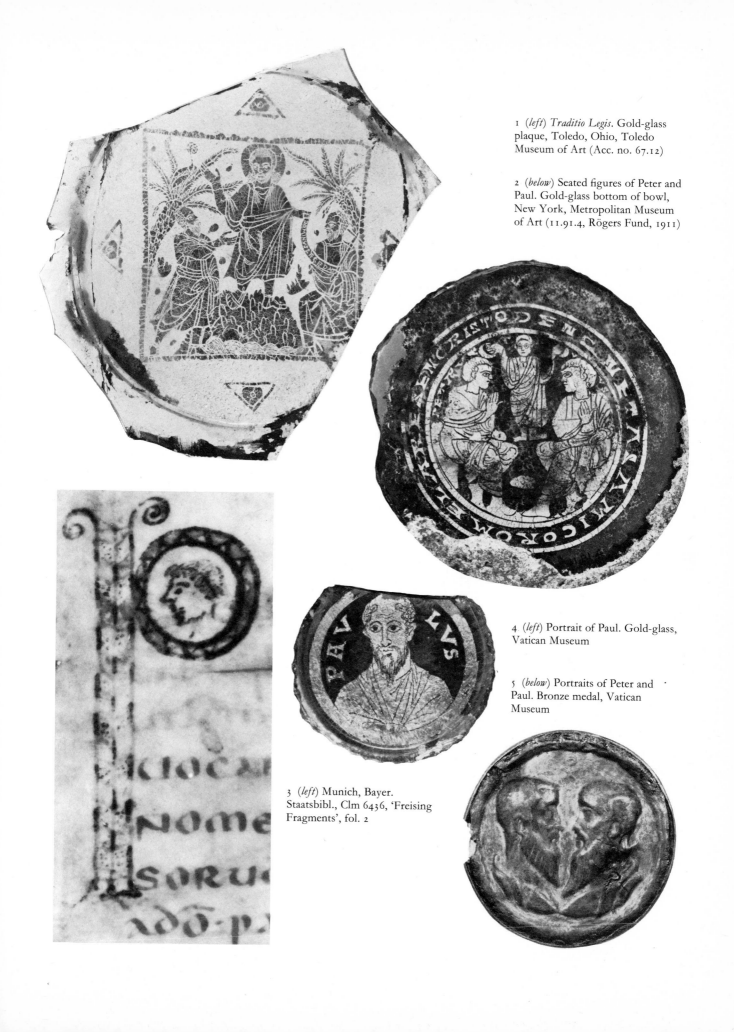

1 (*left*) *Traditio Legis*. Gold-glass plaque, Toledo, Ohio, Toledo Museum of Art (Acc. no. 67.12)

2 (*below*) Seated figures of Peter and Paul. Gold-glass bottom of bowl, New York, Metropolitan Museum of Art (11.91.4, Rögers Fund, 1911)

4 (*left*) Portrait of Paul. Gold-glass, Vatican Museum

5 (*below*) Portraits of Peter and Paul. Bronze medal, Vatican Museum

3 (*left*) Munich, Bayer. Staatsbibl., Clm 6436, 'Freising Fragments', fol. 2

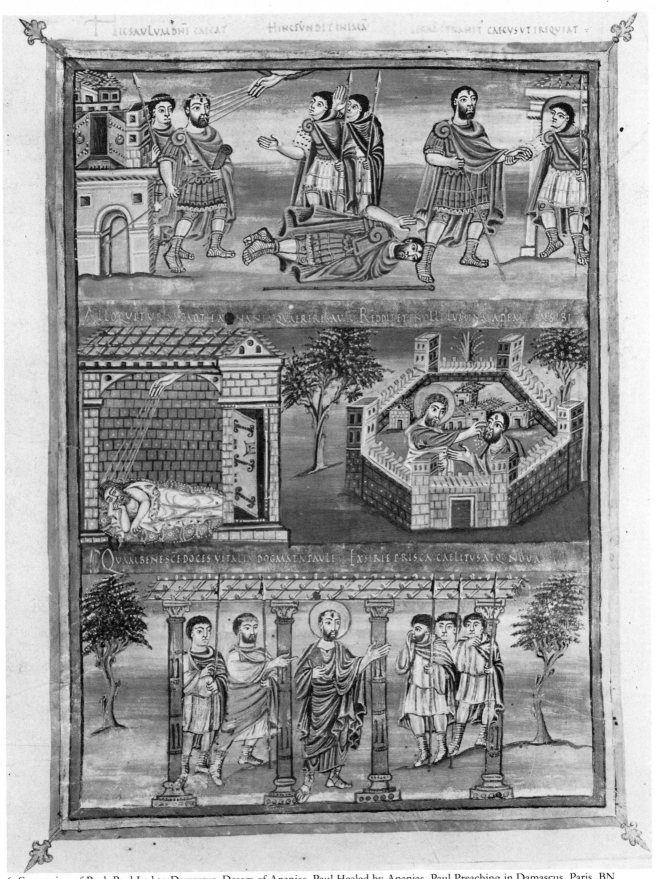

6 Conversion of Paul, Paul Led to Damascus, Dream of Ananias, Paul Healed by Ananias, Paul Preaching in Damascus. Paris, BN, MS lat. 1, Vivian Bible, fol 386ᵛ

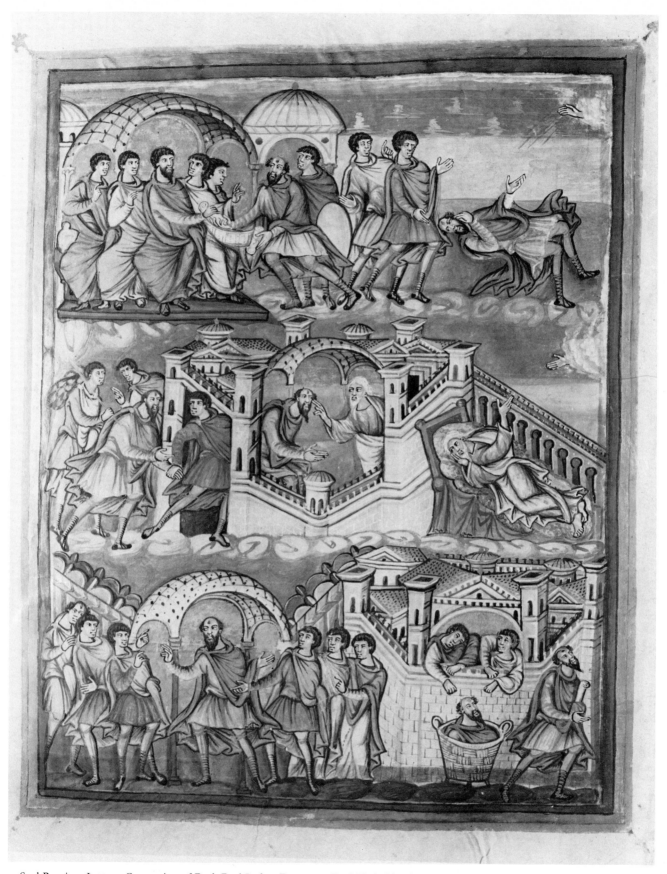

7 Saul Receives Letters, Conversion of Paul, Paul Led to Damascus, Paul Healed by Ananias, Dream of Ananias, Paul Preaching in Damascus, Paul's Escape from Damascus. Bible of San Paolo fuori le mura, fol 30 (cccvii)ᵛ

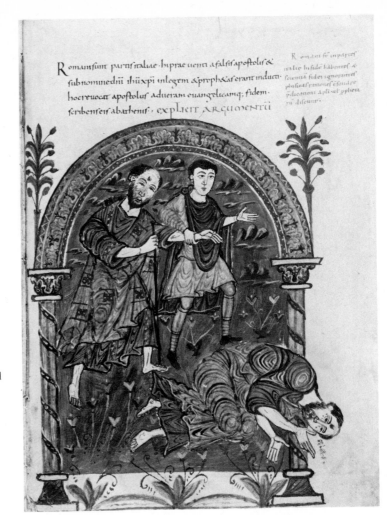

8 (right) Conversion of Paul, Paul Led to Damascus. Munich, Bayer. Staatsbibl., Clm 14345, Pauline Epistles, fol. 7

9 (below) Paul Led to Damascus. University of Chicago Library, MS 965, fol. 115

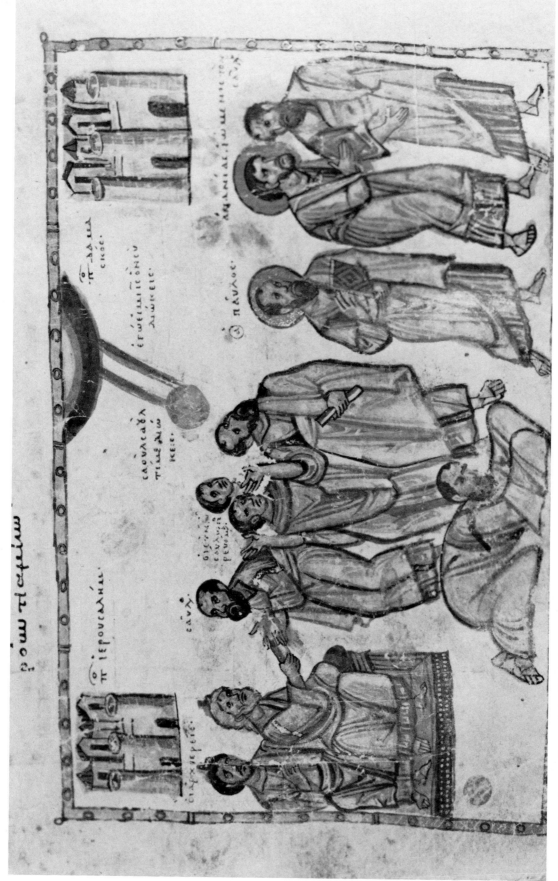

10 Saul Receives Letters, Conversion of Paul, Single Figure of Paul, Paul Led to Damascus. Mount Sinai, St. Catherine's Monastery, MS 1186, Cosmas Indicopleustes, fol. 126v

11 (*left*) Baptism of Paul. Dečani, fresco

12 (*above*) Baptism of Paul. University of Chicago
Library, MS 965, fol. 115ᵛ

13 Saul Receives Letters, Conversion of Paul, Paul Led to Damascus. Dečani, fresco

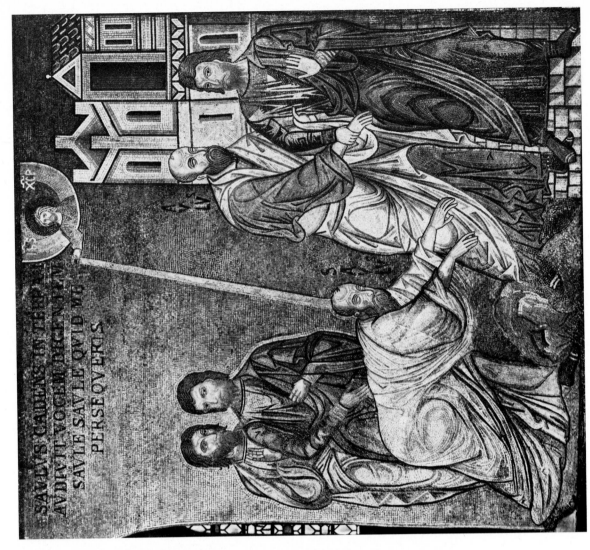

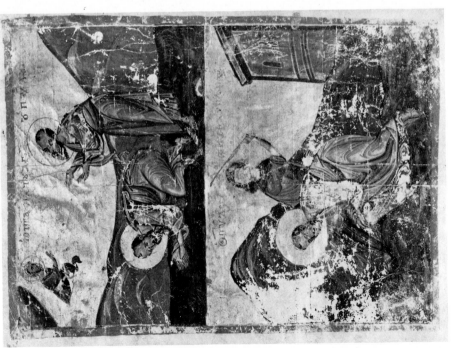

14 (*above*) Conversion of Paul, Execution of Paul. Phillips MS 7681 (London, Robinson Trust), Acts and Epistles, fol. 121ᵛ

15 (*right*) Conversion of Paul, Paul Led to Damascus. Palermo, Cappella Palatina, mosaic

16 (*above*) (From right to left) Saul Receives Letters (?), Conversion of Paul, Paul Led to Damascus, Dream of Ananias (?). San Paolo fuori le mura (Vatican Library, MS Barb. lat. 4406, fol. 89)

17 (*left*) Conversion of Paul. Berlin, Staatliche Mus. Preussischer Kulturbesitz, Kupferstichkabinett, MS 78 A 5, Hamilton Psalter, fol. 104ᵛ

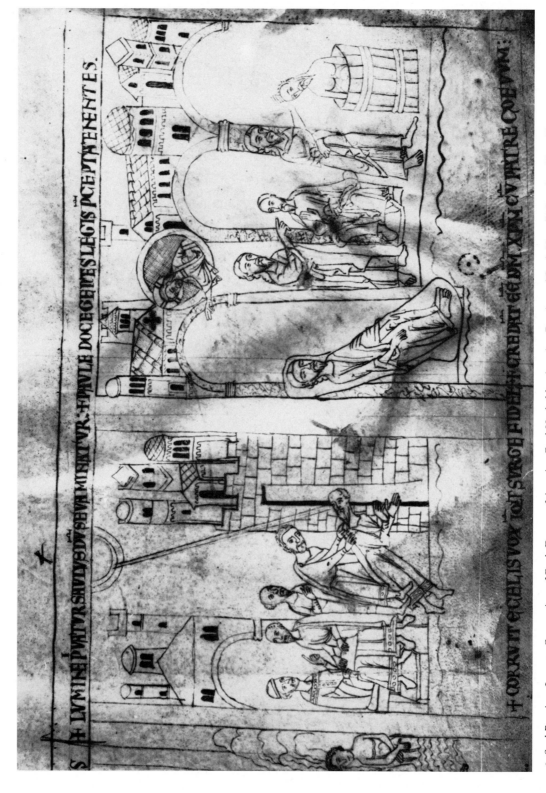

18 Saul Receives Letters, Conversion of Paul, Dream of Ananias, Paul Healed by Ananias, Baptism of Paul. Vercelli Rotulus, Vercelli, Archivio Capitolare

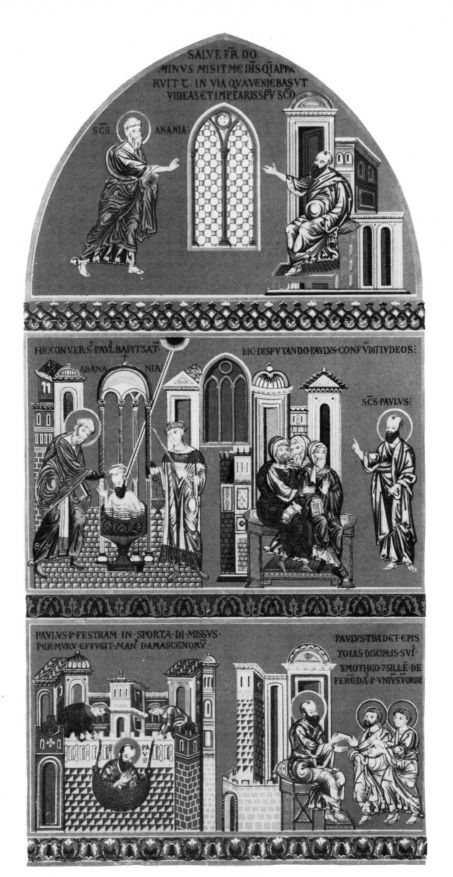

19 Paul Healed by Ananias, Baptism of Paul, Paul Preaching in Damascus, Paul's Escape from Damascus, Paul Giving Letters to Timothy and Silas. Monreale Cathedral, mosaic

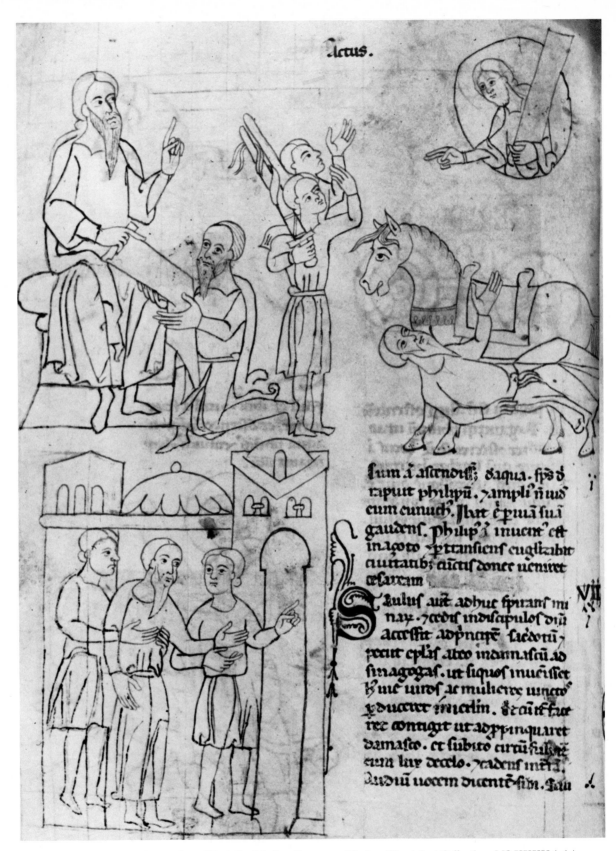

sum̄ x̄ ascenoers̄; oaqua. sp̄s ð
rapuit philipp̄. ꝗampli n̄ uið
eum eunuch̄. Ibat c̄ p̄uiã suã
gaudens. philip̄ z̄ inuent̄ est
in agoto ꝓ transiens euglizabit
ciuitatib; cūctis donec ueniret
cesaream

Saulus aut̄ adhuc spirans mi
nax̄. ꝗædis in discipulos d̄m
acc̄ssit ad p̄ncip̄m sacdotū z̄
ꝓciit epl̄as ab eo indamascū ad
sinagogas. ut siquos inuenisset
h̄ uic̄ uiros ac mulieres uincto
ꝗ ouceret in ierl̄m. Et cū ꝫ fac
rec contigit ut ad ppinquaret
damasco. et subito circū fulsꝫ
eum lux ð celo. ꝗ cadens in t̄.
Audiuit uocem oicentē sib̄. Sau

20 Saul Receives Letters, Conversion of Paul, Paul Led to Damascus. Venice, Giustiniani Collection, MS XXXV (465), New Testament, fol. 128ᵛ

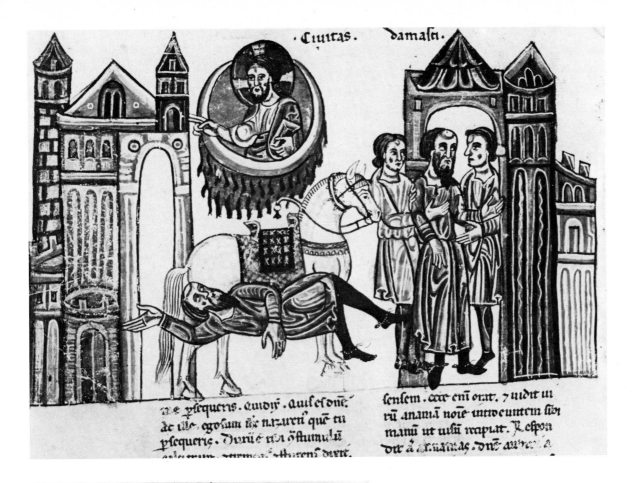

· Ciuitas. damasci.

ne psequeris. cuidis. auis esdne.
de ille. egosum ihe nazareni quem tu
psequeris. Durus tibi ostimulum
...

sensem. ecce enim orat. 7 uidit ui
rum ananiam noie introeuntem sibi
manu ut uisu recipiat. Respon
dit a ananias. dne audiui a...

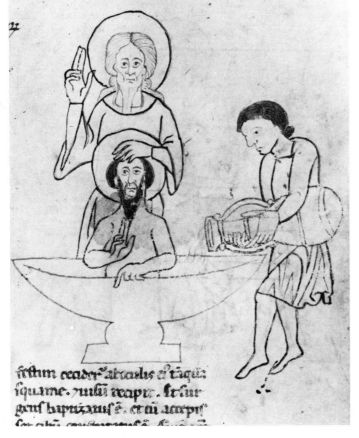

festum ceadet sabaculus est tamquam
squame. 7 uisu recipt. 7 surg
gens baptizatus est. et cum accepisset
...

21 (above) Conversion of Paul, Paul Led to Damascus. Vatican Library, MS lat. 39, New Testament, fol. 91ᵛ

22 (left) Baptism of Paul. Venice, Giustiniani Collection, MS XXXV (465), New Testament, fol. 129.

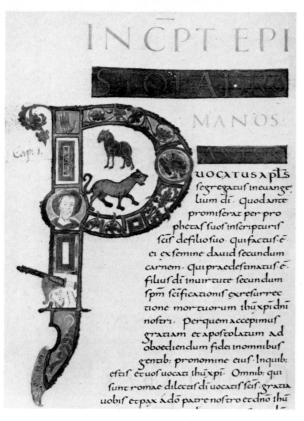

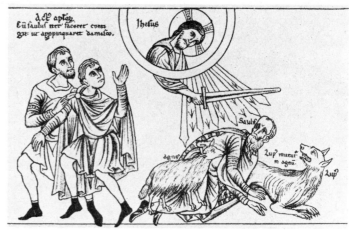

23.(*left*) London, BL, Add. MS 10546, Moutier-Grandval Bible, fol. 411ᵛ (Romans)

24 (*above*) Conversion of Paul. *Hortus Deliciarum*, fol. 189 (Straub and Keller, Supplément, pl. LI bis)

25 (*below*) Conversion and Paul Led to Damascus, Paul's Flight from Damascus. Manchester, Rylands Lib., Lat. MS 7, Pericopes of Prüm, fols. 133ᵛ and 134

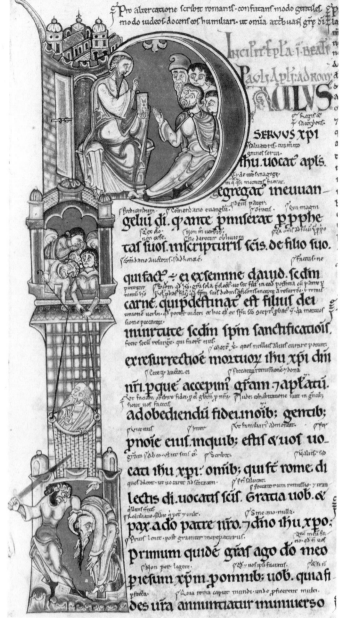

26 (*above, left*) Conversion and Paul Led to Damascus, Baptism of Paul, Paul Preaching in Damascus. Brussels, Bibl. Royale, MS 10752, Works of St. Jerome, fol. 6

27 (*below, left*) Conversion of Paul, Dream of Ananias, Paul Healed by Ananias. Oxford, Bodl. Lib., MS Auct. D.2.6, St Anselm's Prayers and Meditations, fol. 170ᵛ

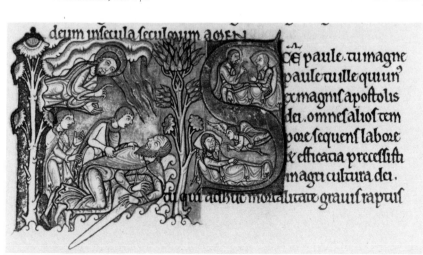

28 (*above, right*) Paul Preaching in Damascus, Flight from Damascus, Execution of Paul. Oxford, Bodl. Lib., MS Auct. D.1.13, Pauline Epistles, fol. 1 (Romans)

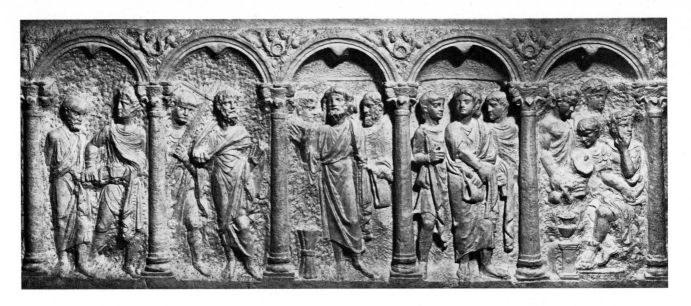

29 (*above*) (1) Arrest of Paul; (2) Execution of Paul; (3–5) Christological Scenes. Sarcophagus, Rome, S. Sebastiano

30 (*right*) Peter Preaching in Jerusalem and Rome, Paul Preaching in Antioch, Peter and Paul before Nero, Flight of Simon Magus, Martyrdoms of Peter and Paul. Vatican Lib., MS Barb. lat. 2732, fol. 75v, copy of mosaics in chapel of John VII, St. Peter's

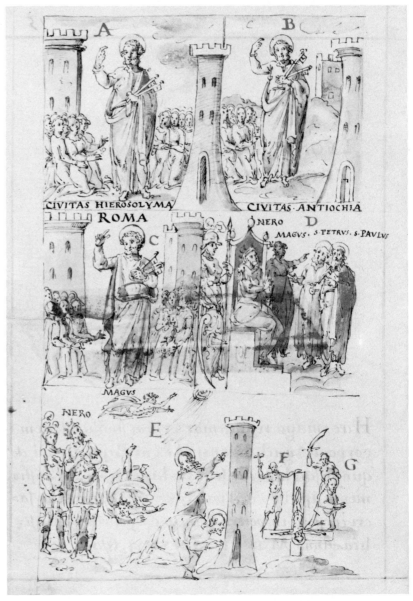

31 (*left*) Martyrdoms of Peter and
Paul. Jerusalem, Library of the Greek
Patriarchate, MS Saba 208,
Menologion, fol. 87ᵛ

32 (*below*) Martyrdoms of Peter and
Paul. London, BL, Add. MS 49598,
Benedictional of Aethelwold, fol. 95ᵛ

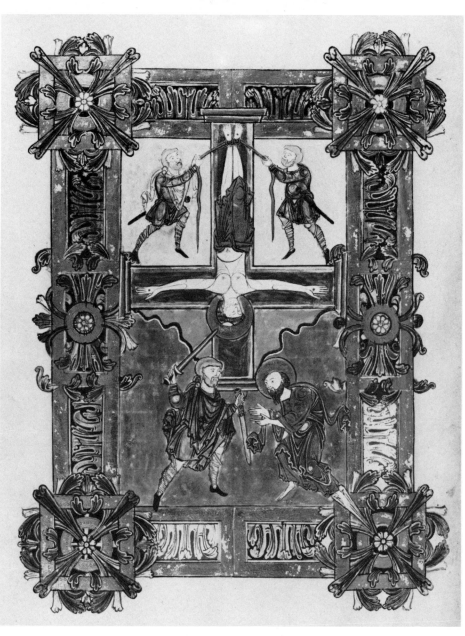

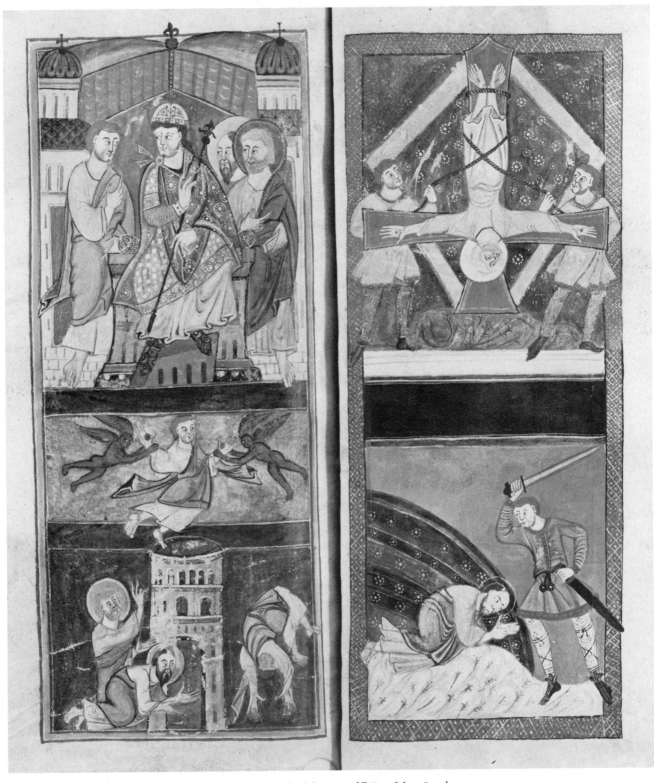

33 Martyrdoms of Peter and Paul. Paris, BN, MS lat. 9448, Antiphonary of Prüm, fols 54ᵛ and 55

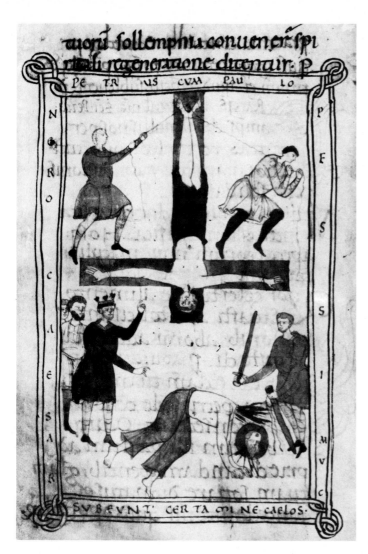

34 (*left*) Martydoms of Peter and Paul. Ivrea,
Bibl. Capitolare, MS LXXXVI, Sacramentary
of Warmundus, fol. 90ᵛ

35 (*below*) Martyrdoms of Peter and Paul.
Göttingen, Univ. Bibl., MS Theol. 231,
Sacramentary, fol. 93

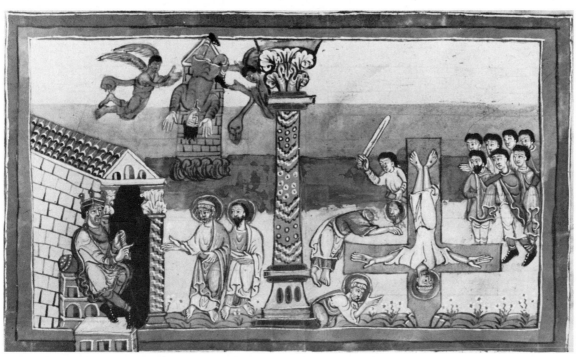

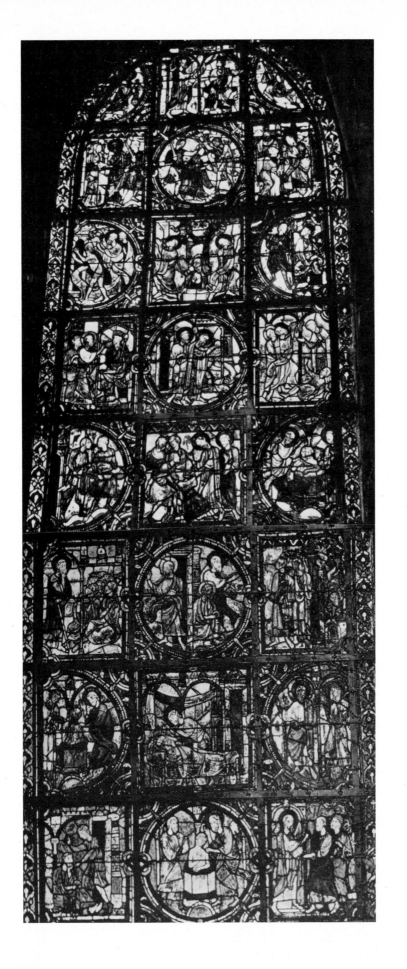

36 (*left*) Chartres Cathedral, Window of Apse

(1, 2, 4–9, 11–15, 27, 28) Modern restoration (1–12 not illustrated)
(10) Arrest of Paul
(16) Scene of baptism
(17) Baptism *in extremis*, or healing scene
(18) Unidentified
(19–23) Miracle of Eutychus (or Patroclus)
(24) Paul baptising three people
(25, 26, 29) *Passio Petri et Pauli*
(30) Nero Orders Death of Paul
(31) Plautilla Gives the Veil to Paul
(32) Execution of Paul
(33) Paul Returns the Veil
(34 and 36) Censing angels
(35) Paul Appears to Nero

37 (*right*) Rouen Cathedral, Window of Sacristy

(1–2) Later addition
(3) Conversion of Paul
(4) Paul Led to Damascus
(5) Paul Fed and Healed by Ananias
(6) Paul Preaching in Damascus
(7–8) Miracle of Eutychus
(9–10) Paul Led before a King
(11–20) Peter and Paul in Rome
(21–22) Peter and Paul before Nero
(23) Paul Receives the Veil
(24) Execution of Paul
(25) Paul Returns the Veil
(26) Angels Bear Paul's Soul

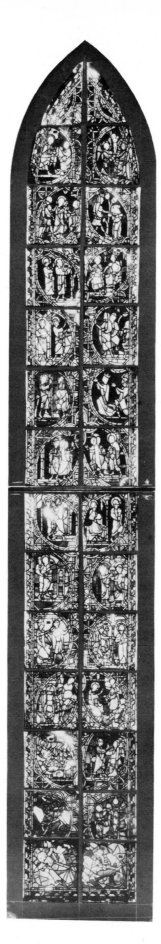

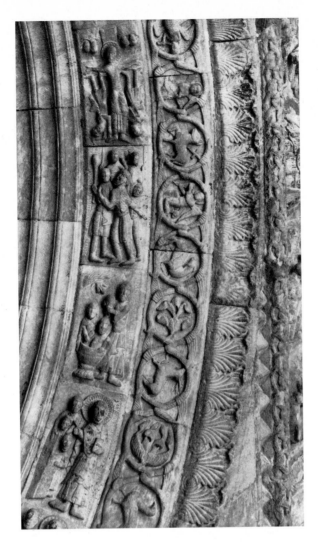

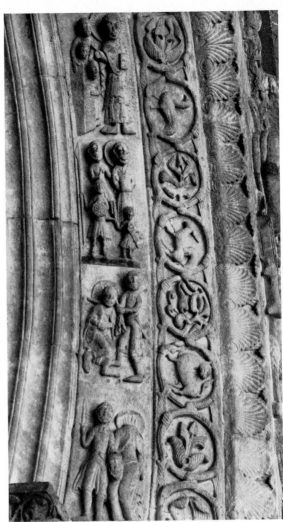

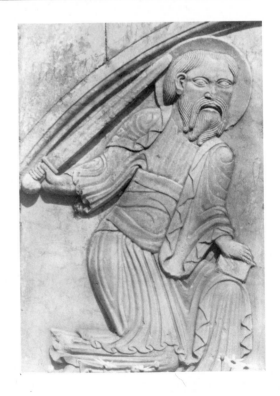

38 (*above, left and right*) Crucifixion of Peter; Pauline scenes: Conversion, Baptism, Paul Preaching or Disputing, Arrest, Execution, Paul Stands Beheaded. Ripoll, Santa Maria, west portal, south archivolt

39 (*below, right*) Paul with a Sword. Maguelonne (Hérault), south transept relief, west portal

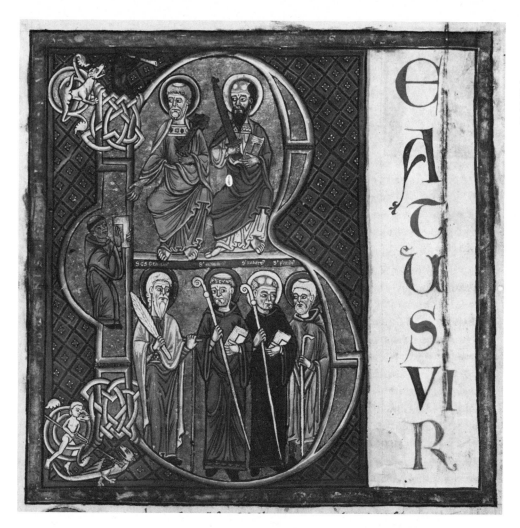

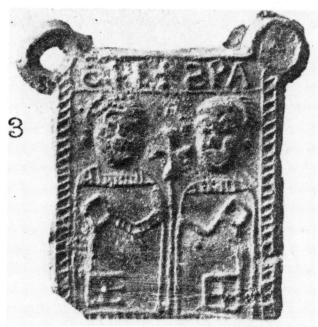

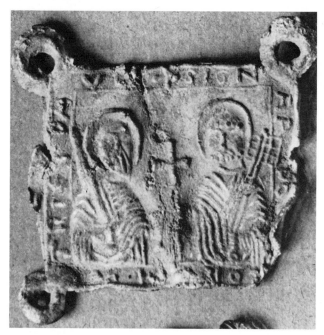

40 (*left*) Peter with a Key and Paul with a Sword. Paris, BN, MS lat. 12004, Commentary on the Psalms, fol. 1ᵛ

41a Peter and Paul Each with a Key. Pilgrim token, Rome, Mus. Camposanto Tedesco

41b Paul with a Sword, Peter with a Key. Pilgrim token, Berlin (DDR), Staatliche Mus., Frühchristlich-byzantinische Smlg., Inv.-Nr. 2998

42 (*above, right*) Conversion of Paul,
Paul Led to Damascus. Vienna,
Nationalbibl., Cod. Ser. Nov. 2702,
Admont Bible, fol. 199ᵛ

43 (*below, right*) Fall of Superbia.
London, BL, Cotton MS Tit. D.XVI,
Prudentius, fol. 14ᵛ

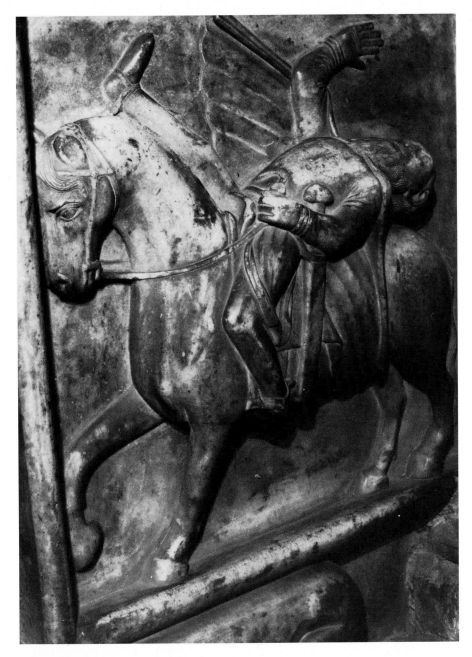

44 (*left*) Conversion of Paul. Parma Cathedral, Episcopal Throne

45 (*below, left*) Conversion of Paul. Amiens, Bibl. Mun., MS 23, fol. 270 (Romans)

46 (*below, right*) Fall of Superbia. Paris, BN, MS lat. 8318, Prudentius, fol. 51ᵛ

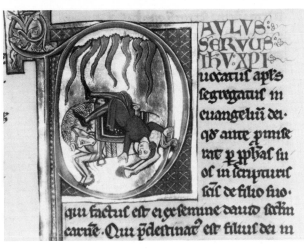

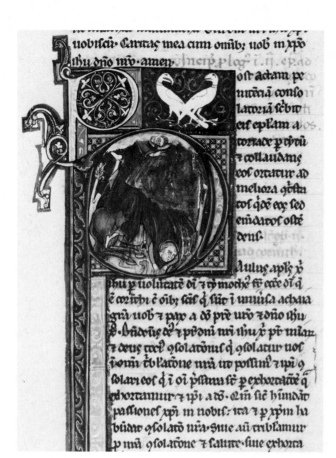

47 (*above, left*) Conversion of
Paul. Vatican Library, MS Urb.
lat. 7, fol. 386 (II Corinthians)

48 (*below, right*) Conversion
of Paul. London, BL, Harley
MS 1526–7, Vol II. *Bible
Moralisée*, fol. 64ᵛ

49 (*above, right*) Fall of Superbia.
Paris, BN, MS fr. 19093, Villard
de Honnecourt, fol. 3ᵛ

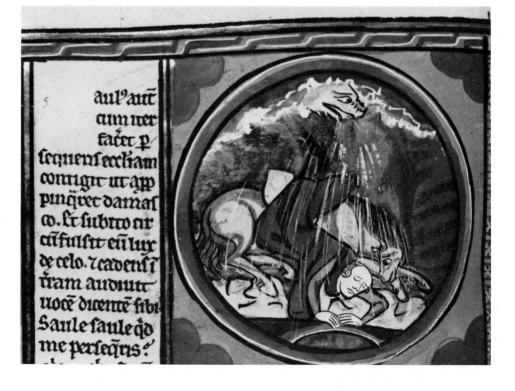

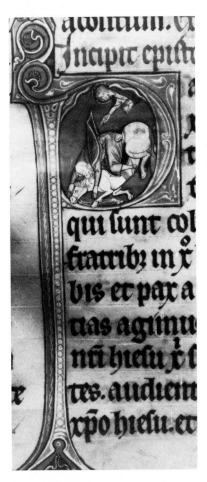

50 (*left*) Conversion of Paul. Lille, Bibl. Mun., MS 835–8, Vol. IV, fol. 192 (Colossians)

51 (*below*) Marcus or Mettius Curtius Relief, Rome, Museo Capitolino Nuovo

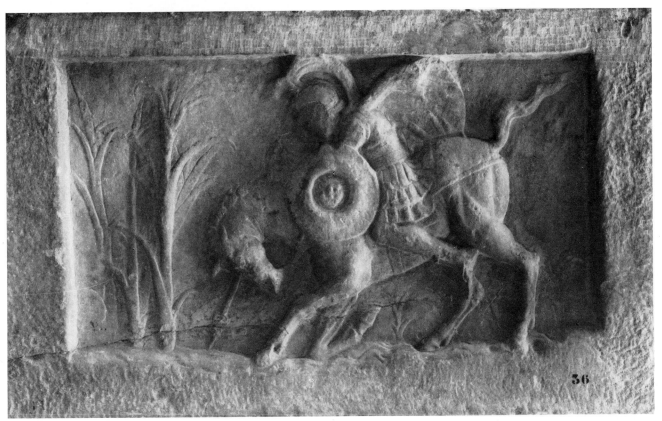

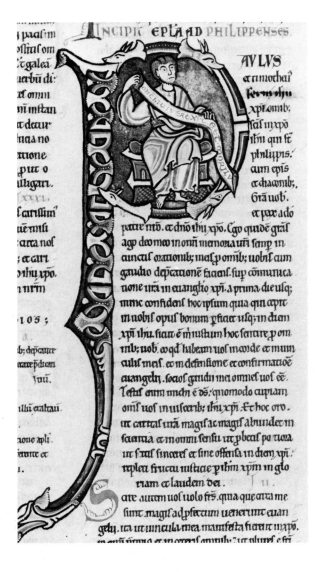

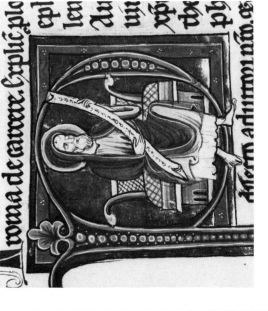

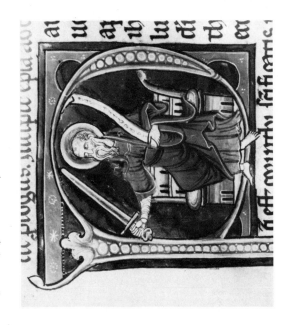

55 (above, right) Reims, Bibl. Mun., MS 34–6, Vol. III, fol. 157 (Philemon)

56 (left) New York, Morgan Lib., MS M. 791, fol. 372ᵛ (Romans)

57 (below, right) Reims, Bibl. Mun., MS 34–6, Vol. III, fol. 124ᵛ (I Corinthians)

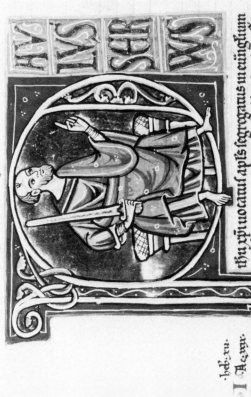

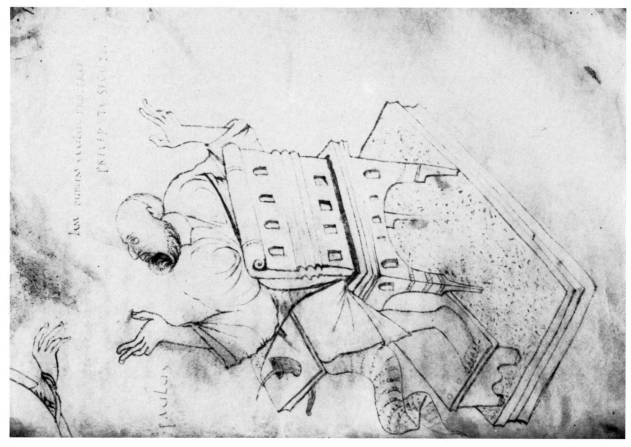

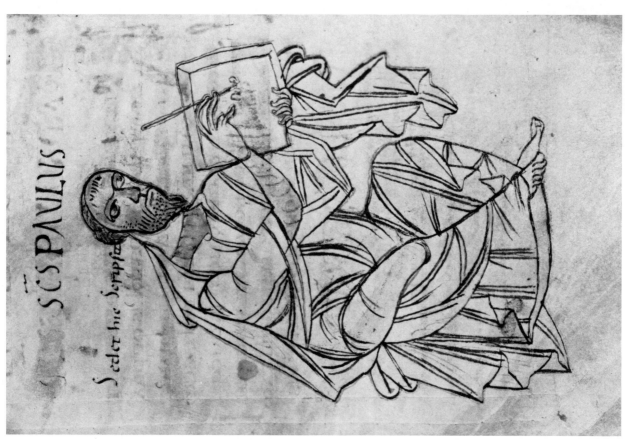

59 Düsseldorf, Universitätsbibl., MS A 14, Pauline Epistles, fol. 120

58 Stuttgart, Landesbibl., Cod. HB II 54, Pauline Epistles, Acts, and Apocalypse, fol. 25ᵛ

68 (*above, left*) Reims, Bibl. Mun., MS 34–6, Vol. III, fol. 138 (Galatians)

69 (*above, right*) Paris, Bibl. Ste. Geneviève, MS 1185, fol. 293ᵛ (Colossians)

70 (*left*) New York, Morgan Lib., MS M. 109–11, Vol. III, fol. 187ᵛ (I Timothy)

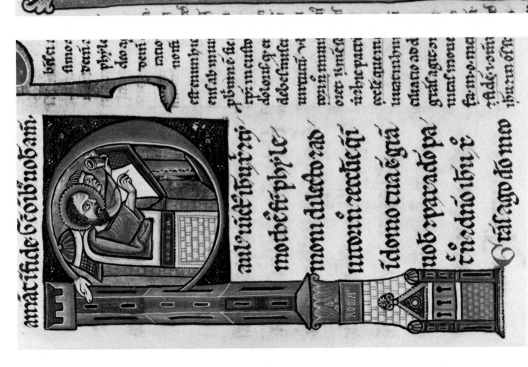

71 (above, left) Paris, BN, MS lat. 648, fol. 190 (Philemon)

72 (right) Paris, Bibl. Assemblée Nationale, MS 2, fol. 277 (Ephesians)

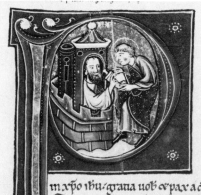

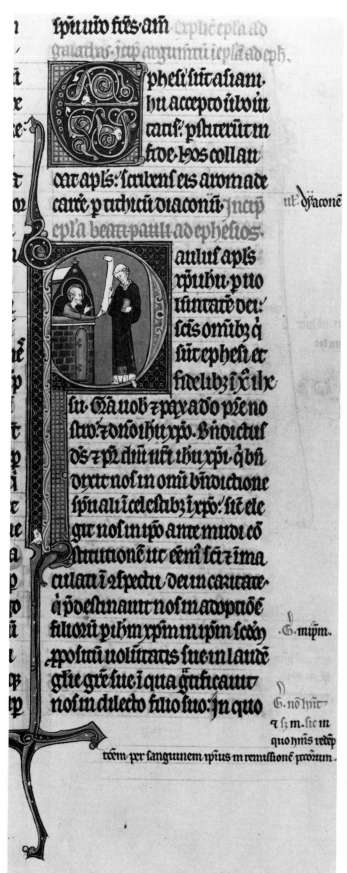

73 (*above, left*) Oxford, Bodl. Lib., MS Laud Misc. 752, fol. 405ᵛ (Colossians)

74 (*right*) Paris, BN, MS lat. 16719–22, Vol. IV, fol. 147ᵛ (Ephesians)

75 (*below, left*) Toledo Cathedral, *Bible Moralisée*, Vol. III, fol. 149 (Marcionite prologue to Ephesians)

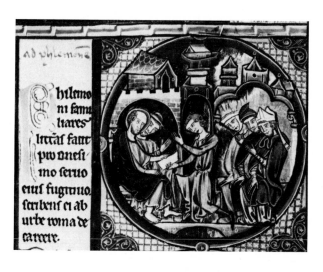

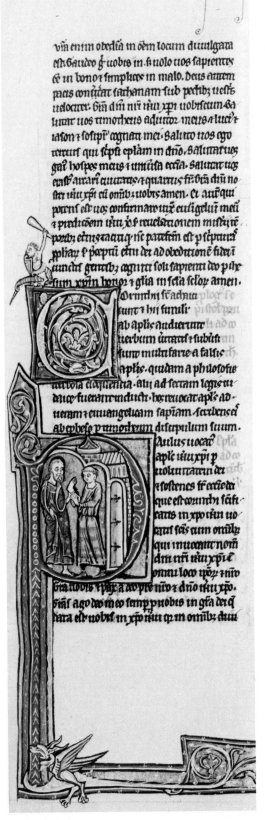

tum puenerint. Colocenses collaudat
quia uelut ignotis scribit z accepto
nuncio ab epafra custodit z euangeli
um gratulatur. Thessalonicenses i pri
ma in ope z fide creuisse gloziatur in se
cunda preterea quod z persequutionem
passi in fide pseuerauerint. Quos z ipsos appel
lat ut illos qui in iudea xpm confessi: ipse
quoqz sozmz tulerit. Ad hebzos z q solitudine
passi sr thessalonicenses ut in mandatis pse
uerantes psequuntur: pmptissime paciarur.
Oins g eple pauli nuo. xiiii. ad romanos
.i. ad corinthios .ij. ad galathas .i. ad ephesi
os .j. Ad philipenses .i. ad colocenses .i. ad the
salonicenses .ij. ad hebzeos .j. quos horta
tur ad similitudine thessalonicensium.
Hec in canone ñ habetur. Reliqz duo ad
timotheum pma queadm agat eccliam
seda. queadm seipm. agat. Ad titum p
ma ut creditam s eccliam: cete ordinet.
ad philomenem. una de onesimo seruo
cum emendat melius fes est. Epla pauli ad roma

Aulus seruus nos
tri xpi uocatus
aplc segregatus
in euangelium
dei q ante pmise
rat p pphas suos
in scripturis scis
de filio suo qui
sus est z ex semie
dd. Pcarnem qui
predestinat est fi
lius dei: i uirtute
secundum spm sanctificationis ex resurrectione
mortuoz ihu xpi z dni nri p q accepim
gram z ad apliarum ad obediendum
fidei in omnibz gentibz p nomine eius.
in quibz estis z uos uocati ihu xpi
omnibz qui sunt rome dilectis uocatis

uia enim obedia in oem locum diuulgata
est. Gaudeo g uobis in .ს. uolo uos sapientes
ee in bono z simplices in malo. deus autem
pacis conturat sathanam sub pedibz uestris
uelociter. Gra dni nri ihu xpi uobiscum. Sa
lutat uos timotheus adiutor meus z luci
jason z sosipr cognati mei. Saluto uos ego
terrius qui scripsi eplam in dno. Salutat uos
gaius hospes meus z uniuersa ecclia. Salutat uos
erastus arcarius ciuitatis z quartus fr. Gra dni no
stri ihu xpi cum omnibz uobis amen. Ei aut qui
potens est uos confirmare iuxta euangelium meum
z predicationem ihu xpi z reuelationem mysterii te
poribz eternis taciti qz nc patefactum est p scripturas
pphay z poeptu etni dei ad obedientem fidei
cunctis gentibz cogniti soli sapienti deo p ihe
sum xpm honor z glia in secla seclox amen.

Corinthii sctachaia ploz se
sunt z hii simuli
ab aplis audierunt
uerbum ueritatis z subiti
sunt multifarie a falsis
aplis. quidam a philosofie
uictoria eloquentia. alii ad sectam legis iu
daice fuerant inducti. hos reuocat aplus ad
ueram z euangelicam sapiam scribens eis
ab ephesis p timotheum discipulum suum.

Aulus uocatus
aplc ihu xpi p
uoluntatem dei
z sostenes fr ecclesia
que est corinthi sctifi
catis in xpo ihu uo
catis scis cum omnibz
qui inuocant nomen
dni nri ihu xpi
in omni loco ipsox z nro
gra uobis z pax a deo patre nro z dno ihu xpo.
Gras ago deo meo semp p uobis in gra dei
data est uobis in xpo ihu z in omnibz diuiti

85 London, BL, Burney MS 3, fol. 498 (I Timothy)

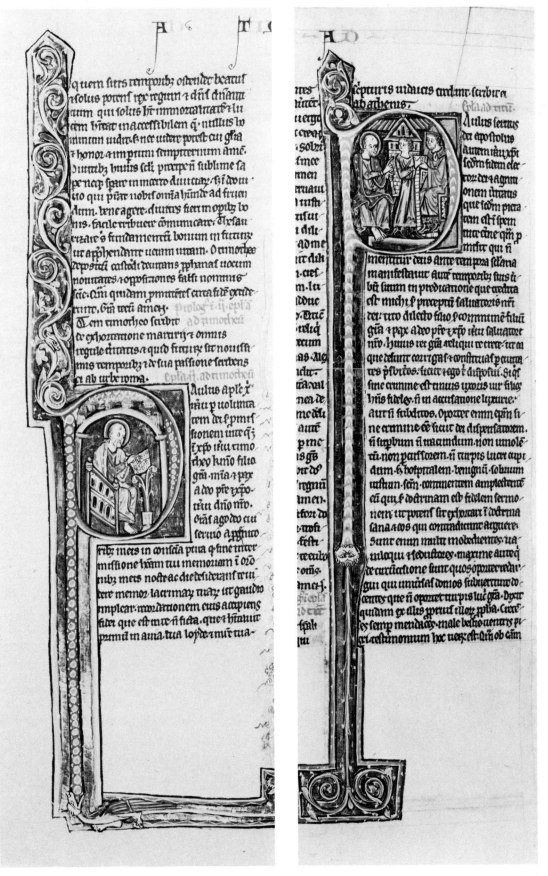

86 London, BL, Burney MS 3, fol. 499ᵛ (II Timothy) 87 London, BL Burney MS 3, fol. 500ᵛ (Titus)

88 London, BL, Burney MS 3, fol. 501ᵛ (Philemon) 89 London, BL, Burney MS 3, fol. 501ᵛ (Hebrews)

90 Oxford, New College, MS 7, fol. 264ᵛ (Romans)

91 Oxford, New College, MS 7, fol. 268 (I Corinthians)

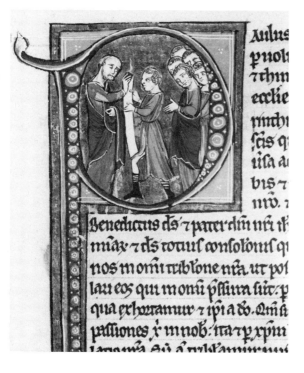

92 (*above, left*) Oxford, New College, MS 7, fol. 271 (II Corinthians)

93 (*right*) Oxford, New College, MS 7, fol. 272ᵛ (Galatians)

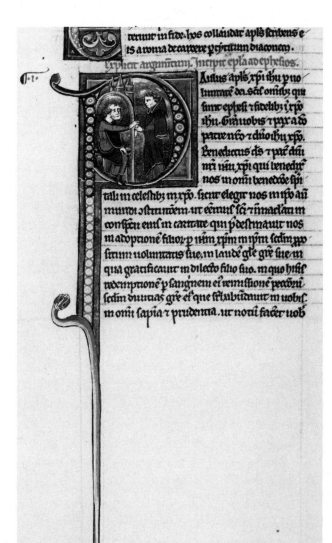

94 Oxford, New College, MS 7, fol. 273ᵛ (Ephesians)

95 Oxford, New College, MS 7, fol. 274ᵛ (Philippians)

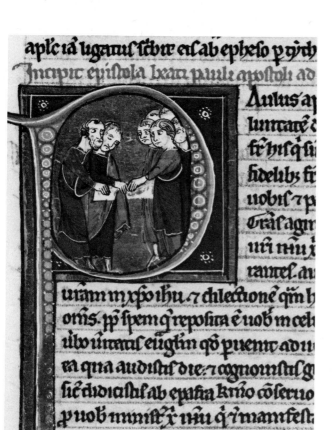

96 (*above, left*) Oxford, New College, MS 7, fol. 275 (Colossians)

97 (*above, right*) Oxford, New College, MS 7, fol. 275ᵛ (I Thessalonians)

98 (*below, right*) Oxford, New College, MS 7, fol. 276 (II Thessalonians)

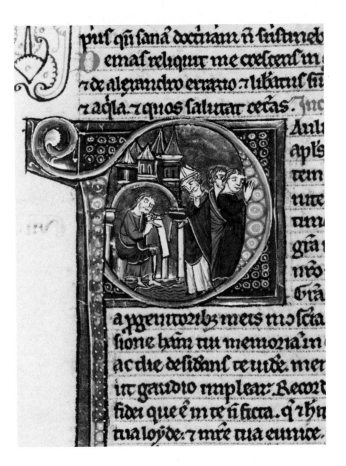

99 (*left*) Oxford, New College, MS 7, fol. 276ᵛ (I Timothy)

100 (*above, right*) Oxford, New College, MS 7, fol. 277ᵛ (II Timothy)

114 London, BL, Add. MS 15253, fol. 307ᵛ (I Thessalonians)

113 Palermo, Bibl. Naz., MS I.F.6–7, Vol. II, fol. 351 (I Thessalonians)

112 Palermo, Bibl. Naz., MS I.F.6–7, Vol. II, fol. 343ᵛ (II Corinthians)

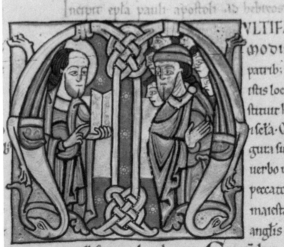

115 (*above, left*) London, BL, Add. MS 15253, fol. 311 (Hebrews)

116 (*below, right*) Paris, Bibl. Assemblée Nationale, MS 2, fol. 282 (Hebrews)

117 (*above, right*) Paris, BN, MS lat. 16719–22, Vol. IV, fol. 163ᵛ (Hebrews)

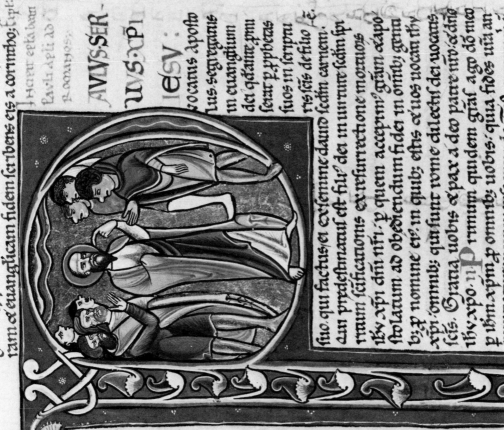

119 Oxford, Bodl. Lib., MS Laud Misc. 752, fol. 391ᵛ (Romans)

118 St. Gall, Stiftsbibl., Cod. 64, Pauline Epistles, p. 12

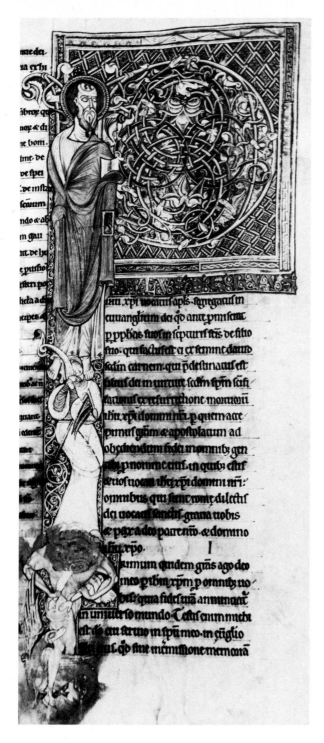

120 (*above, left*) Boulogne, Bibl. Mun., MS 2, Vol. II, fol. 231 (Romans)

121 (*above, right*) Baltimore, Walters Gallery, MS 56, fol. 383ᵛ (Romans)

122 (*below, right*) Toledo Cathedral Lib, *Bible Moralisée*, Vol. III, fol. 152 (Hebrews 4:12)

131 *(above)* Paul led to Damascus. New York,
Morgan Lib., MS M. 163, fol. 378 (Galatians)

132 *(below)* Paul Healed by Ananias. New York,
Morgan Lib., MS M. 163, fol. 379ᵛ (Ephesians)

133 *(right)* Baptism of Paul. New York, Morgan
Lib., MS M. 163, fol. 381 (Philippians)

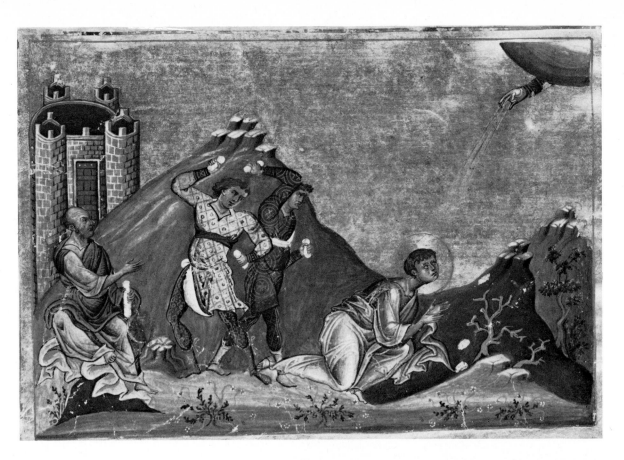

134 (*above*) Stoning of Stephen. Bibl. Vaticana, MS
gr. 1613, Menologion of Basil II, p. 275

135 (*right*) Stoning of Stephen. Munich, Bayer.
Staatsbibl., Clm 14345, Pauline Epistles, fol. 1ᵛ

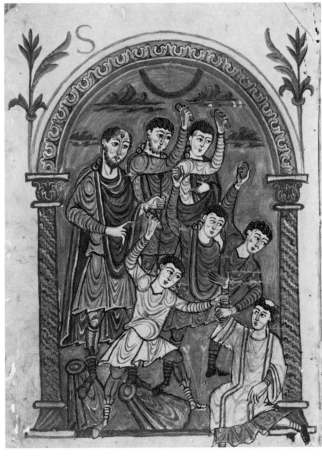

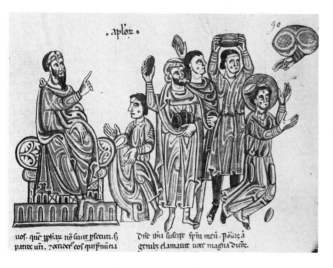

136 (above) Stoning of Stephen. Bibl. Vaticana, MS lat. 39, fol. 90

137 (below) Stoning of Stephen. Paris, Bibl. Mazarine, MS 15, fol. 417ᵛ
(Romans)

138 (right) Stoning of Stephen. Bibl. Vaticana, MS Urb. lat. 7, fol. 382
(I Corinthians)

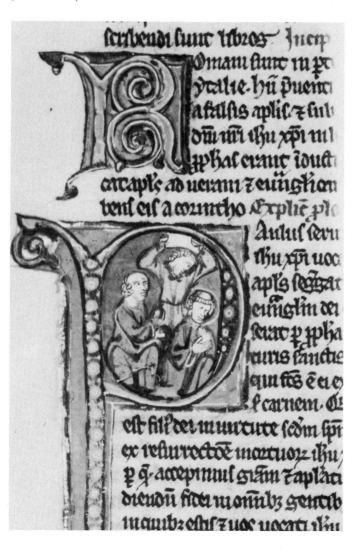

140 Saul Receives Letters. Paris, Bibl. Mazarine, MS 15, fol. 421ᵛ (I Corinthians)

139 Saul Receives Letters. Bibl. Vaticana, MS Urb. lat. 7, fol. 377ᵛ (Romans)

143 (*above*) Conversion of Paul. Avranches, Bibl. Mun., MS 2–3, Vol. II, fol. 269 (Romans)

144 (*right*) Conversion of Paul. Bibl. Vaticana, MS Urb. lat. 7, fol. 388ᵛ (Galatians)

155 (*above, left*) Paul Fed by Ananias. Oxford, Bodl. Lib., MS Auct. D.4.8, fol. 651 (Galatians)

156 (*above, right*) Paul Fed by Ananias. Bibl. Vaticana, MS Urb. lat. 7, fol. 391 (Philippians)

157 (*below, left*) Paul Fed by Ananias. Paris, Bibl. Mazarine, MS 15, fol. 435ᵛ (II Timothy)

158 (left) Baptism of Paul. Troyes, Bibl. Mun., MS 2391, fol. 217ᵛ (Galatians)

159 (above) Baptism of Paul. Avranches, Bibl. Mun., MS 2–3, Vol. II, fol. 289 (Colossians)

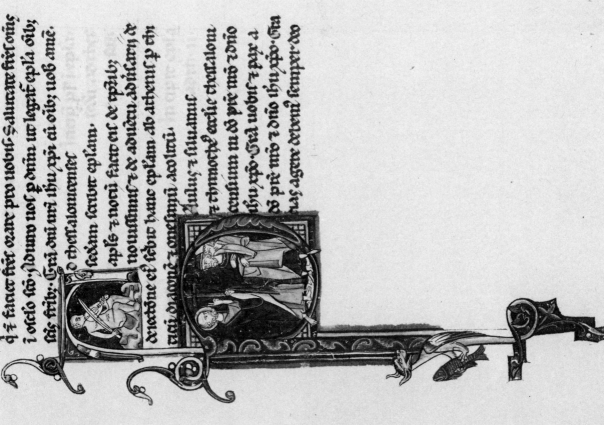

161 Paul Preaching in Damascus. Bibl. Vaticana, MS Urb. lat. 7, fol. 394 (II Thessalonians)

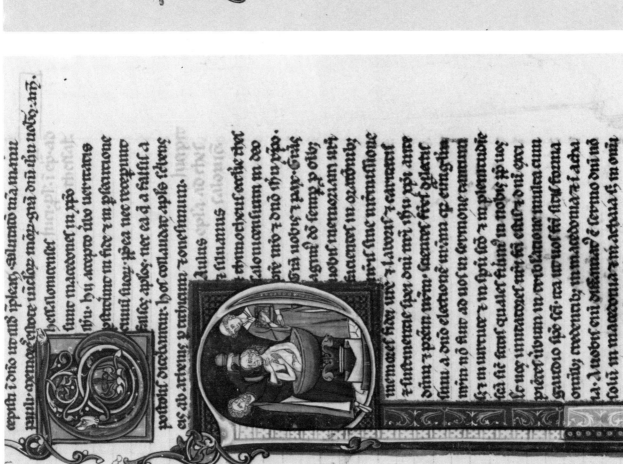

160 Baptism of Paul. Bibl. Vaticana, MS Urb. lat. 7, fol. 393 (I Thessalonians)

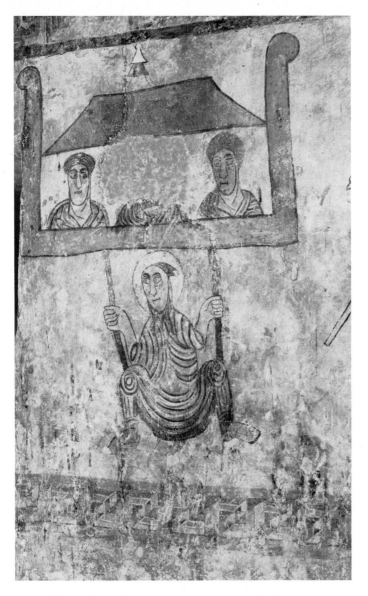

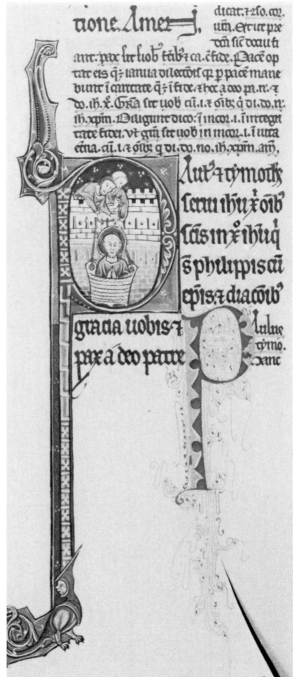

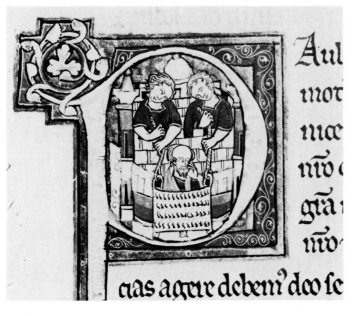

162 (*above, left*) Flight from Damascus. Naturno, S. Procolo, fresco

163 (*below, left*) Flight from Damascus. Avranches, Bibl. Mun., MS 2–3, Vol. II, fol. 291ᵛ (II Thessalonians)

164 (*above, right*) Flight from Damascus. Cambridge, Trinity College, MS B.4.1, fol. 186ᵛ (Philippians)

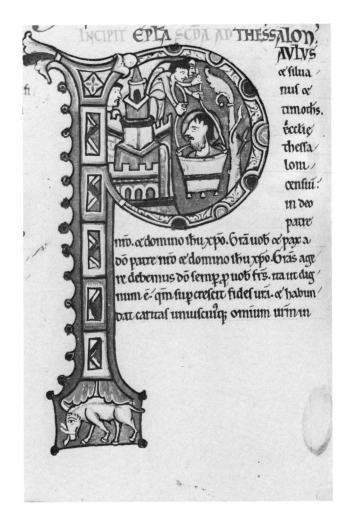

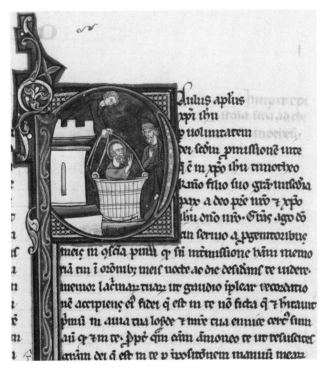

165 (*above, left*) Flight from Damascus. Troyes, Bibl. Mun., MS 2391, fol. 224ᵛ (II Thessalonians)

166 (*below, left*) Flight from Damascus. Enamel plaque, London Victoria and Albert Mus.

167 (*above, right*) Flight from Damascus. Bibl. Vaticana, MS Urb. lat. 7, fol. 395ᵛ (II Timothy)

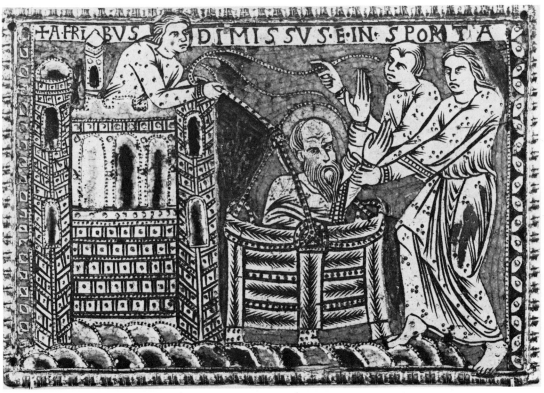

partceps sapientie. sed sapiens immobilitate atq; immutabilitate nature. Ei ergo. sit gla per xpm. cui est honor et gla in sela selorū a os e

adulus uocatus. et cetera. Hanc eplam scribit aplus corinthijs. Corinthij aute sunt achaei. hi ab ipso aplo sunt conuersi. q precepto dni ammonitus. resedit aput corinthios. et per annū unū et mses sex. docens est eos uerbu dei sed post p pseudo apostolos multipharie subuersi sūt. scilicet ut de baptistis se iactarent. ita etenim subuersi erant. ut unitate ecclie scindentes. sacmentor uirtutes et usum. ex ministror meritis iudicarent. Putabat enim sacramenta maioris ee usus. si per bonos tractarent. maioris aute ut minoris ee usus. si per magis ut minus bonos darent. et concepto aplo de sapientia seculi se iactabant. quor eloquentia et terrena philosophia delectabant. ut sub noie xpi his imbuerentque contra sut fidi. Inflati quoq; erāt. eo qd non uen ad eos aplus. fornicatoe q; q uxore patris tenebat. int se se paciebantur. Sut et alia capitula. in suis locis notanda. De his et huiusmodi magna cū fiducia. et caritatis affectu scribit eis aplus. aliqudo comonens. aliqudo blandiens. aliqudo arguiens. Na multe sunt cause. ppt qs scribit eis ab erroab; ad recta fide et a scismatib

168 (right) Flight from Damascus. New York, Morgan Lib., MS M. 939, fol. 70 (I Corinthians)

169 (below) Flight from Damascus. San Paolo fuori le mura (Bibl. Vaticana, MS Barb. lat. 4406, fol. 93)

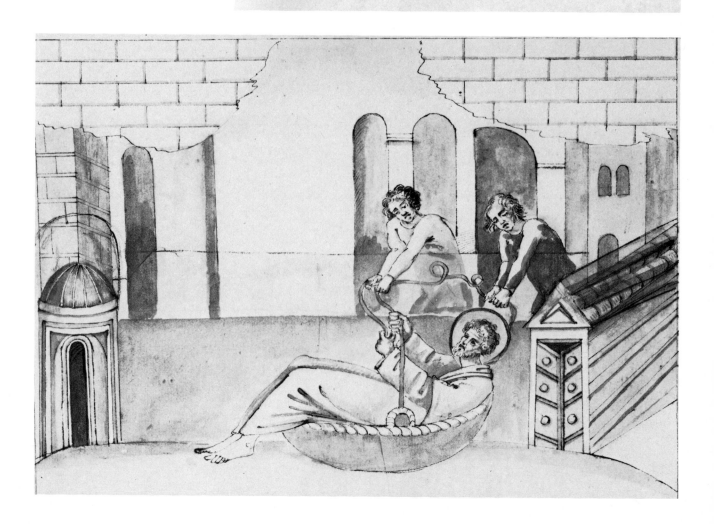

171 Flight from Damascus. Oxford, Bodl. Lib., MS Auct. D.4.8, fol. 657 (Colossians)

170 Flight from Damascus. Berlin, Staatsbibl. Preussischer Kulturbesitz, MS Theol. lat. fol. 379, Bible of Heisterbach, fol. 481v

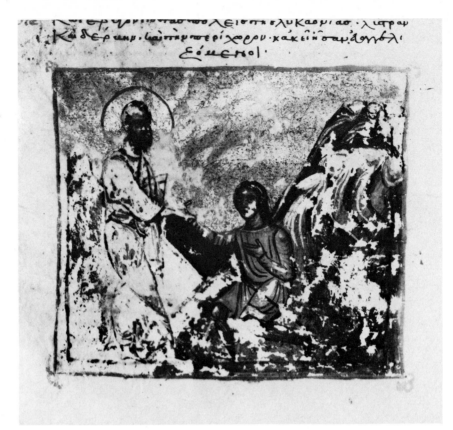

172 Miracle of the Lame Man. University of Chicago Lib., MS 965. fol. 122ᵛ

173 Miracle of the Lame Man. Bibl. Vaticana, MS Chigi A.IV.74, fol. 132ᵛ

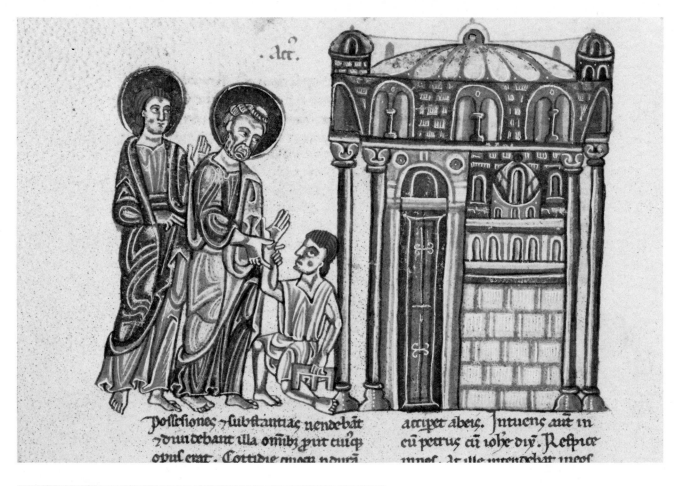

.act.

possessiones ⁊ substantias uendebant ⁊ diuidebant illa omibʒ prut cuiʒq opus erat. Cottidie eman petuā

accipet abeis. Intuens aut in eū petrus cū iohe diʒ. Respice nnoʒ. Ar ille intendebat incos

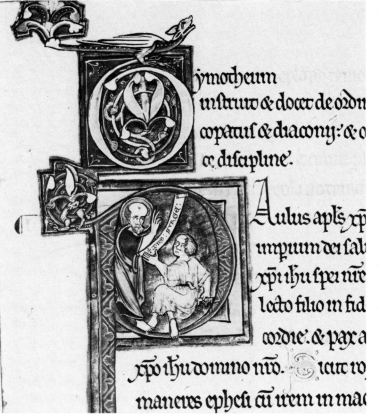

ymotheum
instruit & docet de ordñ
copatus & diacony: & o
ce disciplne.

Aulus aplʒ xp̄i
imprum dei sal
xp̄i ihū spei ñre
lecto filio in fid
cordie. & pax a
xp̄o ihū domino ñro. Dicut ro
maneus ephesi cū irem in mac

174 (*above*) Peter Heals a Lame Man at the Beautiful Gate. Bibl. Vaticana, MS lat. 39, fol. 86ᵛ

175 (*left*) Miracle of the Lame Man. Avranches, Bibl. Mun., MS 2–3, Vol. II, fol. 292ᵛ (I Timothy)

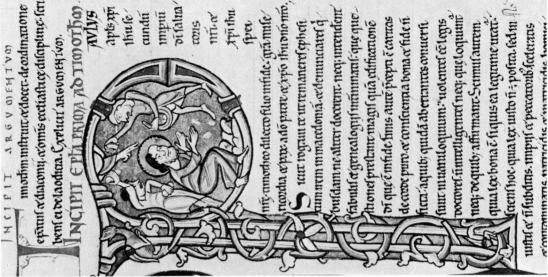

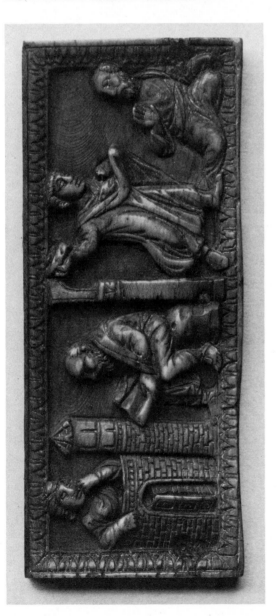

176 (above) Paul Reading to Thecla, Paul Stoned at Lystra. Ivory panel, London, Brit. Mus.

177 (right) Paul Stoned at Lystra. Troyes, Bibl. Mun., MS 2391, fol. 225ᵛ (I Timothy)

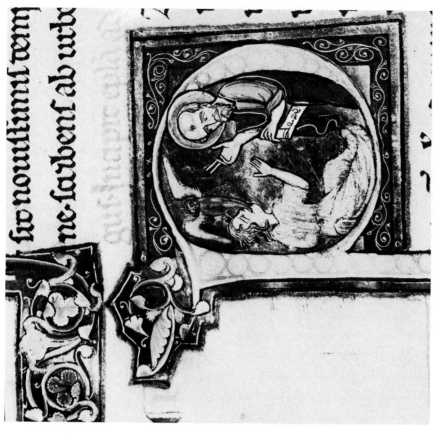

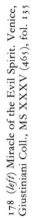

178 (*left*) Miracle of the Evil Spirit. Venice, Giustiniani Coll., MS XXXV (46), fol. 135

179 (*above*) Miracle of the Evil Spirit. Avranches, Bibl. Mun., MS 2–3, Vol. II, fol. 294 (II Timothy)

180 (*above, left*) Paul and Silas Beaten at Philippi.
San Paolo fuori le mura (Bible. Vaticana, MS Barb.
lat. 4406, fol. 97)

181 (*below, left*) Paul and Silas Beaten at Philippi.
Malles, S. Benedetto, fresco

182 (*above, right*) Paul and Silas Beaten at Philippi.
Dečani, fresco (Drawing by Janet Brooke)

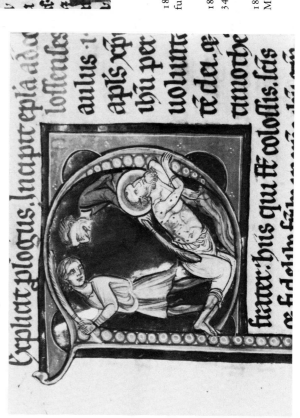

183 (*above, left*) Paul Beaten by the Jews. San Paolo fuori le mura (Bibl. Vaticana, MS Barb. lat. 4406, fol. 103)

184 (*below, left*) Paul Beaten. Reims, Bibl. Mun., MS 34–6, Vol. III, fol. 146 (Colossians)

185 (*above, right*) Paul Beaten. Oxford, Bodl. Lib., MS Auct. D.4.8, fol. 658ᵛ (I Thessalonians)

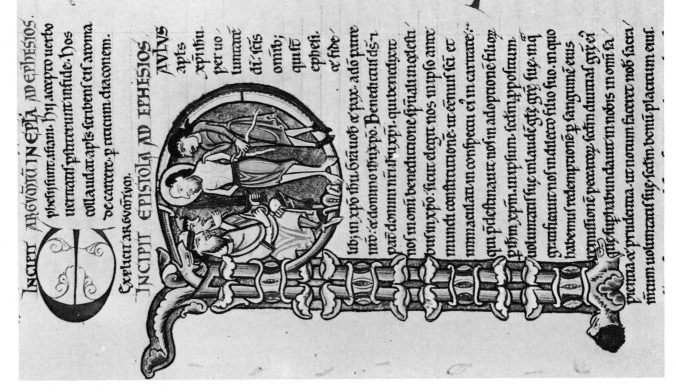

186 (above) Paul and Silas Beaten at Philippi. Bibl. Vaticana, MS lat. 39, fol. 98

187 (right) Paul Judged at Philippi. Troyes, Bibl. Mun., MS 2391, fol. 219ᵛ (Ephesians)

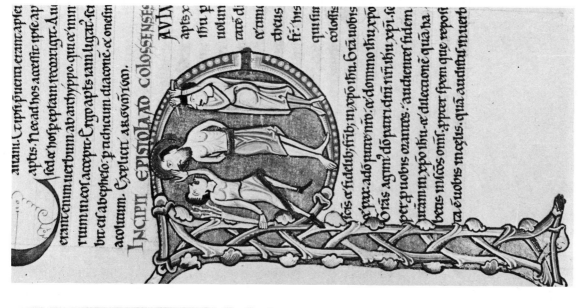

190 Paul Beaten at Philippi. Troyes, Bibl. Mun., MS 2391, fol. 222ᵛ (Colossians)

189 Paul Beaten. Paris, Bibl. Mazarine, MS 15, fol. 429ᵛ (Ephesians)

188 Paul Beaten. New York, Morgan Lib., MS Glazier 42, fol. 354 (Philemon)

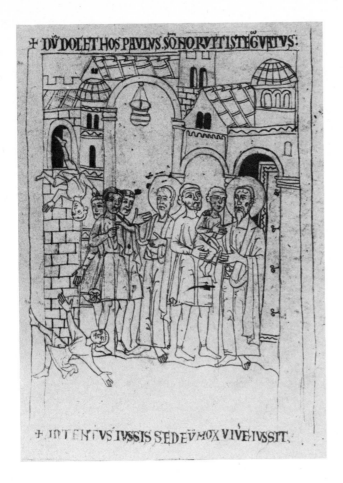

191 (*above, left*) Miracle of Eutychus. Vercelli Rotulus, Vercelli, Archivio Capitolare

192 (*above, right*) Miracle of Eutychus. Cambridge, Trinity College, MS B.4.1, fol. 230ᵛ (II Timothy)

193 (*below, right*) Miracle of Eutychus. Oxford, Bodl. Lib., MS Laud Misc. 752, fol. 403ᵛ (Ephesians)

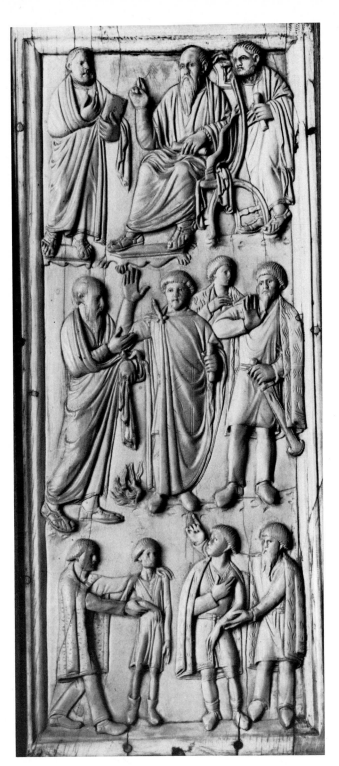

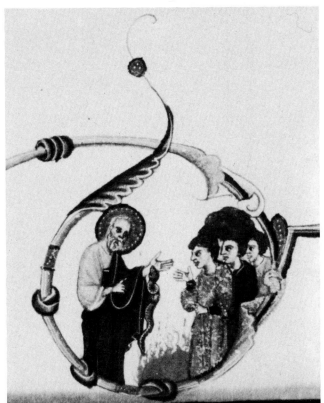

194 (*above, left*) Paul Debating with the Philosophers,
Miracle of the Viper, Afflicted of Malta Waiting to be
Healed. Right wing of ivory diptych, Florence, Bargello

195 (*above, right*) Miracle of the Viper. Abbey Coll.,
MS 7345, fol. 423 (Romans)

196 (*below, right*) Miracle of the Viper. Venice, Giustiniani
Coll., MS XXXV (465), fol. 143

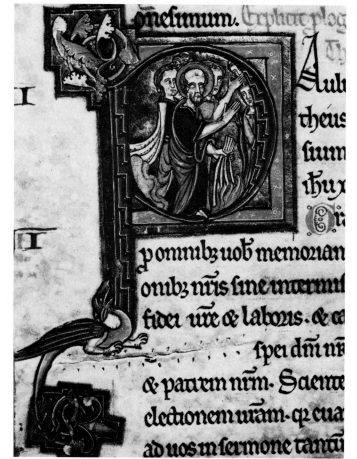

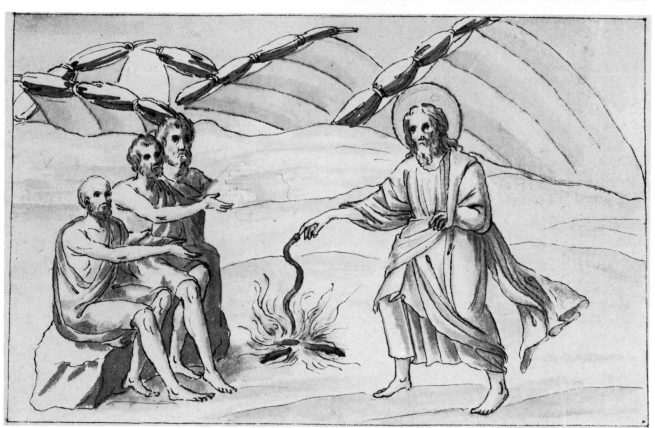

197 (*right*) Miracle of the Viper. Avranches, Bibl. Mun., MS 2–3, Vol. II, fol 290ᵛ (I Thessalonians)

198 (*below*) Miracle of the Viper. San Paolo fuori le mura (Bibl. Vaticana, MS Barb. lat. 4406, fol. 125)

199 (left) Miracle of the Viper. Troyes, Bibl. Mun., MS 458, Vol. II, fol. 211v (Ephesians)

200 (above) Miracle of the Viper. Troyes, Bibl. Mun., MS 2391, fol. 223v (I Thessalonians)

201 (above, left) Plautilla Gives the Veil to Paul, Execution of Paul. Vienna, Nationalbibl., Cod. Ser. Nov. 2700, Antiphonal, p. 368

202 (above, right) Paul before Nero. Avranches, Bibl. Mun., MS 2–3, Vol. II, fol. 280 (II Corinthians)

203 (below, right) Paul before Nero. Bibl. Vaticana, MS Urb. lat. 7, fol. 394ᵛ (I Timothy)

204 (*above, left*) Plautilla Gives the Veil to Paul. Avranches, Bibl. Mun., MS 2–3, Vol. II, fol. 284 (Galatians)

205 (*below, left*) Execution of Paul. Avranches, Bibl. Mun., MS 2–3, Vol. II, fol. 286 (Ephesians)

206 (*above, right*) Execution of Paul. Bibl. Vaticana, MS Urb. lat. 7, fol. 396ᵛ (Philemon)

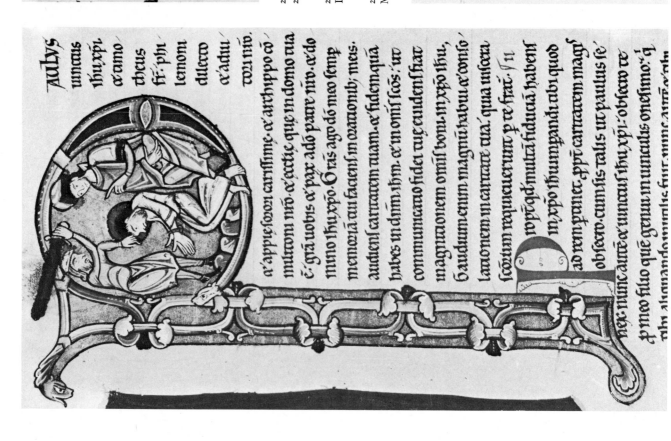

207 (left) Execution of Paul. Troyes, Bibl. Mun., MS 2391, fol. 228v (Philemon)

208 (above) Execution of Paul. Oxford, Bodl. Lib., MS Auct. D.4.8, fol. 665 (Hebrews)

209 (below) Paul Returns the Veil to Plautilla. Avranches, Bibl. Mun., MS 2–3, Vol. II, fol. 295 (Titus)

210 (*above, left*) Paul Appears before Nero. Avranches, Bibl. Mun., MS 2–3, Vol. II, fol. 295ᵛ (Philemon)

211 (*above, right*) Plautilla Shows the Veil to Soldiers. Avranches, Bibl. Mun., MS 2–3, Vol. II, fol. 296 (Hebrews)

212 (*below, right*) Paul Returns the Veil to Plautilla. Bibl. Vaticana, MS Urb. lat. 7, fol. 397 (Hebrews)

213 (*above, left*) Conversion of Paul. London, BL, Add. MS 27694, fol. 407 (Romans)

214 (*above, right*) Baptism of Paul. London, BL, Add. MS 27694, fol. 411ᵛ (I Corinthians)

215 (*below, right*) Baptism of Paul. Paris, BN, MS lat. 13142, fol. 608ᵛ (I Corinthians)

216 (*above*) Flight from Damascus. London, BL, Add. MS 27694, fol. 415ᵛ (II Corinthians)

217 (*right*) Flight from Damascus. Paris, BN, MS lat. 13142, fol. 615ᵛ (II Corinthians)

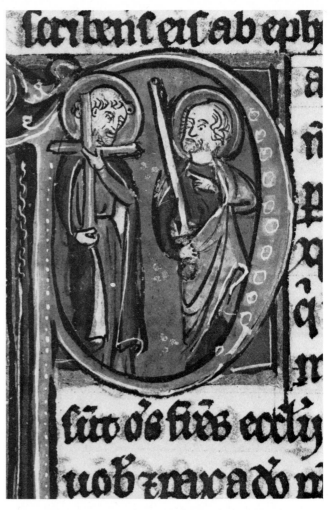

218 (*above, left*) Peter and Paul in Jerusalem. London, BL, Add. MS 27694, fol. 418ᵛ (Galatians)

219 (*above, right*) Peter and Paul in Jerusalem. Paris, BN, MS lat. 13142, fol. 620 (Galatians)

220 (*below, left*) Miracle of the Lame Man. London, BL, Add. MS 27694, fol. 420 (Ephesians)

221 (*below, right*) Miracle of the Lame Man. Paris, BN, MS lat. 13142, fol. 622 (Ephesians)

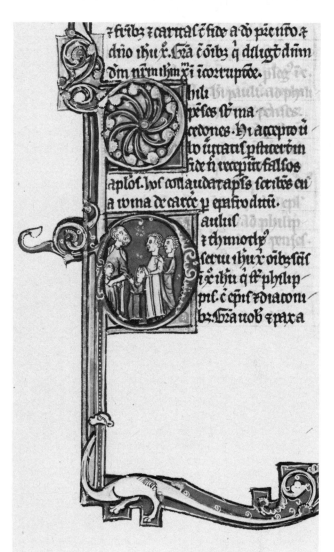

222 (*above, left*) Paul Takes Timothy (?). London, BL, Add. MS 27694, fol. 421ᵛ (Philippians)

223 (*above, right*) Paul Takes Timothy (?). Paris, BN, MS lat. 13142, fol. 624ᵛ (Philippians)

224 (*below, left*) Paul Takes Timothy. Abbey Coll., MS 7345, fol. 444ᵛ (II Timothy)

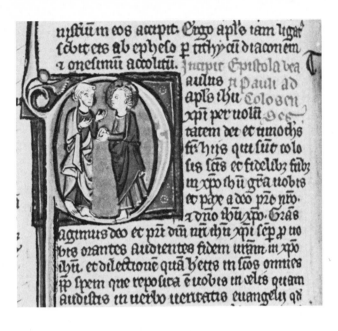

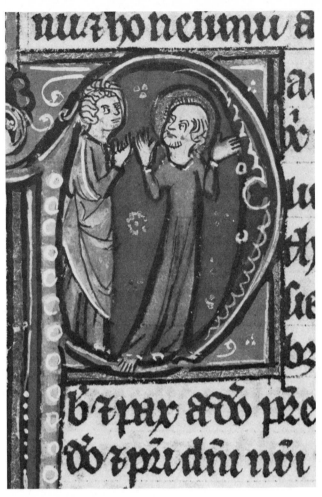

225 (*above, left*) Unidentified scene. London, BL,
Add. MS 27694, fol. 422ᵛ (Colossians)

226 (*above, right*) Unidentified scene. Paris, BN, MS
lat. 13142, fol. 626 (Colossians)

227 (*below, left*) The Raising of the Dead. Paris, BN,
MS lat. 13142, fol. 628 (I Thessalonians)

228 (*below, right*) The Raising of the Dead. London,
BL, Add. MS 27694, fol. 424ᵛ (II Thessalonians)

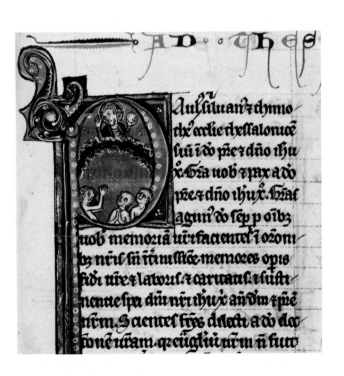

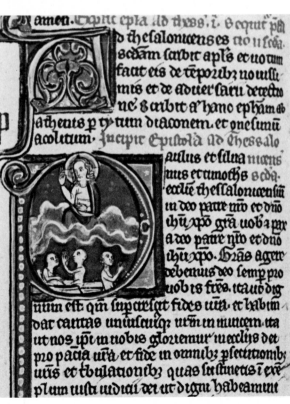

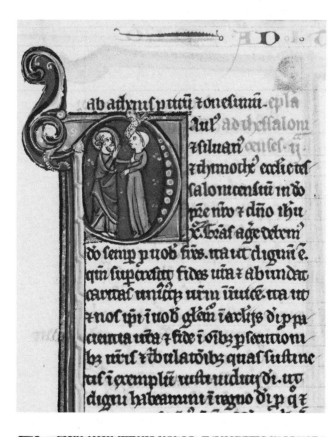

229 (*above, left*) Miracle of the Evil Spirit. Paris, BN, MS lat. 13142, fol. 629ᵛ (II Thessalonians)

230 (*above, right*) Miracle of the Evil Spirit. London, BL, Add. MS 27694, fol. 423ᵛ (I Thessalonians)

231 (*below, left*) Paul with a Bishop. London, BL, Add. MS 27694, fol. 425 (I Timothy)

232 (*above, left*) Miracle of Eutychus. Paris, BN, MS lat. 13142, fol. 632 (II Timothy)

233 (*above, right*) Paul with the High Priest. London, BL, Add. MS 27694, fol. 427 (Titus)

234 (*below, right*) Paul with the High Priest. Paris, BN, MS lat. 13142, fol. 633ᵛ (Titus)

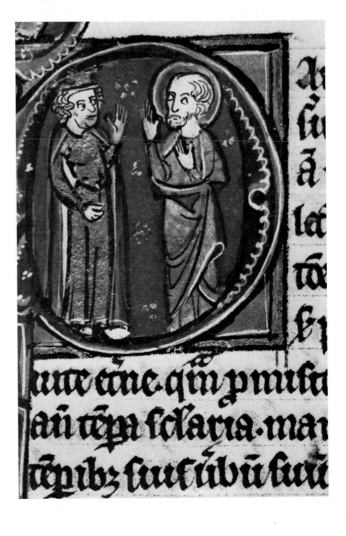

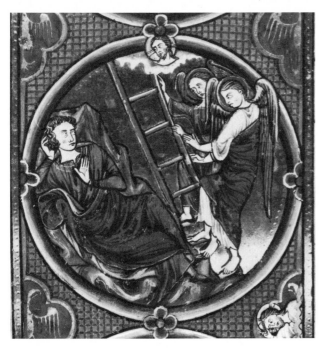

241 Vienna, Nationalbibl., Cod. 1179, *Bible Moralisée*, fol. 12

242 Toledo Cathedral Lib., *Bible Moralisée*, Vol. III, fol. 74

243 London, BL, Harley MS 1527, *Bible Moralisée*, fol. 107

244 Toledo Cathedral Lib., *Bible Moralisée*, Vol. III, fol. 25

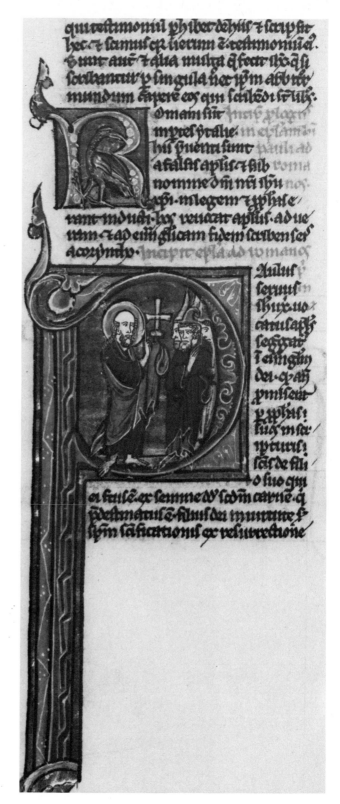

245 (*above*) Paul Preaches to the Jews. Göttweig,
Stiftsbibl., MS 55, fol. 257ᵛ (Romans)

246 (*right*) Paul Preaches to the Jews. Vatican
Library, MS Rossiana 314, fol. 444 (Romans)

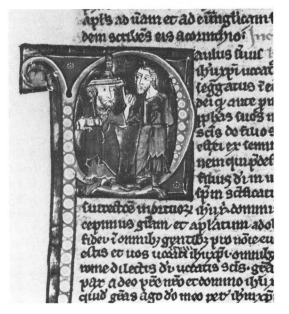

247 (*left*) Paul Preaches to the Jews. New York, Morgan Lib., MS M. 269, fol. 384 (Romans)

248 (*above, right*) Paul Argues with a Jew. Paris, Bibl. Ste. Geneviève, MS 1180, fol. 334ᵛ (Romans)

249 (*below, right*) Romans 1:1–7 and moralization. Toledo Cathedral Lib., *Bible Moralisée*, Vol. III, fol. 127

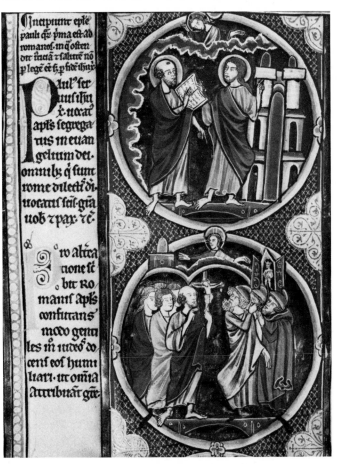

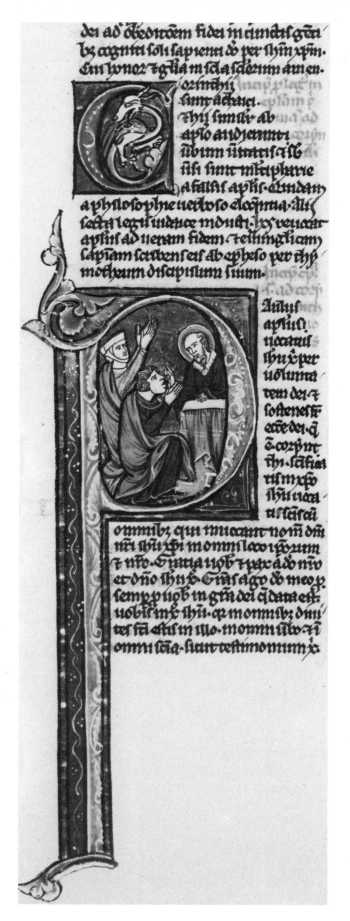

250 (*above*) Paul Celebrates Communion. Göttweig, Stiftsbibl., MS 55, fol. 260ᵛ (I Corinthians)

251 (*right*) Paul Celebrates Communion. Vatican Lib., MS Rossiana 314, fol. 449 (I Corinthians)

252 (*above*) Paul Celebrates Communion. Paris, Bibl.
Ste. Geneviève, MS 1180, fol. 338ᵛ (I Corinthians)

253 (*right*) Paul Celebrates Communion. New York,
Morgan Lib., MS M. 269, fol. 388ᵛ (I Corinthians)

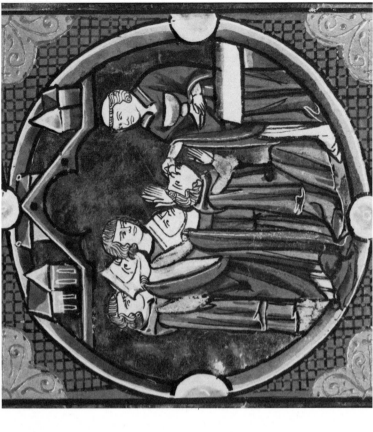

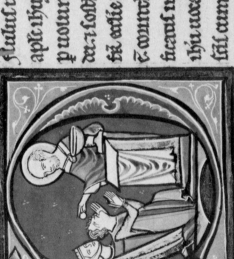

254 (left) Paul Celebrates Communion. Cambridge, Fitzwilliam Mus., MS 1, fol. 396ᵛ (I Corinthians)

255 (above) Paul Celebrates Communion. London, BL, Harley MS 1526–7, Bible Moralisée Vol. II, fol. 59ᵛ

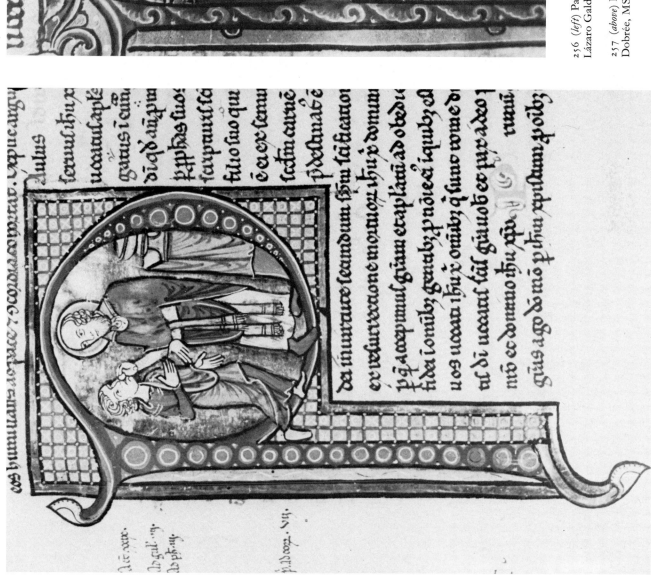

256 (left) Paul Celebrates Communion. Madrid, Fundación Lázaro Galdiano, Inv. 15289, fol. 287 (Romans)

257 (above) Paul Celebrates Communion. Nantes, Musée Dobrée, MS VIII, Vol. II, fol. 443ᵛ (I Corinthians)

258 (*above*) The Angel of Satan Visits Paul. Göttweig, Stiftsbibl., MS 55, fol. 263ᵛ (II Corinthians)

259 (*right*) The Angel of Satan Visits Paul. Vatican Lib., MS Rossiana 314, fol. 454 (II Corinthians)

260 (*above*) The Dream of Cornelius. London, BL, Harley MS 1526–7, *Bible Moralisée*, Vol. II, fol. 66v

261 (*right*) The Angel of Satan Visits Paul. New York, Morgan Lib., MS M. 269, fol. 392v (II Corinthians)

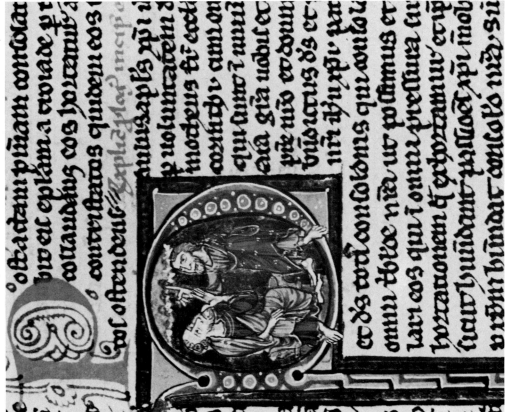

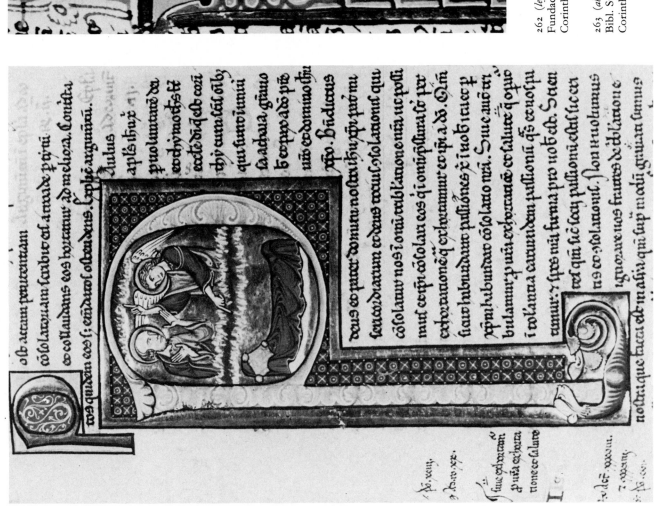

262 (left) The Angel of Satan Visits Paul. Madrid, Fundación Lázaro Galdiano, Inv. 15289, fol. 293 (II Corinthians)

263 (above) The Angel of Satan Visits Paul. Paris, Bibl. Ste. Geneviève, MS 1180, fol. 342 (II Corinthians)

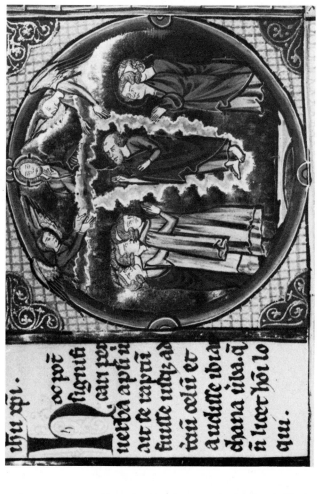

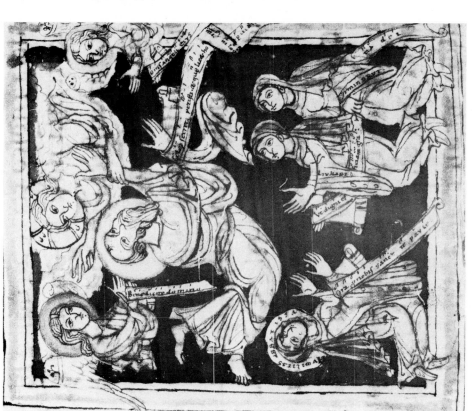

264 (*left*) Paul Raised to the Third Heaven.
Admont, Stiftsbibl., MS 289, fol. 44ᵛ

265 (*above*) Paul Raised to the Third Heaven.
Toledo Cathedral Lib., *Bible Moralisée*, Vol. III; fol.
132

266 (*above*) Paul Expels Hagar. Göttweig, Stiftsbibl., MS 55, fol. 266 (Galatians)

267 (*right*) Paul Expels Hagar. Madrid, Fundación Lázaro Galdiano, Inv. 15289, fol. 295 (Galatians)

268 (*above*) The Expulsion of Hagar, Philadelphia, Free Lib., Lewis MS 185, Psalter, fol. 34

269 (*right*) Paul Expels Hagar. Paris, Bibl. Ste. Geneviève, MS 1180, fol. 345 (Galatians)

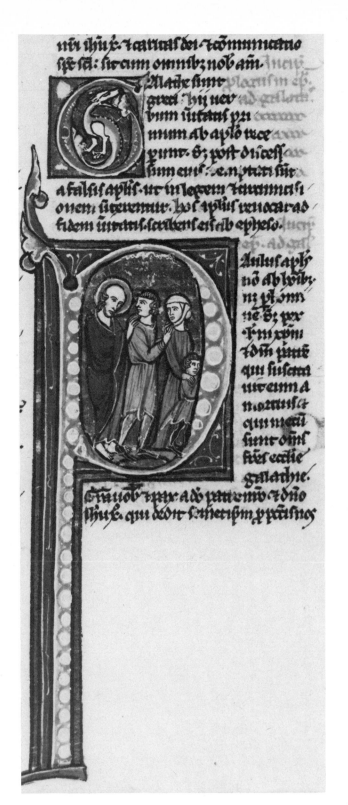

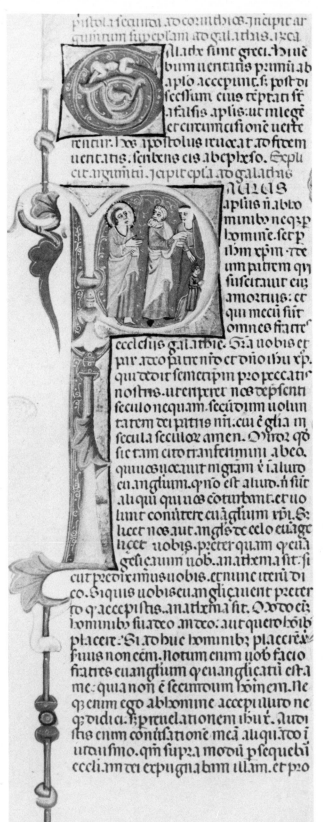

270 (*above*) Paul Expels Hagar. Vatican Lib., MS Rossiana 314, fol. 457 (Galatians)

271 (*right*) Paul Advocates the Expulsion of Hagar. Cava, Bibl. Mon. Naz., MS 33, 'Guido Bible', fol. 446ᵛ (Galatians)

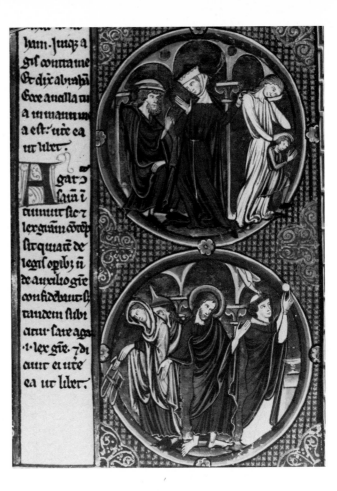

272 (*left*) Paul Expels Hagar. Paris, BN, MS lat. 14397, fol. 337 (Galatians)

273 (*above*) The Expulsion of Hagar and moralization. Oxford, Bodl. Lib., MS Bodley 270b, *Bible Moralisée*, fol. 13ᵛ

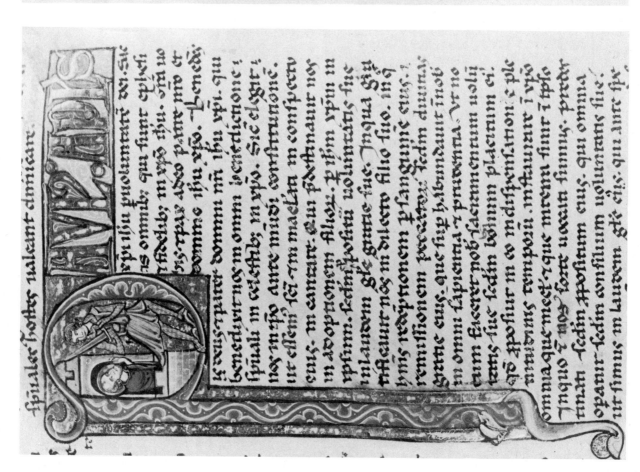

274 Paul Describes the Christian Soldier. Göttweig, Stiftsbibl., MS 55, fol. 267 (Ephesians)

275 Paul Describes the Christian Soldier. Madrid, Fundación Lázaro Galdiano, Inv. 15289, fol. 296 (Ephesians)

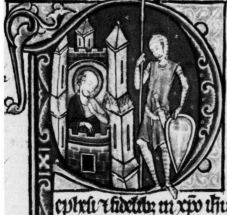

276 (*above, left*) Paul Describes the Christian Soldier. Nantes, Mus. Dobrée, MS VIII, Vol. II, fol. 503 (Ephesians)

277 (*above, right*) Paul Describes the Christian Soldier. Paris, Bibl. Ste. Geneviève, MS 1180, fol. 346 (Ephesians)

278 (*below, right*) Paul Describes the Christian Soldier. Formerly Florence, Olschki Collection, fol. 368 (Ephesians)

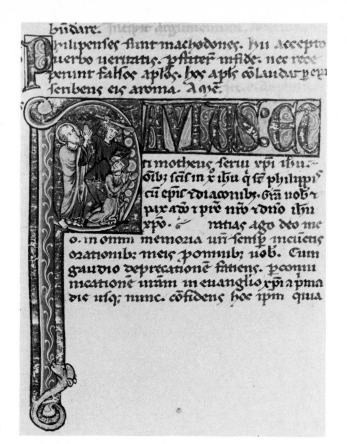

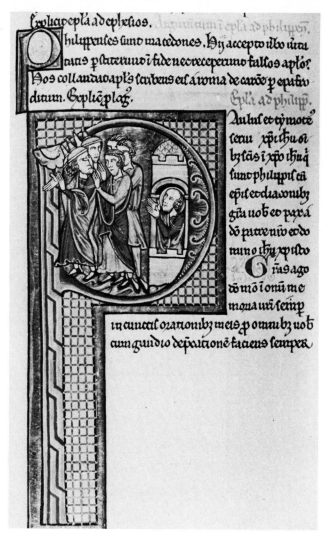

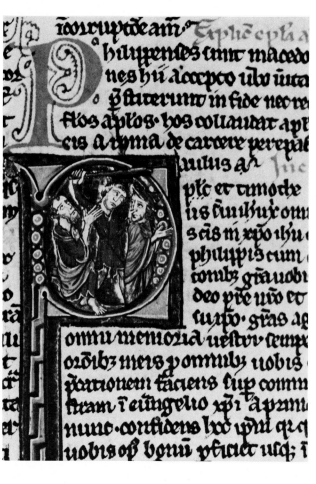

279 (*above, left*) Paul Predicts the Destruction of the Enemy of the Church. Göttweig, Stiftsbibl., MS 55, fol. 268 (Philippians)

280 (*below, left*) Paul Predicts the Destruction of the Enemy of the Church. Paris, Bibl. Ste. Geneviève, MS 1180, fol. 347ᵛ (Philippians)

281 (*above, right*) Paul Predicts the Destruction of the Enemy of the Church. Madrid, Fundación Lázaro Galdiano, Inv. 15289, fol. 297 (Philippians)

282 (*above, left*) Paul Beaten. Vatican Lib, MS Rossiana 314, fol. 460ᵛ (Philippians)

283 (*below, left*) Paul Beaten. Bologna, Bibl. Univ., MS 297, Vol. II, fol. 57 (Philippians)

284 (*above, right*) Paul Predicts the Destruction of the Enemy of the Church. Cava, Bibl. Mon. Naz., MS 33, 'Guido Bible', fol. 449ᵛ (Philippians)

285 (*above, left*) Paul Declares the Bondage to the Law to be Broken. Göttweig, Stiftsbibl., MS 55, fol. 269 (Colossians)

286 (*above, right*) Paul Declares the Bondage to the Law to be Broken. Cambridge, Fitzwilliam Mus., MS 1, fol. 407ᵛ (Colossians)

287 (*below, right*) Paul Declares the Bondage to the Law to be Broken. Paris, Bibl. Ste. Geneviève, MS 1180, fol. 348ᵛ (Colossians)

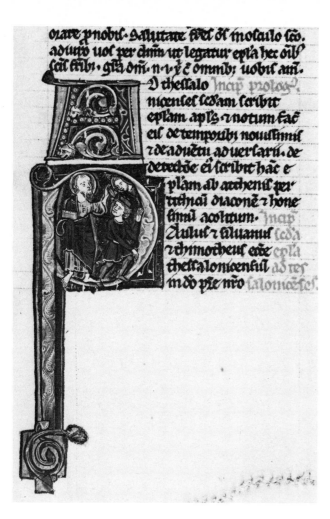

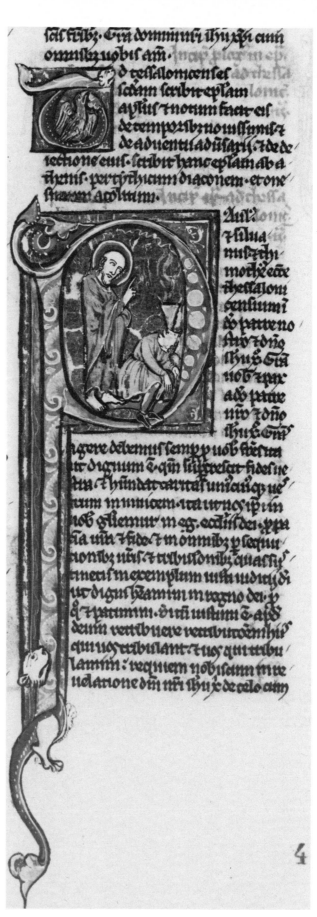

298 (*above*) Paul Prophesies the Destruction of Antichrist.
Paris, BN, MS lat. 14397, fol. 342 (II Thessalonians)

299 (*right*) Paul Prophesies the Destruction of Antichrist.
Vatican Lib, MS Rossiana 314, fol, 464 (II Thessalonians)

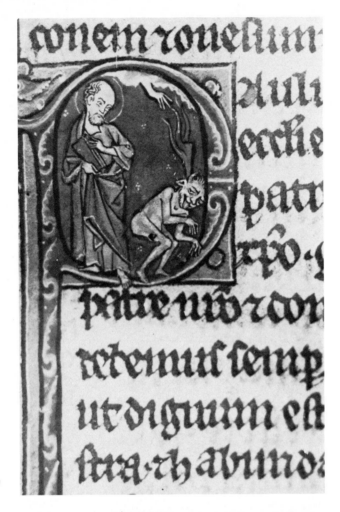

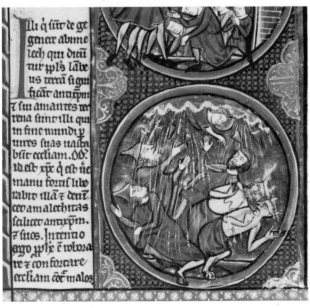

300 (*above, left*) Paul Prophesies the Destruction of Antichrist. Nantes, Mus. Dobrée, MS VIII, Vol. II, fol. 527ᵛ (II Thessalonians)

301 (*above, right*) Paul Prophesies the Destruction of Antichrist. Madrid, Fundación Lázaro Galdiano, Inv. 15289, fol. 299 (II Thessalonians)

302 (*below, left*) The Destruction of Antichrist. Paris, BN, MS lat. 11560, *Bible Moralisée*, fol. 15ᵛ

303 Paul Describes Ordination. Göttweig, Stiftsbibl., MS 55, fol. 271 (I Timothy)

304 Paul Describes Ordination. Madrid, Fundación Lázaro Galdiano, Inv. 15289, fol. 299ᵛ (I Timothy)

305 Paul Ordains a Priest. Paris, Bibl. Ste. Geneviève, MS 1180, fol. 351 (I Timothy)

306 Paul Describes Ordination. Formerly Florence, Olschki Collection, fol. 373ᵛ (II Timothy)

307 (left) Paul Describes Ordination. Bologna, Bibl. Univ.,
MS 297, Vol. II, fol. 61 (I Timothy)

308 (above, right) Ordination of a Priest. Rome, Bibl.
Casanatense, MS 724, Pontifical of Landulfus

309 (below, right) Ephesians 4:22–4 London, BL, Harley MS
1526–7, Bible Moralisée, Vol. II, fol. 107

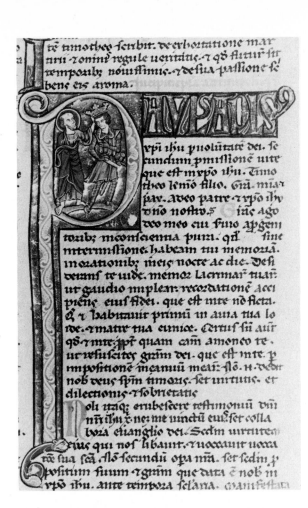

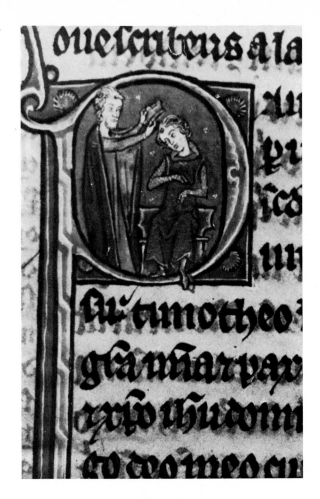

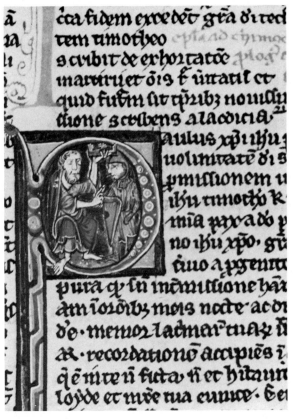

310 (*above, left*) Paul Promises the Martyr's Crown.
Göttweig, Stiftsbibl., MS 55, fol. 272 (II Timothy)

311 (*below, left*) Paul Promises the Martyr's Crown.
Paris, Bibl. Ste. Geneviève, MS 1180, fol. 352 (II
Timothy)

312 (*above, right*) Paul Promises the Martyr's Crown.
Nantes, Mus. Dobrée, MS VIII, Vol. II, fol. 536ᵛ (II
Timothy)

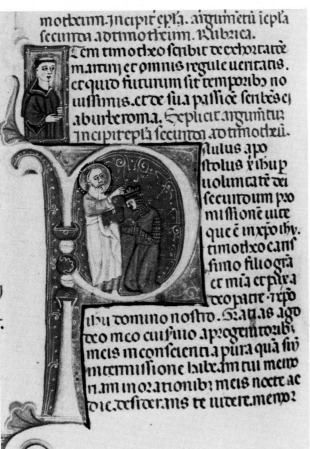

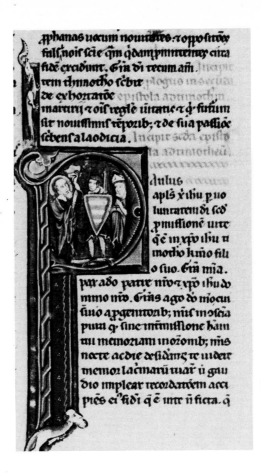

313 (*above, left*) Paul Promises the Martyr's Crown. Cava, Bibl. Mon. Naz., MS 33, 'Guido Bible', fol. 454ᵛ (II Timothy)

314 (*below, left*) Paul Promises the Martyr's Crown. Madrid, Fundación Lázaro Galdiano, Inv. 15289, fol. 300ᵛ (II Timothy)

315 (*above, right*) Paul Promises the Martyr's Crown. Bologna, Bibl. Univ., MS 297, Vol. II, fol. 62 (II Timothy)

316 (*below, right*) Paul Promises the Martyr's Crown. Toledo Cathedral Lib., *Bible Moralisée*, Vol. III, fol. 147

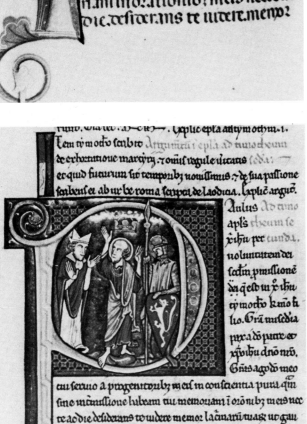

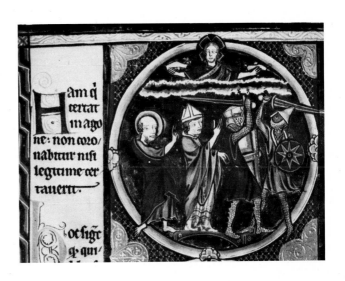

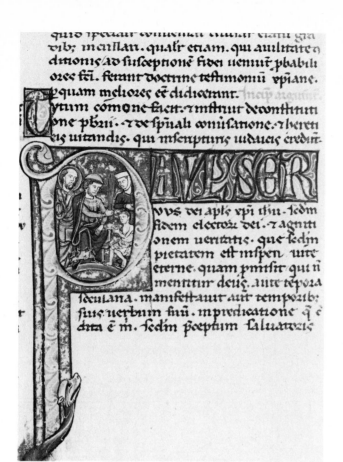

317 (above) The Duties of Various Ages and Classes.
Göttweig, Stiftsbibl., MS 55, fol. 272ᵛ (Titus)

318 (right) The Duties of Various Ages and Classes.
Vatican Lib,. MS Rossiana 314, fol. 467 (Titus)

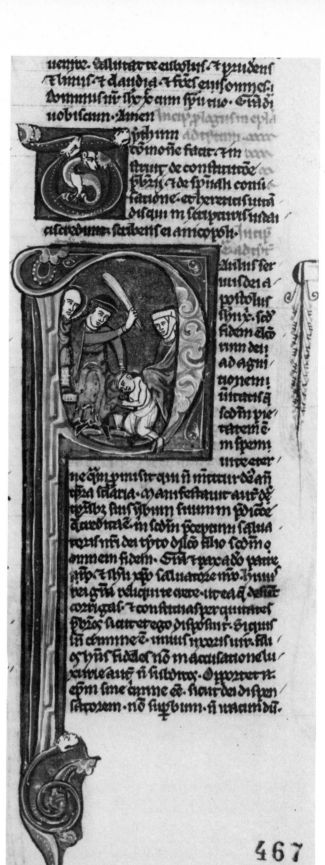

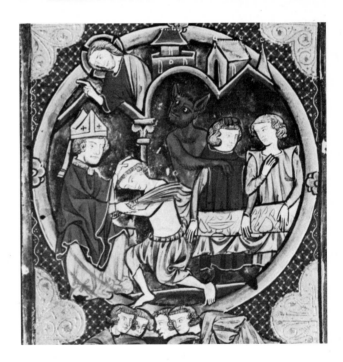

319 (*above, left*) The Duties of Various Ages and Classes. Bologna, Bibl. Univ., MS 297, Vol. II, fol. 63 (Titus)

320 (*above, right*) The Duties of Various Ages and Classes. Paris, Bibl. Ste. Geneviève, MS 1180, fol. 353 (Titus)

321 (*below, right*) Mark 5:15–18 moralization. Toledo Cathedral Lib., *Bible Moralisée*, Vol. III, fol. 25

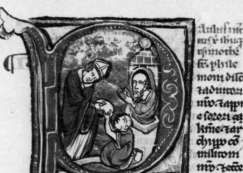

322 (*above*) Paul Advocates Christian Charity.
Göttweig, Stiftsbibl., MS 55, fol. 273 (Philemon)

323 (*right*) Paul Advocates Christian Charity.
Bibl. Vaticana MS Rossiana 314, fol. 468 (Philemon)

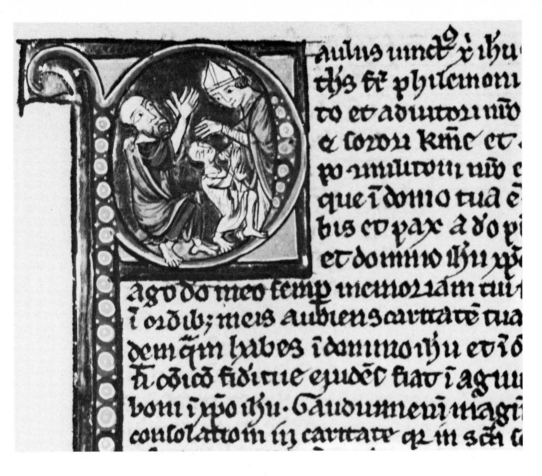

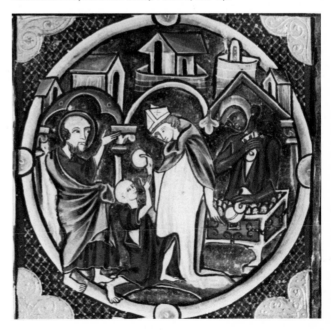

3.27 (*above*) Paul Speaks to the Jews. Göttweig, Stiftsbibl., MS 55, fol. 273ᵛ (Hebrews)

3.28 (*right*) Paul Triumphs over Synagogue. Paris, Bibl. Ste. Geneviève, MS 1180, fol. 353ᵛ (Hebrews)

329 Christ and a Saint. Bologna, Bibl. Univ., MS 297, Vol. II, fol. 64 (Hebrews)

330 Two Saints. Cava, Bibl. Mon. Naz., MS 33, 'Guido Bible', fol. 456ᵛ (Hebrews)

331 Paul Speaks to a Jew. Nantes, Mus. Dobrée, MS VIII, Vol. II, fol. 543ᵛ (Hebrews)